E. DALE SAUNDERS

MUDRĀ

A STUDY OF SYMBOLIC GESTURES
IN JAPANESE BUDDHIST SCULPTURE

BOLLINGEN SERIES LVIII

PRINCETON UNIVERSITY PRESS

Published by Princeton University Press, 41 William Street,
Princeton, New Jersey 08540

In the United Kingdom: Princeton University Press,
Guildford, Surrey

First Princeton Paperback printing, 1985

LCC 59-13518 ISBN 0-691-09796-8 ISBN 0-691-01866-9 (pbk.)

THIS IS THE FIFTY-EIGHTH IN A SERIES OF BOOKS SPONSORED BY
AND PUBLISHED FOR BOLLINGEN FOUNDATION

Text designed by Andor Braun

Clothbound editions of Princeton University Press books are printed on acid-free paper,
and binding materials are chosen for strength and durability. Paperbacks, while
satisfactory for personal collections, are not usually suitable for library rebinding.

Printed in the United States of America by Princeton University Press,
Princeton, New Jersey

BOLLINGEN SERIES LVIII

TO MY PARENTS
Ernest D. Saunders
Mélanie Douhet Saunders

Mudrā: A PICTORIAL INDEX

Mudrā: A PICTORIAL INDEX

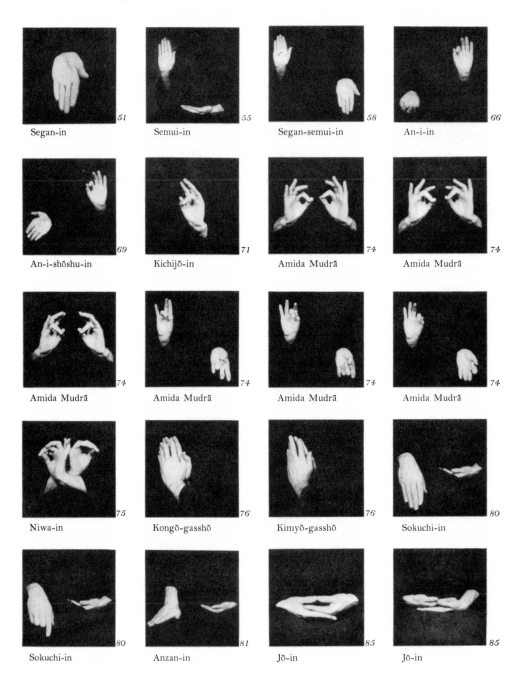

51	*55*	*58*	*66*
Segan-in	Semui-in	Segan-semui-in	An-i-in
69	*71*	*74*	*74*
An-i-shōshu-in	Kichijō-in	Amida Mudrā	Amida Mudrā
74	*74*	*74*	*74*
Amida Mudrā	Amida Mudrā	Amida Mudrā	Amida Mudrā
75	*76*	*76*	*80*
Niwa-in	Kongō-gasshō	Kimyō-gasshō	Sokuchi-in
80	*81*	*85*	*85*
Sokuchi-in	Anzan-in	Jō-in	Jō-in

The eight principal and six secondary symbolic gestures, with variants. The numbers indicate the pages of the text where each mudrā is discussed.

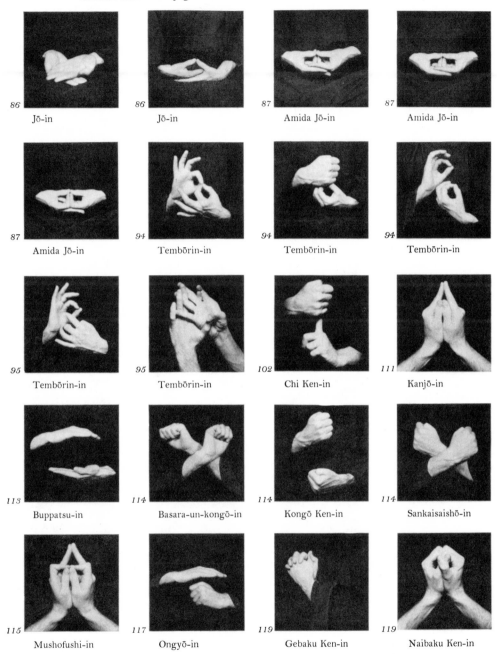

86 Jō-in

86 Jō-in

87 Amida Jō-in

87 Amida Jō-in

87 Amida Jō-in

94 Tembōrin-in

94 Tembōrin-in

94 Tembōrin-in

95 Tembōrin-in

95 Tembōrin-in

102 Chi Ken-in

111 Kanjō-in

113 Buppatsu-in

114 Basara-un-kongō-in

114 Kongō Ken-in

114 Sankaisaishō-in

115 Mushofushi-in

117 Ongyō-in

119 Gebaku Ken-in

119 Naibaku Ken-in

PREFACE

THIS INTRODUCTION to the study of mudrā was begun in 1949. It was originally hoped that the entire range and variety of gestures could be organized and presented in a way which would make them accessible to the student of Buddhist iconography. But as research progressed, it became apparent that a definitive treatment would be a very long task. The problem was complicated by the diversity of traditions concerning the gestures and the contradictory sources that often make general classifications hazardous. I decided, however, that a preliminary study, despite its limitations, might be of service for the history of Far Eastern art in general and for Japanese sculpture in particular. The following pages are presented as an aid to the student of iconography in organizing in a general way the common symbolic gestures that occur in Far Eastern art. Since this study is based largely on sources that may not be readily accessible, linguistically, to the average student of iconography, and since it has been necessary to use a number of hitherto unfamiliar terms, an attempt has been made to facilitate the use of the material by means of a pictorial index, the use of which requires no previous knowledge of the nomenclature. Above all, I should like to emphasize the introductory quality of this work. The text is general in nature; the greater part of the scholarly comment is brought together in a body of notes at the end of the volume, which will be of use and interest particularly to the specialist. It is my hope that the present work will inspire others to undertake more detailed studies of these symbolic gestures.

I am indebted to a number of friends and colleagues for assistance and advice. First, I should like to mention my former professors Dr. Jane

Gaston-Mahler, of Columbia University, and the late Dr. Alfred Salmony, of New York University, who gave ceaselessly of their help and encouragement.

I should like to express my thanks as well to Dr. Louis Renou, professor at the Sorbonne, who most graciously accepted the chairmanship of my doctoral committee, and to Dr. Jean Filliozat, professor at the Collège de France; both of these scholars permitted me to benefit by their numerous and valuable suggestions. Most particularly I should like to express my appreciation to Dr. Charles Haguenauer, Directeur d'études at the Ecole des Hautes-Etudes, who has taken a constant interest in my work, encouraged me, and given me the benefit of his numerous corrections both of ideas and of form. I am indebted to him for numerous additions to my text.

I am most grateful, too, for the help I received from Japanese associates during my stay in Japan in 1953–55: particularly to Nakagawa *inge* of the Shinnō-in, Kōya-san, and to Matsumoto Isamu, who were instrumental in facilitating my visit to Mount Kōya and my studies there.

For assistance and courtesy in the collecting of photographs I am indebted to several persons: Mr. Gregory Henderson, Mr. A. B. Griswold, Mr. Frank Caro, Mr. J. R. Belmont, Mr. V. L. Devkar (Baroda Museum), Mr. P. C. Sestieri (Archaeological Survey of Ceylon), Mrs. Emily H. Tupper (Seattle Art Museum), Mr. Usher P. Coolidge (Fogg Art Museum), Mr. T. Ishiguro (Benridō Company), Mr. John A. Pope (Freer Gallery of Art), Mr. Sherman E. Lee (Cleveland Museum of Art), Miss Eleanor Ferry (Detroit Institute of Art), Dr. Alexander Soper (New York University, Institute of Fine Arts), and Miss C. Louise Flesch (*Artibus Asiae*, Ascona). Most of the photographs were originally in Professor Salmony's picture collection.

Finally, I wish to express my profound gratitude to many devoted friends who assisted me in perfecting the text: above all, Denise Krasnoff, my loyal adviser in preparing the first draft; and Ardelle Coleman, Charlotte Chadwick, and Joanne Palmer, who spent many hours with me

poring over my translations. Most particularly I wish to thank my dear friend Bernard Frank, from whom I have always received unfailing help and scholarly advice. My sincere thanks go to the officials of the Musée Guimet, who facilitated my initial research; to Mark Hasselriis, for his diagrams and drawings, both from published works and from life; to Jeanyee Wong, for her calligraphy; to Dr. Schuyler Cammann and Dr. Ernest Bender, for their patience with my endless questions; and to the Bollingen Foundation, to which I am deeply indebted for the publication of this work.

New York, July 2, 1959 E. D. S.

CONTENTS

LIST OF PLATES

LIST OF TEXT FIGURES

with yellow eyes, chews its lips; the middle one is blue and expresses the Compassion of the god. The attributes are: left, wheel, trident, lasso; right, three-pronged *vajra*, baton, *vajra*-sword. After Gonda and Ōmura, p. 91, fig. 295.

NOTE ON PRONUNCIATION

THE PRONUNCIATION of JAPANESE words is very simple: the vowels are like those in Italian and the consonants like those in English (*g* is always hard). There are no silent letters (e.g., *semui-in = se-mu-i-in*).

In the pronunciation of SANSKRIT words, the accent usually falls on the penult when it is long, otherwise it shifts to the next preceding long syllable. Long syllables contain vowels bearing a macron (e.g., *ā*), diphthongs (and *e* and *o*), and vowels followed by two or more consonants (except *h*). The following list of equivalents is based on the one given in de Bary, ed., *Sources of Indian Tradition*, p. xiv:

a	as *u* in *but*	e	as *é* in *cliché*	th	as *th* in *anthill*
ā	as *a* in *father*	ai	as *ai* in *aisle*	kh	as *kh* in *blockhouse*
i	as *i* in *pin*	o	as *o* in *go*	gh	as *gh* in *doghouse*
ī	as *i* in *machine*	au	as *ow* in *how*	dh	as *dh* in *roundhouse*
ṛ (vowel)	as *er* in *river*	c	as *ch* in *church*	bh	as *bh* in *clubhouse*
u	as *u* in *pull*	ś, ṣ	as *sh* in *shape*	ph	as *ph* in *uphill*
ū	as *u* in *rule*	g	as *g* in *get*	ṃ (ṅ)	as *ng* in *sing*

In pronouncing CHINESE words, it will be sufficient to observe the following equivalents. Aspiration is indicated by an apostrophe, and aspirated letters are followed by a strong puff of breath.

a	as *a* in *father*	p	as *p* in *spy*
ai	as *ai* in *aisle*	p'	as *p* in *pie*
au	as *au* in *sauerkraut*	t	as *t* in *sty*
e	as *e* in *error*	t'	as *t* in *tie*
ei	as *ei* in *eight*	k	as *k* in *sky*
u	as *u* in *rule*	k'	as *k* in *kite*
ou	as *ou* in *soul*	ch	as *j* in *jute*
i	as *i* in *machine*	ch'	as *ch* in *church*
final ih	as *er* in *corner*, with the tip of the tongue curled far back	hs	as *sh* in *ship*, with slight initial aspiration
		ts	as *ts* in *tsetse* fly
		initial j	as *s* in *pleasure*, with the tongue tip curled back

I

Introduction

I Preliminary

THE SYMBOLIC GESTURES called *mudrā* [1] may be divided, despite the multiplicity and confusion of traditions, into two general groups: mudrā in the sense of signs symbolic of the metaphysical aspect of Esoteric ceremonies; and mudrā used, particularly in iconography, to evoke a specific episode of the Buddhist legend or to identify divinities.

The gestures of the first group are "ritual"; they form an integral part of religious ceremonies. When they are made by the priest, the rapidity of their execution as well as the fact that they are often made under the stole may render them imperceptible to the eyes of those present. Under this heading belongs the greatest number of mudrā. For example, the *Si-do-in-dzou*,[2] a manual intended for the edification of the Shingon practician, lists 295: 164 for the Matrix World (*taizōkai*) and 131 for the Diamond World (*kongōkai*). But numerous repetitions both of form and of nomenclature are at once apparent.

The mudrā of the second group, the "iconographic," have multiplied greatly in sculpture and in painting, especially in the graphic representations of the cosmos called *maṇḍala*. For example, in the VI century of the Christian era, the *Murimandarajukyō*,[3] probably the first sūtra to codify the formation and the use of the mudrā, does not mention more than sixteen; [4] yet with the passage of hardly a century, the *Daranijikkyō* [5] lists more than three hundred. Among these mudrā, many belong to what may be considered lesser divinities, and these are, consequently, of secondary importance. Only about fifteen are of sufficient interest to make a study of them particularly useful for students of Buddhist iconography.

These are the mudrā of the principal personages of the Buddhist pantheon. But they are also the principal mudrā of the greater part of Far Eastern art.

In sculpture, the great diversity of mudrā is reduced to a few basic gestures.[6] Consequently, it is specifically Japanese sculpture which has been chosen as the basis of this study, for Japan is the end point in the development of the Buddhist tradition, and Japanese Buddhist art is illustrative of iconographic mutations at the extreme limit of Buddhist expansion.

It is easy to see that the study of all existing mudrā would overwhelm the scholar with a profusion of secondary details. For the identification of rare or special mudrā, then, which do not figure in the present text, reference should be made to the specialized works indicated in the notes.[7]

2 Definition of Terms

A GREAT RANGE OF OPINION as to the interpretation of the term "mudrā" exists among authorities in the field of Buddhist iconography. Most of them converge toward a dominant idea contained in the original word: that of a hand pose which serves as a "seal" either to identify the various divinities or to seal, in the Esoteric sense, the spoken formulas of the rite. Coomaraswamy [1] calls the mudrā "an established and conventional sign language"; Rao,[2] "hand poses adopted during meditation or exposition"; Woodward,[3] "finger-signs." The translation in the *Si-do-in-dzou* [4] is *"geste mystique"*; in the *Bukkyō Daijiten*, "the making of diverse forms (*katachi*) with the fingers." Soothill [5] defines them as "manual signs indicative of various ideas." According to Getty,[6] the mudrā is a "mystic pose of the hand or hands." According to Eitel, "a system of magic gesticulation consisting in distorting the fingers so as to imitate ancient Sanskrit characters, of supposed magic effect." [7] The use of mudrā was introduced into Japan by Kōbō Daishi, and they are used chiefly by the Shingon sect.[8] Franke [9] proposes as a translation of mudrā *"Schrift (oder Lesekunst)"*; Gangoly,[10] "finger plays"; and last of all Beal,[11] "a certain manipulation of the fingers . . . as if to supplement the power of the words."

All these opinions, inspired by the Sanskrit word, reveal a diversity that could be explained only with difficulty if the word itself did not include various meanings. The etymology of the term "mudrā," a depository of varied significations, is interesting and useful to know; one may note in this fundamental word the elemental principle which serves as a

basis for the names of the symbolic gestures that pullulate throughout Esoteric Buddhism.

It is difficult to follow very exactly the evolution [12] of the word "mudrā," the origin of which remains uncertain. Hommel would see in it a derivation from the Assyrian *musarū*, a seal used in writing; this word, undergoing in Old Persian the change of *z* to *d*, would show the following evolution: *musarū* = * *muzrā* = *mudrā*.[13] Such an evolution is at most hypothetical,[14] and scholarly research in this realm has remained inconclusive. Appearing first in the post-Vedic literature of India, at a very early period the word "mudrā" designates the idea of a seal or the imprint left by a seal. Onto this idea have been grafted various meanings: mark (in a general sense or in the sense of a mark produced by a seal), ring (i.e., seal ring), passport, sign, and last of all "piece of money" struck by means of a seal.[15] Certain modern Indian dialects [16] still keep this last meaning. In Esoteric rites, the word takes on the meaning of "way of holding the fingers," an expression which carries a special interest because it designates very precisely the ritual gesture. The Esoteric sense is not so far from the meanings just mentioned as one might be tempted to believe, for the various symbolic gestures formed by the fingers are, in a certain sense, equivalent to a kind of mystic gesture meant to guarantee the authenticity or efficacy of the rites.[17] In this religious sense, the gesture had already in the Vedic period taken on an importance at once magical and ritual. It served to indicate by its vertical movement the accents of the words of the rite.[18] Here it was a question of an essentially grammatical use, which, nevertheless, presages the later development of the symbolic, iconographic gesture. Even in later times, always in close relationship to the spoken word, the gesture was enhanced with mystic and magical values.

To these definitions may be added also that of the Pāli *muddikā*, which derives from *muddā* (authority).[19] A balanced relationship exists between the command and royal authority, between the stamped amulet and divine authority, and above all between the ritual gesture and magic

power.[20] A later contribution of Tantrism should also be noted: mudrā as *śakti*,[21] the feminine counterpart of a god.

All of these interpretations [22] may be summarized by the following categories:

1 seal (and the imprint left by a seal); whence, stamp, mark (in a general sense or the mark made by a seal), piece of money, etc.;

2 manner of holding the fingers; [23]

3 counterpart (*śakti*) of a god.[24]

At first glance, the three groups would seem to be quite distinct from each other. But Przyluski points out a most interesting connecting thread which unites them. Beginning with the idea of "matrix," which he compares to a mold used for the printing or stamping of objects, he establishes a relationship between meanings 1 and 3. This is, in effect, the one which exists between the matrix of a woman in which is formed the embryo of the child she will bear, and the seal which impresses on the piece of clay its form or design. The same bond exists between the second meaning — i.e., symbolic gesture — and the other two, if one accepts that the position of the hands constitutes, to a certain extent, a mystic seal.

Among the various meanings of the word "mudrā" in Sanskrit, the idea of sign as a seal is predominant in Esoteric thought. This notion crossed the frontiers of India with the *vajrayāna* and spread to China and later to Japan. In effect, it was by the Chinese word *yin* (Sino-Jap. *in*), "seal," that the first translators were likely to render what seemed to them the dominant meaning of "mudrā" in the canonical writings. Thus it is that the diverse compounds designating mudrā which are frequently met with in Sino-Japanese compounds all contain the vocable *in*. Among the most important are *shu-in, kei-in, mitsu-in, sō-in, in-gei, in-sō*, and simply *in*.[25] On the other hand, certain authors or translators, anxious to note the Sanskrit word more precisely than the single ideogram *in* would permit, used Chinese characters phonetically in an attempt to reproduce the syllables "mu-da-ra." [26] Such transliterations of the Sanskrit

word are doubtless richer in content from the technical and religious aspect than a simple translation. Yet the word "mudrā" itself had probably been drained of meaning for most non-Indian readers, and the ideogram *in* came largely to express the totality of the idea.

The notions expressed by the Chinese ideogram (*yin*) at the time Buddhism borrowed it may be traced far back in Chinese history. As early as the Shang dynasty, ideograms as probatory seals, so to speak, were impressed on bronzes. Even today, whether in art, in literature, or in daily affairs, the seal stands as testimony to the authenticity of the document to which it is put. Thus since ancient times it has played a main role, sanctioned by Chinese tradition and by usage — and likewise in Japan, where the Chinese concept was transferred. It is not surprising that a notion as deeply rooted in the native tradition [27] should have been so easily adapted to expressing the religious traits imposed on it by Esoteric Buddhism. Just as the "seal" (*yin*) guarantees the authenticity of documents,[28] the mudrā (*yin*), on a mystic and religious level, eliminates any possibility of lie or of error. To make the mudrā is to recognize the authenticity of the doctrine as well as the power and the efficacy of the ritual magic. The gesture is a sign, a ritual seal; seal implies authenticity, and, by analogy, the efficacy of the mudrā stands in direct proportion to absence of error.[29] The mudrā, whose value is determined by the doctrine,[30] serves to "fix" the magic of the rite. Hence the word "*in*" takes on the meaning of a fixed resolution,[31] for it is, in fact, the gesture which makes it possible to "sign," to seal with a metaphysical cachet, the solemn "contract" of the ritual. "It is the sign of a pact, of a solemn contract which binds the officiant to the world of the divinity and which permits him to become integrated into this world." [32] Accompanying the mystic formulas (*dhāraṇī*), the mudrā guarantees the absence of error (assuring the right path) and the efficacy of the mystic words. All these ideas are based on ancient Indian concepts, and "too much emphasis cannot be placed on the fact that 'mudrā' always implies the idea of name (*nāma*) and of form (*rūpa*) which, according to Indian theories, are eminently productive of strength, of force, and of efficacy." [33]

The term *"in"* lent itself early to broad interpretation.[34] Beginning with the original meaning of seal, as a sign or mark which identifies, *in*, in the sūtras, notably in those of Esoteric Buddhism (cf., *Dainichikyō*, ch. 9), refers not only to the symbolic gestures of the hands but also to the objects, the attributes, which the Buddha and the Bodhisattva hold.[35] Thus, *"in"* designates, for example, the lotus, the sword, the stūpa — in brief, all the attributes of divinity by which the original vows of the Buddha and the Bodhisattva are symbolized.[36] They are all, as it were, marks of divine identity; in this concept reappears the original meaning of the word "mudrā." To these two meanings of *"in"* — gesture and symbolic attribute — may be added finally that which designates even the mystic formulas (*dhāraṇī*) [37] and the images of the Buddha. It is a matter then, with respect to the Sino-Japanese term, of a phenomenon of extension analogous to what has been noted for the Sanskrit term. Just as the notion of matrix is a connecting thread binding the various meanings of "mudrā," the idea of sign binds the three significations of *"in"*:

1 symbolic gestures of the hands used as "seals," which guarantee the efficacy of the spoken word;

2 the symbolic objects, as well as the images and the statues, which are used as "marks of identity";

3 *dhāraṇī*, spoken formulas, which "seal" the magic of the rites.

3 Origins and First Representations

T HE STUDENT OF ICONOGRAPHY is confronted by numerous more
or less plausible explanations of the origins of the symbolic ges-
tures. Toganoo Shōun [1] claims that the ritual and iconographic mudrā
derive from natural gestures made under certain conditions, representing
for the most part homely actions, such as calming by raising the hand,
offering a gift by extending the arm, and so on. Renou adds: "It is sup-
posed, without great reason, that the mudrā were inspired by the written
form of the initial letter of a mantra." [2] Whatever their origin may be,
in Esoteric Buddhism these gestures assume metaphysical meanings, and
they multiply infinitely under the effect of Tantrism. As an iconographic
symbol (Sk. *pratīka*), the mudrā was to come into existence at about the
same time as the beginning of the Christian era. It seems to have accom-
panied, moreover, the appearance of the image of the Buddha. [3] It was a
question then of several "poses" of the hands, which were specially
intended to establish the symbolic character of statues by recalling certain
episodes of the Buddhist legend. First, these gestures were related only
to the life of the historical Buddha; later, under Tantrism, they formed
the point of departure for an evolved symbolism. With the development
of Esotericism, they became endowed with clearly magico-religious
values. But the question of what distant sources Buddhism had drawn
upon for a system of gestures is difficult to resolve. The fact is, at the
time of their entrance onto the stage of iconography, these gestures had
undergone a long evolution. This is manifest in the stereotyped forms
they assumed in the first Gandhāran statues of India. There is no doubt

that, from a very early time, "the theory of mudrā must have covered a wide range, for the *Mañjuśrīkalpa*,[4] the *Mahāvairocana-sūtra*, and the *Guhyasamāja*[5] presuppose the knowledge of numerous gestures."[6]

According to the Indian tradition, the dance was conceived and transmitted to the people by Brahmā. In the first chapter of the *Nātya Śāstra* of Bharata, we read:[7] ". . . turning away from Indra, he who knows the essence of every matter, seated in Yoga posture, called to his mind the Four Vedas, thinking, 'I shall make a Fifth Veda, to be called Nātya (Drama), combined with epic story, tending to virtue, wealth (pleasure and spiritual freedom), yielding fame — a concise instruction setting forth all the events of the world about to be, containing the significance of every Scripture, and forwarding every art.' Thus, recalling all the Vedas, the Blessed Brahmā framed the Nātya Veda from the several parts of the Four Vedas,[8] as desired. From the Ṛg Veda, he drew forth the words, from the Sāma Veda the singing, from the Yajur Veda gesture, and from the Atharva Veda the flavor."

The mention of the choreographic or dramatic gesture in this traditional literature[9] attests the important place of this type of symbol at an early date. But one may say even more, for since time immemorial, the dance has been a spontaneous mode by which man has expressed the magic and the mystery of the primitive rite. Undeniably, even in pre-Buddhist times, choreography had an important place in the primitive religion of India. The use of the gesture to express both religious and secular ideas must go back to some ancient source closely connected with the primitive dance, which, it would seem, furnishes the prototype of the iconographic and ritual gesture of later times.

At a very early date, dance gestures must have acquired a religious usage. They were integrated early into a ritualism which, while depriving them of their former freedom, imposed on them a hierarchy, a classification according to cult, which tended to stabilize them through centuries of visual transmission. For the needs of worship, later religions had only to adapt the choreographic gesture to their rites; the idea as well as the form of the hand movements had already existed for a long time.

But the mere fact that the dance existed as early as the Vedic period offers no indication as to what point the symbolism and the form had been stylized. Moreover, the part of the dance and of dramatic art in the stylization and the transmission of the mudrā is difficult to define. The mudrā, which is of the domain of movement, constitutes in iconography an "active" symbol, marking, to some extent, the end point of an evolution which began with the initial idea of choreographic rhythm. These gestures which accompany the dance are an integral part of the rhythmic expression. But what is more, since they could be seen rather distinctly from afar, they constituted already in the dance a conventional method of expression which supported the word or the song. The materialization of these gestures in iconography, through the intermediary of the rites, tended to blur their former rhythmic character, and this passed necessarily onto a secondary level. Nevertheless, it remains that "the elementary hand gestures of the divinities in iconography are no more than *mudrā* in an undeveloped state." [10]

It is hardly within the scope of this study to retrace the origins of the dance, though subsequent research may tend to clarify whatever influence choreography may have exercised in the early formation of the gestures in both the Brahmanic and Buddhist art of India. It may suffice here to remark that the form, the artistic rhythm, even the symbolism of Buddhist statues are a visual manifestation of the unquestionable bond which united iconography and the dance. These gestures, an integral part of the Indian patrimony, were adopted by Buddhism. They constituted a group of symbolic movements with a magico-mystical value which never ceased to be perceptible but which, somewhat blurred during the period of the Gandhāran sculptures, underwent a revival of importance in Tantrism, which exploited them rather than discovered them. There remains, unfortunately, no sculptural example from the early pre-Buddhist period which would enable the scholar to trace infallibly the evolution of the mudrā during those primitive times.

The preponderant function which Esoteric Buddhism bestowed upon the mudrā seems, in fact, to have been only a continuation of the "imme-

morial magical ritual language" (Renou) which they constitute. In the
Veda, they are used to note accentuation and, in the schools of the gram-
marians, the rhythm of words.[11] In Vedic Sanskrit, the fingers are as-
signed definite roles: for example, the thumb, by virtue of its form, which
resembles the lingam, represents Bhairava, the redoubtable aspect of
Śiva; the middle finger represents Caṇḍikā, the violent aspect of Durgā.[12]
For the enrichment of the mudrā, at least, Brahmanism [13] served as a
convenient and permanent treasure house to the needs of Buddhist ico-
nography. Buddhism, inheriting the mudrā, bestowed upon them new
and mystical meanings according to its own genius.[14]

A well-known *jātaka* of the V century attests the use of mudrā in the
earlier lives of the Buddha. "Śākyamuni met a woman whom he con-
sidered taking for wife: not knowing, however, whether she was un-
married, he resolved to ask her at once 'by a gesture of his hand' (*hat-
thamoddāya* in Pāli). If she is educated, he thought to himself, she will
understand and answer me. Thus he raised his closed fist, and the woman,
in order to answer, showed him her empty hand." There is no doubt,
remarks Auboyer, that the Bodhisattva was already practicing an estab-
lished usage, the conventional modalities of which were well known at
the time of the composition of the *jātaka*.[15]

Generally, the origins of Indian sculpture are assigned to the III
century B.C. It was at this time, in Mathurā, that Indian iconography had
its beginning. Thenceforward, the cult element became more and more
important. It is well to remember that the representation of the historical
Buddha in human form first took place about the II century of the Chris-
tian era. Until then, the Buddha had been represented by symbols, such
as the wheel of the Law, the throne, the pillar, or the tree; [16] the omission
of the Buddha image itself was imperative,[17] proscribed as it is in several
passages of the Buddhist canon.[18]

As soon as the need of a representation was felt, the "image" was
developed in two places: Gandhāra, in northwest India, and Mathurā,
on the banks of the Jumna River. In the heart of the Kuṣāṇa empire,
Gandhāra, the statues representing the Buddha were executed by men

13

who were the inheritors of the anthropomorphic ideal of the Greeks and Romans.[19] From this leaven resulted images of the Buddha which recall the Hellenistic type of Apollo the Orator that ultimately inspired it. This initial Greco-Roman influence was of profound consequence. Indeed, the statues produced by the Gandhāran school drew their inspiration from both Greco-Roman and Indian sources. From the first the Gandhāran school borrowed the human form, from the second the complex symbolism which, even at the beginning of the Christian era, existed in India. So it was that the Buddhist art of Gandhāra found itself playing an intermediary role between Greece and India on the one hand and the whole Far East on the other: the sculptural mudrā were adopted by Buddhism and propagated across Asia along with the expansion of this religion.

Gandhāran iconography was born of an extremely involved metaphysical system. The Buddhist image of these northwest regions developed in a direction situated halfway between Greek art, which was in the "margin of realism," and Indian naturalism. Despite the Greek influence, Indian naturalism predominated; and the statues of the historical Buddha, consequently, even though taking the form of a man, were never intended to represent an anatomical unit capable of functioning. Thus, at the very beginning, Buddhist sculpture draws on a group of symbols long established according to a conventional stylization.[20] The head, for example, takes the form of the perfect oval of the egg; the eyebrows, that of the curve of the Indian bow; the eyes, that of the lotus bud; the ear, that of the graphic form of a certain Sanskrit character; and the neck, with its three folds, that of the conch shell. The wide breast and narrow waist are taken from the body of the lion, on which is superposed the head of the bull; the arm is the elephant's trunk; the hands, lotus petals, etc.[21] The symbol in Buddhist statues and other images is not an "afterthought" intended to add to the meaning of the work, but an integral part of the representation. Thus, while the Greeks in representing their divinities tried to bring to perfection the anthropomorphic ideal, the Indians in representing the Buddha conceived purely intellectual creations. This accentuation of the symbolic aspect of images was naturally to favor the development of iconographic signs as symbols.

In the early times (that is, in Gandhāra) of the utilization of the mudrā in Buddhist art, no definite prescription seems to have established the precise value of the symbolic gestures.[22] Rules developed little by little, especially toward the middle of the first millennium of the Christian era. With the birth of the *vajrayāna* (Esotericism), the mudrā were subjected to formalization and impregnated with a symbolism at once metaphysical and magical. It is not surprising then that the few mudrā which figure in the Greco-Buddhist art of northwest India have a multiple utility. For example, a single mudrā, the *semui-in* (*abhayamudrā*), may be [II used for the receiving of gifts or homage, the expression of welcome, the subjugating of the elephant, the Predication of the Doctrine, and even the turning of the wheel of the Law.[23] The different roles of the personages performing this gesture are made perfectly clear either by attributes — e.g., the wheel and the gazelles indicate the Predication of the Law — or by the presence of the gesture within a specific symbolic framework. On the other hand, if one gesture alone may play several different roles, a specific episode of the Buddhist legend may be symbolized by several mudrā. In order to represent the Predication of the Law,[24] for example, the Gandhāran Buddha may form very different symbolic gestures: the *jō-in*, which was to represent later the entrance of the Buddha into profound meditation; the *semui-in*, mudrā of the Gift of Intrepidity; even the *seppō-in* (*tembōrin-in*), which alone would indicate, when the use of the [XI, XII mudrā was more definitely established, the act of preaching or disseminating the Law.

Nevertheless, in Gandhāran art, one may already notice the habit of assigning certain mudrā to certain personages, doubtless in order to differentiate among the various Buddhas and Bodhisattvas: these mudrā later became each the characteristic attribute of such and such a one among them. With time, usage became more exact, for the plethora of Esoteric divinities required a more precise means of identification than was provided by the comparatively few Gandhāran mudrā. The *semui-in* finally limited itself to representing the absence of fear; the *segan-in*, charity; the *tembōrin-in*, the Predication of the Doctrine, etc. In Gandhāra, however, Buddhist sculpture did not seem to have come out of what Foucher

calls *"la période flottante"* which characterized the origins of Buddhist iconography.

The uncertainty of Gandhāran usage, however, was rapidly to give way to the codification imposed by the genius of Esotericism. Consequently, the Tantric school, which presides over the modifications of the gestures, or better, over their expansion, plays a central part in the evolution of the mudrā.

4 The Contribution of Tantrism

A T THE BEGINNING OF THE CHRISTIAN ERA, the role of the mudrā in Buddhist symbolism derives from traditional Buddhism, but it is to Tantrism [1] that it owes a fuller development. Probably toward the middle of the first millennium A.D., the Yogācāra master Asaṅga (Sino-Jap. Mujaku: c. 350) had already conceived a mystic doctrine founded at once on Yoga practices and on the principal ideas of Mahāyāna Buddhism. This doctrine was elaborated in a vast body of religious texts known generically as *tantra*. They were largely devoted to the exaltation of the Goddess. And along with a number of lateral teachings, both philosophic and cosmogonic, they contained numerous elements (*dhāraṇī*, mudrā, etc.) which were in large part secret and were practices intended to assure the identification of the faithful with the Supreme Unity.[2] This type of belief, appearing in the IV century and reaching its apogee in the VIII, evolved in two main currents, which are known as Left-handed and Right-handed Tantrism. Left-handed Tantrism, to which the term *vajrayāna* is usually applied, postulates feminine counterparts of the Buddhas, Bodhisattvas, and other divinities, places emphasis on these "Savioresses," or Tārās, as they are called. They are believed to represent, among other things, the active aspect of their masculine counterpart. The unification of the pair is symbolized by the sexual act. Right-handed Tantrism, on the other hand, emphasizes devotion to masculine divinities; and, although great importance is attached to magical practices, this branch of Tantrism has largely avoided the extremism in act and symbol characteristic of the Left-handed type.

Right-handed Tantrism spread to China, and then on to Japan, where today it is alive in the form of the Shingon school. It is particularly to the Right-handed branch that the word "Esoteric" refers in the following pages. This style of Buddhism, which places great importance on magic formulas, is sometimes known in Sanskrit as the *Mantrayāna*. At the earliest stage of Tantrism, the mudrā, going beyond its simple role of a sign evocative of the Buddhist legend (as in Gandhāra), possessed powers at once mystical and magical. Esotericism did not limit itself to making the gestures a metaphysical symbol but, by allotting them a very important place in the cult, it saw in the mudrā the active bond by which the *dhāraṇī* and the *mantra* (mystic formulas) might permit the worshiper to identify with the Supreme Unity.

The sage Vajrasattva (Sino-Jap. Kongōsatta), dwelt in an iron tower in the south of India. According to the Sino-Japanese tradition, it was to him that Vairocana himself transmitted the secret doctrine of the Esoteric school. In the venerable line of patriarch-transmitters of the Law, it was Vajrasattva who must have taught the *maṇḍala* of the two parts (*kongōkai* and *taizōkai*) to Nāgārjuna (Sino-Jap. Ryūju; II century A.D.), who, in his turn, is said to have transmitted it to his disciple Nāgabodhi. Nāgabodhi passed the doctrine on to Vajrabodhi (Kongōchi), who taught it to Amoghavajra (Fukū), the founder of the Esoteric sect (*mi-tsung*) in China.

In 719,[3] Vajrabodhi, accompanied by his disciple Amoghavajra,[4] traveled to China, and there introduced the Esoteric system. At the beginning of the IX century, the Buddhist monk Kūkai [5] (Kōbō Daishi) left Japan in order to study the doctrine under the great Chinese master, Hui-kuo [6] (Kei-ka Ajari), a disciple of Amoghavajra. Upon returning to Japan in 806, Kūkai founded the Shingon sect; and in 816, he established its seat on the wooded summit of Mount Kōya, not far from present-day Osaka. Thus the Esoteric school, grafted onto Mahāyāna Buddhism in the IV century under the inspiration of Asaṅga, spread in less than four centuries over the greater part of Far Eastern Asia, culminating in Japan, where it is still an active sect.[7]

The Tantric Vehicle, assuming organized form in India about A.D. 600, drew upon the metaphysics of the Greater Vehicle; it accentuated the syncretistic tendencies. The basic idea of Esoteric Buddhism, upon which rests the magico-symbolic superstructure, is the concept of the Three Mysteries: [8] thought, word, and act. They represent three ways of approaching the ONE and are three inseparable aspects of the Great Unity. Equivalent each to the other, they are united in every phenomenon of the ordinary world. The doctrine of the Three Mysteries "maintains that thought, word, and activity are only different expressions for one and the same reality, for in the great Oneness reigns equality and identity 'in the same way that the ocean has everywhere the same salty taste.' The doctrine of the fundamental unity (*samatā*) of the three actions is a dogma essential to Esotericism, for it alone permits one to consider as equivalent, or even as identical, meditative imaginations, mystical formulas, and exterior, material things; such is the condition required for all practical activity of a magical nature." [9] The mudrā, thanks to this triple unity, were endowed with an importance equal to the True Word: they were checks, guarantees of transmission. Three-in-One, All-One, equivalence of the Three Mysteries and consequently of all reality—these are the very essence of the Tantric teaching.

It was toward the VII century that the religious books known as *tantra* [10] made their appearance. They are manuals,[11] so to speak, which concern themselves with the accomplishment of the rites, with the establishment of the *maṇḍala*, and with the elaboration of statues. In a certain sense, they are actual iconographic collections. The tantras may be considered sacred writings, but because of the essentially practical goal of the rites, their metaphysical and literary content is probably not so lofty as that of the sūtras. "The prescriptions," Glasenapp has written, "to which they subject each one of the rites considered in all its detail are made to relate to a metaphysical view of things. The basis of any ceremony to be performed is a general world concept, related to magic, and developing the fundamental idea which requires that all the phenomena of the cosmos depend as closely as possible on each other: mysterious bonds

then connect each word, each action, and even each thought to the eternal basis of the universe." [12] This opens up the limitless vistas, in the domain of the mystic, that such a unity implies. The gesture is no longer a simple act: it contains the essence of the Three Mysteries, and this fact alone inspires it with an infinite mysticism.

The mudrā, thanks to this triple unity, were accorded an importance equal to that of the word (dhāraṇī). Their metaphysical value was compounded of a primitive magic, which reached far back into pre-Buddhist times.[13] This magic stems from a stratum of occult beliefs in prehistoric India. As early as the Vedic period, despite the condemnation of the high cult, magic of an official nature existed, and charms could be wrought by a slight modification of or addition to the ordinary ritual.[14] The mantra was used at once to bless and to curse.[15] The preventive processes (silence, retreat, etc.) and positive remedies (ablution, lavage) were used to banish evil influences (śānti); [16] anointing and food offerings were used to attract useful forces.[17] In execration and in the sermon (śapatha),[18] the use of the formula, reinforced by invocation and emphasizing "truth," was already pre-eminent. The formula was to reappear in Tantric Buddhism, where its use is similar and certainly of no less importance. Even the practices of meditation go back to pre-Buddhist antecedents. "The Vaikhānasadharmasūtra gives details on yogi adepts, attesting that the Vedic tradition was progressively infused with ascetic practices; born of a prehistoric stratum and nourished by speculation, they were to flower with the theory of the āśrama (§768)." [19]

This old magic exerted its influence in Tantrism: [20] noxious magic (expulsion, the causing of death), unction,[21] ritual impurity [22] (death, birth), even medical magic [23] were all practices which, originating in ancient India, reappeared in Esoteric Buddhism.[24]

"The magical act depends in large measure on a transference or on a symbolic representation." [25] It follows that mudrā, words, and thoughts of the Three Mysteries assume in Tantrism metaphysical and even magic values. Certain students see in these tendencies a degeneration of early Buddhism. The exaggerated formalization of Esotericism seems indeed

to justify this point of view. It is, in fact, undeniable that certain aspects of Tantrism permitted the development of rather grotesque magical rites: but it must be added that such practices appear quite as fantastic to the traditional Buddhist as to the Western spectator. Tantrism was nevertheless able, from many points of view, to avoid a total deterioration: in support of its metaphysics, it even brought new expressions, especially of an artistic nature. It was actually this essential dogma of the equivalence of word, act, and thought that was responsible for raising Esoteric art to a place of undisputed importance in the religious system. This unitary concept leads to a close interdependence [26] by which artistic forms become the image of the Tantric doctrine: the statue is henceforth the concrete manifestation of concepts related to the energies existing in the order of things. Thus does art occupy an important place in the rites and in iconography. It manifests, moreover, in Buddhist countries situated beyond the frontiers of India, a most fruitful inspiration. This artistic expression should be sufficient in itself to spare Tantrism the injustice of summary condemnation.

The "word" of the Three Mysteries is represented by the magical formulas.[27] They are prescribed in the sūtras in which are outlined the bases of Tantric magic. It is noted, for example, in chapter XXI of the *Lotus of the Good Law:*

"Thereupon the Bodhisattva Mahāsattva Bhaiṣajyarāja rose from his seat, and having put his upper robe upon one shoulder and fixed the right knee upon the ground, lifted his joined hands up to the Lord. . . .

"Then the Bodhisattva Mahāsattva Bhaiṣajyarāja immediately said to the Lord: To those young men or young ladies of good family, O Lord, who keep this Dharmaparyāya of the Lotus of the True Law in their memory or in a book, we will give talismanic words for guard, defense, and protection; such as, anye manye mane mamane citte carite same, samitāvi, sānte, mukte, muktatame, same avisame, samasame, jaye, kṣaye, akṣīne, sānte sanī, dhāraṇi ālokabhāṣe, pratyavekṣaṇi, nidhini, abhyantaravisiṣṭe, utkule mutkule, asaḍe, paraḍe, sukāṅkṣī, asamasame, buddhavilokite, dharmaparīkṣite, saṅghanirghoṣaṇi, nirghoṣaṇi bha-

yābhayasodhanī, mantre mantrākṣayate, rutakauśalye, akṣaye, akṣava-
natāya, vakulevaloḍa, amanyatāya. These words of charms and spells,
O Lord, have been pronounced by reverend Buddhas (in number) equal
to the sands of sixty-two Ganges rivers. All these Buddhas would be
offended by any one who would attack such preachers, such keepers of
the Sūtrānta.

"The Lord expressed his approval to the Bodhisattva Mahāsattva
Bhaiṣajyarāja by saying: Very well, Bhaiṣajyarāja, by those talismanic
words being pronounced out of compassion for creatures, the common
weal of creatures is promoted; their guard, defense, and protection is
secured.

"Thereupon the Bodhisattva Mahāsattva Pradānaśūra said unto the
Lord: I also, O Lord, will, for the benefit of such preachers, give them
talismanic words, that no one seeking for an occasion to surprise such
preachers may find the occasion, be it a demon, giant, goblin, sorcerer,
imp or ghost; that none of these when seeking and spying for an occasion
to surprise may find the occasion." [28]

The abundance of such passages in the sūtra indicates the importance
accorded the magical formulas. Tantrism lost no time in developing them.
The *dhāraṇī* [29] pullulated. They are texts, generally short, often simply a
group of mystic syllables, employed primarily for the purpose of medita-
tion or of magical action or serving as "supports" for meditation. By
their use, one may supposedly succeed in practicing a specific magic or,
on the metaphysical plane, in identifying oneself mystically with the
supreme divinity. At the end of the *dhāraṇī* is generally found a short
explanation of the goal of the prayer. These formulas lent themselves to
the most diverse uses, such as causing rain, halting epidemics, etc.

At the beginning, end, and sometimes in the middle of a *dhāraṇī* oc-
curs a *mantra*,[30] a sequence of mystic syllables most often without literal
meaning. The phenomenon of the mantra and the extreme importance
which it assumed in the Indian sphere, notably in Tibet, are characteristic
of the evolution of Tantrism. By means of the vibrations which the reso-
nance of the mantric syllables creates in the body, the mantra is capable of

producing certain states of consciousness, which lead, on an extra-corporeal plane, to a religious experience. The mantras constitute objects ("supports") of meditation for the Conscience. Consciousness of them comes during meditation on them by the development of the "seeds" (*bīja*) which they contain. It is a question here of the aspect of Unity which exists between word and thought: the mudrā becomes, therefore, a symbolic act identified with and representing both.

A Tibetan mantra well known in the West may serve as a model. It is six syllables, *"oṃ maṇi padme hūṃ"* (Ah! The jewel is in the lotus). According to Getty, this formula can penetrate the Six Regions of Beings and preside over the final liberation from the Wheel of Life — that is, from the eternal cycle of birth and rebirth. Sometimes syllables without meaning are used with a word of precise import,[31] such as *"oṃ Ak-ṣobhya hūṃ."* [32] A vast religious system, related to the purest, not to say most primitive magic, arose on these bases. Every syllable of the mantra — *"oṃ maṇi padme hūṃ,"* for example — is identified with a color: *oṃ* white, *ma* blue, *ṇi* yellow, *pad* green, *me* red, *hūṃ* black. The fingers, in their turn, are identified with colors and syllables and are closely allied with symbolic sounds: [33] they are endowed by this identification with magical forces and divine qualities.

The mantra *oṃ* contains in itself all the others. It is composed of three phonemes, *a, u, m,* plus the dot (*bindu*) that marks the nasal resonance. It is identified with the *brahman,* the Veda, the yoga Iśvara, and later with the *trimūrti* (*a* being Viṣṇu, *u* Śiva, and *m* Brahmā).[34]

Tantrism developed among other usages that of the *shuji* (Sk. *bīja*) or germ syllable,[35] which ends generally with *ṃ* (on the example of *oṃ*). These syllables replace a mantra, a word, a symbolic object, and "every divinity, or better, each aspect of a divinity has its *bīja*" (Renou). The *bīja* is imposed (*nyāsa*) [36] on the body of the faithful "by means of the ends of the fingers, and with the accompaniment of the recitation of the *bīja* in question" (Renou). The body is thereby "impregnated with the energies and essences contained in the germ syllable." Thus it is that the hands supervise the exact transmission of the thought expressed by

1 The Germ
Syllable A

the word. The word is the vehicle of the ideas: the gestures are the vehicle of the forms.

The *dhāraṇī* and the mantra belong to the domain of the "word"; in art (painting and sculpture), the visual aspect of this "word" is set forth in several ways. In painting, one of the characteristic forms is the *mandara* (Sk. *maṇḍala*),[37] a geometric disposition of symbolic attributes, germ syllables, or images endowed with magic power. It is the point of departure for a system of specific meditation, which aims at assuring

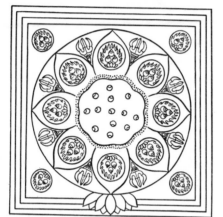

2 Maṇḍala

the ultimate, mystic union with the Supreme Unity (in Japan, Dainichi Nyorai; Sk. Vairocana).[38] The *mandara* corresponds, for the initiate, to the complex symbols of an integration for the mathematician (Maraini). It can assume a number of forms according to the use for which it is intended: in rites, it may be traced on the ground, used at a specific moment, and then erased. The best-known form is the one which is permanently fixed on paper, silk, linen, etc. and is meant to be used as the object of successive meditations. The use of the *maṇḍala* is to be particularly noted in Tibet and in Japan. Japanese *mandara* are regarded highly from the ritual point of view and are often of considerable artistic quality. They exhibit most often Buddha or Bodhisattva images, Sanskrit signs,[39] or symbolic attributes. These last two are supposed to

possess a magical power as effective, in this instance, as that of the Buddha image. This power may be explained by the system of equivalences in the Esoteric dogma, where Buddha and symbolic sign are identical. But there are other kinds of cosmic representation. Actually, in Esoteric Buddhism the hands become a *mandara*. Thus, Auboyer writes, concerning the *hastapūjāvidhi*, the rite of the offering on the hand:

"The devotee is able to reconstruct on his left hand a *maṇḍala* of three concentric zones. The outer circle is formed by the fingers, on which the devotee evokes successively the five elements with their feminine manifestations: on the thumb, earth and Pātanī; on the index, water and Māraṇī; on the middle finger, fire and Akarṣaṇī; on the annulary, air and Narttesvarī; on the auricular, ether and Padmajālinī. The middle circle is formed by the nails, on which the devotee evokes the five *jina* or spiritual Buddhas, their colors, and their respective sacred syllables: on the thumb, Amoghasiddhi, white, *oṃ haḥ nāmaḥ*; on the index finger, Vairocana, yellow, *hi svāha*; on the middle finger, Amitābha, red, *huṃ vauṣat*; on the ring finger, Akṣobhya, black, *he huṃ huṃ hoḥ*; on the little finger, Ratnasambhava, green, *phaṭ haṃ*. Last of all, the inside circle is drawn on the palm in the form of a red lotus with five petals. The devotee begins his evocation by the eastern petal, and turns through those of the north, the west, and the south, situating successively in them the five goddesses: Yāminī, black, *hāṃ yoṃ*; Mōhanī, white, *hrīṃ moṃ*; Sañcālinī, yellow, *hreṃ hrīṃ*; Santrāsinī, green, *ngaṃ ngaṃ*; and Chaṇḍika, gray, *phaṭ phaṭ*. The end is at last realized in the pericarp of the lotus, which contains the germ of the mandara, figured by the goddess Vajravārāhī (red, *oṃ vaṃ*)." [40]

The object of the Esoteric system is the psychic union of the faithful with the Universal Spirit.[41] But in order to arrive at this final union, it is not sufficient to pronounce the magical formulas of the *dhāraṇī* and the mantra, to meditate on the *mandara* or the statues of the Buddha; it is necessary also to make the explicitly correct mudrā. This primitive gesture of the exorcist assumes a great importance in assuring the exact transmission of the words. Words and thought are closely connected, and

likewise sound and gesture; the gesture expresses visually "the activity of the body" and the mystery of the word. It is thus that the mudrā in its ritual form takes on the value of a seal: "it is the sign of a pact, of a most solemn contract, for it is the one that binds the worshiper to the world of the divinity, and integrates him into that world." [42]

This idea of contract is reflected in the Japanese word *kei-in: kei*, "contract," *in*, "sealed" by the worshiper, who, by reciting the ritual words and by executing the correct mudrā, strives to unite himself with the divinity. Thus the expression *kei-shin* means "to make a pact with a spirit." *Kei* serves also to designate the little carved notches which constituted a form of writing in ancient China. These notches were "signs," and the meaning of the character *kei* in this way may be seen to have a relationship to the meaning of "*in*." In like manner, the bond which exists between the symbolic attribute and the magical sound is brought out in the expression *immyō* [43] or *ichi-in ni-myō*, "one *in* and two *myō*": here *in* stands for symbolic attribute, *myō*, mystic syllable or *dhāraṇī*. In this expression the symbolic attribute is the pagoda (*stūpa*), the ("Convention Form") attribute of both *kongōkai* and *taizōkai* Dainichi. Besides the pagoda, two different germ syllables (*myō*) correspond to the two Dainichi; hence the expression "two *myō*." In the phrase "*in wo musubu*," one "binds" (*musubu*) a mudrā (*in*), which, in its turn, "forms a pact" (*musubu*) between the worshiper and the supreme divinity. The term "*inkan suru*" expresses the act of "making a mudrā" and at the same time "realizing" through contemplation the (statue or image of a) Buddha. *In* (mudrā) corresponds to the "body" [act] of the Three Mysteries and is a visible form, while *kan* (meditate on) symbolizes the "thought" of the threefold Esoteric concept. While contemplating (*kan*), the Buddha (or any other divinity) is "realized" by an abstract psychic identification, the whole process being symbolized concretely by the hand gesture, which assures the union of the believer and the divinity.

Because the mudrā establishes a bond between the adept and the divinity, the gesture becomes the symbol in Esoteric Buddhism of the

26

"World of the Buddha": [44] that is, "the World of Essence" (*hokkai*, Sk. *dharmadhātu*) of which it constitutes the visual representation. This world of the Buddha is attained as much by the gesture as by meditation on the symbolic attributes.[45] Inasmuch as it symbolizes the *hokkai*, the mudrā becomes the symbol of the Buddha.

The Shingon rite aims, by means of *dhāraṇī* and mantra, accompanied by mudrā, to unite the worshiper with the Supreme Spirit. It is complemented by a system of meditation peculiar to Tantrism, in which powers are transmitted from the object of meditation to the person meditating. Certain ways of breathing produce a state of consciousness which permit the worshiper to withdraw himself from the sensations of this world and to unite himself thus with the One. It is a state where there is neither thought nor annihilation of thought, a state consisting of the Six Happinesses of the body and of the mind, from which the adept (*yogī*) obtains supernatural magical powers.[46]

The complete series of ritual mudrā should, by an action on the nervous system, produce certain effects of both a psychological and a physiological kind.[47] The mudrā "composed of certain groupings of movements and of gestures are traditionally based on the results of physiological phenomena: fear, joy, modesty. . . . Thus it is that the gesture attains its most abstract subtlety. It is the science of the hidden meaning of exterior appearances, the fluid formation—but exactly defined by concrete poses—of a traditional, mental image, which one must project on the sensibility of the spectator, who in turn will react according to a traditional pattern. It is a series of suggestions linked by the sequence of the gesture, provoking in the mind of the spectator a subjective reaction." [48] Though Auboyer is speaking primarily of choreographic gestures, these observations are generally valid for the iconographic mudrā as well.

5 Rites

RITES BEGAN TO ASSUME an important role in Esoteric Buddhism as the magic concepts developed. The ritual basis was furnished by traditional Buddhism, for "all the formulas and all the ceremonies are reputed to be no more than the visible expression of thoughts seized and held through the power of concentration." [1] The tantra show excessive preoccupation with ritual detail—with the acts and words, mystical and magic, which are believed to lead one toward the ultimate attainment of occult powers. The material of this preoccupation was most particularly the use of the *dhāraṇī*, the *mantra*, and the *maṇḍala* as well as the meaning of the mudrā. [2] Thus the rite strives to bring all the senses into a participation in the religious act and so to facilitate higher meditation; but it is none the less true that ritual questions predominate at the expense of speculation and that Esotericism was imbued with a veritable anxiety of detail, which seems at times devoid of a more profound metaphysical impulse.

Certain of these rites, clearly of Indian origin, were celebrated in Japan at a relatively early time. De Visser describes the Tantric ceremony of the Ninnō rite, [3] which must have been performed in Japan as early as the VII century. The priest seats himself in *padmāsana*: [4] that is, his legs crossed, the soles of the feet upward. Before officiating he is supposed to bathe himself, or at least to anoint his hands, with perfumed water and incense and to wipe them on his stole. Then, his heart full of devotion, he makes the mudrā of purity. [5] Holding his two hands in front of his heart, empty of passions, he joins his palms. [6] He scatters lotus

flowers and recites three times the tantra (given in the Ninnōkyō text). Whereupon he makes these correct mudrā: [7]

1 Convention (*sammaya*) mudrā of the Buddha section.[8] Here "Convention" is the original vow of the Buddha and the Bodhisattva to save Sentient Beings from the errors of the Six Senses.

2 Convention mudrā of the Bodhisattva section.[9] The priest who uses this mudrā is pure in the three actions (body [act], word, thought) and exempt from all calamities.

3 Convention mudrā of the *Vajra* section.[10] By this mudrā the priest is endowed with the strength of the *Vajra*.

4 Mudrā for the protection of the body.[11]

5 Mudrā for the suppressing and warding off (of evil influences).[12]

6 Mudrā which invites all the saints to descend upon the altar.[13]

7 Mudrā for offering perfumed water to the saints.[14]

8 Mudrā for offering precious seats to the saints.[15]

9 Mudrā of universal offering (to the saints).[16]

10 Original mudrā of the *Prajñā-pāramitā*.[17] Placing his hands over his heart, the priest reads seven times the *dhāraṇī* mentioned in the sūtra. Whereupon he is transformed and perfected.

In the same manner, mudrā of other rites, such as those of the Mysterious Laws [18] and those celebrated before the *taizōkai mandara*,[19] are noted in explicit fashion. This exactness is not without importance, for all the magic and the efficacy of the rite depend on it. The results of a correctly performed rite are varied: the power of the symbolic gesture is such that the ordinary man may succeed in "commanding demons," [20] in avoiding calamities, in endowing himself with a whole range of powers, and finally in identifying himself with the universal Unity.

More and more concentrated on magico-religious means of salvation, Esotericism took on a complexity which, compounded in great part of a primitive magic, appears rather extravagant in view of the metaphysical flights of so-called traditional Buddhism. The Tantric impetus is expressed by sequences of sometimes incomprehensible syllables, a

complex ceremonial, and an art, although vital, profoundly subjected to traditionalist controls. Tibet, which is particularly faithful in respect to Buddhist iconography as it has been transmitted from India, presents one of the culminations of the tendencies inherent in Esotericism. In this country Tantrism keeps its sense of the mysterious and of the great propositions of earlier Buddhism, but it finds itself caught up in a complexity of exorcistic rites of rather primitive inspiration. In all countries where Tantrism became implanted, however, its iconography expressed the mystic aspect of the rites—sometimes fantastic, as in Tibet, sometimes peaceful, as in Japan. And it may be said truthfully that Esotericism, despite its complexity and excessive hierarchization, has manifested always a highly organized artistic sense which has been able to complete very happily the profound feeling for mystery that is the essence of its doctrine.

In Esotericism the earlier role of the mudrā as a device to indicate the episodes of the Buddha legend passed onto a secondary plane. To take its place, a new symbolism of the hands arose, based on a combination of magico-religious ideas and complemented by features borrowed from other philosophical systems. The hand became a sort of universe in miniature, representing a complete cosmogonic system, with its own particular vocabulary. The "wings" (hands) represent the sun (right) and the moon (left),[21] intelligence and meditation.[22] The fingers are called the Ten Degrees, the Ten Wheels, the Ten Lotuses, the Ten Worlds of the Law, the Ten *Shinnyo* (*Tathatā*), the Ten Summits.[23] They are arbitrarily associated not only with the Five Elements and the Ten Degrees, but also with magic signs (Sanskrit and Chinese). The combination of ideas that the fingers represent is very complex. A passage from the *Fudarakukaieki* [24] will serve to give some idea of the Esoteric meaning that Tantric literature attributes to the hands.

"The left hand is Appeasement (*jakujō*, 'elimination of obstacles') and is called Principle (*ri*, 'ideal'): this is the Matrix World. The right hand discerns diverse things and is called Knowledge (*chi*): this is the Diamond World. The five fingers of the left hand represent the Five

Knowledges (*go chi*) of the Matrix World: the five fingers of the right hand represent the Five Knowledges of the Diamond World.

"The left hand is Concentration (*jō*): the right hand is Wisdom (*e*). The ten fingers are the Ten Stages (*jūdo*). They are called the Ten Worlds of Essence (*hokkai*) or the Ten Thusnesses (*shinnyo*). By reduction, (all) this comes to the One: by extension, there are many names. The left little finger is Charity (*dan*); the ring finger, Discipline (*kai*); the middle finger, Patience (*nin*); the index, Energy (*shin*); the thumb, Contemplation (*zen*). The right little finger represents Wisdom (*e*); the ring finger, Means (*hō*); the middle finger, Vow (*gan*); the index, Power (*riki*); the thumb, Knowledge (*chi*).

"The little finger represents earth; the ring finger, water; the middle finger, fire; the index, air; and the thumb, void."

According to this text, we can draw up a table of the relationships of [Diag. I the fingers and their symbolism.[25] Here may be seen in a schematic way the whole of the meanings devolving on the hands as well as details concerning the symbolism of each mudrā. The simple joining of the two hands into mudrā, which will be treated in the remainder of this study, should consequently be related to the symbolism of the fingers as set forth in our table. Each mudrā is affected, then, by the details of the symbolism pertaining to the fingers, and it should be noted that in the following study these details are not repeated with the consideration of each different gesture.

To summarize briefly: It is certain that the ritual gesture we know as the mudrā existed even before the organization of Buddhism into a religious system. Its use in the Veda is attested, while its presence in the magical rites of primitive Buddhism is undeniable. The appearance of mudrā in Tantrism constitutes, we may say, a sort of renaissance of the earlier gestures, probably blurred during the first centuries A.D. Nevertheless, it is probable that the mudrā was used in uncodified rites as early as that period, though the question of its exact ritual value is at present unsolved. It is, consequently, impossible to evaluate the influence that the ritual gesture was able to exercise on early iconography. For India,

DIAGRAM I

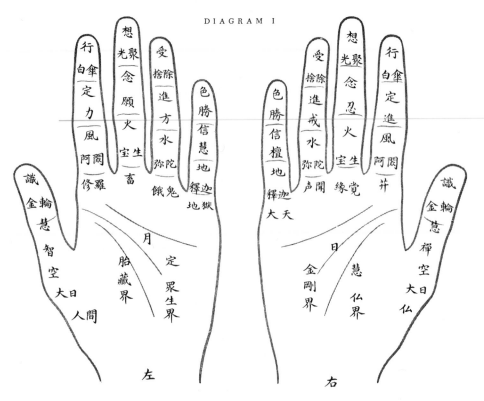

Left Hand Right Hand [1]

THUMB	INDEX	MIDDLE	RING	LITTLE		LITTLE	RING	MIDDLE	INDEX	THUMB
Discernment	Operation	Perception	Reception	Form	The Five Aggregates [2]	Form [3]	Reception [4]	Perception [5]	Operation [6]	Discernment [7]
Konrin	Byakusan	Kōju	Shajo	Shō	The Five Bodhisattvas [8]	Shō [9]	Shajo [10]	Kōju [11]	Byakusan [12]	Konrin [13]
Wisdom	Visionary Meditation	Memory	Energy	Faith	The Five Roots [14]	Faith [15]	Energy [15]	Memory [17]	Visionary Meditation [18]	Wisdom [19]
Knowledge [25]	Power [24]	Vow [23]	Means [22]	Wisdom [21]	The Ten Virtues [20]	Charity [26]	Precepts [27]	Patience [28]	Effort [29]	Contemplation [30]
Void	Air	Fire	Water	Earth	The Five Elements	Earth	Water	Fire	Air	Void
Dainichi	Ashuku	Hōshō	Amida	Shaka	The Five Buddhas [31]	Shaka	Amida	Hōshō	Ashuku	Dainichi
Human Beings	Asura [33]	Animals	Preta [32]	Hells	The Ten Essence Worlds [34]	Gods	Śrāvaka [35]	Pratyeka Buddhas [36]	Bodhisattvas	Buddhas

NOTES TO DIAGRAM I

1 The right hand represents the world of the Buddhas, the Diamond World (*kongōkai*); the left hand, the world of Sentient Beings, the Matrix World (*taizōkai*). According to Mochizuki, *BD*, p. 177, the hands symbolize the following:

Left Hand	Right Hand
Moon	Sun, standing for the mirror, represents the Four Transcendental Knowledges: 1) the Mirror Knowledge, 2) the Knowledge of Equality, 3) the Knowledge of Profound Insight, 4) The Knowledge of Perfection. It also represents the pinacle of supernatural faculties.
Arresting the active mind	Observation
Intent Contemplation (*samādhi*)	Wisdom
Blessedness	Knowledge
Principle	Reason
Temporal Reality	Ultimate Reality
Following	Offering
Inner	Outer
Samaya	Prajñā
Memory of Affection	Memory of Compassion

2 Sk. *pañcaskandha:* Filliozat (personal communication) translates *skandha* as *"grosses ramifications d'un tronc, membres, ensembles,"* which he considers better than Aggregates. The aggregates are, in this instance, the constituents of an intelligent Being.

3 Sk. *rūpa:* the physical form as opposed to the organs of the senses; the smallest particle of matter having resistance (Soothill). *Forme; sensible* (Filliozat); form (Eitel); *forme (Hō.)*.

4 Sk. *vedanā:* reception, sensation, sensibility; the function of the mind or the senses in affairs or in things (Soothill); *sensations* (Filliozat); *impression (Hō.)*.

5 Sk. *saṃjñā:* connotation, conception (*Hō.*); function of the mind in distinguishing (Soothill); *perceptions* (Filliozat); consciousness (Eitel).

6 Sk. *saṃskāra: complexes du psychisme* (Filliozat); the functioning of the mind in its proc-

esses regarding like and dislike, good and evil (Soothill); action (Eitel); *opérant (Hō.)*.

7 Sk. *vijñāna: Connaissances, pensées* (Filliozat); mental faculty in regard to perception and cognition; Knowledge (Eitel); *notation (Hō.)*.

8 The Five Bodhisattvas, placed sometimes to the left of Śākyamuni, indicate the five forms of Knowledge. Cf. *Hō.*, pp. 148 ff. and Pls. XI and XII.

9 Shō (Victorious), or Shushō Bucchō; Sk. Jaya, who holds the sword, symbol of Knowledge or of Discretion; Germ-syllable = *śa*, "appeasement."

10 Shajo (who wards off), or Joshō Bucchō (warding off obstacles); Sk. Vikīrṇa, who disperses and distroys all painful illusions; symbol = hook (Soothill); germ-syllable = *hrīṃ*, "freed from the Aggregates."

11 Kōju, Kaju (mass of flame) or Hōkō Bucchō; Sk. Tejorāśi, collected brilliance with insignia of authority (Soothill); germ-syllable = *trīṃ*, "immaculate Thusness."

12 Byakusangai Bucchō Rin-ō (white parasol) or Byakusan Bucchō, carries a white parasol, symbol of pure mercy. One of the names of Avalokiteśvara. Sk. Sitātapatra; cf. *Hō.*, p. 221b, s.v. Byakusangaibucchō; germ-syllable = *laṃ* "compassion."

13 Also Saishō (supremely victorious). Sk. Vijaya, who is figured with a golden wheel, symbol of the unequaled power to preach the doctrine; germ syllable = *sī* "Lotus of the Law."

14 Sk. *Pañcendriyāṇi: indriya =* faculté, pouvoir, activité des organes (Filliozat). They are the Five Roots (*go kon*), i.e., the Five Organs of the Senses: eyes, ears, nose, tongue, and body as roots of Knowledge (Soothill). Cf. *Chaḍāyatana* (Eitel, p. 198); *Die Fünf Wurzeln* (Hackmann, *Erklärendes Wörterbuch*, p. 313b); de Visser, "The Arhats in China and Japan," p. 98.

15 Sk. *śraddhā*.

16 Sk. *vīrya.* Cf. *shōjin haramitsu.* This is progress toward enlightenment. *Hō.* (p. 90b and p. 77b) gives *"Bonne Volonté"*; Eitel (p. 204a) gives "zealous advance"; Hackmann (p. 313b) gives *"Energie."*

17 Sk. *smṛti*.

18 Sk. *samādhi:* visionary meditation (Soothill).

19 Sk. *prajñā:* wisdom (Soothill).

[continued on p. 34]

it is imperative to avoid the chronological error of attributing to the mudrā used before the codification of the *Vajrayāna* the varied meanings which they were to assume from the VII century on. One is obliged to define the principal role of these first gestures in Gandhāra as that of evoking the specific function of Gautama Buddha. After the VII century in India, the VIII in Tibet and in China, and the beginning of the IX in Japan, the influence of the *Vajrayāna* was felt throughout the Far East, and the various mudrā appertaining to this school were henceforth liable to Esoteric interpretations based on the highly organized notions presented in our table of relationships.

20 The Ten Degrees or Virtues, that is, the *pāramitā* (perfections). The Six *Pāramitā:* the six things that ferry one beyond the sea of mortality to *nirvāṇa* (Soothill).

21 Sk. *prajñā.* Wisdom (Soothill), with reference to principles or morals; cf. n. 25, infra.

22 *Hō* (*ben*); Sk. *upāya,* method (Soothill); *moyen* (Hō.).

23 (*Se*) *gan*; Sk. *praṇidhāna.*

24 Sk. *bala.* Cf. Eitel, p. 28/a.

25 Sk. *jñāna,* "defined as decision or judgment as to phenomena or affairs and their principles, of things and their fundamental laws" (Soothill, p. 374b).

26 Sk. *dāna: charité* (Hō.).

27 Sk. *śīla:* discipline, *défense* (Hō.).

28 Sk. *kṣānti.* "The power of patient endurance in the desire realm and the two realms above it, necessary to acquire the full realization of the truth of the Four Axioms" (Soothill). Cf. Soothill, p. 36a (the Eight Patiences).

29 (*Shō*)*jin:* effort, industry (Soothill).

30 Sk. *dhyāna:* meditative concentration; meditation (Soothill); *extase* (Hō.).

31 The Five Buddhas of the *kongōkai* and the *taizōkai* are: Shaka (Sk. Śākyamuni), incarnation and *nirmāṇakāya;* Amida (Sk. Amitābha), wisdom in action; Hōshō (Sk. Ratnasaṃbhava), bliss and glory; Ashuku (Sk. Akṣobhya), immutable and sovereign; Dainichi (Sk. Vairocana), eternal and pure *dharmakāya.* Concerning the mudrā of these Buddhas, Soothill (p. 113a) notes: "The manual signs by which the characteristic of each of the Five Dhyāni-Buddhas is shown in the Diamond-

realm group, i.e. Vairocana, the closed hand of wisdom; Akṣobhya, right fingers touching the ground, firm wisdom; Ratnasaṃbhava, right hand open uplifted, vow-making sign; Amitābha, samādhi sign, right fingers in left palm, preaching and ending doubts; and Amoghasiddhi, i.e. Śākyamuni, the karma sign, i.e. final nirvāṇa."

32 *Preta:* hungry spirits of which there are various classes. Soothill (p. 454a) notes: "They are of varied classes, numbering nine or thirty-six, and are in differing degrees and kinds of suffering, some wealthy and of light torment, others possessing nothing and in perpetual torment; some are jailers and executioners of Yama in the hells, others wander to and fro amongst men, especially at night."

33 *Asura* is an ambivalent term originally meaning spirit(s), sometimes good, sometimes bad. Here they may be thought of as enemies of the gods, especially Indra, with whom they wage constant war (Soothill, p. 285a).

34 Cf. Soothill, p. 51a.

35 *Śrāvaka,* "hearer," meaning those who listened to the Buddha, i.e., his personal disciples and hence disciples in general. Soothill (p. 462a) says: "but its general connotation relates it to Hīnayāna disciples who understand the four dogmas, rid themselves of the unreality of the phenomenal, and enter nirvāṇa; it is the initial stage."

36 Pratyeka-buddha: a Buddha who lives alone and gains enlightenment for himself in contrast with the altruistic Bodhisattva principle. See Soothill, p. 441a.

6 Classification

TRADITIONAL CLASSIFICATION assigns the mudrā to two general categories: the so-called "with form" (*ugyō*) and the "without form" mudrā (*mugyō*).[1] The *Dainichikyō* [2] explains that in the term "mudrā-form" (*in-gyō*), *in* signifies that which is held in the hand (the wheel, the sword, the *vajra*, etc.), while *gyō* refers to the color (blue, yellow, red, etc.), or to the shape (oval, triangular, etc.) of the objects in question. Consequently, attributes fall under the heading of "with form," for they constitute a concrete object of meditation. Such seems to be the idea of Buddhaguhya.[3] On the other hand, anything of an immaterial nature — thoughts, consecrations (*kaji*), mystic formulas (*dhāraṇī*) — is in a sense formless, and therefore it falls under the heading of "without form" (*mugyō*). The hand gesture endows these "without form" elements with a visible shape, thereby crystallizing an immaterial state.[4]

And so it may be said that the "with form" category (*ugyō*), as related to hand gestures, refer to those mudrā occurring in Buddhist statues as well as to the gestures of priests performing the Esoteric ritual. Since they are visible, they have form (*ugyō*). In statues, these "with form" gestures stand for the original vow of the personages represented, while in living persons they are thought to stand for meditation on the Buddha in one's heart, such being the goal of the Esoteric concentration. A celebrant of the rites, by making mudrā, arrives at the state of concentration known as *butsunyūga*, *ganyūbutsu*, the fusion of Buddha and self, self and Buddha. It may be noted here that consecration mudrā (*kaji-in*)

are used in accompaniment to a *kaji* and are classified as form mudrā; their object is either to purify or to exorcise evil spirits.

Owing to the confusing abundance of literature surrounding the mudrā, it is almost impossible to subject them to a rigid classification. Buddhist authors explain them sometimes one way, sometimes another. Zemmui Sanzō [5] divides mudrā into hand signs (*shu-in*) and pact signs (*kei-in*). The hand signs are essentially those mudrā formed by the contortion of the fingers, while the pact signs would seem to be distinguishing symbols such as the lotus, sword, or the like. Pact signs are objects of meditation. However, hand sign (*shu-in*) may be thought of as being a generic term for all mudrā, and as such it is often used. In practice, it stands quite well for the mudrā of the ritual as well as for those used in iconographic representations; it is not, however, an entirely correct name for all mudrā. In the *Kongōchōkyō*,[6] for example, four main types of mudrā are mentioned. The first is called the Great sign (*dai-in*) or great mudrā. In this type, the celebrant, by means of seed syllables (*bīja*), attributes, and statues, concentrates on achieving a unification with the divinity of his meditation—the so-called "concentration on the five stages of Vairocana Buddhahood," that is, concentration on entry into the *bodhi*-mind and maintenance of this state once it has been achieved, concentration on the attainment of the diamond mind and the realization of the diamond embodiment, and finally the perfect attainment of the Buddha state.[7] The second type is called the mudrā of distinguishing symbols (*sammayagyō-in*), sometimes known as the mudrā of convention form. Such mudrā are hand gestures which represent conventional symbols (e.g., lotus, sword).[8] The third type is styled *karma* sign (*komma-in*). These are gestures which stand for respect-inspiring deportment and for the acts of the Buddha. The fourth type is called Essence sign (*hō-in*), being nothing more than the recitation of Esoteric mystic formulas. A diagram of these gestures may be helpful.

The relation of these four mudrā types is not absolutely clear, and here again Buddhist authorities seem to differ in their interpretation. Vajra,[9] who commented on Buddhaguhya's *Tantrārthāvatāra*, mentions

Diag. II]

DIAGRAM II

NOTES TO DIAGRAM II

1 Dai-(chi-)in (Sk. *mahājñānamudrā*) are image forms (Soothill, p. 176.2). Cf. *BD* 727b, s.v. *shichi-in*: the Four Sorts of *Mandara* (Glasenapp, *MB*, p. 109). (The diagram is based on Toganoo, *MK*, p. 486.) Toganoo, *Mikkyō shisō to seikatsu*, p. 96, says that the *dai-in* are the postures of the Buddha's body. *Dai* may also stand for the Five Elements.

2 Sammayagyō-in (Sk. *samayajñānamudrā*) are the symbols and the manual signs (Soothill, p. 176.2); Smidt, III, p. 191, says that the attributes symbolize the sounds: cf. *BD* 727b, s.v. *shichi-in*.

3 Komma-in (*karmajñānamudrā*) are the emblems of specific functions (Soothill, p. 176/b). According to the *BD* (727b), the *komma-in* represent the revered works of the Buddha.

4 Hō-(chi-)in (Sk. *dharmajñānamudrā*) are the magical formulas (Soothill, p. 176/b) and, according to the *BD* (727b), the germ syllables, the *sammaji* of the Essence Body, and the exoteric *dhāraṇī*.

Toganoo, *MK*, p. 486, notes that, according

to the *Tantrārthāvatāra* by Buddhaguhya (tr. by Vajra, under the title of *Tantrārthāvatāra-vyākhyāna*), all the *in* derive from the *hō-in* or from the *dai-in*. *In* are rather "effects" than "causes." The Cause is the *bodaishin*, the enlightened heart (cf. Soothill, p. 388b). The *dai-in* come from the *bodaishin*, and the Virtue (*kudoku*) of knowledge produces the others. This is attested in the *Dainichikyō* and the *Kongōchōkyō*. Zemmui Sanzō, in the *Dainichikyōsho* (15: 8, 40), states: ". . . the germ syllables of the Buddhas derive from the *bodaishin* . . . All the *in* also derive from the *bodaishin*."

Toganoo, *Mikkyō shisō to seikatsu*, p. 96, notes that the *hō-in* are those mudrā used in the predication of the Law to avoid error.

5 According to Mochizuki, *BD*, 177a, li. 17 ff., *kei-in* signifies the symbolic objects that the divinities hold in their hands — the lotus (Kannon), the sword (Monju), etc.

6 Ibid.: *shu-in* signifies the symbolic gestures — *chi ken-in* (*kongōkai* Dainichi), *hokkaijō-in* (*taizōkai* Dainichi).

that some maintain that mudrā stem from the Law signs while others claim they come from the Great signs. In this they are wrong, he says, for mudrā are effects, not causes. "Their cause is in the *bodhi*-heart. From the *bodhi*-heart came the Great signs, and the other mudrā came from the virtue of Knowledge." [10] Zemmui Sanzō comments that "all the Tathāgata are born of the *bodhi*-heart, and the seed syllables (*bīja*) of the Buddha nature. We must realize this. Also, all mudrā stem from this *bodhi*-heart." [11]

In contrast to the four types of mudrā set forth in the *Kongōchōkyō*,[12] the commentary to the *Dainichikyō* [13] mentions two types: pact signs (*kei-in*) and hand signs (*shu-in*). Here, "pact signs" regularly designate visible distinguishing symbols — that is, syllables, attributes, and images — while "hand sign" designates more precisely actual hand gestures formed by worshipers. Thus, in diagram II, it may be seen how the four categories of "signs" set forth in the *Kongōchōkyō* compare with the twofold category of the *Dainichikyō*. It may be observed that the *Kongōchōkyō* Essence Signs do not fit into either of the *Dainichikyō*'s two headings. In point of fact, the designation "hand sign" (*shu-in*) often refers to that type of gesture which imitates forms — i.e., the lotus, the *vajra;* they were later complicated by a technical symbolism. This technical type of *shu-in* first appears in the *Murimandarajukyō*,[14] which lists sixteen.[15]

The above mudrā are all based on two groups of fundamental hand signs which are known as mother signs (*in-mo*). They are perhaps most systematically treated in Zemmui Sanzō's [16] commentary on the *Dainichikyō*.[17]

3]

3-1]
The Four Types of Fist (*shishu-ken*) are the Lotus Fist, the Diamond Fist, the Outer Bonds Fist, and the Inner Bonds Fist.[18] The Lotus Fist [19] (*renge ken-in*), also called the Womb Fist (*tai-ken*), is thought of as being the mother sign of the *taizōkai maṇḍala*. This mudrā is made by folding the fingers into a fist with the thumb pressed against the side of the

3-2]
index.[20] It is thought to represent an unopened lotus.[21] The second, the Diamond Fist [22] (*kongō ken-in*), is the most important; it is considered to be the mother sign of the Kongōchō section in the *maṇḍala*. The *karma*

mudrā set forth in the *Kongōchōkyō* are all based on this Diamond Fist.[23] This gesture is formed by the middle, ring, and little fingers grasping the thumb while the tip of the index touches the thumb knuckle.[24] Methods for making this Diamond Fist vary. In the *Kongōchōkyō*,[25] it is called the

3 THE SIX FISTS

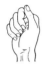

1 Lotus Fist

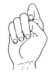

2 Diamond Fist

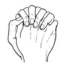

3 Outer Bonds Fist

4 Inner Bonds Fist

5 Anger Fist

6 Tathāgata Fist

"mudrā of diamond bond Knowledge, the body speech and heart of all the Tathāgata" (*issainyoraishingonshinkongōbakuchi-in*), a title which expresses the unity of the Three Mysteries (body, speech, and thought) of all the Tathāgata.

The third, styled the Outer Bonds Fist (*gebaku ken-in*),[26] is formed [3–3] by clasping the hands, palm to palm, with the fingers on the outside. In the *Kongōchōkyō*,[27] it is called Diamond Bonds (*kongōbaku*), and the space between the two hands is likened to the moon.[28] The convention-form mudrā (*sammaya-in*) of the *Kongōchōkyō* all have this Outer Bonds mudrā

as their mother sign. Some see in this gesture a relation to the lotus: that is, the gesture seems to represent the moon resting on a lotus, the eight fingers representing so many lotus leaves.[29] But this would seem a rather arbitrary interpretation, and it is not, as far as I know, based on any textual prescription. Some would see in the ten fingers a representation of moonbeams,[30] and it is true that for certain meditations on the moon disk this Outer Bonds gesture is made.[31]

3-4] Number four, the Inner Bonds Fist (*naibaku ken-in*), is explained in the *Dainichikyō-sho* as a two-handed fist.[32] In this gesture the ten fingers are joined with the tips on the inside. The Inner Bonds Fist is the mother sign of the *taizō* section and is not much used in the *kongō* section of the *maṇḍala*. The space between the two hands again represents the moon, on the analogy with the Outer Bonds Fist. This gesture of the Inner Bonds may be thought to represent the *bodhi*-heart, symbolized by the moon, i.e., the space between the hands, the fingers being a kind of aureole.[33]

To these four basic fists are sometimes added the Anger Fist (*funnu ken-in*) [34] and the Tathāgata Fist (*nyorai ken-in*),[35] making in all the not

3-5] uncommon group of the Six Types of Fist. The Anger Fist is formed by closing the middle and ring fingers over the thumb while the index and

3-6] little finger are held erect, slightly curved. The Tathāgata Fist is made by forming a Lotus Fist with the left hand and a Diamond Fist with the right, the left thumb being inserted into the right fist by the little finger.

4] The second group of fundamental hand gestures is called the Twelve

4-1] Handclasps (*jūnigōshō* or *jūnigasshō*). The first is the *nebina gasshō* or the clasp of the firm and sincere heart (*kenjisshin*).[36] The two hands are placed together, palm against palm. No space is left between them. The second,

4-2] the *sanfuta* (Sk. *saṃpuṭa*) clasp is that of the empty heart (*koshin*).[37] The ten fingers are brought together, but between the hands a slight space is

4-3] left. Number three is the *kumma(n)ra* (Sk. *kamala?*) clasp, representing the unopened lotus.[38] The space between the hands is slightly more than in

4-4] the preceding. Number four, the *boda* (Sk. **pūṇa*) clasp, is called the newly opening lotus.[39] Here the ten fingers join, and the index, middle,

4-5] and ring fingers are slightly separated to leave an opening. Number five,

40

4 THE TWELVE HANDCLASPS

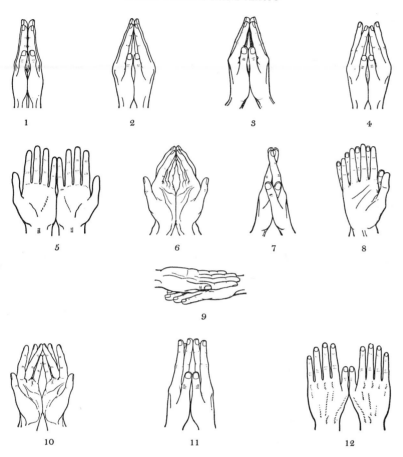

the *ottanasha* (Sk. *uttānaja*) clasp means the clasp of clear exposition (*kenrō*).[40] The two palms are presented open side by side, fingers up. In number six, the *adara* (Sk. *ādhāra*) clasp, which stands for the gesture of holding water, the hands are cupped.[41] In number seven, the *haranama* (Sk. *praṇāma*) *gasshō*, the clasp of refuge (*kimyō*),[42] the fingers of the right hand are interlocked at the tips with those of the left, the right hand

[4-6]

[4-7]

4–8]

4–9]

4–10]

4–11]

4–12]

on top. This is in fact the Diamond Fist as it is set forth in the *Kongō-chōkyō*. Number eight, the *miharita* (Sk. *viparīta*) *gasshō*, is known as the backhand clasp.[43] In it the right and left hands are joined back to back, the ten fingers being interlocked with each other. Number nine, the *biharari-eisata* (Sk.* *viparyasta*) *gasshō*, means that the hands are placed back to back one on top of the other. The gesture is made by holding the left hand palm down while the back of the right hand is placed upon it.[44] Number ten is the *teiriei gasshō*, which means the clasp of construction-support-fingers.[45] The palms face each other but only the middle fingers touch, the rest being held apart and erect. Number eleven, the *adara* (Sk. *ādhāra*) clasp is called the "covering hands facing downward."[46] The two hands are held side by side, palm downward, thumbs touching, while the two middle fingers are brought together at their tips. In number twelve, the *fukushu* clasp,[47] or the clasp of the covering hands, the two hands are held palms down touching at the thumbs and spread wide.[48]

7 Generalities

A s h a s a l r e a d y b e e n n o t e d, the mudrā of the first Buddhist
statues in India had no precise iconographic meaning.[1] Moreover,
the number of symbolic gestures used during the early times of Gandhāra,
at Amarāvatī, and at Mathurā appears to have been very small.[2] But
little by little the mudrā multiplied, and a specific nomenclature as well
as a more exact iconographic signification was attributed to them. This
organization had taken place in large part by the VII century A.D. Before
Esotericism, around the beginning of the Christian era, the symbols used
in the aniconic representations of the Buddha, such as the wheel, the lotus,
etc., were replaced by the figuration of the historical Buddha in human
form. Mudrā were used especially to clarify the symbolic sense of the
statue. On the gestures then devolved, to a certain extent, the former
identifying role of the symbols employed in aniconic representations.

Despite their small number, these first mudrā were to furnish the
principal symbolic gestures that spread beyond the Indian frontiers. The
most common mudrā in Gandhāran art is found on statues of the Buddha: [II
he holds with his left hand a corner of his stole, while the right hand is
raised, the palm outward. According to the texts, this raised hand should
be the gesture which stands for the Predication of the Law. It later sym-
bolizes the moment in which the Buddha subdues the drunken elephant
who was on the point of crushing him. Thus it is the gesture which is to
symbolize the Buddhist quality of fearlessness. But in Gandhāra, this
same mudrā signifies indiscriminately the Predication,[3] the Enlighten-
ment, or the Temptation by the demons. A later gesture (called in Japa-

XI, XII] nese the *tembōrin-in* — mudrā of the Turning of the wheel of the Law), which is fully developed at Ajaṇṭā and at Sārnāth, will express quite specifically the Predication of the Law. Subsequently, by undergoing modifications of form and of meaning, this same gesture may possibly

XIV] have evolved, under the influence of Esoteric Buddhism, into the *chi ken-in*. As for the Enlightenment and the Temptation, these two episodes

X, XVI] are respectively represented in Esoteric art by specific mudrā, the *jō-in*

VIII] and the *sokuchi-in*.

It is manifest, however, that from the beginning of iconic Buddhist art until the IV and V centuries, the raised hand (of the Predication of the Law) [4] was the mudrā the most frequently represented in India. This predominance is manifest in other countries as well: in China with North-

XX] ern Wei statues, and in Japan with Suiko statues, which prove the con-

III, XXVI] tinuity of this gesture across Asia. In China this gesture was to keep its predominance during the T'ang, and ceded its place only under the Five Dynasties and the Sung, that is, toward the XI–XII centuries. [5]

XI, XII] In India, the *tembōrin-in* begins to prevail over the *semui-in* around the V and VII centuries and becomes characteristic of Gupta and post-Gupta statues. According to Hsüan-tsang and Wang Hsüan-ts'e, the *tembōrin-in* begins to predominate in China at the beginning of the T'ang. This ascendancy was reflected in Japan toward the IX–X centuries. [6]

Besides their role as metaphysical symbols, the mudrā may, in certain cases, permit the identification of specific Buddhas. It has been noted that few formal rules governed the symbolic gestures in early Gandhāran sculpture. Yet it appears that already in Gandhāra gestures had begun to designate specifically certain Buddhas, [7] and in time this tendency was to become generalized. However, the mudrā (and the attributes) which will be treated in this study do not by any means constitute a proof of identity by themselves. While frequently appearing on the statues of the historical Buddha, they may not be taken as exclusively characteristic of the Buddha Śākyamuni. "It is difficult on this basis alone (and this is true of Buddhist sculpture in general) to know whether a Buddha represents Śākyamuni, Amitābha, or Vairocana." [8] Nevertheless, mudrā and attri-

44

butes, although not absolute evidence of identity, help to individualize the various Buddhas by completing with other iconographic details the symbolic framework of statues. The possibility of identifying by means of gestures and attributes is more and more manifest as Buddhist iconography evolves: certain attitudes and certain mudrā are associated, if not infallibly, at least frequently enough to draw certain generalities of identification. Thus the universal occurrence of such associations as Dainichi and the *chi ken-in* (*kongōkai*) or the *hokkai jō-in* (*taizōkai*); Amida and the [XIV, XVI *semui-in* or the *mida jō-in*; Shakamuni and the *sokuchi-in*; and Yakushi and [IX, VIII the *an-i-in* or the *semui-in*.[9]

The spread of Buddhism throughout Asia imposed on the mudrā considerable modifications of form and of meaning. These became more and more apparent as the mudrā moved further from the country of their origin. In India, differences are less marked. "The mudrās," writes Sirén, "have a precise meaning; they must be represented in conformity with recognized rules. The artist may reproduce them either as completely conventional clichés or he may lend to them more or less freedom and grace: in no case may he modify their essential traits. The gamut of personal variations is very limited: it is a question of nuances and of suggestions rather than of differences in form." [10]

The modifications brought about beyond the frontiers of India may be explained in several ways. It is possible that in China the artists who continued the Indian tradition had only superficial notions of Indian iconography; they were doubtless even less aware of the texts which underlay the elaboration of these statues.[11] Working from simple instructions, they were probably but little preoccupied with precision in things artistic. For instance, Davidson notes that in China when a particular Buddha was commissioned to be represented, a stock figure may have been produced and then identified by inscription rather than by position and attributes.[12] In India,[13] on the other hand, the sculptor in creating the statue accomplished a pious work, of religious significance. The observance of iconographic details set forth by religious writ was of fundamental importance. By the VII century, accurate drawings of Indian

Buddhist statues were brought back to China by returning pilgrims.[14] Despite this fact, in non-Indian Asia "the iconographic tradition became obliterated . . . little by little and there were created works so far from the traditional pose and so devoid of significant attributes that they escaped any attempt at a very precise definition." [15] Thus, in India, certain statues originally bore in hand one or several specific attributes. At the time of the passage of these statues beyond Indian frontiers, the attributes — the sculptured objects themselves — very likely came to be lost, and there remained in the hand that had held them only a gesture devoid of meaning. Nevertheless, this gesture was sometimes reproduced and given the value of a mudrā whose prototype may be found no place in India. Such may well be the case of the *an-i-shōshu-in*.[16]

9] The freedom of interpretation which characterizes Chinese and Japanese works as contrasted with Indian works sometimes resulted in considerable iconographic modifications. On the one hand, this would arise from the obsolescence of the "iconographic traditions" of which Sirén speaks, or, in Japan, from a simple lack of models as well as of careful observation on the part of the Japanese artisan. Moreover, the Japanese did not have a fundamentally philosophic or metaphysical turn of mind. Unlike the Indian with his exactness, the strictly precise meaning of details, as in the instance of symbolic gestures, probably meant little to the Japanese, less, probably, than the general aspect of the statue. The explanation may be found in the fact that Japan, being the end point in the Buddhist tradition, inherited a Buddhism already imprinted with the influences of non-Indian personalities and countries. The Japanese tradition was composite. Buddhism was a religion which the Japanese had adopted and not conceived. They were busier assimilating than developing it during the VII–X centuries. It is natural then that the iconographic variants deriving from the different national characters encountered *en route* should be reflected in the art of this country, and that the details of the iconographic tradition of India should become blurred.

The meaning of a specific mudrā during a geographical evolution may be clarified, to a certain point, by examining statues and images. But

46

the meaning of the mudrā during its evolution in time — a problem of no less importance — is more difficult to fathom, for the sacred texts and the ritual commentaries do not permit the student to follow the development of the mudrā in an uninterrupted line. For example, is the symbolism of the *tembōrin-in* in Gandhāran India in the II century the same as in China under the Wei in the IV century, or in Japan under the Fujiwaras in the XI century? The answer to such a question is obviously no, for the mudrā, as it has been seen, were subjected to numerous modifications in the course of their passage across Asia. It is evident that each of the various national characters brought to them its own genius. (Hence it is to be hoped that some future study may arrive at a more exact evaluation of the mudrā in time as well as in space. This question is brought to the reader's attention with respect to the present work and should serve to caution him of the general nature of the present treatment of mudrā symbolism. The author is aware of what may be construed as slight attention to the particularities due to different sects and different periods; yet it is to be hoped that such a shortcoming will not outweigh the value of the information assembled in the following pages.)

The meaning, especially ritual, of the mudrā differs according to the sect which employs it. The same is true for the meaning of the iconographic gesture. It will be necessary, then, in attributing any symbolism to a mudrā, to take into consideration the close relationship between the rites and iconography, the latter being largely the representation in art of the former. Given a variety of meanings of the same ritual gesture, care must be taken not to attach, a priori, a definitive meaning to the iconographic mudrā, but maximum attention must be given to the sect of which the statue is an icon and the period in which the statue was created. These two considerations may be found to modify considerably the interpretations of the symbolic gesture.

In the face of an immense body of confused and contradictory documentation, it would appear useful to make an attempt at clarifying all this information; this is an aim of the present study. In every statue, "the gestures and the attitudes are precisely the essential symbolic element:

47

thus, on the whole, it comes down to formulas more definite than types or than attributes. In fact, these latter are in many cases too inexact or undifferentiated to give us information on the name and the role of a Buddha or of a Bodhisattva. Only the gesture and the attitude make the personage intelligible to us as a symbol of a religious or metaphysical idea. This is why it is indispensable to know the attitudes and the gestures that are most often met with in Buddhist imagery in order to understand the meaning of the statues." [17]

II

The Principal Symbolic Gestures

1 Mudrā of the fulfilling of the vow

Segan-in 施願印

5

CH. *Shih-yüan-yin*

SK. *Varamudrā, varadamudrā* [1]

[XXIII

I N THE SEGAN-IN,[2] the hand is lowered, the palm turned outward in a gesture of offering. According to the *Dainichikyō* (4): [3] "Then the right hand (called Wisdom hand) is directed downward and forms the *segan-in*. *Gāthā:* the yogan[-in] is like [this gesture]. And the Buddha explains: 'if one makes this mudrā then the Buddha(s) will fulfill all vows.'"

The palm should be completely exposed to the spectator, open and empty; the fingers may be slightly bent as if to support a round object.[4] When the personage who makes this gesture is standing, he holds his arm slightly extended to the front. In seated statues, the hand remains at [III about breast level, a little to the side, the palm up; very often the other hand holds a corner of the *kesa* (monk's stole).[5]

In older statues, notably in those of the Suiko period, it may be observed that the fingers are most often rigid and unbent. This is also apparent in Chinese Wei figures, in which the mudrā is integrated into the characteristically set arrangement of the very linear works of that period. In Japan, the Wei-Sui form tends, as early as the Suiko period, toward a more subtle rhythm. In the Yakushi of the Kondō (Hōryūji) as well as in the Shaka Trinity,[6] the little finger and the ring finger of the left hand [III are slightly inflected. The rigidity of the older statues gives way to a softening in the later periods, in which the fingers of the hand that makes the mudrā present a very supple and natural aspect. The arm, formerly extended in India, may as early as the Wei in China be bent at a rather

abrupt angle in order to adapt to statues in a seated position. The relative flexion of the fingers seems to be a modification effected by the artisan himself, for texts limit themselves rather to indicating the general position [7] of this mudrā. It is equally probable that the artisan was not well informed concerning the elaborative details of these texts. Passages in the canon [8] pertinent to the mudrā note generally that the *segan-in* should be made by the right hand, but already in India examples [9] are to be seen, though rare, in which the gesture is made with the left hand, a tendency which was to be accentuated in China. In fact, one has but to refer to Wei sculpture to realize that with few exceptions the statues make the gesture

I] of the *segan-in* with the left hand. Japan carries on the Wei-Sui themes. Nevertheless, the opinions of iconographers differ on the subject of the hand which is to make the gesture.[10] In Japan, the *segan-in* is habitually proper to the left hand, and the designation of the gesture of the downward pendent hand, as it is noted under the heading of *semui-in* (cf. *infra*), may be rather ambivalent. In India, however, one may make a very clear distinction between the downward hanging hand of the *segan-in* (*varamudrā*), and the raised hand of the *semui-in* (*abhayamudrā*).[11] As a general rule, this study will treat the traditional form.

I, III] The *segan-in* is very often displayed in association with the *semui-in*. The first gesture is formed by the left hand, especially in early statues (Suiko), and the second by the right hand. This association is also apparent in Wei and Sui statues, where the simultaneous use of these two mudrā may be noted. In China also, the *segan-in* is almost always formed by the left hand,[12] the *semui-in* by the right. Sometimes in Japan the left hand makes the *segan-in* while the right hand holds an attribute. On multiple-armed statues, the *segan-in* accompanies the *an-i-in*, the *seppō-in* (*vitarkamudrā* in India), the attitude (*āsana*) of meditation, or the *kongō gasshō* (*añjalikarmamudrā*). Even in multiple-armed statues, the *segan-in* is almost always formed by a left hand;[13] however, in these, it may sometimes be formed by a right hand in order to maintain esthetic balance.[14] Sometimes the gesture is displaced from the left to the right hand, especially if the left hand holds a symbolic attribute: mention may be made

of the Kichijō-ten of the Jōruriji (Kyōto), who carries in the left hand her particular attribute,[15] the wishing jewel. [XXIV, 75

There is a variant of the *segan-in:* the palm is open, the thumb, the ring finger, and the little finger are bent, but the index and the middle finger remain stretched downward, and seem to indicate some lower point. In India there appears to be no example of this variant, but in China,[16] as early as the Sui, it is frequently reproduced, and in Japan it is present on the statues of Kannon of the Suiko and Heian periods.[17] In Japan, the rigidly bent fingers seen in Sui statues are considerably relaxed to make the characteristic gesture of Amida.[18]

SYMBOLISM

The *segan-in* indicates the charity of the Buddha, for it is the gesture of dispensing favors.[19] Moreover, the Sino-Japanese transcription emphasizes the idea of charity, of alms which the Buddha gives for the well-being of the world: *se,* "to give alms" (Sk. *dāna*). This transcription also underlines the notion of the materialization of the Vow: *gan,* "vows" (Sk. *praṇidhāna*). It follows that the variants of this designation all express the realization of the vows offered by the Buddha as assistance, or alms, to Sentient Beings; *yogan-in,* mudrā of giving, of granting desires through the charity of the Buddha; *mangan-in,* mudrā of fulfilling (*man*) the Vow. This notion of charity, of granting the Vow, represented in the Sino-Japanese transcription, reflects the meaning of the Sanskrit term *vara* or *varada.*[20] Beginning with the idea of the charity accorded by the Buddha, this mudrā grants all desires and becomes, by extension, the symbol of the "Gift of Truth" made by the Buddha, Truth of the Doctrine, Truth of the means to salvation.[21] The open hand, the extended fingers, symbolize the flowering of this Perfect Truth. The double aspect of the gesture, consequently, is apparent in these titles. There is, of course, the connecting thread of "charity," but in *segan* the emphasis is put on the fulfillment of the Vow, i.e., the original Vow of the historical Buddha to strive for the salvation of all Sentient Beings. In such desig-

nations as *yogan* and *mangan* appears the somewhat profane idea of fulfillment of wishes, not on the part of the Buddha as he acquits himself of his responsibility toward Sentient Beings, but on a much lower plane, that of satisfying the worldly desires of Sentient Beings even though these be chiefly to acquire salvation. The direction of these two aspects of charity is quite different; the second may be considered of a more profane nature, though it stems, of course, from a quite natural popular extension of the religion.

This gesture [22] is characteristic of several divinities, the most important being Kannon. In India, this mudrā was the most frequent symbolic gesture of Avalokiteśvara (Kannon). Present as early as the beginning of the Gupta [23] period (IV century), it prevailed from the VIII century until the decadence of Bengalese Pāla-Sena art. It becomes an habitual gesture of the multiple-armed Avalokiteśvara.[24] In Japan, Kannon,[25] Nyo-i-rin Kannon,[26] Shōkannon, and Jūichimen (Twelveheaded) Kannon [27] make this mudrā, most often with the left hand, more XXIII] rarely with the right. In paintings, Kannon is sometimes depicted letting drop from the ends of the fingers of her right hand the nectar of life which the divinity diffuses around her for the Beings who worship her: this is the expression of the Compassion of Kannon. Early, in India, this miracle was cited "for the great relief of the hosts in the world of the dead." According to the *Kāraṇḍa-vyūha*: "Then Avalokiteśvara approaches the City (of the Dead), it freezes up; the guardian is kind; Avalokiteśvara the Compassionate causes to flow from her fingers ten *vaitaraṇī*, the water of the eight elements, a true water of life, which will permit the dead to reconstitute themselves. When they partake of this water, they are reembodied. When Avalokiteśvara has saved them, they are transported into the Sukhāvatī heaven, where the Bodhisattva finds them." [28]

The *segan-in* figures on the statues of the Five *dhyāni* Buddhas,[29] and constitutes a particular symbol of Hōshō [30] (Ratnasaṃbhava). It is also seen on statues of Roshana [31] (Vairocana), of Shakamuni,[32] and of Amida,[33] as well as on those of the Bodhisattvas Miroku, Yakushi,[34] and Monju, and the popular deity Kichijō-ten.[35]

2 Mudrā which grants the absence of fear

Semui-in 施無畏印

CH. *Shih-wu-wei-yin*

SK. *Abhayamudrā, abhayaṃdadamudrā* [1]

6

THE SEMUI-IN, like the *an-i-in* a gesture of preaching, would seem to sustain the theory that symbolic gestures originally sprang from natural movements. Certainly the outstretched hand is an almost universal iconographic symbol. In the Mediterranean world, for example, the outstretched right hand of the king has magical power; there must be a close connection with the power of salvation in the right hand of the Roman emperors. This all-powerful hand, or *magna manus*, as it was called, was connected with emperor and deity alike: Constantine signifies the act of ruling by stretching out his right hand,[2] and God, as a savior, makes the same gesture.

The origin of the raised right hand should probably be sought in the Middle East, whence it must have spread both eastward and westward. It is a common gesture in Gandhāran sculpture; and in Roman art from the time of Severus (c. 200), the emperor is depicted with the raised right hand.[3] In Semitic religious ritual, for example, this gesture was used as a magic blessing having apotropaic powers. "When it is made by a god, it protects his servants against all malign influences and evil spirits: thus it becomes a tutelary sign, a symbol of benediction. When the faithful worshiper himself makes it, he reinforces thereby his prayer or his incantation, and the action of the hand is added to that of the sacred words, in order to save him from all evil." [4] In Persia, the cosmocrator Ahura Mazda in the world ring stretches out his right hand [5] in a similar gesture of power. Moreover, there are numerous Biblical references to the magical powers and omnipotence of the *magna manus:* [6] "Thou hast a mighty

[II

arm: strong is thy hand, and high is thy right hand" (Psalm 89 : 14,3). This concept of the right hand apparently penetrated into ancient Greece, but it fell into disuse until around the third century A.D. The use of the gesture in Christian iconography is attested very early. By this sign Christ[7] is designated as the all-powerful monarch, cosmocrator and pantocrator. It may be noted, too, that the gesture evolved from a sign of power and rule to one of transmitting the law. According to the so-called *traditio legis*, this is the sign of Christ who gives his doctrine to the world.[8] And, like Christ the lawgiver and pantocrator, the Buddha assumes the double role of lawgiver and protector. "The preference for the right hand is perhaps connected with the apparent course of the sun from east to west, and the consequent idea that a sunwise course, keeping the object always on the right hand, is of good omen and the opposite of evil."[8a]

The *semui-in*, the hand raised to appease, is formed, according to the *Shugokokkaishudaranikyō*, in the following way: "The right hand exposes the palm; the five fingers, stretched vertically at the level of the shoulder, face toward the outside. [The gesture] is called the *semui[-in]*. This mudrā has the power of giving tranquillity and absence of fear to all Beings."[9]

According to the *Dainichikyō:* "It is with the Wisdom hand (i.e., right hand) raised and exposed that the form [of the gesture] of the *semui* is made: *gāthā:* to all the categories of Beings, it has the power of giving absence of fear. If this *dai-in*[10] is formed, it is called *semui-sha*, the one that grants the absence of fear." And from the same: "Vipaśyana makes the mudrā called the *semui-shu*. This is the sign (mudrā) of the one who confers intrepidity."[11]

According to the majority of authorities in matters of iconography, the position of the hand for the *semui-in* is that which is set forth in the preceding texts. Rao indicates that the fingers stretched upward, the palm exposed toward the outside, derives from the Hindu manner of greeting.[12] Auboyer calls the *abhayamudrā* "the right hand raised for appeasing." In fact, the position of the raised hand, the palm toward the front, may be

considered as being the *semui-in*; the hand pendent, the fingers downward, is rather the *segan-in*, "the mudrā of charity." These two mudrā by reason of their similar meaning have tended to blend. In Japan the designation *semui-in* may apply either to the hand raised, the fingers stretched upward, or lowered, the fingers stretched downward. Sūtra texts support this statement. The *Senkōgenkyō*,[13] for example, endorses the double form of the gesture in the following way: "In the *semui[-in]*, the right hand is stretched out; the five fingers are held downward, the palm exposed." And in the *Kōōbosatsudaranikyō:* [14] "The right arm hangs down. The five fingers are all stretched downward in the *semui-shu*. From the end of each of the five fingers rains the ambrosia [15] [which the Bodhisattva] gives as alms to [all] the Beings of the Five Destinations." [16]

Even when the title of *semui-in*, "mudrā of fearlessness," is attributed to the lowered hand, the symbolism is none the less that of *segan-in*, "mudrā of charity," the usual designation of the lowered hand. The Japanese term *semui-in* may then encompass the *abhayamudrā* and the *varamudrā*,[17] but the symbolism of the two gestures remains different. Certain texts tend to relate these mudrā by giving them a common meaning, that of bestowing. The *segan-in* bestows the gift of charity; the *semui-in*, the gift of intrepidity. The essential meaning differs in that the upward-stretched fingers of the *semui-in* indicate the act of offering, while the downward-stretched fingers of the *segan-in* indicate the act of conferring from above to below, from the higher level of the Buddha to the lower level of Sentient Beings. The dominating idea of gift tends probably to unite these gestures; *gan* (vow of charity) and *mu-i* (intrepidity) note only the distinction of kind and of aim of the gift. The mutual contamination of these two gestures in Japan may have come about as in the case of the *an-i-in* (see *infra*). This rather imprecise usage, founded on diverse traditions in Japan, does not exist in India, where the mudrā in question remain distinct from each other. The *abhayamudrā* [18] is formed by "right hand raised, the palm outward, the fingers stretched and joined"; [19] the *varamudrā*, by the fingers hanging downward; and the *vitarkamudrā*, by joining the thumb and the index.

Certain mudrā, such as the *segan-in*, are made by either hand. The *semui-in*, on the contrary, is uniquely a mudrā of the right hand, and from the II century in India, in Central Asia, and China, this mudrā is iconographically constant. Since the beginnings of Buddhist iconography in Gandhāra, the exact position of the hand seems to have changed: on the earliest statues it is at shoulder level, but it was gradually to lower until around the V century it seems to have become fixed somewhere above hip level.[20] Actually, in Japan as well as in China, this gesture is always situated a little higher than the hips in standing statues, which is in conformity to the Wei-Sui types.[21]

This position of the hands, perhaps the most frequent of all the mudrā,[22] is characteristic of standing statues, in which it is often associated with the *segan-in* (*varamudrā*). The reason that these two mudrā are used together, in what will be referred to as the compound *segan-semui-in*,[23] is probably due to the community of symbolic meaning as much as to the suitability of a double gesture to the artistic equilibrium of the statue.

7 Segan-semui-in

SYMBOLISM

Traditionally, the position of the hand in the *semui-in* derives from the legend [24] of the malevolent Devadatta,[25] who, wishing to hurt the Buddha, caused an elephant to become drunk. As the elephant was about to trample him, Śākyamuni raised his right hand, with the fingers close together. The gesture not only stopped the elephant in his tracks but completely subdued him.[26] Thus the gesture is called *semui-in*, "gesture of fearlessness." According to a later variant of the same legend, the Buddha raised his right hand and from his fingers issued five lions,[27] who attacked the elephant and saved the life of the Buddha. From the five

fingers, furthermore, five-colored rays are supposed to spring forth, hence the *semui-in* may also be called the gesture of the five-colored rays, i.e., *goshokkō-in*.[28] In the first version, Buddhist benevolence triumphs over evil by inner strength and illustrates the concept of "not-hurting," in Sanskrit *ahiṃsā*. The second version, where there is recourse to the force of the lions, an exterior strength, is of a less spiritual nature. As Foucher points out, however, "this intervention of the lions constitutes a rather late interpolation: [29] these are decadent methods, and we cannot see that this popular expedient was ever present even in the most mediocre works of Gandhāra." [30] Moreover, it is interesting to note that a short time after his birth, the Buddha was presented at the temple of Abhaya, the protective divinity of the Śākya, so that already the Bodhisattva was associated with the ideas of fearlessness and protection.

In a passage of the *Sūtrālaṅkāra*, the author, indicated as being Aśvaghoṣa, asks the following question: " 'Why,' wonders a violator of the stūpa, 'do the artisans of this world, possessing wonderful talent and with holy intent, why do they represent the Buddha with the right hand raised? ' And the robber of the stūpa answers his own question: 'It is so that those who are afraid, when they see his image, may be freed of fear . . . (for this is the gesture) which gives confidence to those who are intimidated or frightened.' " [31]

With the notion of fearlessness as a point of departure, the symbolism of this gesture becomes by extension that of intrepidity: *se*, "to give," "gift"; *mu-i*, "fearlessness." [32] It is the gift of living without fear given by the Buddha to Sentient Beings. This gift expresses the benevolence of the Buddha, inspires the repose of the mind, and liberates it from the pains and troubles of this world. The fearlessnesses themselves fall into two series: the Four Fearlessnesses and the Six Fearlessnesses. The Four Fearlessnesses,[33] which the Buddha dispenses, may be subdivided into four groups. The Fearlessness of the Buddha is born of his omniscience, of his perfection, of his power to dominate, and of his power to cause suffering to cease. The Fearlessness of the Bodhisattva is born of his power of memory, of his diagnostic moral power allied to his curative faculty, of

his ratiocination, and of his power to dispel doubts.[34] The Four Fearlessnesses are: [35]

1 *Issaichi mushoi:* Fearlessness which comes from omniscience.[36]

2 *Rōjin mushoi:* Fearlessness which comes from the complete destruction of illusions.[37]

3 *Setsushōdō mushoi:* Fearlessness which comes from the explanation of doubts (obstacles).[38]

4 *Setsujinkudō mushoi:* Fearlessness which comes from the explanation that pain may be caused to cease.[39]

The Six Fearlessnesses are those virtuous acts capable of leading the (Shingon) initiate to salvation. According to the *Dainichikyō*, they constitute one part of a double way to destroy illusions and to retrieve the pure, enlightened heart.[40] The Six Fearlessnesses are:

1 *Zemmui:* The Fearlessness of Good. Awakened to moral good, man may, through the practice of the Five Precepts (*gokai*) and of the Ten Good Actions, win peace.

2 *Shimmui:* The Fearlessness of the body. Through meditation on the impurity of the body, one arrives at rejection of the attachment one experiences for the Self.

3 *Muga mui:* The Fearlessness of Non-Self. The Shingon adept, "meditating on the unconditioned nature of his heart, arrives at ridding himself of attachment for his Self."

4 *Hō mui:* The Fearlessness of the Dharma. To understand the independent nonexistence of every phenomenal form.

5 *Hō muga mui:* The Fearlessness of the Selflessness of the Dharma. Understanding that any phenomenal form is but an aspect of one's Self permits the faithful to succeed in mastering his own heart.

6 *Issaihō byōdō mui:* The Fearlessness of the Identity of all the Dharma. "The faithful perceived partially the true aspect of the pure *bodhi* heart as immaculate as space."

According to the *Si-do-in-dzou:* "Fear is innate, not only in man but

in all that has existence. Birds, animals of all kinds, men, the sun, the moon, the worlds, fear continually of being suppressed by each other or of colliding, and are not for an instant without fear. It is the state that is called 'the world filled with fear and dread.' Despite the joys and the pleasures that one experiences and which constitute 'agreeable feelings,' there exists at the same time the feeling of fear because no earthly happiness is perfect. Thus, by virtue of believing in and following the Law, the faithful may arrive at a state which transcends joy, pleasure, calumny, pain; it is 'the world of the Buddha free from Fear.' " [41]

In ritual ceremonies the officiating priest makes the *semui-in* in order to give Sentient Beings fearlessness. But, as the legend points out, there is more in this gesture than non-fear, a negative expression: this mudrā expresses the gift of assurance. [42] According to the legend, assurance in the face of danger is the fearlessness that calms, [43] that tranquillizes the mind. On a positive plane, this is intrepidity, courage, and audacity. [44] This mudrā, which was able to protect the Buddha against the elephant, will protect [45] the believer against the assaults of evil.

Although the symbolism of the *semui-in* may be summed up in the expression "giving of fearlessness," its use and its meaning were still not established in most Gandhāran works, where this same *semui-in* represents not only the absence of fear but also the predication of the Buddha [II (to the Trayastrimśa gods). "Only (here) he is teaching after the fashion of a Buddhist image which goes back to a time when the gesture of Teaching, like the rest of the mudrā, had not yet been established and hierarchized." [46] Echoes of the indiscriminate Gandhāran use of this mudrā may be found in China as well. Indeed, mention must be made of the *semui-in* as symbol not of fearlessness but rather of the preaching of the Law. This usage is early apparent in China; and in Japan, numerous statues making this gesture would certainly seem to be preaching rather than reassuring by giving the gift of fearlessness. And so there is no doubt but what the *semui-in*, in view of its preponderance in almost all of Asia, appropriated to itself a symbolism other than that of fearlessness alone. For example, it is manifest from the earlier Chinese Buddhist bronzes

that in point of fact the *semui-in* was used rather than the *tembōrin-in* to symbolize the preaching of the Law. Statues [47] which, according to iconographic evidence other than the gesture, may be accepted as being closely associated with the *Lotus Sūtra*, show Śākyamuni in the *semui-in* when he is obviously preaching the sermon in the Deer Park at Benares — for which the *tembōrin-in* would be most commonly used. It must be noted, too, that although in the *Lotus Sūtra* the *tembōrin-in* is definitely assigned to the Buddha Śākyamuni, in order to mark his predication of the Law and more precisely his preaching in the Deer Park at Benares, artistic tradition in China [48] not infrequently permits the use of the *semui-in*. Curiously enough, then, an art convention identifies at Tun Huang, for example, the *tembōrin-in* with the Buddha Amitābha.[49] In Japanese statues of later periods, the *tembōrin-in* is frequently made by the Buddha Amida.

The *semui-in* occurs on statues of many divinities. It is the particular position of the *Dīpaṃkara* Buddha, the twenty-fourth predecessor of the historical Buddha,[50] who, holding his garment at the shoulder or at the hip with the left hand,[51] makes the *semui-in* with his right hand. It is supposed that he appears whenever any subsequent Buddha preaches the *Lotus Sūtra*. According to Foucher, the uncovered right shoulder denotes a ceremonial event. This is corroborated by the *Kongōhannyaparamittakyō*, describing an assembly of monks near Śrāvastī: "Now in the midst of the assembly was the Venerable Subhūti. Forthwith he arose, uncovered his right shoulder, knelt upon his right knee, and, respectfully raising his hands with palms joined, addressed Buddha thus." [51a] In Japan, the first representations in sculpture of the historical Buddha resemble those of the *Dīpaṃkara* Buddha, with the exception that the right hand forms the *semui-in*, while the left hand, which in India was holding the stole,[52] makes the *segan-in*. The right shoulder is generally uncovered.

Already, in India, Avalokiteśvara (Kannon) raises his right hand to reassure; his left hand is held at breast level. The *semui-in* serves at times to hold the rosary or the lotus, two common attributes of this divinity.[53] In India, according to Mallmann, no absolute rule governs the hand positions of Avalokiteśvara, but rather "a certain desire for balance." So, in

III]

general, in four-armed statues of Avalokiteśvara, on each side one hand is
raised and one lowered (*segan-semui-in*); more rarely, the two left hands
are raised.[54] On six-armed statues, the *segan-semui-in* compound is re-
peated after the example of the four-armed statues; sometimes on one
side the three hands are raised and on the other they are lowered. A
variant of this arrangement may be observed: one right hand raised, the
other two lowered, or two left hands raised, one lowered, or *vice versa*.
But, writes Mallmann, "the number of arms, odd on each side, was to
make the task (of balancing these statues) particularly difficult. Perhaps
this reason hastened the abandonment of six-armed forms." [55] The oldest
gesture attributed to Avalokiteśvara, the *semui-in*, appears as early as the
Kuṣāna art of Mathurā,[56] and a close association may be noted between
the idea of the gift of fearlessness and this divinity.[57] This relationship is
borne out by the *Lotus of the Good Law*: "Therefore then, young man of
good family, honour the Bodhisattva Mahāsattva Avalokiteśvara. The
Bodhisattva Mahāsattva Avalokiteśvara, young man of good family,
affords safety to those who are in anxiety. On that account one calls him
in this Saha-world Abhayandada (i.e., Giver of Safety)." [58] The use of
this gesture by Avalokiteśvara continues in Indian art — e.g., at Ajaṇṭā [59]
and at Aurangābād (VII) [60] — until the time of the Pāla-Sena art of
Bengal; but the *varamudrā* (*segan-in*) tends gradually to replace it.

Kannon, in the older statues of Japan (as early as the Suiko period),
strikes two characteristic hand poses: that of the compound *segan-
semui-in* [61] (left and right hand), and that of the *semui-in* (right hand). In ⌜XXVI
seated statues, the ankle of the right leg lies on the left knee, the left hand
leaning on the right heel.[62] These two positions will be replaced towards
the X century, under T'ang-Sung influence, by the languishing attitude of ⌜XXI
the Chinese Bodhisattva. The compound gesture of the *segan-semui-in*
appears in numerous statues of a rather primitive kind, while the seated
attitude, although appearing in Suiko statues, forms to a certain extent a
transition between the Kannon in *semui-in* and the Kannon in *mahārāja-
līlāsana*. In Japan, at least, statues in which Kannon has both hands in
semui-in are exceptionally rare. The Batō Kannon makes this mudrā with

one of her hands: for example, in the statue of the Kanzeonji,[63] the left
hand forms the *semui-in*, the index and the middle finger bent, the index
in contact with the thumb.[64] Bikuchi, "she who frowns," one of the forms
of Kannon in Esotericism,[65] makes the same gesture.

The *semui-in* is also a mudrā characteristic of Yakushi. In the
Yakushinyorainenjugiki [66] is written: "The altar is decorated with diverse
precious things, and in the middle is erected a statue of Yakushi Nyorai.

65b] The *Tathāgata* holds a bowl in his left hand: this is called *muga-jū*,[67]
priceless jewel. With the left hand the divinity forms the mudrā of the
Three Worlds.[68] (Yakushi) wears a monk's robe and is seated in
padmāsana on a lotus throne." [69]

The Yakushi of the Kondō (Tōdaiji) and of the Nara Yakushiji
are in this position. As for the mudrā, sometimes the ring finger is bent
inward,[70] sometimes this gesture shows the middle (or the index) and the
thumb joined at the tips. In China, the right hand of certain T'ang repre-

99] sentations, instead of making the *semui-in*, holds a sistrum (*shakujō*), and
the left hand a bowl. Habitually, in the gesture of Yakushi, the thumb is
inflected toward the palm, slightly bent, more rarely touching the middle
finger: the ring finger and the little finger are very often curved in a
supple and rhythmic gesture.[71] With the other hand the divinity often

65b] holds a medicine jar,[72] his particular attribute, but there are also numerous
statues of the *segan-semui-in* type,[73] for this compound gesture is not at all
uncommon for Yakushi. The first representations of this deity in Japan
show only the *semui-in* accompanied in the left hand either by the jar or by
the *segan-in*. The position which, from the X century on, becomes very
common in statues of this divinity—that of the jar resting on the joined

66] hands in *jō-in*—is, nevertheless, posterior to that of the *semui-in* in
statues of Yakushi.[74]

The *semui-in* is one of the most frequent gestures on statues of
Amida; but oftentimes, in statues of this divinity too, one notes the com-
pound gesture (*segan-semui-in*),[75] respectively in the left and the right
hands. The *semui-in* as a gesture of Amida presents several variants [76]

10] resembling the *an-i-in* or the *kichijō-in*, with the thumb touching the end

of the index, the middle finger, or the ring finger. But these are properly
Esoteric variants and will be discussed subsequently. And, for Amida,[77] [11
the compound gesture *segan-semui-in* shows the thumb and the index
(less often the middle finger) joined to form a circle. On older statues, the
ends of the fingers do not touch, but on statues after the Suiko period, the
thumb and the index often make a closed circle. The right hand is raised
to shoulder level and the left hand lowered in front of the knees, the two
palms turned outward. According to the *Tetsugaku Jiten* (Dictionary of
Philosophic Terms), this would be termed the *hosshin seppō-in* or the
mushofushi-in.[78] It should be added, however, that according to certain
authorities, the latter designation admits of different interpretations. In
the present classification, it would appear more appropriate to consider
these gestures under the heading of *an-i-in*, where, by their form at least,
they seem to fall more naturally.

The compound gesture (*segan-semui-in*) is found on statues of Shaka- [I, III
muni; [79] of Roshana Buddha; [80] of Miroku (rarely); [81] of Monju; and of
Jizō. The last divinity, from the IX to XII centuries, "appears with the
precious pearl in the left hand" and the right hand in *semui-in;* "at the end
of the XII century, he takes the form which is now most widespread,
(with) the pearl in the left hand, the sistrum in the right hand." [82]

In China, numerous Wei Buddhas, the identification of which re- [XX
mains sometimes uncertain, exhibit this hand gesture, which, under the
Wei and the Sui, was by far the most common mudrā.[83]

3 Mudrā of appeasement

An-i-in　安慰印

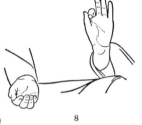

CH. *An-wei-yin*

SK. (*Vitarkamudrā*,[1] *vyākhyānamudrā*[2])

8

BEFORE THE AN-I-IN is considered in its Far Eastern context, a
few general remarks may help to establish the role of this gesture
as a universal sign. Like the *semui-in*, the *an-i-in* would seem to support
the theory that ritual, symbolic gestures originate in natural gestures.
There are numerous examples of the presence of the *an-i-in* type in the
Mediterranean world from ancient times until the present. Quintilian, for
example, notes that "already in heroic times the Greeks had a fully de-
veloped system of significant gestures and a separate doctrine concerning
their correct use: a *chironomia*, a *lex gestus*."[3] Among them figures the
ani-i-in type. In representations of the classical stage, the actor is char-
acterized by both the masks and this gesture.[4] The same sign is present
today in most Latin countries, where it may be seen universally used as a
gesture of argumentation, the present-day users of which hardly sus-
pecting they are following an ancient tradition sanctified by both time and
literature.[5] In the Christian tradition, the sign of the cross,[6] the so-called
benedictio latina,[7] is a reflection of this earlier gesture in Christian
iconography, although it should be noted that this same sign occurs in
profane circles as well. In Christianity, this gesture would seem to ac-
company speech, just as it does in Buddhist tradition, and in Christian art
the "scroll in the left hand contains the written speech; the gesture in the
right one expresses the realization of the written in the living world."[8]
The universal connection of this gesture with speech must modify both
Christian and Buddhist thinking about it, for the Christ, who, like the
Buddha, makes this gesture, should be considered not so much a bene-

66

dictory [9] or blessing figure as a speaking and teaching one. In Christianity as in Buddhism, the raised hand must have accompanied some kind of incantation. This would seem to be so, for example, in the case of the Buddha who raises his hand against the maddened elephant. "When men or heroes raise their right hands in this gesture against wild beasts, it is not the gesture itself, but the spoken word, the ritual or magic formula expressed in it, which gives them the upper hand." [10] The *an-i-in* prototype, then, seems inextricably connected with speech, in a religious as well as a profane context. Although there is an overlapping of use, the Buddha who makes this gesture would seem more to be engaged in the predication of the Law than in the blessing or quieting that the name *an-i-in* implies. Within the context of Christianity, l'Orange notes that "the speech gesture accordingly loses more and more of its original philosophical-discursive significance and becomes increasingly the sign of authority of the Christian dogma." [11] To a certain extent this tendency is present in Buddhist sculpture as well, and the relationship of word, *logos*, and this gesture is maintained when the *an-i-in* is used to represent the divine authority of the Law.

The *an-i-in* [12] is formed in the following manner: the hand (right, [IV generally) is raised, the palm outward, the fingers straight, with the exception of the thumb, which touches the end either of the inflected index or of the middle finger, sometimes even of the ring. [13] This gesture may be confused with one of the *semui-in* forms, notably with the com- [III pound gesture *segan-semui-in*, in which the thumb and the index (or the middle finger) [14] touch, or are brought very close to each other. Rather diverse traditions are at the basis of the variety of forms that characterize this mudrā. [15] According to Mochizuki, [16] this gesture should be made by both hands at the same time, held rather near to each other, the right hand raised, the left lowered: each one forms a closed circle by joining the index and the thumb. Yet iconographers maintain for the most part that this gesture is made with the thumb and the index joined to form a circle.

In India, the mudrā the form of which corresponds to the *an-i-in* is called the *vitarkamudrā*. It seems not to be the symbolic prototype of the

Japanese *an-i-in*; it corresponds rather to the *seppō-no-in*, mudrā of the exposition of the Law. Auboyer observes that the *vitarkamudrā* is formed "with the right hand raised, the thumb touching the index in a gesture of argumentation that the Indians still make mechanically during their conversations." [17] Foucher,[18] the *Bukkyō Bijutsu Kōwa*,[19] Mochizuki,[20] and the *Shimbi Taikan* II [21] make the same description. Rao names this gesture the *chin-mudrā* [22] or the *vyākhyānamudrā*.[23] Certain authorities maintain that the gesture of exposition is formed by joining the thumb with the middle [24] or the index [25] fingers. Getty [26] asserts that there exists in Japan a "variant" of the *an-i-in*, which is called *semui-in* and which is formed by the fingers raised (vertically), the thumb bent over the palm. The only difference between these two gestures would lie, then, in the position of the index, which in the *semui-in* does not touch the end of the thumb. A definitive distinction between the *semui-in* and the *an-i-in* is, in fact, difficult to establish, for these two gestures may assume almost VI] identical forms.[27] This similarity inclines one to think that the *an-i-in*, at the beginning, may have been a form of *semui-in* in which the fingers were inflected, the thumb and the index somewhat brought together. The resemblance in form may have produced a contamination of symbolism by which the *an-i-in* came to express the idea of gift—not that of intrepidity (*mu-i*), but of tranquillity (*an-i*).[28] Moreover, the notion of assurance implied by the *semui-in* presents an obvious affinity with that of tranquillity symbolized by the *an-i-in*. In the case of Avalokiteśvara (in Yunnan), Mallmann suggests that these two mudrā may have been "progressively confused; the notion of 'security' of the first transferring to the second, which, from a gesture of argumentation, may have become a gesture of 'consolation.' The fusion could have been effected, for example, in Ceylon,[29] the intermediary stage between India proper and the outer Indian sphere; we know that there was venerated in this country an Avalokiteśvara protector of hospitals, Siṃhaladvīpe-ārogaśālā Lokanātha, an eminently benevolent divinity, whose gesture was doubtless meant to 'reassure' or to 'appease' the sick." [30] This evolution is certainly not belied in the sculpture of Japan, where the *an-i-in* preserves a clearly

protecting character. In fact, the *Soshicchigiki* [31] calls this gesture the *goshin-in*, the mudrā of the protection of the body,[32] and the *Hachidaibo-satsumandarakyō*, describing Jizō Bosatsu (Kṣitigarbha), gives these indications: "The left hand reposing in the lap holds an alms bowl; the right hand with the palm inverted, turned downward, the thumb and the index joined, 'symbolizes' the (Bodhisattva's) thought of consoling all Beings." [33]

By an arbitrary distinction, these two gestures may be differentiated to a certain extent. In the *semui-in* (hand raised) or *segan-in* (lowered), the habitual form is that of the palm presented outward, all the fingers extended vertically; sometimes the index and the thumb are brought a little together, more rarely do they touch. In the *an-i-in* (hand raised or, less frequently, lowered) the palm is often presented obliquely, and by the junction of the index or the middle finger with the thumb a closed circle is formed. But the identification of this last mudrā is made still more difficult by the existence of several gestures, of less importance perhaps, but which resemble it: the *saṃdarśanamudrā*, which presents the palm well forward; the *uttarabodhimudrā* (Waddell and Williams), the mudrā of supreme Enlightenment,[34] in which the index of each hand touches the end of the thumb, the two hands being held very near the breast and at the level of the heart. According to Waddell, it is the flexion of the thumb that differentiates this gesture from the *semui-in*.[35]

9 An-i-shōshu-in

The designation *an-i-shōshu-in* (Ch. *an-wei shê-ch'ü yin*), the mudrā that "tranquillizes and collects," evolves from the notion of appeasement contained in the denomination *an-i-in*. The *an-i-shōshu-in* is formed by the two hands at the same time: the left hand makes the *an-i-in*, the thumb and the index forming a circle, while the right hand remains at the level of

the hip (in standing statues), the palm turned toward the outside, the fingers slightly inflected, but the thumb and the index separated.[36] Thus with the left hand the divinity appeases Sentient Beings, and with the right hand he gathers them together to protect them or to lead them into his (Amida's) paradise. While the Sanskrit *vitarka* puts the accent on the notion of argumentation, the Sino-Japanese designation of *an-i-in* or of *an-i-shōshu-in* [37] emphasizes the idea of "consoling" all beings,[38] or of consoling and "gathering in" (*shōshu*,[39] Sk. *parigraha*) beings. "All beings who invoke the (name of the) Buddha Amitābha, having been gathered together, guarded, and cared for in the light of the Buddha Amitābha, will be saved and will not be abandoned." [40]

IV]
VI]

11*a, b, c*]

IV]

11*d, e, f*]

The *an-i-in* may be formed either with the right hand (the most frequent form), or with the left, or with both hands at the same time. There are various possible positions, if the gesture is made by each hand at the same time: (1) that which Waddell calls the *uttarabodhi* — the two hands in front of the breast, the palms oblique or facing each other (cf. Amida of the Zenrin-ji); (2) that in which one of the two hands is raised, while the other remains in the lap, the palm up; [41] (3) that in which one hand is raised and one hand is lowered in the fashion of the *segan-semui-in*. In the second variant, the thumb and the index of the raised hand are joined, while in the hand lying in the lap the ends of the thumb and the middle finger touch. This position is characteristic of Amida and of Shakamuni.

The *an-i-in* is also called the *seppō-(no)-in*, the mudrā of the exposition of the Law.[42] The *seppō-in* corresponds exactly to the Sanskrit designation of *vitarka* (Sino-Jap. *bitaka*), the mudrā of argumentation.[43] The term *vitarka* [44] is glossed by the ideogram "*jin*," deliberation: [45] the *vitarkamudrā* is consequently the gesture which indicates the exposition of the Law (*seppō*), the deliberation on the Doctrine. It is the mudrā of the Buddha who explains the Law to the faithful. It is very natural, then, to pass from the idea of instruction to that of teaching. Such a metamorphosis must have taken place as early as the Gandhāran school and have determined to some extent the character of the *vitarkamudrā* in

India. In Indian statues, until the IV–V centuries, the mudrā of the predi- [II
cation of the Law appears to be the most common: the left hand holds a
corner of the stole, while the right hand is raised. This gesture was trans-
mitted to China of the Northern Wei dynasty and hence into Japan with
the passage of Buddhism into that country in the V–VI centuries. It is
fitting then to recall that the *tembōrin-in*, the gesture of turning the [23
wheel of the Law, as a mudrā which designates the predication of
the Buddha, consists logically of two *seppō-in*, which are joined in front
of the breast. It may even be said that despite their form, all the mudrā of
Gandhāra tend to represent the predication of the Law (cf. *tembōrin-in*),[46]
the signification of which would seem to underlie that of argumentation
wherever the *vitarkamudrā* is represented.

The *seppō-in* of the "Esoteric Amida"[47] (*Amida-butsu seppō-in*), [11
that is, the Amida of the Intermediate Class, may be noted to be actually a
form of meditation mudrā (*jō-in*) in which the two hands are joined in the [22
lap, the thumbs touching the index, middle, or ring fingers, thereby
forming a circle. Either by separating the hands and raising them both in
front of the breast, or by raising one and lowering the other in front of the
body, the *jō-in* turns into two *seppō-in*. One may see in this relationship of
forms a similar concatenation of symbolism, for after the Enlightenment,
during which the Buddha sat in *jō-in*, he began to preach, breaking from
meditation into predication: in a like manner the *jō-in* breaks into the
seppō-in.

The variant of the *an-i-in* formed by the joining of the thumb and the
ring finger is called *kichijō-in*,[48] the mudrā of good fortune. This mudrā,
characteristic of the goddess Kichijō-ten,[49] grants to the faithful the good
fortune that the goddess symbolizes. The *Daishoen'okushō* (15)[50] notes
that "by *kudoku*[51] is meant Kichijō *tennyo*. In Sanskrit she is called
Mahāśrī (*makashiri*). *Mahā* means great. *Śrī* has two meanings: merit
(*kudoku*) and good fortune (*kichijō*)." When this mudrā is shown on
statues of Shakamuni, it is called *kichijō-in*, the mudrā of good fortune or
of joy, because by it the world to which the Buddha explains his Law
rejoices (cf. *chi-kichijō-in*, *infra*).[52]

10 Kichijō-in

71

It may be mentioned, in passing, that sometimes the divinity holds flowers, clasping the stem between the thumb and the index finger. The hand assumes a form not unlike the *an-i-in*, a position which is called

XVIII] *jike-no-in*, the gesture of holding flowers. In the strict sense, though, this may be considered not an actual hand gesture nor, for that matter, the bearer of any sort of Esoteric symbolism. Mention is made of it here because in Japanese reference works it does have a specific designation, rather than because it resembles certain forms of *an-i-in*. Such, however,

4–2, 37] is not quite the case of the *koshin gasshō*,[53] which is made by bending the thumb and index until they meet, forming a shape like the conch shell. This gesture, called both *shōgan-in* and *kichijō-hora-no-in*, has a certain symbolic relationship with the *an-i-in*. It is said that by making it, the Buddhas and the Bodhisattvas call all Beings — the *hora* or conch shell being used to summon the faithful by its sound — who subsequently hear the predication and attain *nirvāṇa*.

It is not altogether inappropriate to place the above designations under the *an-i-in* or rather the *seppō-in* heading. Yet it must be borne in mind, particularly in the case of the union of different fingers with the thumb, that the mudrā of exposition, according to the Esoteric system of classifying the gods, is sometimes used to indicate the rank [54] of certain divinities. It follows then that the idea of exposition must necessarily pass onto a secondary plane.

SYMBOLISM

The circle formed by the thumb and the index, a complete form, having neither beginning nor end, is that of perfection; it resembles the Law of the Buddha, which is perfect and eternal. It is very certainly here a question of a mudrā form which recalls the Wheel, one of the attributes which symbolize traditionally the predication of the Law or the teaching of the Doctrine. In Tibet, the "circle" formed by the thumb and another finger is sometimes called "the triangular pose," [55] the mystical gesture of the Tārās or the eight Bodhisattvas.[56] In Esotericism (cf. diag. I),

the gesture is liable to an extended interpretation: [57] the circle of per-
fection represents the exercise of the perfect wisdom of the Buddha,
and the accomplishment of his vows. The gesture also expresses his
great compassion. The left hand represents concentration; the thumb, [Diag. I
which corresponds to vacuity and symbolizes superior intelligence,
unites with the middle finger, which corresponds to fire and symbolizes
the vows of the Buddha. The right hand represents wisdom; the thumb,
which corresponds to meditation, unites with the index, which corre-
sponds to air and symbolizes the efforts of the Buddha. The act of
joining the thumb and the index is symbolical of the diligence and the
reflection which the Buddha brings to his function (of Enlightened One).

In India, the *vitarkamudrā* is a gesture of argumentation or teaching:
consequently, it is a mudrā used particularly by Buddhas. In Japan, the
seppō-in, mudrā of the exposition of the Law, is attributed to Shakamuni [58] [IV
and to Amida.[59] This latter Buddha, according to the *Hōbōgirin*,[60] strikes
the *mushofushi-in*, also known as the (*hosshin*) *seppō-in*, which resembles, [11d, e, f
in fact, the compound mudrā, *segan-semui-in*. "It (the *seppō-in*) is the seal
of the third of the nine Amidas of the nine classes.[61] . . . It is frequent in
standing statues of Amida, notably in the sects Jōdo, Shin, Tendai, etc.
The right hand, which is raised, indicates the search for the Awakening,
and its five fingers represent the Worlds of Auditors, Buddhas-for-self,
Bodhisattvas, Exoteric Buddhas, and Esoteric Buddhas. The left hand,
which is pendent, symbolizes the conversion of Beings, its five fingers
representing the worlds of men, gods, dead, animals, and infernal
(beings)." [62] It has already been noted in the Introduction that the mudrā
are liable, especially in the rites, to variable designations. And the
mushofushi-in may, in fact, designate quite another mudrā, that which is
peculiar to (*taizōkai*) Dainichi and which will be treated under the head-
ing of *mushofushi-in*. [37

Actually, a form of the *an-i-in* may represent six of the nine Esoteric
Amidas — namely, the Amidas of the so-called Middle and Lower Classes.
Middle Class: Lower Life is represented by the two hands held in front [11a
of the breast, each one forming the *an-i-in*, while the ring fingers and

11b] thumbs touch to form mystic circles. Middle Class: Middle Life is represented by the same disposition of the hands but the middle fingers and the

11c] thumbs joined. Middle Class: Upper Life shows also the same disposition of the hands, the *an-i-in* being formed by the indexes and the thumbs.

11d] Lower Class: Lower Life is represented by the right hand raised to

11 AMIDAS OF THE MIDDLE AND LOWER CLASSES

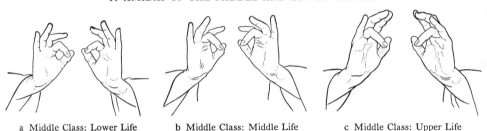

| a Middle Class: Lower Life | b Middle Class: Middle Life | c Middle Class: Upper Life |

 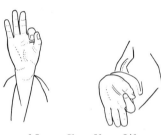

d Lower Class: Lower Life e Lower Class: Middle Life f Lower Class: Upper Life

shoulder level the left hand reposing on the left knee, palm upward. Each

11e] hand makes the *an-i-in* with the ring finger and the thumb. Lower Class: Middle Life shows the same disposition of the hands, while the *an-i-in* is formed by the middle fingers and the thumbs. The same disposition of the

11f, IV] hands obtains for Lower Class: Upper Life, but here the *an-i-in* is formed by the indexes and the thumbs. This mudrā signifies the descent of Amida on the earth to seek the souls of the dead, and is one of the most frequently represented forms of Amida. The remaining three gestures of the Esoteric

74

Amida are properly meditation mudrā and will be treated subsequently under the heading of *jō-in* (see p. 87).

By the *an-i-shōshu-in*, Raigo Amida welcomes souls into paradise: [9 this is the hand which gives and which welcomes.[63] In statues of Raigo Amida, this gesture is called the *raigo-in*, "gesture of welcoming to paradise." The gesture may be made with one hand alone, or, as in the case of the Yamagoshi-no-Amida of the Konkaikōmyō-ji, both hands may be held in front of the breast.

The *an-i-seppō-in* is characteristic of several secondary divinities: [64] Kannon,[65] Miroku [66] and Brahmā [67] as a Buddhist divinity. Yakushi [68] [V sometimes makes the gesture of the *an-i-in* by joining the thumb and the index or sometimes the ring finger.[69] It is probably here a question of a gesture that bears some relationship to the *semui-in*, which is more characteristic of this Buddha. Monju also makes this gesture with his left hand, by joining the middle finger and the thumb.[70] A type of *an-i-in* is a characteristic gesture of Tibetan Tārās. Here the left hand is held vertically in front of the breast while the right is placed below it. Both hands present the palms out, indexes and thumbs joined. Last of all, a gesture deriving, it would seem, from the *an-i-in* [71] may be noted. It is the one made by placing the two hands back to back and joining the thumb with the middle finger of each hand. The little fingers are inter-locked, and the index fingers are vertical. This mudrā is called the *niwa-* [12 *in*, the gesture of the two wings (i.e., hands), and is typical of Gōzanze Myō-ō (Sk. Trailokyavijayarāja), Subduer of the Three Worlds.

12 Niwa-in

4 The diamond handclasp

Kongō-gasshō 金剛合掌

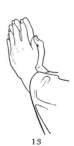

CH. *Chin-kang ho-chang*

SK. *Vajra-añjalikarmamudrā, Añjalimudrā*

13

4–7] THE KONGŌ-GASSHŌ [1] is formed by joining the hands, which are held vertically at the level of the breast, palm against palm, fingers against fingers, interlocked at the tips, the right thumb covering the left.

4–1] In the *kenji(sshin)-gasshō* the hands are simply joined. The arms may be somewhat advanced. The *Dainichikyōsho* [2] describes this gesture thus: "The tips of the fingers are interlocked. All the fingers of the right hand repose on the corresponding fingers of the left hand. This is the *kongō-gasshō*,[3] (also) called the *kimyō-gasshō*. (The transcription of) the Sanskrit is *haranama-gasshō*." [4]

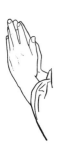

14 Kimyō-gasshō

The *kongō-gasshō* resembles very much the mudrā of supplication called the *shashu-gasshō*,[5] and, according to certain authorities, only the position of the crossed fingertips differentiates them. For example, the *kongō-gasshō* has the thumbs and fingertips interlocked, but in the *sammaya-kai*—that is, rules to be observed before full ordination into Esoteric sects—the thumbs are interlocked but the fingers not.[6] Because of their common signification and their similarity of composition, these several gestures will be treated under the same heading.[7] It may be noted here that the designations *kimyō-gasshō* and *kongō-gasshō* are equivalent, for the *Gyōbōkanyōshō* [8] (I) notes: ". . . At the moment of worshiping the divinity, the *kongō-gasshō* is made; that is to say, the *kimyō-gasshō*. The meaning of the interlocked fingers is that the ten fingers represent the Ten Perfections (*haramitsu*) and the Ten Worlds of Essence (*hokkai, dharmadhātu*)." [9]

76

The *kongō-gasshō* also resembles very much the *kenjisshin-gasshō* (cf. Fig. 4–1: the Twelve Handclasps), but according to Mochizuki,[10] the first shows the fingers crossed, while the second shows the hands joined in a simple attitude of prayer.

SYMBOLISM

These gestures, which ritual as well as iconographic usage tends to relate, are mudrā of adoration. As such they enjoy a common meaning. As a gesture of adoration — the hands are joined (*gasshō*) to honor the Law [11] — the *kongō-gasshō* may derive from Hindu etiquette, in which it is [4–1] a gesture of offering, of adoration, and of salutation. In Hindu dancing, the performer generally forms this mudrā at the end of each presentation in order to indicate that his dance has been an "offering" intended for the pleasure of the spectator. In Buddhism this gesture serves to give homage to divinities accompanying offerings or prayers, and reveals thereby the influence of the old Hindu usage. In India, be it with Brahmā teaching the Veda or in early Buddhist sculpture,[12] this gesture preserves the same use, which is universally prevalent in countries of Buddhist obedience. The hands are joined under the mouth in order to give homage to the Words emitted by it; hence the gesture honors the Buddha and the Law.

The designation *kongō-gasshō*, as a gesture formed by the union of the two hands, recalls the co-existence of the two inseparable worlds, which are really one: the *kongōkai*, the Diamond World (Sk. *vajradhātu*), and the *taizōkai*, the Matrix World (Sk. *garbhadhātu*). These two worlds are the expression of two aspects of one cosmic life and represent the reciprocal action of the spiritual and the material, the static and the dynamic. On the other hand, the *kongō-gasshō* [13] as a simple gesture symbolizes the world of ideas (*kongōkai*), which, like the diamond (*kongō*), is indestructible, eternal, static. The symbol of the diamond represents hardness and utility, indestructible truth, and the action of knowledge. Like qualities are emphasized by another designation, *kenjisshin-gasshō*, the joined hands of the inflexible, sincere heart. The counterpart of the

kongōkai, that is, the Matrix World (*taizōkai*), which represents the perishable, the phenomenal, the material, is symbolized by the *koshin-gasshō,* the joined hands of the heart empty (of passions). As Smidt 4–2] writes: "Since the *kongō-gasshō* and the *koshin-gasshō* play parallel roles, the first signifies the wisdom of the *kongōkai* and the second the knowledge of the *taizōkai.* The 'Empty Heart,' the space which exists between the two hands in this gesture, is the depository of the treasure of the Law, the precious receptacle of the Buddha nature which all Beings represent. The inflexible heart is so inflexibly closed that, between Sentient Beings and the Buddha, there is not even room for a hair. The 'Empty Heart' signifies that there is a way [*Treppe*] between the Buddha and Sentient Beings. Since the Jōdo sect believes that we will be saved by the great Compassion of Amida, this sect [especially] has recourse to the *koshin-gasshō.*" [14]

In these gestures of adoration, the union of the right hand (world of the Buddha) with the left hand (world of Beings) represents the fundamental unity which exists between the *kongōkai* and the *taizōkai.* This unity is a representation of the Esoteric principle of duality-non-duality. The hands are in fact two; but they are joined to form only one unit, a unity, moreover, parallel to that which exists between the Buddha and 4–1] Beings. This notion is reflected in the *kenjisshin*(-*gasshō*), which is a gesture utilized by the Zen sect: just as the two palms are held firmly closed against each other, in the same manner the Zen adept focuses himself in interior contemplation. Thus is explained the phrase *jikishininshin-kenshōjōbutsu,* "directly to attain the human heart (while rejecting all literary aid), perceiving one's (fundamental) nature, and becoming Buddha." [15]

13] The designation *shashu-gasshō* evokes, by the crossing of the ten fingers, the union of the Ten Perfections (*haramitsu*) (cf. Intro., *supra*) 14] and the Ten *hokkai* (*dharmadhātu*).[16] The denomination of *kimyō-gasshō,* the gesture used at the moment of worshiping the divinity, hence the gesture of prayer,[17] admits of three significations as declarations of faith:

1 To take refuge in the Buddha.

2 To submit to the Law of the Buddha.

3 To reduce the basis for life (*myōkon* to its origin [in the heart]).

The *kongō-gasshō* is a gesture of adoration, a gesture which gives honor to a superior state. Consequently it is never represented on a statue of the Buddha. It is a gesture which belongs rather to Bodhisattvas [VII and to lesser personages (Guardian Kings, holy men, etc.), who give homage either to the Buddha or to the Doctrine. It is seen on statues of multiple-armed Kannon.[18] By separating the middle three fingers, the *kenjisshin-gasshō* becomes one of the characteristic gestures of this divinity, the *mifu renge-in*, the gesture of the unopened lotus. According [4–4 to the *Himitsunembutsushō*,[19] Kannon holds an unopened lotus in her hand. The meaning here is that she has the power to make the flower open, in other words, to propagate the Law to all things and to cause them to benefit by her universal compassion. Mallmann notes the use of this gesture with (Ṣaḍakṣara-)Lokeśvara in India, who, on the example of Brahmā teaching the Veda, forms it to worship the six-syllable formula, "*oṃ maṇi padme hūṃ*." [20] But in Japan, as in India, Kannon with two arms does not form the *kongō-gasshō*.[21] This mudrā is also to be found on statues of the Myō-ō ("Knowledge Kings"), holy personages,[22] donors, and Bodhisattvas.[23]

5 Mudrā of touching the ground

Sokuchi-in 觸地印

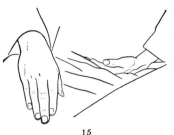

15

CH. *Ch'u-ti-yin*

SK. *Bhūmisparśamudrā* [1]

VIII] THE SOKUCHI-IN, a gesture of the right hand, is peculiar to seated statues.[2] It is formed by presenting the hand pendent in front of the right knee with the palm turned inward,[3] the fingers extended downward touching or "designating" the ground.[4] Sometimes the lowered hand rests on the right knee. Sometimes it remains a little away from the knee, while the left hand holds a section of the stole [5] at the level of the breast

3–2] or lies in the lap, where it may form the so-called Diamond Fist (*kongō ken-in* [6]). The left hand may also lie on the left knee or at the level of the

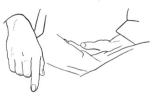

16 Sokuchi-in (*variant*)

navel.[7] This gesture in Japan is the same as its prototype, the *bhūmisparśamudrā*, of the Gandhāran school.

 The *sokuchi-in* is characteristic of seated statues, but there is another gesture which iconographically and symbolically is akin to it; this is the

17] *anzan-in* (Ch. *an-shan-yin*), "the gesture which 'represses' the mountain," a mudrā often found in standing statues. The gesture is regularly formed by the left hand, but sometimes it is made by the right as well. The arm is lowered in the fashion of the *sokuchi-in*, the wrist is flexed in such a way as to present the palm of the hand more or less parallel to the ground—not unlike a natural gesture of suppressing.[8] It is, in fact, the mudrā which signifies the "subjugation of the mountain" (the earth).

80

To the extent that this mudrā symbolizes the victory over the demons, it has the same meaning as the *sokuchi-in*. This community of meaning would seem to justify the study of these two gestures under the same heading.

17 Anzan-in

SYMBOLISM

The *sokuchi-in* is known under several designations, which are connected with the symbolism attributed to this gesture. This symbolism doubtlessly finds its origin in the following legend: At the moment when the historical Buddha was on the point of proving his Buddha perfection, the gods of the earth warned him that he would be attacked by demons. But the Buddha calmed them, saying that he would suppress these evil-doing gods by his power alone; that is, by his *bodhi* knowledge. At this point the demon king appeared and challenged him to put his words into action. The Buddha, pointing to the ground with his finger, called upon [16 the gods of the earth, who rose up and killed the demons.[9] Other versions describe the Buddha seated in *padmāsana* under the *bodhi* tree and touching the earth; whence the term *soku-chi*, "touching the earth." Śākyamuni remains unshakable by virtue of his former merits and his boundless kindness (*maitrī*). Māra (compare with Rāvana, Bali, etc., in Brahmanism), following the defeat of his demon army, nevertheless presses his claim for the *bodhi* throne. He calls upon his troops as witnesses. The Buddha, without supporters, takes Earth as his witness by touching the ground. Whereupon, personified, Earth, trembling in six ways, proclaims the Buddha the rightful occupant of the *bodhi* throne. Still another version has the Buddha making this gesture as a sign of generosity when he was born as Vessantara.[9a] Some designations put stress on the dramatic episode of the demons; thus, *gōma-in* [10] signifies the subjugation of the demons; [11] *hama-in*, the mudrā of the defeat of Māra,[12] the demon king who flung his malevolent legions against the Buddha;

nōmetsubinayaka-in, mudrā of the annihilation of the Vināyakas; [13] *saifuku-shoma-in*,[14] mudrā of the suppression of all the demons, the mudrā by the aid of which Shakamuni must have turned the demons, symbols of evil, to rout at the crucial moment of the final enlightenment. The position of the hand in the so-called *anzan-in* recalls the moment in which the Buddha repulsed the demons.

Another aspect of this gesture relates the historical Buddha's long preparation for enlightenment. According to Conze: "He points to the earth as his witness, and the deity of the earth rises out of the ground, to confirm his statement. She also bore witness to the fact that Śākyamuni had fulfilled the complete discipline and duty of a Bodhisattva. This parable hides a deep spiritual truth. Māra, who corresponds to Satan, is the Lord of this world and of this earth. He claims therefore that the Bodhisattva, representing that which is beyond this world and irredeemably hostile to it, has no right even to the piece of ground on which he is seated in meditation. The Bodhisattva, on the other hand, claims that through his innumerable deeds of self-sacrifice in his former lives, he has won a right to this little bit of earth." [15]

The *kyōhacchijin-in*, the gesture of surprising the gods of the earth, finds its origin in the version of the legend according to which Shakamuni, arriving at the state of Buddhahood, surprised (*kyōhatsu*) the gods of the earth and obliged them to swear him eternal fidelity. As a result, this gesture symbolizes the decisive moment of the Enlightenment of the Buddha, a moment pregnant with meaning, for it is the instant in which Shakamuni ceases to be a Bodhisattva and becomes the Buddha. By the simultaneousness of his transformation, he incorporates the two states — Buddha and Bodhisattva — in one single instant. This metamorphosis recalls the superiority of the knowledge of the Buddha, which is pure *bodhi* perception and the means which enables the Enlightened One to triumph over the demons.

The term *sokuchi* signifies "touching the ground," and the preceding names all stem from the notion of "repressing" the evil which is symbolized by the demons. But the idea of the *kyōhacchijin-in* derives more

directly, perhaps, from the idea expressed by the Sanskrit *bhūmisparśa*, the act of calling the earth to witness.[16] The notion of witnessing is related to the episode of the aforementioned legend, in which Gautama Buddha asks the earth to witness his temptation by the demon king, Māra, or of the unshakable resolution [17] of the Buddha to renounce the world.[18] Thus, the *kyōhacchijin-in* symbolizes the defeat of the demon army.[19]

There remain to be noted such designations as *shichi-in*, a gesture which indicates the earth—this is the mudrā which quiets the shock of the Enlightenment [20]—and the *nōsaibuku-in*, the mudrā of bewitching.[21]

The principal divinities which employ the *sokuchi-in* are Shakamuni [VIII, XXIIᴀ and the Esoteric Ashuku Nyorai (Akṣobhya). In the Gandhāran school, the *sokuchi-in* refers to the scene of the Buddha's Enlightenment and to the subjugation of the demons. Sirén writes: "This gesture alone, among all the gestures, is a distinctive sign of Śākyamuni; the other gestures may be of a common use with several Buddhas." [22] In Esotericism, the mudrā of "touching the earth," as one of the "act seals" of the five Buddhas (*gobutsu komma-in*), pertains to Ashuku,[23] for whom it constitutes the principal iconographic characteristic. "With his right hand, he extends the five fingers and 'represses' the earth: the five fingers of the left hand hold a section of the stole (*kesa*)" [24] at the level of the breast.[25] As an attribute of (*kongōkai*) Ashuku, the mudrā is called *ashuku-in* or *shichi-in*, and symbolizes the suppression of the demon army. Gonda observes that Ashuku holds the *kesa* with his left hand, but sometimes he forms the *kongō ken-in*,[26] Diamond Fist, with the left hand, which then lies in his lap. [3–2

(*Taizōkai*) Tenkuraion Nyorai [27] also makes this gesture, for it may be noted that "a tradition identifies to the Buddha Akṣobhya of the Diamond World the Buddha Divyadundubhimeghanirghoṣa (Tenkuraion) of the Matrix World." [28] And sometimes it is associated with Hōshō (East).[29]

Although this mudrā as a gesture characteristic of the Buddha Amida seems to be extremely rare, if not entirely absent, from Japanese sculpture, one may, nevertheless, note continental examples which would

support the notion of an iconographic confusion in Korea (and in China).[30] Here again, as in the case of the *tembōrin-in*, the artistic tradition differs from that of the texts. Amida, in certain cases, appears to have assigned himself this gesture, which, however, must be considered most characteristic of Shakamuni.

6 Mudrā of concentration

Jō-in 定印

CH. *Ting-yin*
SK. *Dhyānamudrā* [1]

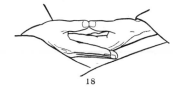

18

THE JŌ-IN, or "gestures of concentration," [2] reflect diverse tradi-
tions, which have led to a variety of designations [3] and forms. It is
possible, however, to bring out the general lines discernible in the *jō-in*
and to impose a certain amount of order on them, without attempting to
make a definitive system of classification. This somewhat arbitrary ap-
proach is taken in order to give the student of Buddhist iconography a
more or less comprehensive picture, from which he can note those details
which interest him.

The *jō-in* is a mudrā universally peculiar to seated statues. The most
common position or "attitude" (cf. *āsana*) is that which is called *kekka
fuza*: the legs are folded so that the right foot rests, sole upward, against
the left thigh, the left foot likewise against the right thigh (cf. *padmā-
sana* [4]). In order to facilitate the classification and the symbolic interpre-
tation, it is possible to divide all the *jō-in* of Japanese sculpture into three
general categories. For the convenience of this exposition, the mudrā of
concentration, according to their form, will be called Type A, Type B,
and Type C.

TYPE A

*The hands lie in the lap, one on
top of the other, the palms up.*

19

The *Shōshinjitsukyō* (II) thus describes Type A, the simplest form of
jō-in: "First, the five fingers of the left hand are extended in front of the

navel, then the five extended fingers of the right hand are placed on those

X] of the left."[5] In Type A, the position of the hands is characteristic; they are placed one on the other, flat, the right on the left, palm up; less frequently, the fingers are enmeshed. This is the Gandhāran *dhyānamudrā*.

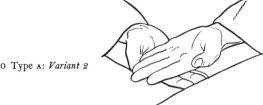

20 Type A: *Variant 2*

This form of *jō-in* is found on Japanese statues especially in the VIII–X centuries, but after the X century it is less frequent than Types B and C. Type A is frequently found in China in Wei sculpture.[6]

Two variants of Type A, although rare in Japan, may be placed under this heading: (1) the legs in *padmāsana* and the hands placed one on top of the other in inverted position and held parallel to the feet, the

20] palms turned toward the body;[7] (2) the hands placed on top of each other, the palms up, and crossed at about a 45° angle, the right hand on the left hand or vice versa.

Type A, of Indian origin,[8] spread throughout all parts of Asia of Buddhist obedience, notably China[9] and southeast Asia.[10]

TYPE B

The hands lie in the lap, one on the other, the palms up; the thumbs, extending toward each other, sometimes touch, or are raised to form a triangle[11] with the palms of the hands.

21

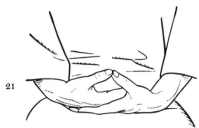

XVI] In the form of Type B which is probably oldest, the ends of the thumbs join over the fingers of the superposed hands. Absent or infrequent in India, this form is frequently seen on Chinese Wei statues,[12] and the first Japanese statues serve as indications of the passage of this type to

Japan.[13] The position in which the thumbs are slightly separated is probably a somewhat later one.[14] Most of the authorities in iconography maintain that this gesture is made by placing the right hand on the left,[15] as in Type A, but several examples exist in which the left hand is placed on the right. Doubtless it is a question here of a simple lack of iconographic precision. Some of the texts, which have a tendency to give rather general indications [16] for the gestures, do, however, show that the left hand should occupy the upper position.[17] Nevertheless, universally in India, the right hand is placed on the left.

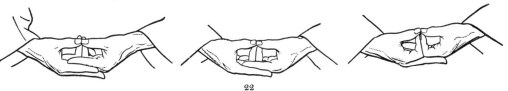

22

TYPE C

The hands lie in the lap, one on the other, palms up. The last two phalanges of the indexes are in a vertical position and touch back to back. The thumbs join at the ends of the indexes forming thus two circles.[18]

This type, which is later [19] than the other two, is frequently used in Japanese Esotericism, especially in statues of the so-called Esoteric Amida. It is not present in Indian sculpture. It has three aspects, characterized by circles formed with the thumbs and indexes, middle fingers, and ring fingers. Each aspect stands for a specific rank in the Amida hierarchy. [IX

SYMBOLISM

The symbolism of the *jō-in* is closely associated with the Indian concept of *samādhi* (*sammaji*): the complete absorption of thought by intense contemplation of a single object of meditation,[20] in such a way that the bonds relating the mental faculties to so-called "real phenomena" are broken, and the worshiper is thus enabled to identify himself with the Supreme Unity [21] through a sort of super-intellectual *raptus*. Two cate-

gories of thought processes fall under the heading of *samādhi*: the *sanjō*, or "scattered meditation," exercised under the influence of the World of Desire, characterizes the ordinary fashion of thinking; and the *zenjō*, or "ecstatic meditation," [22] exercised in the World Beyond Forms.[23] This latter type is one of the attributes of the Essence Body (*hosshin*), a state which implies absolute calm, impassivity, tranquillity, wherein one is "exempt from exterior sensations." In the *jō-in*, the position of the hands (especially in Types A and B but also in Type C) is that of the adepts of yogic contemplation. Thus the *jō-in* symbolizes specifically *zenjō*, ecstatic thought (N.B. the designation *zen-in*), for it is the gesture which indicates the suppression of all spiritual disquiet in order to arrive finally at the complete concentration on the truth.

The position of the hands in the mudrā of concentration derives, in accordance with the tradition, from the attitude which the historical Buddha assumed when he devoted himself to final meditation under the *bodhi* tree. This is the attitude he was found in when the demon armies of Māra attacked him. He was to alter it only when he called the earth

15] to witness, at the moment of his triumph over the demons (cf. *sokuchi-in*). Consequently, in the Gandhāran school, the position symbolizes specifically the supreme meditation of the historical Buddha, but also the Buddhist qualities of tranquillity, impassivity, and superiority.[24] According to a variant of this legend, the Buddha as Liberator of the Nāga [25] is symbolized by the *jō-in* (*dhyānamudrā*) or by the *uttarabodhimudrā* [26] (*renge-in*, mudrā of the Lotus). The mudrā of concentration under the designation of *zen-in* also serves as a gesture peculiar to the Buddha Fukūjōju (Amoghasiddhi), who, in India, is represented in the position of meditation and protected by the serpent Mucilinda. As early as the art of Amarāvatī, however, the hand of this divinity is raised to make the *abhayamudrā* (*semui-in*), which subsequently becomes the characteristic gesture of Amoghasiddhi.[27]

It will be noted that the junction of the thumbs, in the position of the
21] hands joined in the lap, especially in Type B, takes on the aspect of a triangle. This mystic triangle (*trikoṇa*) is associated closely to the one

which is constituted by the straight torso and the legs of the statue seated in *padmāsana*. The triangle symbolizes both the *tri-ratna* (Buddha, doctrine, community) and, according to the beliefs of certain sects, the *yoni*, womb-source of all things.[28] The symbolic value of the triangle may be found to originate in the words of the Buddha himself. The Supreme One spoke about the symbol of Self by using three points, ∴, arranged in the form of a triangle resting on its base. This geometric form was used to symbolize the embodied aspect of the *Tathāgata*.[29] The symbolism of the triangle "seal" extends far back into the history of Buddhism. As Steinilber-Oberlin writes: "According to an ancient translation brought back from India, and adopted by Buddhism, the Body of Fire is triangular. So the Seal of Hokai-Chō consists in forming a triangle by joining the tips of the two extended forefingers, the other fingers remaining closed. It symbolizes the production of Fire, which must destroy all that is impure in the World of Law, and render the world sacred and saintly." [30]

In Esotericism, the symbolism of the position of the hands shows considerable amplitude: the *jō-in* title signifies "the complete renouncement of the Buddha and his evasion from the chain of causality." [31] The *zen haramitsu* (*dhyānapāramitā*) is actually the fifth perfection, *dhyāna* or meditation, fifth of the Six Perfections which lead to *nirvāṇa*. It is thus the mudrā which symbolizes the crossing of the sea of life and death by means of "ecstatic concentration," to arrive at Extinction. The right hand, which symbolizes the World of the Buddha, reposes on the left hand, which symbolizes Sentient Beings. Together they emphasize not only the relative position which these two worlds occupy but also the fact that Buddha and Sentient Beings form one and the same unity.[32]

The circle formed by the fingers in Type C means the perfection of [22 the Law (compare with the circle-wheel of the Law), because, of course, the circle is a perfect form.[33] So in the *hokkai jō-in*, the single circle-like shape of this mudrā represents the universe. The formation of the two circles by the two hands representing, respectively, the world of the Buddhas and that of Sentient Beings, indicates that the Law conceived by the Buddha is sustained by Sentient Beings, who integrate themselves

JŌ-IN

into it completely. The two juxtaposed circular shapes represent the accomplishment and the perfection of Buddhist Law in its relationship to all Beings. The right-hand circle symbolizes the divine law of the Buddha, the left-hand circle, the human law of the Buddha. Side by side, the circles symbolize the harmony of the two worlds, that of Sentient Beings and that of the Buddha.[34] The fingers are entwined or superposed; those of the left hand represent the five elements of the world of Beings, and those of the right hand the five elements of the world of the Buddhas. Moreover, the fingers symbolize by their respective position the superiority of the world of the Buddha in its relation to the world of Sentient Beings. Also in those cases in which the left hand (Sentient Beings) is placed on the right (Buddha), the relative position of the two would symbolize that the world of the Buddhas sustains the world of Beings.

22] The two circles of Type C also stand for the two aspects of cosmic unity; the Diamond World (*kongōkai* or *vajradhātu*) and the Matrix World (*taizōkai* or *garbhadhātu*). These circles are separated from each other because they are formed by two different hands. The circles are joined in this mudrā to constitute a single unity which symbolizes, by the forms and their juxtaposition, the double aspect of a single world, and the concept of All-One, the basic principle of Esotericism. The *jō-in* that indicate the two Worlds are often called *hokkai jō-in*, a designation which denotes the entrance into profound meditation on the World of Essence (*hokkai*). In fact, Zemmui states that *in* is actually a symbol of the (body of the) world of essence and that it is from this relationship that the *hokkai jō-in* derives its name.[35]

The mudrā of concentration are difficult to denominate and to classify in a completely precise fashion. For example, the different *jō-in* of *taizōkai* Dainichi and of *taizōkai* Amida change their names and their symbolism with slight differences of position of the fingers and of the hands. In order to succeed in distinguishing the principal variants, however, a somewhat arbitrary order may be imposed upon them. It may be seen that the *jō-in* let themselves be apportioned to three categories,[36] according to the nature of the divinities that make them, and their position in the *maṇḍala*.

XVI, IX]

Mudrā of the Buddha Section

The *hokkai jō-in*, concentration mudrā of the Dharma world, is [21, XVI
associated with (*taizōkai*) Dainichi of the Matrix World, whence the
name *Dainichi jō-in*.[37] This denomination usually applies to Type B of
the *jō-in* in which the thumbs are held level with the fingers. In the case
of Dainichi of the Matrix World, the symbolism of the union of the two
hands would be essentially the unity of the material and the spiritual.
The *hokkai jō-in* is the counterpart of the *chi ken-in*, which characterizes [31, XIV
the (*kongōkai*) Dainichi of the Diamond World.[38] Together these two
gestures represent the Six Essence Worlds (*rokudai hokkai*) of the two
(*taizōkai* and *kongōkai*) Dainichi. Several texts officially establish the
position of the *jō-in* for (*taizōkai*) Dainichi; among others, the *Sonshō-
bucchōshuyugahōgiki* and the *Ryakushutsukyō*(I),[39] which indicate that the
statue of the divinity should be in a seated position (*kekka fuza*) with
the soles of the feet up. The two hands in *hokkai jō-in*[40] symbolize here
the oneness of knowledge (*chi*) and of principle (*ri*).[41] Thus Dainichi
Nyorai is customarily seen seated in the middle of nine gods on an eight-
petaled lotus throne: he makes the *nyū jō-in* or *hokkai jō-in*.[42] It should
be noted that the *jō-in* (that is, the *hokkai jō-in*), such as it is formed by
Dainichi of the Matrix World, is distinctive in that the thumbs touch
each other. Yakushi also on occasion makes the *hokkai jō-in* (Hokkaiji,
Yamashiro): hands flat, tips of thumbs touching. This mudrā is con-
venient for holding a medicine pot, the usual attribute of the divinity. [66

Jō-in of Amida,[43] or Lotus Section *Jō-in*

Amida is perhaps the most important of all the divinities that display [IX
the *jō-in*. Consequently the *jō-in* of Amida are comprised of the variously
named concentration mudrā formed by this Buddha. In the Amida con- [22
centration mudrā, the fingers are interlocked on the outside (*gebaku*),
while the indexes of both hands touch the thumbs to form two circles.
The *rengebu-no-jō-in* of Amida is also known under the name of *myōkan-*

zacchi-in, mudrā of the Mirror Knowledge,[44] a gesture denoting perspicacity, a particular virtue of Amida.[45] This is "one of the five Knowledges of Vairocana (i.e., Amida from the point of view of equality, all Buddhas being equal), whose role it is to conduct Beings toward enlightenment by retrenching doubts relative to the predications of all Buddhas."[46] According to the *Bukkyō Daijiten*, this is one of the four Knowledges of the Exoteric Doctrine,[47] the knowledge of the exposition of the Law through "perspicacity" (*myōkan*), which vouchsafes the understanding of the whole teaching.[48] The Tendai school gives of the *myōkanzacchi* another explanation according to which "*myōkan*" becomes the name of a triple system of meditation.[49] The *jō-in* of Amida are known under other designations: [50] *saishōsammai-in*, mudrā of supreme meditation; *rengebu jō-in*, concentration mudrā of the lotus section; *shiyui-in*, mudrā of the mind at work; *jūsammaji-in*, mudrā of perseverance in meditation; *josanranshin-in*, mudrā of dispersing the disorders of the heart (in the toils of the passions of this world, in order to arrive at enlightenment); *Mida jō-in*,[51] mudrā of concentration in Amida; *rikitan jō-in*, mudrā of concentration in the extreme strength (of the Buddha); and *Muryōjunyorai-in*,[52] mudrā of the *Tathāgata* Muryōju (i.e., Amida). The *jō-in* is the "act seal" of the five Buddhas (*gobutsu komma-in*, which corresponds to Amida in the Diamond World).

11] The mudrā of the Esoteric Amida, that is, the Amida of the nine classes,[53] are known as *kuhon-in* and serve to indicate the rank of the
22] Amida in question. The *jō-in* are reserved for the Upper Class. For example, Upper Class: Lower Life presents the Type C *jō-in*, in which the two raised ring fingers form with the thumbs two circles. The indexes and the middle fingers are entwined. Upper Class: Middle Life presents Type C *jō-in*, in which the two erect middle fingers form with the thumbs the two circles, the other fingers being entwined. Upper Class: Upper Life also presents the Type C *jō-in*, in which the two raised indexes form with the thumbs the two circles, the other fingers being entwined. Other mudrā designating the Amida of the nine classes were discussed above under *an-i-in* (see p. 74).

Jō-in of the Diamond Section and others

The *jō-in* of the Kongō section is the *baku jō-in*, mudrā of concentration on the bonds which attach Sentient Beings to the passions of the world; it is a characteristic gesture of Tenkurai Nyorai [54] and is regularly formed by interlocking the fingers (*gebaku*), letting the tips [19 of the two thumbs touch. While the three foregoing may be considered most important, there are other concentration mudrā characterizing different *maṇḍala* sections. Since they are essentially pictorial, they may be summarily mentioned. For the treasure section (*hō-bu*), Amida's [22 *jō-in* is formed: the two indexes in contact with the thumbs make the circles characteristic of the Type C concentration mudrā. This gesture is called the *samben hōju jō-in*, "concentration mudrā of the trilobate jewel" (q.v.). The *kamma-in* of the karma section is formed by interlocking the fingers (*gebaku*), letting the thumbs and little fingers touch at their tips. Despite the variety of forms and uses, among the above concentration mudrā, generally speaking, the *hokkai jō-in* symbolize the Womb World of Essence (*taizō hokkai*), while the *kongō-bu jō-in* symbolize the Diamond World of Essence (*kongō hokkai*). The concentration mudrā of the Buddha, Diamond, and Lotus sections are collectively known as the *sambu jō-in*, "concentration mudrā of the Three Sections." They apply to the *taizōkai*, in which the images are enclosed in three circles. To these three are added two more: treasures and karma, which form the five circles of the *kongōkai*. The collective concentration mudrā of the Five Sections are hence called the *gobu jō-in*.

No one of these three groups of *jō-in* should be considered as being exclusively distinctive of the principal divinities mentioned above. Thus, numerous Buddhas,[55] and Bodhisattvas.[56] holy men, and sages [57] form the *jō-in* at times to recall the legend of the historical Buddha, at other times to invoke the Esoteric power of the gesture. The mudrā also symbolizes Zen meditation. Contrary to the *sokuchi-in*, which — in Gandhāra — is peculiar to Śākyamuni, the *jō-in*, of ecclesiastic and secular use,[58] is rarely sufficient to identify the personage who makes it.

7 Mudrā of turning the wheel of the Law

Tembōrin-in　轉法輪印

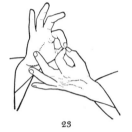

CH. *Chuan-fa-lun-yin*

SK. *Dharmacakramudrā*[1]

23

XI]　THE TEMBŌRIN-IN is characterized by a diversity of forms during the course of its development across Asia. Even India offers a variety of aspects: in general, the right hand is held at the level of the breast, palm facing outward, while the index and the thumb, joined at the tips to form the mystic circle,[2] touch one of the fingers of the left hand, whose palm is turned inward; such is the form manifest as early as Sārnāth.[3] In a Buddhist fresco at Ajaṇṭā, the two hands are held in front of the breast, the left hand grasps a corner of the stole, and the right hand, whose index and thumb are touching, seems to press upon the little finger of the left hand.[4] In another Ajaṇṭā example, the hands are held close together but do not touch. This type is reflected in the Hōryūji Amida. In a work of Gandhāra, the right hand, with the fingers rather close together and the palm turned inward, loosely envelops the joined

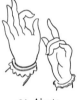

24 Ajaṇṭa
Tembōrin-in

XII]

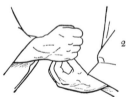

25 Gandhāran Tembōrin-in

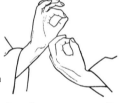

26 Tibetan Tembōrin-in

ends of the thumb and index of the left hand: the other fingers are negli-
XIII]　gently closed.[5] Another form occurs in Tibet: the right hand is held erect in front of the breast, as in the *an-i-in* (index and thumb joined at the tips —cf. Fig. 9), the palm fully turned outward; the left hand with the palm turned toward the inside touches, with the ends of the thumb and the

94

index (also in the form of an *an-i-in*), the mystic circle formed by the right hand.[6] The left hand may either hide the right palm or be fixed on a slightly lower plane in such a fashion as to leave it exposed. This gesture, which exists in China in identical form,[7] was said to have been transmitted

27 Hōryūji Tembōrin-in

there in the early T'ang dynasty through Hsüan-tsang and Wang Hsüan-t'se. A Japanese example is to be seen on the Hōryūji Amida. In Japan, these diverse Indian forms have favored the occurrence of several variants. The most common one very much resembles the corresponding [26 Tibetan mudrā: the left hand forms the "mystic circle" by joining the middle finger and the thumb, the extremity of the index touches the joined ends of the thumb and index of the right hand, and the little finger of the left hand lies on the base of the right thumb. The index constitutes thus a symbolic bond between the two hands.[8]

It is fitting to note here another variant [9] of secondary importance. [28 The hands are placed back to back, the left palm turned outward; the entwined fingers touch at their extremities, and the left thumb meets the right thumb on the right palm. This variant has not been noted in India, and even in Japan,[10] especially in sculpture, it is rare.

28 Tembōrin-in (*variant*)

SYMBOLISM

By virtue not only of its designation ("turning the wheel of the Law") but also of its form (the two circles recalling the aspect of the wheel), the Esoteric significance of this mudrā is based on the symbolism

of the wheel.[11] This attribute, which may be appropriately classified under the heading of the gesture to which it is so closely associated, is charged with meaning since the earliest antiquity.[12] Before Buddhism, the wheel had doubtless already taken on with the Indo-Europeans a role emblematic of the sun and of fire.[13] And so it is that in Buddhism Vairocana,[14] who

29 Wheel: at right, from early coin

carries this attribute, marks his clearly solar nature;[15] he dissipates lies and error, just as the sun dissipates morning clouds.[16]

29] By virtue of a possible identification with the solar disk, the wheel comes to designate the course of the sun, the "revolution of the year: the incipience of its movement constituted then the primordial act of creation." [17] "In the sense that Time is the Sun," writes Coomaraswamy, "a circle is its centre, the Wheel represents the Sun, but more exactly the movement of the Sun, in his heavenly car, with one or two correlated wheels." [18] The solar character of this attribute in Buddhism is manifest as early as Bārhut and Amarāvatī. The Buddha is represented at both sites as the "sempiternal sun." [19]

As a solar emblem, the wheel appears in a double form: that is to say, the two wheels of the solar chariot at once bound together and held away from each other by the same axle. It is the emblem of the world seen from two different but inseparable [20] points of view (in Shingon, the indivisibility of the *taizōkai* and the *kongōkai*). The sun lights the sky and the earth; in the same way the two wheels touch, one the heavens and the other the earth. The axle is identified with the cosmic axis, which at the same time separates and binds together these two points.[21]

Even in the pre-Buddhist period, the *cakravartin* [22] (*cakra*, "wheel"; *vartin*, "he who has the movement or who puts into movement"), the king who causes the wheel to turn,[23] uses the wheel as a symbol or dis-

tinctive arm.[24] Legend has it that at his investiture a golden wheel fell from the sky.[25] The *cakravartin* is nevertheless inferior to the Buddha, who as *dharmacakravartin*, the one who causes the wheel of the Law to turn, conquers the world for Buddhism by universalizing the Doctrine. Thus the wheel presents a meaning of double aspect: that of destroying, and that of lighting — both deriving from pre-Buddhist notions. A close relationship may be established between the Buddha and the universal sovereign, for the Buddha as the all-powerful monarch is "he who puts the wheel in motion" (*cakravartin*), the wheel that, as it passes through the world, crushes [26] all evil, all error, all enemies of the Law. "There where it keeps itself is the unshakable place in which should reside such a sovereign, he who, by definition, is stable, firm, omnipresent, linked to the center of the universe from where he reigns." [27] Only he who sets the wheel in motion, who performs the creative act, may be a monarch reigning over the whole world. So the indestructible Wheel of the Cosmos illustrates the action of the Buddhist Doctrine, which crushes all illusion and all superstition, as the wheel crushes all it passes over.[28] Wheel of protection, wheel of creation [29] such are its qualities as the arm of the universal sovereign. Moreover, the *Praśna Upaniṣad* adds: "On whom the parts stand fast, as it were spokes on the nave of the wheel, Him I deem the Person to be known." [30]

Dr. Coomaraswamy gives a résumé of the rich symbolism of the wheel in Buddhist metaphysics: "Its dimensions are indefinite, its radius the variable distance between an undimensioned (*amātra*) point and an immeasurable (*asaṅkhya*) circumference: there in the 'middle space' (*antarikṣa, ākāśa*), between the 'I' and the 'not-I,' essence and nature, lie procession and recession (*pravṛtti, nivṛtti*), there are good and evil (*dharmādharmau*), joy and sorrow (*sukha, duḥkha*), light and shade (*chāyātapa*), birth and death, all local movement and affection: and that motion and passibility are greater the greater the distance from the centre. Beyond the felly lies only the inexistence of the irrational, an impossibility of existence, as of square circles or the horns of a hare; within the nave, the non-existence of the supra-rational.

"The cycle of ego-consciousness," Coomaraswamy continues, "implies an outward movement from the nave to the ever-receding felly, and a return from the however distant felly to the unchanging centre. A progressive enlightenment (*krama-mukti*) can then be expressed as a gradual contraction of the radius, bringing the circumference ever closer to the centre, until that which seemed to enclose the point is seen to be contained within it, knowledge being thus con-centrated into a single form, which is the form of very different things. That is *Nirvāṇa*, unitary being, 'with residual existential elements,' and by a vanishment of the point becomes also *Parinirvāṇa*, without residuum of existence." [31]

According to the legend, the historical Buddha is supposed to have transmitted the original design of the wheel to his disciples by tracing it with grains of rice gathered while he was teaching in a rice field.[32] However it may be, before the representation of the historical Buddha in human form, the wheel, identifiable with the universal sovereign, figured in the place of the Buddha.[33] It was represented in the form of a "Principial Wheel" standing upon a universal terrain.[34] During the first centuries of the Christian era, at the time of the representation of the Buddha in human form, the wheel appeared some place on the Tathāgata's body or on the
II] throne on which he was seated. It served to indicate the sermon of the Deer Park at Benares. The *dharmacakramudrā*, by assuming a part of the role of this aniconic attribute, symbolizes in iconographic representations this same episode of the Buddhist legend.[35]

The wheel presents an affinity with the lotus.[36] Represented at first in the form of a solar disk whose rays came to constitute the eight [37] spokes of the Buddhist wheel, it demonstrates early a "decorative contamination with the red lotus (*padma*), whose cosmological value is doubled with a profound philosophical sense." [38] Thus the lotus fully opened, also bearer of a clearly solar character, symbolizes the divine birth, the purity of the law. It is divided into eight petals, which indicate the eight cardinal
30] points, the eightfold path, etc. In Japan, the *rimbō* [39] of the Shingon sect—which displays a lotus in the guise of the nave, from which proceed eight rays—constitutes evidence, in this instance, of the fusion of these two

symbols.[40] The wheel and the lotus become, as it were, the "secret pivot of the world" around which the diverse constituents are disposed in symmetrical fashion. In India the wheel surmounting a pillar (*cakrastambha*) recalls the opened lotus at the top of its stem; [41] and in Nepal the Wheel of Vairocana is actually represented by the calyx of a lotus containing the procreating seeds of the flower.[42]

30 Eight-spoke Rimbō

Buddhist art utilizes first the symbol of the wheel and then the *tembōrin-in* in order to recall the precise moment of the Buddhist legend at which the Buddha, having triumphed over the attacks of the evil demon, Māra, attains *bodhi*, and gives his first sermon in the Deer Park at Benares. This is the moment in which the Buddha puts into motion the wheel of the Law. In aniconic representations of the historical Buddha, the scene was symbolized with the help of a pillar surmounted by a wheel and flanked by two affronted deer. In iconographic representations, this same wheel persists, but appears now either traced on the body of the [II Buddha or held in his hands—one may cite numerous Buddhas in *jō-in* who hold on their joined hands an eight-spoke wheel [43]—or represented by the symbolic gesture of the *tembōrin-in*.[44] This mudrā appropriates for itself the symbolism of the wheel and acknowledges the omnipotence and the sovereignty of the Buddha by affirming his identification with a universal monarch. The *tembōrin-in* itself, whose form represents two juxtaposed wheels of the Law, recalls, in Esoteric symbolism, the "principial" unity of the *taizōkai* and the *kongōkai* and, according to the non-Tantric explanation, the Teaching of the Buddha and the dissemination of his Law. This gesture is also called the *seppō-in*, mudrā of the exposition of the Law.[45] The *tembōrin-in* symbolizes the destruction of human ills, as

99

well as the constant progression of Buddhist doctrines which penetrate to all Beings and which, without limits, like the cosmic wheel, exist universally. This is a symbolism which accentuates the movement of the wheel, a continual movement of the Law which is constantly being transmitted to all Beings; it emphasizes the "incessant repetition of the fundamental moral doctrines of Buddhism." In the Japanese Esoteric sects, making this mudrā, accompanied by the right ritual words, may for the celebrant take the place "of all sermons, for no predication is more perfect than the Law." [46]

The *tembōrin-in*, according to the symbolism that has just been traced, is with one exception reserved to the exclusive use of the Buddhas; that exception is the Bodhisattva Miroku (Maitreya). Miroku as XIII] the future Buddha makes the *tembōrin-in*, for it is he who in time to come will turn the wheel of the Law. Thus in India this mudrā is associated 46, 47, 48] with Maitreya, especially when he is seated on a throne, his legs pendent in front, in the so-called "European attitude," [47] a characteristic position of this divinity.

The Buddha Shakamuni, as early as the Gandhāran school, uses the *tembōrin-in* to identify the legendary scene when, after the Illumination, he made his first sermon and exposed the Doctrine. It was at that time that he put into motion the wheel of the Law, which was to move throughout the universe, to crush the forces of evil, and to work for the salvation of Beings. Doubtless in Gandhāra, this gesture alone would have sufficed to recall the predication of the Law if the use of the mudrā had not been indeterminate at that time (cf. Introduction, pp. 43 ff.).

Before and after the introduction of Esotericism [48] into Japan, the 27] *tembōrin-in* is a gesture of the Buddha Amida.[49] As a Buddha exposing the Doctrine, Amida makes the *tembōrin-in*, composed of two wheels of the Law. The circle formed by the thumb and the index of the left hand is that of Beings and represents the precept *jōgubodai:* "on high to seek *bodhi*" [50] — "to aspire . . . toward divine knowledge, in order to reach the world of the Buddhas"; [51] consequently, the fingers of the left hand are erect. The circle formed by the thumb and the index of the right hand is

that of the Buddhas and represents the precept *gekeshujō:* "below to convert all Beings (plunged into error)"—that is to say, seeking the salvation of Beings through the intermediary of the Buddha; [52] consequently, the fingers of the right hand are lowered.

The *tembōrin-in* which reflects the ancient symbolism of the wheel is associated also to Dainichi Nyorai and to Miroku.[53] The name of Dainichi [V
Nyorai (= Great Solar Tathāgata) clearly illustrates the nature of this association. As the sun shines, Dainichi, as supreme Buddha,[54] in the center, dissipates by the light of his knowledge untruths and errors.

There remains to be noted the designation *ōjin-seppō-in,*[55] which is also a mudrā of the predication of the Law.[56] This is a gesture characteristic of Shakamuni as predicator. It is also called *chi-kichijō(no)in.* Shakamuni explaining the Law [57] makes with his right hand the (*chi*) *kichijō-in,* mudrā of the Felicity of Knowledge, for in propagating his [10 doctrine, he delights the world. The left hand turned toward the interior represents the *naishō,* "inner attestation," [58] and the right hand turned toward the outside, the *geyō,*[59] "exterior use."

8 Mudrā of the Knowledge fist

Chi Ken-in 智拳印

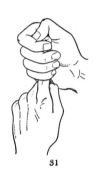

CH. *Chih-ch'üan-yin*

SK. *Vajramudrā* (?),[1] *jñānamudrā* (?),[2] *bodhaśrīmudrā* (?)[3]

31

THE STATUE (of Dainichi)[4] on which the *chi ken-in* figures is in a seated position, the soles of the feet facing upward; this is the posture of interior concentration (*padmāsana*). To make this gesture, the right thumb is inflected onto the right palm, where it is enfolded and grasped by the other fingers so as to form a solid fist the center of which is the thumb. This fist is called the *kenrō kongō ken(-in)*,[5] "adamantine, diamond fist" (cf. *kongō ken-in*). The left hand is held at the level of the navel,[6] the palm turned toward the right; the raised index (i.e., the "Diamond Finger")[7] is inserted as far as the first joint[8] into the fist formed by the right hand, which is now superposed over the left. The left index is held by the right little finger. The right index is grasped at the first joint by the right thumb in such a way as to bend the index. This mudrā is called the *bodaiindōdaiichichi-in*, "first Knowledge mudrā which conducts souls to enlightenment"; or the *nōmetsumumyōkokuan-in*, "mudrā which is capable of suppressing darkness and spiritual shadows"; or the *biroshananyoraidaimyōchi-in*, "mudrā of the great and marvelous Knowledge of Vairocana" (cf. n.27). According to the *Shugokokkaishudaranikyō* (II): "Then the right hand is made into a diamond fist and held in front of the breast; [this right hand] grasps the left index. This is called *nōyomujōbodaisaisonshō-in* and is the sign of Vairocana, the original teacher." But all texts do not agree with this disposition of the hands. And according to the *Kongōchōrengebushinnenjugiki*: "Then the Diamond

3-2]

102

Fist is formed and, in meditation (*samāhita*—in which both mind and body are concentrated), there are two [divisions]. The left Diamond Fist grasps the right index." [8a] And the *Shobutsukyōgaishōshinjitsukyō* (II) notes: "Further, the tip of the right index contacts the end section of the right thumb; it is held in front of the breast. This is called the *bodaiindōdaiichichi-in* (the first Knowledge mudrā leading to enlightenment). . . . By means of this mudrā (by means of its *kaji* [9]), the various Buddhas, on behalf of the adept, impart the sign of the surpassing *samādhi* of perfect enlightenment, that is, Vairocana's great and marvelous Knowledge mudrā." [10] In this gesture, both left and right hands form the Diamond Fist. The left is held in front of the breast, the index is extended and is grasped by the right fist. There are two traditions concerning this gesture, one being the foregoing and the other being that the left thumb is extended and is held in the right fist.

Since the *chi ken-in* is fundamentally an Esoteric gesture, it does not appear in Japan before the introduction of *mikkyō* (Esotericism), officially around the beginning of the IX century. In India the examples of this gesture, even after the codification of the *Vajrayāna*, must be very rare: none have come to the attention of the present author. Certain authorities [11] maintain that the *chi ken-in* may have originated in the mudrā of the predication of the Law, the *tembōrin-in*. As early as Gandhāra, there existed several variations of the classic *tembōrin-in*—prototype of the gesture [25, 27 of the Amida Trinity in the Hōryūji [12]—which are sculpturally very close to the *chi ken-in*. By referring to Foucher's *L'Art gréco-bouddhique du Gandhāra* (figs. 405, 426, 456, and 459), one may perceive the hypothetical evolution which, in Japan, is said to have ended in the *chi ken-in*. [13] According to the present writer's opinion, however, such a theory is based on the erroneous assumption that this so-called "evolution of form" is in itself sufficient proof of the relationship between *chi ken-in* and *tembōrin-in*. The fact that any similarity in symbolic meaning is quite lacking should, it would seem, preclude such a hypothesis. Considering, too, that the formulation of new gestures must require no great imaginative effort or time, it is not hard to suppose that Esotericism simply created, as in so

103

many other cases, a new gesture in order to express the metaphysical notions which were to be newly symbolized.

SYMBOLISM

This gesture is closely associated with Vairocana.[14] According to Tantric symbolism, the *chi ken-in* emphasizes not the propagation of the Law on the example of the *tembōrin-in*, but the aspect of Knowledge (*chi*), the Knowledge of Vairocana as supreme divinity. Two different roles of this god are thus underlined by the use of these two gestures: the *tembōrin-in* is attributed to Vairocana as *dhyāni*-Buddha and the *chi ken-in* is attributed to him as Ādi-Buddha,[15] for the Ādi-Buddha is said to have produced the *dhyāni*-Buddha by means of the activity of the Five Knowledges (*go chi*).

XIV] The *chi ken-in* is the mudrā of Dainichi in the *kongōkai*[16] (*vajra-dhātu*), "Diamond World." By reducing this gesture to its constituent elements, one finds that it is actually composed of two fists called *kenrō*

3-2] *kongō ken-in*, "adamantine, diamond fists," which symbolize the Diamond World, the spiritual World to which Knowledge (*chi*) belongs. But this Knowledge is militant, for it represents the power to destroy (cf. *kongō, vajra*) the passions of this world; it is also an intellectual force which gives the power to all Beings to attain to Buddha Knowledge; for, as the *Hokkegisho* notes: "Possessing a seal, a man enters a country in peace. If he does not possess a seal he may not enter. In like fashion, [by means of the *chi ken-in*] the Bodhisattva attains this concentration (*sammai*) [on Knowledge,] and comprehends reality." [17]

According to the Esoteric symbolism of this gesture, the left index (World of Beings) is surrounded and protected by the fingers of the right hand (World of the Buddha[s]). The five fingers of the right hand represent the Five Elements of which man is composed: the little finger, earth; the ring finger, fire; the middle finger, water; the index, air; the thumb, void.[18] The fingers symbolize also the *rokusho* (*ṣaḍāyatana*),[19] the *gokon* (*pañcendriyāṇi*); that is to say, the five organs of the senses, as roots (*kon*) of Knowledge, to which is added the sixth element, *manas* (men-

tal). The index of the left hand, which plays the role of the sixth finger, "represents the flame-symbol of Ādi-Buddha, for the sixth element, the mind (*manas*), is a particle of his essence." [20] Thus the denomination "gesture of the Six Elements" [21] is intelligible: the six elements are the five which compose man plus the sixth,[22] which is of the Buddha. The two hands symbolize the two inseparable worlds of the *taizōkai* and the *kongōkai*, and are here connected by the left index,[23] the diamond finger (*kongōshi*), which constitutes at once a bond between the hands and the way between the worlds. ". . . the fingers of the right hand clasp the forefinger of the left . . . the gesture symbolizes the unity of the cosmic and individual souls in the final spiritual enlightenment." [24] In the *garbha-dhātu* (*taizōkai*) form, the two hands hold the *dharmacakra*, implying their distinction on the plane of operation. According to Getty, the *kongōkai* (Spiritual World) is represented by the raised left index, which joins the right hand, whose five fingers represent the *taizōkai* (Matrix World). The two together symbolize the oneness of the spiritual and the material (worlds), the oneness of the cosmic soul and the individual soul, the oneness of Knowledge and Principle.[25]

[30

A specific symbol of the Knowledge of the Buddha Dainichi of the *kongōkai*, this gesture is named *daichi-in*, "gesture of the Great Knowledge." By making this mudrā, the Buddha (or the celebrant who identifies himself with the Buddha) enters into possession of the *chi-hokkai*, "Essence World of Knowledge" (i.e., the Knowledge of all the Buddhas together).[26] This is the knowledge peculiar to (*kongōkai*) Dainichi, the knowledge of the substantial nature of the *dharma* [27] (*hokkai taishō chi*), which is symbolized by the *chi ken-in*.

Considered in Japan on a metaphysical plane as symbolic of the Knowledge of Dainichi or even of the Five Elements, this gesture — especially in Tibet, according to the *śakti* [28] cult — takes on significance of a clearly sexual character. Thus it may be seen, through the erotic interpretation accorded this gesture, that Tantric ideas were subjected to strong non-Indian influences. As Conze says: "The erotic mysticism and the stress on the female principle owed much to the Dravidian stratum

of Indian culture which, in the cult of the *Village Goddess* had kept alive the matriarchal traditions about the *Mother-Goddess* to a greater extent than the Vedic religion had done." [29]

For Buddhism the procreative act is not in itself reprehensible; the union of the sexes is forbidden more precisely because it attaches the participants more firmly to life by nourishing passion and desires that Buddhism tries endlessly to annihilate. But in the unitary concept of Esotericism, the physical plane becomes involved in the metaphysical plane, and thus permits women to take a place in the religious pantheon in order to represent "divinely" the passions, on a high and spiritualized plane.[30] While Buddhism in general was cognizant of feminine attitudes and did, in fact, incorporate them in numerous feminine deities, the relations existing between the masculine and the feminine principles were rather unemphasized. In Left-handed Tantrism, however, such as the Tibetan type, sexuality was introduced as a means to ultimate identification with the godhead. Such notions, it must be said, do not run at all contrary to Western thought. Modern psychologists, in fact, are of the opinion that sexuality may enter directly into the so-called mystical experience, and it is undeniable that even the most abstract metaphysical thought may contain references to or be directly influenced by the libido. Thus, as Conze points out, "the authors of the *Prajñāpāramitāsūtras* were aware that the pursuit of perfect wisdom could easily assume the character of a love affair with the Absolute. The persistent elusiveness of perfect wisdom on its own would maintain interest to the end. We are, as a matter of fact, told explicitly that a Bodhisattva should think of perfect wisdom with the same intensity and exclusiveness with which a man thinks of a 'handsome, attractive, and beautiful woman' with whom he has made a date, but who is prevented from seeing him." [31]

Now, in the *chi ken-in*, the left hand (Beings) symbolizes the masculine principle, Vairocana himself as procreator, making union with the feminine principle represented by the right hand. The sexual act is found to be endowed with metaphysical interpretations. It is thus that the *chi ken-in* symbolizes at once the abstract side of Mahāyānist inspi-

ration and the concrete side of the life of this world. It is the exalted expression of creation on the human plane and on the divine plane, the expression of an act fundamentally pure, without passion; for the supreme divinity himself accomplishes it.

Maraini comments: "An idea typical of the Tantras is that of the Energy which emanates from a god; it becomes something external and objective and ends by incarnating itself in a female body (*śakti*). Metaphysically, a *śakti* is the line of force according to which the One, the Absolute, differentiates itself and acts. A *śakti* is generally represented as engaged in a carnal embrace with the god who generated her and has become her mate. This orgiastic symbolism became enormously popular, and initiates read innumerable meanings into it. Perhaps the most widespread and best-known interpretation is that the male divinity represents *karuṇā*, compassion, while the female stands for *prajñā*, gnosis, or perfect knowledge. Gnosis means a lightning intuition of the truth which leads to liberation, but that is nothing if it is not intimately united with the active, altruistic force of compassion, which causes him who knows and sees to immolate and sacrifice himself for him who does not know and who does not see. Such unity can adequately be represented only by the symbolism of a lovers' union. That is what the eye of the initiate reads into the amorous embrace which confronts him on the altar." [32]

Renou [33] notes that this union of *upāya* (means) and *prajñā* (gnosis) is free from any pain connected with ignorance, and that it may be realized through psychic exercises as well as by actual sexual intercourse. Actually, for the Mahāyāna, the most important impulsion was that of compassion (*karuṇā*). *Upāya* and *prajñā* are in reality compassion and Void, the sexual interpretation being secondary. In the final analysis, it may be admitted that "the theoretical justification for the introduction of eroticism into Tantrism by the symbolism of *upāya* and *prajñā* (means and knowledge) was encouraged, if not produced, among the Tantric adepts, through the action of their libido, or of their subconscious instincts. In any case, the sublimation of sexuality appears to be a concept already known to Asaṅga." [34]

III

Six Secondary Mudrā
and the Āsana

9 Mudrā of the ceremony of unction

Kanjō-in 灌頂印

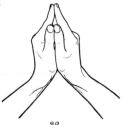

32

CH. *Kuan-ting-yin*

SK. *Abhiṣeka(na)-mudrā* [1]

THE MUDRĀ called the *kanjō-in* [2] is one of the gestures which accompanies the ceremony of unction (*kanjō*). It is formed by placing the palms of the hands against each other, the fingers crossed and folded on the interior (*naibaku*) of the "fist" thus formed; the thumbs and forefingers remain erect and touch at the tops.[3]

SYMBOLISM

The ceremony of unction,[4] used principally by the Esoteric sects for ritual consecration, presents an analogy, superficial as it may be, to Christian baptism. The Buddhist *kanjō*, however, is more than a rite which marks the entrance into religion; it is the affirmation that the neophyte has accomplished a given step toward *bodhi* and, hence, is further engaged on the path toward supreme enlightenment.[5] According to Kōbō Daishi, who is thought to have introduced the *kanjō* ceremony to Kyōto in the IX century, it is a question of the "bestowal [6] of the Buddha's great mercy upon Sentient Beings to enable them to obtain the highest perfect Enlightenment." [7]

The ceremony of unction is probably to be traced to the universal custom, in ceremony, of anointing the head with oil. Aspersion at the investiture of a king was already practiced in ancient India. The Vedas [8] attest the association of a ceremony of unction with the royal consecration. Since ancient times, the aspersion of the head of the sovereign with

water taken from the Four Great Oceans symbolized the universality of his reign.

The ceremony of unction was rapidly contaminated through contact with magical practices inherent in Esotericism. It evolved toward rather diverse objectives, such as assurance of progeny, restoration of the power of a king,[9] dispensation of happiness,[10] and increase in "utility" (i.e., in health, in riches); it was even used to avoid the distress of adversity.[11] Nevertheless, during the first centuries of the Christian era, the *abhiṣeka* rite took on a spiritual sense.[12] While Buddhism of the most ancient type associated the *kanjō* uniquely with the investiture of a sovereign, after the development of Esotericism the ceremony is clearly stamped with a magico-religious character. It became then a ritual aiming at procuring powers attainable through the magic of the rite. For the Mantrayāna,[13] the unction water symbolizes the Five Knowledges of the Buddha,[14] which are symbolically granted to the neophyte by the ceremony. "In the first place," Glasenapp says, "the Buddhist *abhisheka* aims at conferring on the subject, through a consecration, the required aptitude for the study of a tantra. As the initiation into the mysteries proceeds by degrees, most of the systems recognize a hierarchic order established with (relation to) several *abhishekas* to be received, each in turn, until the pupil equals his master in knowledge as well as in magic power, and until he himself is authorized to confer the consecration to others." [15] In China this ceremony is sometimes celebrated on behalf of important secular figures.

This mudrā is most often made by personages of an inferior order. It is never made by a Buddha, sometimes by a Bodhisattva, and most often by holy personages (gods, *myō-ō*) [16] to indicate the receiving of an *abhiṣeka*, notably that *kanjō* which is supposed to grant to the celebrant the Knowledges of the Buddha (Dainichi).

10 Mudrā of the Buddha's alms bowl

Buppatsu-in　佛鉢印

CH. *Fo-puo-yin*

SK. *Buddhapātramudrā (?)*

33

To FORM THIS GESTURE,[1] the celebrant is seated in *yogāsana*,[2] the soles of the feet up, the two hands held at the level of the navel [3] on two different planes, facing each other. The left hand sometimes holds two corners of the *kesa*,[4] while the right is held directly above it, palm downward. This gesture is also called the *shakamuni-daihachi-in*.[5]

A variant of this gesture seems to be the one mentioned under the *jō-in* (cf. n. 56, p. 231): the two hands are superposed, one above the other, the palms up, the fingers slightly flexed [6] "as if for holding a bowl. By forming this seal, one is identified with the Tathāgata. The result is that all Beings who are not Receptacles (that is, who do not have the "caliber" to receive the Good Law) become Receptacles of the Law (*hōki*, epithet for the Alms Bowl)." [7]

The *buppatsu-in* is one of the mudrā distinctive of Shakamuni.[8]

11 Basara-un diamond mudrā

Basara-un-kongō-in 縛日羅吽金剛印

CH. *Chuan-yüeh-lo-hung chin-kang-yin*
SK. *Vajrahūṃkāra-mudrā*

34

T HIS MUDRĀ, characteristic of Vajra-hūṃ,[1] whose diamond-like strength and terrible anger it expresses, is made by crossing the wrists in front of the breast, the fists turned toward the outside, the right superposed on the left. Usually, the right hand holds a *vajra*, the symbol of the Knowledge which destroys passions and of the adamantine Truth of the Law which nothing can destroy; the left hand holds the bell or *ghaṇṭā*,

101, 68]

35 Kongō Ken-in

36 Sankaisaishō-in

the symbol of the Law and of the assembling of the faithful.[2] These objects are not necessarily present, for the meditation of the adept may supplant their absence. In meditation, the hands remain in position for holding the objects; or, as the case may be, they may form two *kongō ken-in* crossed: the right hand (Buddha) symbolizes Sentient Beings in whom intelligence of the Buddha exists in a perfect state, and the left hand (Beings) rings the bell in order to disperse illusion and error.[3] When the wrists of the hands in *basara-un-kongō-in* are turned toward the inside, contrary to the previous form, the mudrā may be called *sankaisaishō-in* (*trailokyavijaya* [*mudrā*]),[4] "mudrā of the Victor of the Three Worlds."

XV]

This mudrā is peculiar to Kongōzōō and to Kongōsatta (Vajra-sattva).

114

12 Mudrā of the ubiquity (of the Three Mysteries)

Mushofushi-in 無所不至印

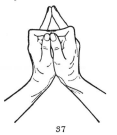

37

CH. *Wu-so-pu-chih-yin*

THE MUSHOFUSHI-IN [1] is formed by joining the palms of the two hands: the middle, ring, and little fingers are raised and touch at the ends. A space is left between the hands.[2] The indexes are flexed, and at their tips they join the thumbs, which are erect, side by side. To this grouping of the fingers the following symbolism is applied: the erect fingers (middle, ring, and little) represents the Six Original Substances;[3] the thumbs and the indexes, the Four Kinds of *Mandara*;[4] and (according to the Kegonkyō) the two thumbs, Hōshō (left) and Shaka (right). The three apertures formed by the indexes and the erect fingers symbolize the Three Mysteries (*sammitsu*), word, thought, and body (act), which form the triple Unity, the basic principle of Esotericism. As Smidt says: "Thus are represented substance, semblance, and activity which, all three, are present in all phenomena: 'there is no place which they do not reach' (*mushofushi*)."[5]

This mudrā may be named *ritō-in*,[6] "mudrā of the 'principial' [Diag. III stūpa." So designated, the mudrā is peculiar to Dainichi Nyorai,[7] who symbolizes the supreme Principle (*ri*) of the Esoteric system. Other names are: *hen hokkai mushofushi-in*, "mudrā which reaches to all the Essence Worlds"; *mushofushi tō-in*, "ubiquitous stūpa mudrā"; *dai sotoba-in*, "great stūpa mudrā"; *butsubu sotoba-in*, "stūpa mudrā of the Buddha section"; *Biroshana-in*, "mudrā of Vairocana." All these names refer to this gesture as specifically connected with Dainichi (Vairocana) whose attribute is the "principial" stūpa. Since the knowledge sword is also an [100 attribute of this divinity, the *mushofushi-in* is also called *Dainichi ken-in*,

115

"mudrā of Dainichi's sword," or *Dai etō-in*, "Great knowledge sword mudrā." These mudrā are known as the gestures of the ultimate mystery of (*taizōkai*) Dainichi.

13 Mudrā of hiding forms

Ongyō-in 隱形印

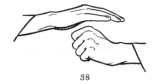

CH. *Yin-hsing-yin*

38

T HE ONGYŌ-IN [1] is formed in the following fashion: the left hand forms the fist called the Fist of Void (*kūken*); it is covered by the right hand, whose fingers are extended horizontally.[2] This gesture is also known as the *Marishitenhōbyō-in*, "mudrā of the precious receptacle of Marishi-ten."

The magical object of this gesture is to dissimulate, to hide the form (of the body), to subtract oneself from the view of others.[3] The notion of dissimulation is closely associated with the goddess Marishi-ten (Sk. Marīcī). In China, Marishi, who is also called the Queen of the Sky, is the goddess of the light which supports sun and moon.[4] In Tibet, she is the goddess of the sunrise.[5] In Japan, she is supposed to reside in one of the seven stars of the Great Bear.[6] Marīcī [7] is one of the attendants of Sūrya, the sun god, around whom she ceaselessly revolves, so rapidly that she is quite invisible. He who makes the *ongyō-in*, pronouncing at the same time the required formulas, is supposed to be able to render himself invisible on the example of this divinity.

The *ongyō-in* is used in connection with the so-called *ongyō-hō* or method of dissimulating form, and in Esoteric sects it is believed that the practician, by pronouncing the correct mantra and making the *ongyō-in*, is enabled through the power of "incantation" (*kaji*) to exorcise all demons. According to the *Marishitengyō* [8]: "At that time, the Buddha spoke thus to the monks: 'There is a goddess called Marishi. She has great supernatural (and superhuman) powers. She is forever passing in front of the gods of the sun and moon, yet they cannot see her, though she

117

can see the sun. Men cannot perceive or recognize her; they cannot capture or bind her; they cannot hurt or deceive her; they cannot take her possessions; they cannot condemn or punish her and those who are resentful cannot obtain her aid.' (Then) the Buddha spoke to the monks saying: 'If you know Marishi-ten's name and constantly keep it in mind, men cannot perceive or recognize you, neither can they catch, bind, or hurt you. Moreover, people cannot deceive you. Your property will not be taken and you will not be condemned or punished; yet her help will not be had by those who are resentful.' " Further, the same sūtra explains the gesture: "Next, the *Marishi ansosona-in* (which means hiding shapes) is formed. The left hand is made into an 'empty fist' (i.e., hollowed) with the thumb slightly bearing against the fingernail of the index as if forming a ring. The remaining three fingers are grasped into a closed fist. An aperture is to be left within the fist and it is to be placed in front of the breast. One should meditate on entering into the hole and being contained therein. Revolve the right palm (hand) in a right-hand motion and rub the mudrā (formed by the left hand), that is, cover the top of the hole. Think of this mudrā as the body of Marishi Bosatsu, and of your own self as being held hidden within the heart of Marishi-ten Bosatsu. Concentrate with all your might, ceaselessly. . . . (Only) if one is respectful and sincere and puts forth one's heart, then one will certainly obtain the awesome protection of the divinity and be invisible to all resentful and evil people, and able to avoid all disasters." [9]

14 The outer bonds fist

Gebaku Ken-in 外縛拳印

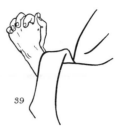

CH. *Wai-fu ch'üan-yin*

39

THE GEBAKU KEN-IN [1] is formed by joining the two palms and by [3-3 crossing the fingers so that they are on the outside of the fist thus formed. This gesture may be compared to the mudrā called the *naibaku* [3-4 *ken-in*, "gesture of the inner bonds," which is the same as the *gebaku ken-in* except that the entwined fingers, held within the fist formed by the two hands, constitute "inner bonds." This mudrā is called also *shizaige ken-in*, "fist with the fingers outside." The *Dainichikyōsho* (13), *shingonshugyō-shō*, notes that this mudrā "is variously named *kengo baku[-in]* (stable bonds mudrā), *kongō baku[-in]* (diamond bonds mudrā), or *gebaku ken-in*. [The gesture] signifies release from the bondage of the passions and expresses the perfection of the Ten Stages." [2]

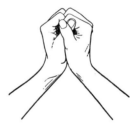

40 Naibaku Ken-in

According to the position of the fingers, these two mudrā are differentiated on the symbolic plane: the *gebaku ken-in* represents the vow of Beings (to become Buddha); the *naibaku ken-in*, that of the Buddha(s) (to help Beings). The *Si-do-in-dzou* gives two ritual forms of *gebaku ken-in*, that of the *taizōkai* and that of the *kongōkai*. The first, *mashu gebaku*,[3] is formed after having made the required offerings. The joining of

119

the two hands symbolizes the harmony (of the two worlds); "the en-twining of the fingers forms a round figure, that of the full moon, which indicates that the mind of the priest has no stain within and that it is 'full (of purity) like the full moon.' " [4] The second, *dai yoku* (great avidity), indicates the love of Vairocana for all Beings, a love, which, in man, is represented by the limited desire for affection: in Kongōsattva (Vajra-sattva, the Bodhisattva who emanates from Vairocana), this love is trans-lated by an Avidity (yoku) [5] to love all Beings at the same time. Thus in Shingon ritual, the *gebaku ken-in*, emblematic of Great Avidity, symbolizes the Heart and the Compassion of the Buddha. The aperture which exists between the thumbs and the indexes is to permit Beings — by virtue of the power of the ritual *dhāraṇī* — to gather within the fist of the Buddha (i.e., the celebrant). "Holding them thus in his hands, he proposes to convert them in order that they may all have the same idea and the same feeling (of goodness and of reciprocal love)." [6] At this moment in the ritual, the *gebaku ken-in* is made — it is called *dai raku* — so that the hands, closely locked, hold the Beings that were assembled in the preceding mudrā.

This gesture is most often made by holy personages,[7] but most par-ticularly those of secondary rank. It is never made by a Buddha.

15 Postures and Thrones

Za 坐

CH. *Tso*

SK. *Āsana*

41

T HE ĀSANA [1] may correctly be considered to be of the domain of the
mudrā, and it is particularly fitting to approach this subject with
reference to the gestures, for the postures of the body, notably the pose of
the legs — āsana (*za*) — enter into the symbolic framework of the statue. It
is also true that the mudrā and the āsana are generally treated under the
same heading in Japanese texts relating to iconography. Even a super-
ficial study of these āsana will enlarge the scope of the symbolism that has
been outlined for the symbolic gestures.

The technique of assuming particular postures goes far back into
Indian asceticism. Āsana are mentioned in the *Upaniṣads* and in Vedic
literature, although extensive lists are to be found most usually in tantric
treatises. "The purpose of these meditational positions is always the
same: 'absolute cessation of trouble from the pairs [of opposites]'
[*dvaṃdvānabhighāta:* my reading. E.D.S.]. In this way one realizes a
certain 'neutrality' of the senses; consciousness is no longer troubled by
the 'presence of the body.' One realizes the first stage toward isolation of
consciousness; the bridges that permit communication with sensory ac-
tivity begin to be raised." [1a]

It is certain that the āsanic posture, in iconography, is meant to
differentiate the state of the man so portrayed from that of human beings
in general. Man is constantly in movement, he is physically active, dy-
namic, constantly alternating between composition and decomposition.
In this he is different from objects which are static, non-mobile. Thus the
āsana emphasizes a change in man's status. To a certain extent he has

121

rejected his human qualities and withdrawn from the surroundings which affect him as a human being. In this sense, then, the āsana symbolizes a transcendent state corresponding for the body to the ecstatic condition that concentration produces in the mind. The Buddha by his posture makes clear that he is a being no longer completely in the world of men, that the constant human processes of change have been suspended for him, and that he now stands as a transcendent being, changeless and stable.

Lotus posture (and throne): *Renge-za*

41] The *renge-za* (*padmāsana*), as the designation for seat [2] or for socle,[3] is universally used in Northern Buddhism, where almost all the divinities, with very few exceptions, are represented either standing [4] on a lotus flower, which is sometimes stylized into a socle, or seated on a lotus throne, which in such cases serves as a dais.[5] The early Buddha, as a tangible human being, stood on the ground, but in Mahāyāna Buddhism he became the epiphany of a transcendental essence, and properly he is placed upon the lotus, the cosmic flower. "Precisely as the transcendent substance of Viṣṇu, the primeval water, brings forth the phenomenal, dynamic form of Brahmā (who then evolves the phenomenal universe), so likewise, the transcendent adamantean essence of enlightenment, the sheer 'suchness' (*tathatā*) which underlies the universe, gives forth the VIII, IX] saviors. That is why the Buddhas, the first-born of that reality, are entitled no less than Brahmā to the lotus throne. This lotus symbol, which in its original association with the goddess Padmā-Lakṣmī denoted divine physical life-force, the life-sustaining, transcendent yet immanent substance of the timeless waters, in Mahāyāna Buddhism connotes the supramundane (*lokottara*) character of the Buddhas and Bodhisattvas, who are, as seen, mere phantoms, mere luminous reflexes on the several phenomenal planes of celestial and terrestrial intellection." [5a] The lotus also constitutes, in some instances, an individual support for the foot or feet of seated divinities.[6] In Tibet, Nepal, China, and Japan, the lotus

generally bears two or three rows of petals, or even more: the outside
row is bent down, and the inside row raised so as to delimit the flat part
that will support the statue.[7]

When the *renge-za* designates a seated attitude, this posture is [42
formed by crossing the legs and bringing each foot, the sole up, onto the
opposite thigh. In Exotericism (*kengyō*), all Buddhas and Bodhisattvas
assume this position. In Esotericism (*mikkyō*), the left leg is first placed
on the right thigh. According to the *Kongōchōgyōichijichōrinnōyugais-
saijishonenjujōbutsugiki:* "The left leg presses on the right thigh, while the

42 Kekka fuza

right leg is placed on the left thigh. This is the *nyorai* posture." [7a] This
position, characteristic of the yogi, is favorable to meditation and to
ecstatic concentration: it is called in Japanese *kekka fuza*,[8] in Sanskrit
padmāsana. (The latter designation, however, which serves to indicate
indiscriminately either the lotus seat or the posture called the *kekka fuza*,
is somewhat confusing.) There are two types of full lotus posture: the
kichijō, [posture of] good fortune, and the *gōma*, demon-subduing [pos- [VII
ture]. In the *gōma-za* the left foot rests on the right thigh, and in the
corresponding hand gesture (*jō-in*) the left hand is placed on the right
one. The *kichijō-za* is just the opposite. Such designations as *zenka-za*, [VIII
"full crosslegged posture," and *zenka, honka-za, daiza*, all of which are
designated here by the term "full lotus posture" stand in opposition to
the posture in which only one leg is crossed, i.e., *hanka-za* (see p. 125),
which is here termed "half lotus posture."

In India until the end of the Gupta period, this was the habitual [II, XI, XII
attitude of seated statues [9] — an attitude, moreover, which spread through-

123

out all Asia of Buddhist obedience. In India from the VII century on, other
manners of representing seated statues came into use, such as the so-called
46, XIII, 45] "European position" and the attitudes of royal ease. When the Buddha is
seated on his diamond throne, *kongō-za* (Sk. *vajrāsana*),[10] that is to say,
the one on which he was seated in meditation under the *bodhi* tree, this
fact is indicated by the presence of a *vajra* [11] on some part of the throne.
Sometimes in certain Shingon representations, the *vajra* is represented on
the body of the Buddha rather than on the dais.[12]

The *kongō-za* (*vajrāsana*) posture is the same as the *kekka fuza* except
that the legs are even more firmly locked. In Sanskrit this attitude is also
called *vajra-paryaṅka*.[13] The *vajra-paryaṅka*, the adamantine and unshak-
able posture, may be explained, psychologically, as representing a mental
quality of Him who is seated (on the adamantine throne); his heart is like
the diamond [14] (*vajra-upama citta*), unshakable, hard. This position evokes
not only the most profound meditation of the Buddha on the diamond
throne, but also the calling of the earth as witness, at the moment of the
VIII] defeat of the demons (cf. *sokuchi-in, supra*) and the supreme enlightenment
to which the Buddha attained on this throne. Consequently there exists a
close association between the *jō-in* (*dhyānamudrā*) and the *sokuchi-in*
(*bhūmisparśamudrā*) — both of which derive from the episode under the
bodhi tree — and the posture called *kongō-za*. In Coomaraswamy's words:
"*Padmāsana* and *vajrāsana* are equally symbols of that *sthāyitā* [exist-
ence]: both express visually *sadā sthita*, and *tiṣṭhati*, with respect to the
Buddha or any Angel; both differentiate the station of Sambhogakāya
from that of the Dharmakāya, which is inaccessible even to the angelic
eye." [15] Sometimes it is noted that the left leg folded over the right is the
attitude of subduing demons, while the right over the left is the attitude
of blessing, the hands being placed in similar order.[15a] Moreover, the
right leg stands for the world of the Buddha(s) while the left leg stands
for that of Sentient Beings. Placing the right on the left symbolizes that
the world of Sentient Beings is gathered (*shōshu*) into the world of the
Buddha and also that the world of the Buddha takes refuge in the world of
Sentient Beings.

124

In the *vajrāsana* the symbolism of the *vajra* is fused with that of the wheel, for the adamantine throne is situated in the center of the universe [104 and supports itself on the wheel of gold. The term "adamantine throne," designates the purity and solidity of the support. Without this throne the earth could not last, and He who wishes to be victorious over the demons must sit upon it. The Buddha(s) of the present all attained enlightenment on it. Were the earth to be shaken on its foundations, the throne would remain unmoved.[16]

Despite its close connection to Śākyamuni, this attitude is not at all [II limited to the Buddha(s). It is a pose characteristic of numerous Bodhi-sattvas,[17] holy men, monks, and secular as well as ecclesiastic worthies. [VII, XV The mudrā which accompany this posture and its variant, the *vīrāsana*, are consequently diverse: among them are the *semui-in*, the *an-i-in*, the [III, X, XXIIA, XII *jō-in*, the *sokuchi-in* and sometimes, especially when the lotus is supported by lions or elephants, the *tembōrin-in*.

43

Half (lotus) posture: *Hanka-za*[18]

The *hanka-za* (*vīrāsana*,[19] "attitude of the Hero") is a variant of the so-called *vajrāsana* posture. Other names are: *hankafu* (half lotus posture); *hanka shōza* (correct half posture); *hanka-za, hanka, hanza* (half posture); *han-kekka* (half [lotus] posture); *kenza* (Knowledge posture). According to the *Jūhachikeiingishakuseiki:* "The *hanka-za* is formed by [43 placing the right foot on the left thigh. This symbolizes the Right Way and the suppression of heterodoxy. The right signifies Right (correct), and left means erroneous. Another name given to this posture is *bodai-za,* '*bodhi* posture.' "[20] There is a revealing passage in the *Makasōgiritsu* (XL) concerning the use by nuns of the *hanka-za* instead of the full lotus posture. "At that time, the *bhikṣuṇī* [were in the habit] of sitting con-

125

tinually in the full lotus position (*kafu*). At one time a snake appeared and entered into the 'wound' [of one of them]. . . . The Buddha said: 'Why do you sit thus in the lotus posture? Henceforth I will not permit [you to do so]. The way of sitting is thus: You should bend one leg and put the heel of the other (leg) over your "wound." Those *bhikṣuṇī* who sit in the lotus posture will transgress [against the rules].' " [20a] This position represents the Bodhisattva as the Victorious One (*shōja*), triumphant over the demons of evil, the universal sovereign who, by spreading his Law, represses the forces of malevolence. In the two *maṇḍala* (*taizōkai* and *kongōkai*) Bodhisattvas like Kokūzō, Senju Kannon (Thousand-armed), Kongōzōō, Hannya, etc., all are portrayed seated on a lotus in the *hanka* posture.

VIII]
VII]
There are in practice two types of *hanka-za*: the *gōma*, the demon-suppressing seat, and the *kichijō*, seat of good fortune. The *kichijō-(hanka-za*) is formed by placing the right leg on the left thigh, the *gōma-(hanka-za*) by placing the left leg on the right thigh. The *kichijō hanza* is most common in Esotericism, while the *gōma hanza* is perhaps most usual as an ecstatic-concentration (*zazen*) posture. The *kekka-za* is for Tathāgatas and the *hanka-za* for Bodhisattvas.[21]

<center>✳</center>

In the *yuga-za* [22] (*yogāsana* [23]), the meditation posture associated with yoga meditation, the knees are held slightly elevated by a band which goes round them; [24] in sculpture this band is very often absent. More precisely, this attitude may be called *paryaṅka bandhana* [25] (cf. *kekka fuza*, *supra*). The Sino-Japanese designation of *yuga-za* tends to become a generic term which indicates any posture of meditation—*kekka fuza*, *hanka-za*, or *yuga-za*—without distinguishing one from the other. The *yuga-za* is the position in which the celebrant devotes himself to concentration "on one single point in order to suppress all thought." [26] He is thus enabled to possess magical powers [27] which permit him to make his body lighter or heavier than air, smaller or larger than any thing; which

permit him to penetrate everywhere, to take on diverse forms, etc. (Eitel). The yogic pose, and this holds for all yogic techniques, puts emphasis on "unification" and "totalization." On the plane of the body, Eliade notes, "*āsana* is an *ekāgratā*, a concentration on a single point; the body is 'tensed,' concentrated in a single position. Just as *ekāgratā* puts an end to the fluctuation and dispersion of the states of consciousness, so *āsana* puts an end to the mobility and disposability of the body, by reducing the infinity of possible positions to a single archetypal, iconographic posture." [27a]

44

Posture of relaxation: *Lalitāsana* [28]

In this attitude, the personage represented is seated on a lotus dais, [IV one foot (the right, generally) is pendent and the other, folded on the socle, supports the opposite knee. The hanging foot very often rests on an individual lotus, which, for this purpose, is in front of the throne. This is a [49 characteristic Bodhisattva attitude. In India, Avalokiteśvara assumes this posture in the latest caves of Ellorā, and after the X century "most of the divinities are thus represented." [29] In China this same attitude is often used, especially in representations of Kuan-yin (Avalokiteśvara), during the T'ang and the Sung dynasties.[30]

The mundane postures of ease, like the *lalitāsana* and the *mahārājalīlāsana* below, recall the world of Beings by their elegance; while by the severity of their position, the *padmāsana*, *vīrāsana*, and *yogāsana* (*kekka fuza*, *hanka-za*, and *yuga-za*) evoke the solemnity of the Doctrine or the calm of meditation and thus suggest the world of the Buddha.

127

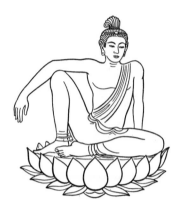

Posture of royal ease: [Mahā]rājalīlāsana [31]

This is the attitude of "royal relaxation." The left leg of the statue, which is in a seated position, is folded horizontally in such a fashion that the sole of the foot is exposed; the right foot rests on the edge of the seat. The right knee, erect, may support the right arm of the statue. The palm of the right hand is turned either out or in, and the left hand braces itself against the throne.

This posture, common for Bodhisattva(s), is assumed most frequently by Monju [32] (Mañjuśrī) and by Kannon (Avalokiteśvara).[33] Certain authorities [34] call it the "Enchanter's pose," for Mañjuśrī; but, as Foucher correctly points out, the attitude is not peculiar to this divinity alone.[35] In India this position is associated with the lion throne,[36] which would seem to confirm its royal character. In Getty's *The Gods of Northern Buddhism* (Pl. x), a group of wooden statues represent Śākyamuni, who is still in the state of an ascetic, in this attitude. Three of the statues out of four present the left knee raised; only one shows the right knee erect. Since this elegant attitude of ease and nonchalant unconstraint has the most worldly character, the position is formally forbidden to monks.[37]

XXI]

46

Posture of Maitreya [38]

XIII

This attitude, which shows the two legs pendent, sometimes crossed at the ankles (the feet are sometimes supported by individual lotuses),[39] is reserved almost completely [40] for statues of Miroku. As a "posture of Maitreya" it is closely associated with the *tembōrin-in* (*dharmacakra-mudrā*), the gesture of turning the wheel of the Law, by which Miroku, as the Buddha of the future, emphasizes the symbolism of sovereignty

47 Posture of Maitreya (*variant*)

48 Posture of Maitreya (*variant*)

characteristic of the wheel (cf. *tembōrin-in, supra*). In India, the fact that this attitude is associated with royalty is indicated by the presence of other elements which symbolize sovereignty, such as the rearing lion and the elephant. In the VI–XII centuries, these elements figured in statues of the Buddha(s) seated in the so-called "European fashion" and forming the *tembōrin-in*.[41] This position, which is found at Benares [42] and which, at Mathurā, was reserved for royal statues,[43] becomes habitual from the

129

Gupta period on. A statue now located in the Bombay Museum is seated in this fashion. It is of the Gupta period (IV–V centuries) and comes from the stūpa at Mīrukān (Sind). It is noted as being seated in *bhadrā-sana*, "good posture." It must have penetrated around the VII–VIII centuries into other Indianized countries,[44] into China,[45] even to Japan,[46] although this position is rarer in the Buddhist art of these two lands.

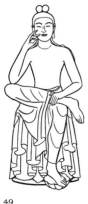

49

Pensive attitude

This the so-called pensive attitude does not seem to figure among the mudrā or the āsana studied by Japanese authorities on iconography. To the knowledge of the present writer, the modalities of its composition are not established by any text. Nevertheless, the following indications will serve to define in general lines what is called here the pensive attitude.

Statues represented in this position show the elbow resting on a raised knee, the foot or the ankle on the opposite knee, the hand raised toward the cheek, and the head slightly inclined in an attitude of contemplation or of reflection. The opposite hand lies on the foot (or the ankle, less often on the calf) of the crossed leg.[47]

It is possible to trace the origins of this attitude of reflection, whose variations in detail are numerous indeed, as far back as India. Already at Mathurā, toward the beginning of the II century, there was an example of a standing statue, the right hand raised, the fingers (with the exception of the index and the middle finger) inflected. The raised hand delicately touches the end of the chin.[48] Moreover, Greco-Buddhist art from the province of Tokht-i-Bahai furnishes the figuration of a seated Bodhisattva, the right hand raised, the index extended at the level of the hair, the right elbow braced against the erect knee.[49] This figuration doubtless constitutes a prototype for numerous Wei and T'ang statues represented in the same position.[50] Under the Wei, the attitude remains rather stiff,

obeying thereby the linear character of this period; but under the T'ang [51] and the Sung,[52] it was to show all the voluptuous languor which marks the statues of Bodhisattva in *mahārājalīlāsana*. This tradition is present in [XXI Japan as early as the Suiko period in numerous statues, of which the most famous is probably that of the Chūgūji at Nara.[53] In China, either the right or the left hand could be raised, for it would seem that the aesthetic balance of the statue was adapted to the position and to the use of the icon.[54] In Japan numerous variations of the position of the hands, the fingers, and the palms are encountered, but generally this attitude shows the right hand raised toward the face (chin, cheek, or forehead), while the left lies on the left leg (instep, ankle, or calf).

This attitude in Japan, as in China, is especially characteristic of two Bodhisattvas: Kannon and Miroku. For Kannon,[55] it is the end-point of the non-Tantric tradition of Avalokiteśvara in the form of Nyo-i-rin Kannon, either two-armed or with multiple arms.[56] But this position is [XVII still (and specially) characteristic of Miroku.[57] One foot of this divinity invariably rests on the ground, the other lies across the opposite knee, and the chin is brushed by the index and the middle finger (which may vary in position [58]) of the raised hand. The Miroku of the Chūgūji is one of the most famous examples of this posture in Japan. It may also be added here that in meditative statues, like the Chūgūji and the Kōryūji Miroku(s), which are seated in *hanka-za*, the left leg hanging down from the pedestal, the attitude is called *hanka shi-i-za*, half (lotus) posture of thoughtful (meditation).

Thrones

Certain elements of a decorative nature may be discussed together with the āsana. Elements such as the *kūrmāsana*, or "tortoise throne," [59] the *makarāsana*,[60] "throne supported by *makara*," the *siṃhāsana*,[61] "lion [50, 54, 63, XII throne," a symbol of royalty, the elephant seat, a symbol of sovereignty and wisdom,[62] etc., are necessarily connected with the symbolic framework

of the statue. A summary list of the more common types of thrones would include the following, some of which are also illustrated:

1 Kongō-za. The seat of the Buddha under the Tree of Wisdom. Usually in the form of a square platform.

50] *2 Shishi-za.* A throne in the form of a lion or supported by lions. The lion, king of the animals, carries the Buddha, king of the Law. The use of this animal as a throne probably derives from the Indian legend that a lion was often in attendance on the Buddha or near the Buddha's throne. When the Buddha figure first appeared, he stood on the ground, or, when seated, he was shown not on the lotus throne but on the lion throne (*siṃhāsana*). The Buddha, who is a "lion among men," preaches sermons which are the "lion's roar" (*siṃhanāda*). The lion throne is associated with Dainichi Nyorai and the Bodhisattvas Monju and Hokkai Kokūzō (Sk. Ākāśagarbha; Gaṇagarbha), etc. Ichijikinrinbutchō has seven lions, and Rasatsu (Rākṣasa) has a white lion.

III] *3 Ten-i-za.* A platform draped with the heavenly robe (*ten-i*). Examples are to be found in Gandhāra, Tibet, India, and China. In Japan, the famous Hōryūji Yakushi and Shaka are seated on thrones of this sort.

I, VII] *4 Renge-za.* The eight-petaled lotus throne (see *supra*, p. 122). But lotuses with as many as one thousand petals may also be used. Both Chinese and Japanese lotus thrones show the influence of southern Indian Buddhist images. In the post-T'ang period (in Japan after Temmu, 672–86), almost all thrones are in the shape of the lotus. Attendants of the Buddha are sometimes, as in the Tachibana shrine or the Hōryūji Amida Trinity, supported by lotus buds.

51] *5 Banjaku-za.* A kind of throne in the shape of a rock of which two styles may be discerned: a simple rocky structure, and pieces of wood of curious shapes. This type of dais (also called *iwa-za*) is characteristic of the *Myō-ō* or Guardian Kings.

52] *6 Kayō-za.* A platform throne in the shape of an inverted water-lily leaf. It is used by various divinities.

53] *7 Sendai-za.* A throne in the shape of the cosmic mountain Sumeru: hence also *sumi-za.* This throne is rectangular in its plane form, the

50 Kongara Dōji on Lion

51 Fudō on Rock

52 Karuṇā

53 Sumeru Throne

upper surface being the largest and surmounting a series of flat rectangular blocks, gradually diminishing toward the base. It resembles somewhat the ideogram *sen*, whence still another name, *senji-za*. This type of throne is particularly used by Nyorai (cf. the central statue of the Shaka Trinity, Hōryūji Kondō, and the Yakushi Nyorai of the Yakushiji Kondō). It is, however, used by other divinities, e.g., Makeshura (Maheśvara), Emmaten, Suiten (Varuṇa, *nāga vajra*), Ishura, and Taishaku-ten. According to the *Kongōchōrengebushinnenjugiki*,[63] the Sumeru king expresses the *bodhi* mind of Sentient Beings. There are thirty-two gradations in all; sixteen rising from the center upwards and sixteen descending from the center downwards. They doubtless correspond to the thirty-two divinities of the *kongōkai*.

8 *Chōjū-za* or *Kinjū-za*. A throne in the form of a bird or of a specific beast:

 a The elephant of Fugen, Ashuku, Kongō Kokūzō, and Taishaku (Indra).

54 Taishaku on White Elephant

b The peacock of Kujaku-ten, Amida, Renge Kokūzō, and Kumara-ten (Kumāra).

The lion of Dainichi Nyorai and the Bodhisattva(s) Monju and Hokkai Kokūzō (Sk. Ākāśagarbha; Gaṇa-garbha), etc. Ichijikinrinbutchō has seven lions, and Rasatsu (Rākṣasa) has a white lion.

c The horse throne is associated with Hōshō Nyorai, Nemyo-bosatsu, Hōkō Kokūzō. Nichiten (Sūrya) of the twelve heavenly beings has five horses,[64] and Nichiten of the outer Diamond Court of the *taizōkai mandala* has four. Nichiten of the *taizōkai* Diamond Court has three.

d The *karura-za* or *garuḍa* (bird) throne is seen with Fukūjōju Nyorai, Gyōyō Kokūzō, and Naraen-ten[65] (Nārāyaṇa).

e The ox (buffalo) throne is used by Dai Itoku Myō-ō (with water buffalo), Emma-ten (white water buffalo), Daijizai-ten (black water buffalo),

55 Kujaku on Golden Peacock

56 Nichiten on Horse

57 Naraen-ten on Garuḍa

58 Emma-ten on Water-ox

59 Suiten on Tortoise Throne

60 Fūten on Deer Throne

61 Gatten seated on
White Geese Throne

62 Marishi-ten on Boar

136

Katen (blue ox), Izana-ten (Īśāna; yellow water buffalo). While the type of ox may differ, all are classified under the general term of *ushi*. *f* A few somewhat less common creatures are also used as seats: the ram for Daijizai-ten, who is known as Uma-hi (Maheśvara-umā) and is seated on a red goat; the tortoise for Suiten (Varuṇa); the deer for Fūten, one of the four Diamond gods of the *kongōkai* (cf. *BD* 1506); the goose (or geese) for Gatten (Candra); the wild boar for Marishi-ten; the demon seat used by Daigen Myō-ō and Myōmon-ten, who rides on a *yakusha-oni* (*yakṣa*), and by Uzu-sama Myō-ō (Ucchuṣma), who rides on a *binayaka* (i.e., a demon symbolizing evil; Sk. *vināyaka*).

63 Daigen Myō-ō on Demons

IV

The Attributes

Introduction

THE ATTRIBUTES (Sk. *lakṣaṇa* [1]), that is, the objects which divinities — except the Buddha(s) [2] — hold in their hands, serve as mudrā in the sense of signs. They help to identify the gods and to mark their symbolic character. Certain attributes are used in aniconic representations in order to replace the body of the historical Buddha.[3] Later, in the course of the development of Buddhist iconography, these objects became closely associated, in the capacity of accidental details, to the Buddhist statue or image. Divinities which resemble each other on the mystic plane are distinguished iconographically by the attributes which serve as mudrā, in this instance as "signs of identity." Thus Vajrapāṇi carries the *vajra*; Fudō, the sword and the lasso; Kannon, the lotus or the vase, etc. There exist several interchangeable series of these symbolic objects. Like the mudrā, however, no one group of attributes suffices on its own to permit the identification of a specific divinity. For example, as Glasenapp says, "in the Shingon sect, several symbols are often attributed to a same entity; reciprocally, there are many that diverse entities possess in common. Thus the Shingon sect attributes as arms to Vairocana a stūpa, while according to Advayavajra,[4] it should be a wheel. The attribute of Amitābha, after the Shingon sect and Advayavajra, is none other than a lotus, but a tradition attested elsewhere makes it a stūpa and a jewel." [5] The diverse series vary, yet the principal symbolic objects remain relatively few.[6] Certain ones reappear constantly in sculpture. In order of their frequency of use and according to their importance, the following may be mentioned:

lotus, *vajra* (lightning bolt), stūpa, jewel, alms bowl, sistrum, rosary, bell, conch shell, sword, knot and rope, trident, bow and arrow, scroll and brush, mirror, ax, and fly whisk. In the following, they are dealt with in English alphabetical order.

I Alms Bowl

Hachi[1] 鉢

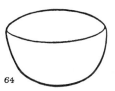

64

CH. *Po*

SK. *Pātra*

SEVERAL LEGENDS describe the alms bowl, the small vessel which the mendicant priests of Buddhist countries still use today. According to one of these, at the end of seven weeks of meditation, two merchants, Trapuṣa and Bhallika, were passing in a caravan near the place where the Buddha was sitting. This happened near Oṛīsā, in central India. Miraculously the caravan stopped, and the two men discovered the Buddha. They offered him refreshments of barley mixed with honey, but the Buddha, resolving to set an example for the community of monks, accepted only that food which was presented to him in an alms bowl. At once the Four Guardian Kings (*lokapāla*) of the cardinal directions offered him four bowls made of precious stone: the Buddha, however, refused them as unbefitting his estate. Then the Guardian Kings offered him four other bowls of ordinary stone. The Buddha, taking the four bowls, piled them one on top of the other to make a single vessel, which he used to hold the offerings [2] of the merchants.[3] Therefore, the *pātra* is one of the Six Personal Things [4] of a monk, the utensil which corresponds to the respectful offerings of others.[5] On the example of the stūpa, the alms bowl as a receptacle becomes the symbol of the *dharma* (*hō*, "essence") and, consequently, is identifiable with the Buddha himself.

The *pātra*, as it is universally represented in the Far East, probably [XXIIA derives from an Indian prototype.[6] In general, the Buddha(s) do not carry any attribute-objects, these being reserved rather for the Bodhisattvas. The *pātra* is an exception, however, to this custom, and it constitutes the characteristic attribute of both Amida and Shakamuni: (in

China) on statues of Amida, it lies on the two hands joined in the lap
(in *jō-in*); [7] on statues of Shakamuni, it is borne by one hand alone.[8] In
India, Avalokiteśvara is but rarely seen among the Bodhisattvas who hold
the alms bowl; Mallmann, in fact, makes mention of but one image (cf.
n.6). Such would seem to be the case also in Japan, for sculptural ex-
amples of Kannon with two hands, carrying a *pātra*, are completely absent.
Her attributes are rather the vase and the lotus, although multiple-armed

65a Ajaṇṭā alms bowl

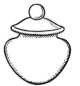

65b Yakushi's medicine bowl

Kannons are frequently represented with the alms bowl.[9] The *pātra* in the
form of a medicine bowl (*ruri-yakkon*, a medicine bowl of lapis lazuli) is
often carried in Japan by Yakushi.[10] Elisséeff notes that in very an-
cient statues of this divinity, sometimes the bowl does not figure, but that
its presence is indicated by the hands lying in the lap in such a position
that they suggest its presence.[11] This mudrā is called *yakkon-in*. Yakushi
does not always hold the bowl in two hands but sometimes simply in one
hand — the left — which he holds away from his body: [12] in this case, the
other hand makes a mudrā, most often the gesture of the absence of fear
(*semui-in*), the sentiment which the divinity is supposed to inspire.

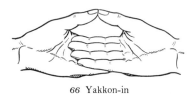

66 Yakkon-in

2 Ax

Ono 斧

CH. *Fu*

SK. *Paraśu*

67

T HE A X, *fu*, meaning "to cut" (according to Williams), is doubtless analogous to *fu*, "to begin," for in order to make any object of wood, it is necessary to begin by felling or cutting the tree.[1] The ax is considered to symbolize, consequently, the act of building, of making, of developing (the Doctrine). It is more probable, however, that this symbolism of the ax is connected — like that of the bow, the arrow, and the sword — to the idea of protection. Since it is an arm of war, the divinities who carry it would use it to cut out all Evil which menaces the Law.

It is carried by secondary divinities, habitually those gods represented with multiple arms.[2]

145

3 Bell

Kane[1] 鐘

CH. *Chung*

SK. *Ghaṇṭā*

68

69 Five-pronged
Vajra bell

THE BELL is one of the most ancient of attributes, its origin going back to pre-Buddhist times. The common, utilitarian use of this instrument assured it a place in Brahmanic iconography. It is present as a symbol of Śivaite divinities,[2] and it may be considered as one of the specific attributes of Śiva himself. The presence, therefore, of the *ghaṇṭā* reflects Śivaite influence on Buddhist iconography. The bell is used in all times to warn or to call; in Buddhist ritual it is used to call the faithful to prayer [3] and to the ceremonies of the cult.[4]

In Japan, as in India, the present form of the ritual bell is a small, metallic-sounding instrument with a handle [5] and an inside clapper often in the form of a tulip. This attribute rarely figures alone in the hands of divinities, but is generally found accompanied by the *vajra* or the drum (*ḍamarū*). Sometimes in Esotericism the bell and the *vajra* [6] are fused so that they become one attribute, the *vajra* forming the handle of the bell. In this combination, the bell represents the phenomenal world (*taizōkai*), the *vajra* the adamantine world (*kongōkai*). Needless to say, the fusion of the two attributes into one denotes the unity existing between the spiritual and material worlds. These attributes symbolize in Śaktism the exteriorization of the masculine principle (*vajra*) and the feminine principle (bell).

The bell stands for impermanence, an idea which underlies so much of Buddhist thought. "The sound which it emits is perishable: it is perceived but it may not be kept." [7] The phenomenal world, then, is like the sound of the bell, "it is perceived, but it may not be kept." All things are

146

perishable; they exist through the senses of the observer but have in themselves no reality. Like dew or the sound of a bell, they are transitory. So human life, similar to the ever-receding sounds of the bell, is changing, inconstant, unstable, predestined to that impermanence which is the essence of all things.

There are five kinds of bells used by the Shingon sect in Japan. Their names derive from the *vajra* form of the handles.

1 *Goko rei:* The five-pronged *vajra* bell
2 *Hō rei:* The treasure bell
3 *Ikko rei:* The single-pronged *vajra* bell
4 *Sanko rei:* The three-pronged *vajra* bell
5 *Tō rei:* The stūpa bell

In the construction of a *maṇḍala* or an altar, the first four are placed at each corner, while the fifth or stūpa bell is situated in the middle.

The *ghaṇṭā* is the sporadic attribute of several divinities. Perhaps the most important are the Guardian Kings (*myō-ō*) [8] and Kannon with multiple arms.[9] These gods almost always hold the bell in their left hand, which represents the World of Beings, the *taizōkai*, and Wisdom.

70 Stūpa bell

[72

4 Bow and Arrow

Yumi / Ya 弓矢

CH. *Kung / Shih*
SK. *Cāpa / Śara*

71

62] THE ARROW represents one of the Buddhist weapons against Evil.[1] It is often associated with the bow,[2] which, in statues with multiple arms, is held by the corresponding opposite hand.[3] This arrangement would seem to aim at keeping the aesthetic equilibrium of the statue. There are, however, cases where the two objects are held in the same hand.

72] Elisséeff notes, in speaking of Aizen Myō-ō, that the arrow and the bow chase away forgetfulness, which is composed of carelessness (in observing the Buddhist Precepts) and neglect (of the Law). On the other hand, according to the *Hōbōgirin*, "the bow and the arrow . . . the contact of which symbolizes Love [4] . . . represent Concentration and Wisdom, by means of which the false View of Self in the individual and in the Essences is attacked. . . ." And later, speaking of the ordinary form of this god (*T.* 867, chap. V), that is, Aizen with one head and six arms: ". . . in the left hand, middle, he holds a Diamond bow, in the right a Diamond arrow, as if he were discharging starlight in order to create the Essence of the Great Attraction. . . . Another form (of the divinity) called after the heavenly bow, Tenkyū Aizen, lets fly an arrow toward the sky. A three-headed form holding a bent bow and seated on a lion must have been introduced from China to Japan by Chishō Daishi in the IX century." [5]

Mention may also be made of the arrow of Kāma, god of love [6] in Brahmanism, as well as of an Esoteric Bodhisattva, Kongō Ai Bosatsu, who is one of the Bodhisattvas surrounding Ashuku of the *kongōkai:* "he holds (sometimes) in his left hand a bow, and in the right an arrow." [7]

148

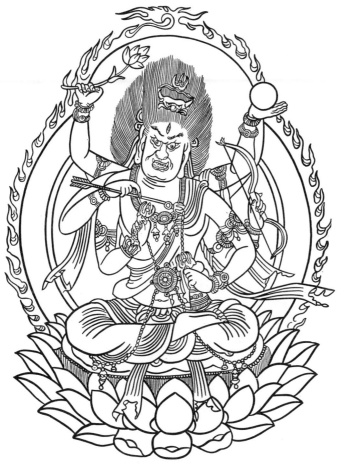

72 Aizen Myō-ō

5 Conch Shell

Hora[1] 法螺

CH. *Fa-lo*

SK. *Dharma-śaṅkha*

THE CONCH SHELL was used in ancient India as a trumpet. It served in the army to transmit the orders of the officers to troops deployed in the field. At that time, it symbolized royalty and authority, i.e., sovereignty. It is but one step to the symbolism which was imposed on it by Brahmanism and later by Buddhism. In Brahmanism, the conch was one of the attributes most commonly used by divinities of Viṣṇuite origin. It became, in fact, the specific symbol of Viṣṇu, who used it, by virtue of the horrific sounds it emits, to spread terror among his enemies. As an attribute of this god, it is represented in the form of a simple shell. The use of the conch in Buddhism is only an adaptation of this early symbolism. Since the original use of the conch was the diffusion of the words of the commander to the armies of men, such was the case for its use as a Buddhist symbol, for here it signifies the spreading of the Law throughout the world. The *Dainichikyō*[2] states: "With his left hand he transmits the Law-shell (*dharma-śaṅkha*), and again thus he expounds the *gāthā*."[3] And again in the *Dainichikyōsho* it is noted: "He turns the wheel of the Law. At that time, by means of a single sound, he diffuses (the Law) in the worlds in all directions and puts all Beings (into a state of) Awakening; this is why one says 'blow the great conch.' "[4]

The conch symbolizes not only the act of diffusing the Law but also its universality[5] and its strength: in the ears of the world the Law will resound, impressive as the sound of the *hora*. This is really the voice of the Buddha, who, by an imperious call, assembles the faithful to hear the

150

predication of the Law—religious assembly comparable to military assembly.

Williams sees in the conch the symbol of a prosperous voyage. On the example of the spiral curls of the Buddha's hair (such being the normal shape of any Buddha's hair), he observes that, since ancient times and throughout many countries, these shells were sacred things because of the clockwise spiral, which had a mysterious connection with the sun and its course in the heavens.[6]

The *Si-do-in-dzou* [7] describes the mudrā of the conch. It is formed by bringing the hands together, without completely joining them, in such a way that the last three fingers of each hand touch at the extremities: the thumbs are erect, and the inflected indexes touch the thumbs at the base of the nail. They form what is called "the aperture of the conch" (this is the form of the *mushofushi-in*). The regular alignment of the fingers is meant [37 somehow to recall the circumvolution of the shell, while the opening formed by the fingers evokes the aperture of the conch itself.

Divinities with multiple arms, especially, are seen represented with this attribute.

6 Fly Whisk

Hossu 拂子

CH. *Fu-tzu*

SK. *Cāmara*

74

BY MEANS OF THE FLY WHISK, said to be made correctly from a deer's tail—in Tibet from that of the Tibetan ox—the priest touches the head and the body of the disciple. By this action he symbolically repels any obstacle to enlightenment. Like the sistrum, the whisk symbolizes obedience to the Law, particularly the observance of the precept of "not-hurting," in this instance, the not-hurting of any small animal, which may be warned away by the movement of the whisk. The origin of this symbol must be attributed, in part at least, to the tradition that at birth the Buddha at once arose upright on a lotus. He was protected at this point by a parasol and a fly whisk—both of which were white.[1]

The *shubi*—another term for *hossu*—is so called, according to the *Gyōjishō*,[2] because it is taken from the stag who serves as a leader for the herd of deer just as the teacher serves as a leader for his disciples. The deer follow this stag's tail (*shubi*) and so are safely led. The teacher holds the whisk and imparts knowledge to his pupils. The *Gyōjishō* notes, however, that it would constitute an infringement on the Law to make the whisk from the tail of a domestic animal. Other names for the *shubi* are *byaku hotsu* (*hae-harai*) [3] and *hossu*,[4] which are defined as whisks used to chase away insects. They are made from animal hair, bark, or threads. The *Binayazōji*,[5] in fact, notes that its use was prescribed by the Buddha and that there are five kinds: sheep's wool, hemp, finely shredded fabric, old rags, and tree branches and twigs.

According to the *sādhana* of the Buddha-*vajrāsana*, the fly whisk

152

should be carried in the right hand of all the "Lokeśvara" attendants of [XIX
this Buddha.[6] And it is not uncommon among Indian Buddhist trinities to
find two attendants standing to the right and left of the Buddha and hold-
ing whisks. As a matter of fact, for the historical Buddha, the fly whisk,
like the parasol, is a symbol of his royalty. These two attributes are
either carried by attendant divinities or float through the air near him. In
the hand of Kannon the fly whisk symbolizes the Compassion of the
divinity, for by its use he avoids hurting even the smallest and most in-
significant of creatures.

The fly whisk is often carried by ecclesiastical dignitaries. It sym- [XXVₐ
bolizes the spiritual direction which the master exercises over his sub-
ordinates in order to lead them toward enlightenment. The fly whisk,
like the scepter, constitutes a mark of superiority for the personage who
bears it.[7] Ennin speaks of seeing the fly whisk used in Buddhist cere-
monies in China. After a reading, he notes that the lecturer, "grasp-
ing his chowry, read the patrons' names one by one and made sup-
plications for each individually. After that the debaters argued the
principles, raising questions. While they were raising a question, the
lecturer would hold up his chowry, and when a questioner had finished
asking his questions, he would lower it and then raise it again, thank [the
questioner] for his question, and then answer it." [8]

7 Jewel

(Nyo-i) shu[1] 如意珠

CH. *Ju-i-chu*

SK. *Cintāmaṇi*

T HE SANSKRIT WORD *maṇi* is a generic term that designates a precious stone, a jewel, and precisely a pearl.[2] Despite a diversity of opinion among competent authorities,[3] the *maṇi*, as represented in Japanese sculpture, usually takes the form of a pearl: [4] the *cintāmaṇi* (*nyo-i-shu*) is the jewel (pearl?) which grants all wishes.

On the symbolic plane, there exist several groups [5] of precious objects: in Japan, the Three Jewels (*tri-ratna*) — i.e., the Buddha, the *Dharma* (Law), and the *Saṅgha* (Community) [6] — is the group perhaps most frequently encountered. In *śaktism*, the *tri-ratna* assumes a larger signification: the Buddha becomes the masculine principle (*upāya, hōben*); the *dharma* (Law), feminine Knowledge (Gnosis); and the *saṅgha* (community), the posterity resulting from the union of this couple.[7] In Japan, the three jewels are often fused in a single pearl surmounted by a three-pointed flame: [8] but this pearl, as it appears in sculpture, is generally devoid of the fire-halo which often figures in painting.[9] When the flame is present in sculptural figurations, it is divided often into three tongues which meet at the top and which thus divide the stone into three equal parts.[10]

In China, for Taoism, the pearl becomes the emblem of riches and prosperity.[11] According to one legend, this precious stone finds its origin in the luminous pearl which the Dragon King of the sea sent to Miao Chen. In Buddhism, the *maṇi* by its luminosity and its brilliance symbolizes the Buddha and the Doctrine: [12] as a pearl, an emblem of purity,[13] it represents the truth of the Buddha and the veracity of the Law.

154

According to the Esoteric doctrine, the *cintāmaṇi* in the form of a pearl represents the *manas* or sixth sense,[14] and is "the 'glorious vesture of the soul,' the radiant vehicle of the divine essence which, united with matter, forms man." [15] This pearl is generally presented in a spheric, oval, or round form, sometimes even in the shape of a heart.[16] The contours of the triple fold or of the quintuple fold stand respectively for the Buddha, the *dharma*, and the *saṅgha* or the Five Knowledges (cf. n.27 under *chi ken-in*). The *cintāmaṇi* sometimes figures as a stūpa. And since the stūpa symbolizes the Buddha, the jewel, assuming the traits of a reliquary, represents the benevolent Buddha as granter of wishes.

Buddhist texts abound in stories concerning the origin of the jewel. In the *Daijōrishurokuharamittakyō*,[17] there is the story of the merchant who was an example of filial piety, sacrificing himself for the welfare of his parents. Seeing, however, that they were poor and suffering, he wondered what means (*hōben*) he could adopt to succor them. Finally, he brought them from the sea a *hō-i ju*, which henceforth saved them from all sorrows and misery. As for the origin of this attribute, the *Zappōzōkyō*[18] reports that this jewel came from the brain of a giant fish (*makara*) that measures 280,000 *ri* in length. According to this text, the gem is named *kongō-ken*. Again, according to the *Kambutsusammaikaikyō*,[19] Nanda, a Nāga king, took the heart of a *garuḍa* bird and made it into a luminous jewel, and the *dharmacakravartin* (i.e., the Buddha) made it into the gem which grants wishes. The *Daichidoron*,[20] on the other hand, notes that the jewel came from the brain of a *nāga* and that, possessing it, one may escape from harm and poisons and entering into fire one will remain unburnt; possessing it, all earthly desires are fulfilled.

The *cintāmaṇi* is the specific attribute of a type of Kannon known as [XXVI Nyo-i-Kannon, granter of desires. As a rule, the divinity (with two arms) holds the jewel in one hand or between her two hands.[21] In the Suiko period, one of the more common positions is that in which the two hands are held in front of the breast, one holding the jewel and the other covering it. If the divinity holds the jewel in one hand (most often the left), the arm is bent and the hand, half raised and advanced, makes the gesture of

offering the gem which she holds on her palm [22] or between her thumb and the middle finger. The jewel does not always appear in the hand of the divinity, but sometimes on the diadem or on the socle.[23]

XXIV] Kichijō-ten (Śrī-devī) is always represented with the wishing jewel, which in this instance symbolizes the power she has to make Beings happy by granting their wishes. The divinity holds the jewel in her left hand, while the right hand forms various mudrā, most often the *segan-in*. This gesture seems to be naturally associated with the *cintāmaṇi:* both of them make a gift and both are supposed to be able to grant the desires of the worshiper.[24] The *Saishōōkyō* notes a type of *dhāraṇī* called "Precious Pearls which grant all desires" (*nyoi hōju*). These formulas are supposed to be efficacious against all kinds of calamities, including thunder and lightning.[25]

Batō Kannon holds the *cintāmaṇi* in the right hand; it is white and is surrounded by a red aureole. In the *Nyoirindaranikyō*,[26] Nyoirin Bosatsu is said to bear this attribute and thereby to grant all wishes. The same is noted for Jizō [27] (*Jizōbosatsudaranikyō*), who also holds this gem, by which he grants the fulfillment of all desires.

Other divinities who sporadically carry the jewel are Fugen, Monju,[28] and especially Hōshō (Ratnasaṃbhava), whose distinctive attribute it is.[29]

8 Lance and Trident

Hoko / Sanko geki 矛 三鈷戟

CH. *Mou / San-ku-chi*

SK. *Kunta / Triśūla*[1]

76 77

THESE TWO INSTRUMENTS, which were ancient weapons of war and of the hunt throughout Asia, constituted early in Buddhist iconography symbolic arms against Evil. In India the *triśūla* was used in aniconic representations,[2] along with the wheel, etc., and stood for the Buddha essence. The trident also appears in China as an attribute of Taoist divinities. In Tantric, Lamaistic Buddhism the *triśūla* is an exorcising instrument, a magic wand to conjure power over demons.

The trident is, as it were, the end-point in the evolution of the single-pointed lance.[3] In India, the *triśūla* takes the form of a triple pike made of metal and often mounted on a wooden shaft. On the handle, around which sometimes is entwined a snake,[4] figure various religious emblems, signs of power and authority. In Tibet, these emblems include dried skulls; such funereal emblems are regularly absent in Japan.

78 Indian Triśūla

[102

This symbolic object must derive from other sources than Buddhism or even Jainism. These two systems seem to have taken over an ancient symbol of fire, from which they created the trident symbol for their own religious iconography. Fire symbolism is associated with the *vajra* and these two attributes may have a similar origin. The trident, however, is to be symbolically identified with the pillar which "supports apart" heaven and earth and, in fact, is the axis of the universe.[5] Combaz would see in this triform attribute an affinity with the wheel[6] that represents the Buddha and the Law. In fact, the juxtaposition or superposition of these two emblems produces a composite symbol which is known as the *vardhamāna*.[7] This sign goes back much further than Buddhism:[8] it is

79 Trident support

[78

157

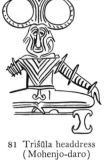

80 Trišūla and
Law Wheel

LANCE AND TRIDENT

already present on a seal from Mohenjo-daro, where a seated personage, surrounded by a lion, a bull, and an elephant, wears a trident-shaped head-dress.[9]

Senart sees in the *trišūla* a symbol of fire.[10] And significantly, the trident is a sign "naturally representing either the three aspects of Agni Vaiśvānara, or the primordial Agni as the triunity of the several angles."[11] Such a relationship, moreover, would speak in favor of this attribute as a symbol for Śiva. One cannot help but see here too a parallelism with the *vajra*, for the handle of the trident, like that of the *vajra*, is most certainly closely connected with the Pillar (*stambha*) that "supports apart" heaven and earth. The symbolism most commonly ascribed to this attribute is that of power,[12] authority, and protection. In addition, the three tines of the trident may be said to represent the three Jewels (*tri-ratna*): that is, Buddha, the Doctrine, and the Community.

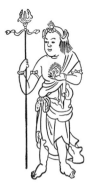

81 Trišūla headdress
(Mohenjo-daro)

The trident is often present in the hands of the Guardian Kings, who, by routing the demons of Evil, protect and defend the Doctrine.[13] It is also carried by Izana-ten (Īśāna).[14] By the trident, Monju symbolizes the spreading of the word through his three acts (works, speech, thought), and Kannon with multiple arms the dissemination of her Compassion.

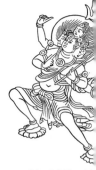

82 Munōshō's trident

Mallmann speaks of a triple-stick (*tridaṇḍa*)[15] which normally accompanies the water vase in the statues of Avalokiteśvara in India. This triform instrument is, nevertheless, distinct from the trident. The triple-stick was originally intended to be used as a tripod support for a vase, and it evolved into a kind of fork with three points. No example of the triple-stick exists in Japan, to the knowledge of the present writer.

83 Eki Dōji's trident

158

9 Lotus

Renge 蓮華

CH. *Lien-hua*

SK. *Padma*

84

T HE LOTUS, one of the oldest Buddhist symbols, is among the most frequently represented attributes both in painting and in sculpture. It has developed a very considerable symbolism.

The lotus flower, by reproducing from its own matrix, rather than in the soil, is a symbol of spontaneous generation (*svayambhū*).[1] And the lotus which serves as seat or throne for the Buddha(s)[2] indicates, therefore, divine birth.[3] The Ādi-Buddha (first Buddha) is manifested as a flame springing from a lotus flower.[4] Popular imagination, particularly in Amidist sects, has established an identification of the lotus flower with Sentient Beings. The blossom of the lotus offered by the worshiper to the divinity signifies the surrender of his own existence to its origin, the abandonment of his own nature to the Buddha, the renouncement of an independent existence.[5] The lotus flower arising from the waters represents usually "the ground (*pṛthivī*) or substance of existence, both that whereon and that wherein existence is established firmly amidst the sea of possibility."[6] Northern Buddhists believe in the existence of a lotus pond in the Western Paradise of the Amida Buddha. At the birth of a Buddhist, a lotus bud is thought to emerge on the surface of the water and, according to the life of the believer, to flourish or wither.

The lotus grows in mud, yet rises immaculate to the surface of the water to bloom: thus it symbolizes purity and perfection. On the example of the lotus, the Buddha was born into the world but exists above the world.[7] Like the lotus, whose fruits are mature at the moment of the blooming of the flower, Truth, preached by the Buddha, produces

immediately the fruit of enlightenment.[8] The lotus signifies ontologically a solid base in the middle of the possibilities of existence, a birth and a manifestation which are produced essentially in the intelligible world and later also in the world of the senses; it signifies ethically the detachment particular to him who is in the world but who is not attached to it.[9]

The lotus becomes by extension the symbol of summer, of fruitfulness,[10] of strength, both spiritual and material.[11] Tantrism makes of it the emblem of the feminine principle. This evolution ends logically in Śaktism, where the lotus has the role of symbolizing the female sexual

85 Nyorai-ge on lotus 86 Blue lotus of Gakkō Bosatsu

organ; in support of this, the *Śatapatha Brāhmāṇa* affirms that the "lotus leaf is the matrix." The *vajra* becomes then the symbol of the male sexual member, and the representation of the *vajra* on the lotus, which is often encountered, symbolizes the union of masculine and feminine, of Knowledge and Principle, the expression of fulminatory identification with the godhead.

The lotus as symbol of the Matrix World (*taizōkai*) appears in the mantra *"oṃ maṇi padme hūṃ"*: the lotus (*padma*) represents the material element (*taizōkai*) and the jewel (*maṇi*) the spiritual element (*kongōkai*). The same is true of the lotus in the vase (=*kongōkai*), where lotus and vase represent the union of the spiritual and the material.

Lotus flowers may be divided into three general groups according to their color: [12] the red lotus [13] with rounded petals, the blue lotus [14] with pointed petals, and the white lotus.[15] These lotuses may take different forms. The red lotus (*padma*) is usually represented fully opened, the center exposed, while the blue lotus may be represented either with all the petals erect or with several rows of outer petals bent down; the center of this type is always hidden. In China and Japan, for divinities who carry this flower in their hand or in a vase,[16] the lotus bud is the most common form. There is also variation in the shape of the buds. Three forms are found especially in painting.[17] The three-stemmed lotus symbolizes the three divisions of the *taizōkai mandara* (Buddha = Vairocana, Lotus, and Vajra) [18] as well as the Three Virtues of a Buddha,[19] by which the divinity attains to enlightenment and to knowledge in order to save all Beings. The five-stemmed lotus [20] represents the Five Knowledges of the *kongōkai*. The lotus fully opened is seen most often in the form of a flower with eight petals, which represent the Eightfold Path; the whole symbolizes the Teaching of the Buddha. There exists a connection between the lotus with eight petals and the wheel of the Law with eight spokes (cf. *tembō-rin-in*). Both represent the superiority and the strength of the Law.

87 Three-stemmed lotus

In representations of the *mandara*, the lotus with eight petals lends itself particularly well to the figuration of the usual eight *maṇḍala* divinities: the center is reserved for the principal god and the petals [21] for the attendants. In sculpture, the lotus may serve as a throne [22] either in the form of a seat to support the statue of a divinity or in the form of a flower sustaining each foot,[23] for the "characteristic of the lotus leaf is to support all the worlds, *puṣkara-parṇasya sarvajagad-dhārakatva.*" [24] As a throne (cf. *supra*, p. 122), the lotus has the advantage that it can be enlarged; it is hence adaptable to statues of different dimensions. Very often the throne is composed of an open lotus, stylized, whose outer row of petals are bent down over the socle, with which they fuse and which they hide. (It is not the object of this study to consider in detail the evolution of the lotus as a throne. This development has been studied in other works [25] to which the reader may refer.)

88 Five-stemmed lotus

161

Since the lotus is universally used as a seat for the Buddha, it is natural that this flower became associated with sovereignty. This relationship would be proof, moreover, of iconographic contamination with the wheel (cf. *tembōrin-in*). The Buddha as Universal King makes it his seat. Hence, when divinities other than the Buddha use the lotus, they assume those qualities symbolic of the authority represented by the dais in lotus form.

The lotus, symbol of mercy and compassion, is one of the most ancient attributes associated with the divinity Kannon.[26] In India, the water vase may be considered as the oldest attribute [27] of Avalokiteśvara,[28] but the red lotus (*padma*) is the most frequent. It symbolizes the creative force of Padmapāṇi. Mallmann divides the lotus which Avalokiteśvara holds into five groups: The first is constituted by the "lotus in the form of a ball, seen in profile . . . and situated at the end of a long stem which the Bodhisattva holds in his left hand." It suggests the form of a closed, double tulip. The model is present from the VIII century at Nālandā. The second group, constituted by the lotus in the form of a ball observed in full front view, appears only in Pāla-Sena art.[29] It is the third group, "the naturalistic lotus, seen in front view" which is the most frequent. Present from the Gupta art of Nālandā on, it persists throughout the most decadent art. It is represented in the form of a large double dahlia in full bloom. A long subsidiary stem (which springs from the same trunk as the seat) sometimes supports a water vase. This lotus is also the attribute of Śrī and of Sūrya, whose groups are composed of "naturalistic lotuses, seen in profile," with one row of petals for the fourth group and two rows for the fifth group.

In China, the lotus continues to be the most frequent attribute of Kuan-yin. The Bodhisattva usually holds in her right hand a lotus bud situated at the end of a long stem; often in her left hand she holds a vase. From about the VI century on, a willow branch, either in a vase or in one hand, may take the place of the lotus.[30] In Japan during the Suiko period, this same willow branch attests the continuity of this usage imported from Sui China.[31] Habitually, at this time, Kannon holds the lotus in

89 Kuan-yin's willow branch

either hand.[32] When the divinity has a lotus in one hand, the other may either hold a vase, or form a mudrā, very often the *segan-in*.

The lotus is also the attribute of other divinities: the Knowledge [33] [55, 72, 85, 86,
Kings (*myō-ō*); Jizō,[34] who may be represented with a yellow lotus XVIII
under one foot and a white lotus under the other; [35] Amida, "notably in
the circles (of the two Worlds) where [he] figures seated on a lotus seat
(symbolizing the purity which his Esoteric name implies)"; [36] and the

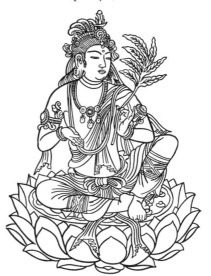

90 Yaśodharā's willow branch

historical Buddha, who is often represented seated on a lotus throne.
According to tradition, after attaining enlightenment the Buddha hesi-
tated to teach the Doctrine. He decided to do so mainly through a vision
in which he saw Sentient Beings like so many lotuses. Some had risen
to the light and had no need of help; some were so deeply immersed that
there was no hope that they would ever rise; some were near the surface
of the water and needed but little assistance to come forth into the light.
He resolved, by spreading the Buddhist Doctrine, to bring the latter to
full bloom.[37] Among other divinities having the lotus as an attribute, we
may note: Jishibosatsu (Miroku) of the *taizōkai mandara*, in the north-

163

east, carrying a lotus in a vase in his right hand; [38] and Monju, holding a lotus which represents the teaching of the Buddha and which supposedly takes the place of the *Prajñāpāramitā*.[39] Last of all, mention may be made of the lotus which serves as throne to support an image or a statue of a holy man, a Buddha, or a Bodhisattva. In the first case, it is the emblem of Buddhist qualities and symbolizes the Law: as a throne of a Buddha or a Bodhisattva, it symbolizes most particularly the sovereignty of the personage represented, or the authority of the Law.

10 Mirror

Kagami [1] 鏡

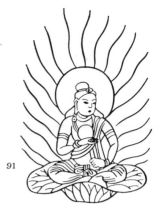

CH. *Ching*
SK. *Ādarśa*

91

THE MIRROR symbolizes the image of void, for it reflects all the factors of the phenomenal word, but deprives them of substance.[2] The phenomenal world is thus exactly illustrated, for all substance is illusory, every thing is no more than the subjective idea one has of it. As Glasenapp says: "The mirror is supposed to make known that no transitory factor of existence (*dharma*) has any more self-reality than the reflection which it presents in the mirror." [3] It thus represents the notion of the evanescence of material illusion, that which is "idea" as contrasted to that which is "phenomenon."

It is carried by Avalokiteśvara [4] with multiple arms and constitutes the distinctive attribute of Ashuku.[5] And, of course, it is the special attribute of Nichiten, the sun god, in whose hands it represents the solar disk. [56, 72

165

11 Reliquary

Sotoba[1] / tō 率都婆 塔

CH. *Shuai-tu-p'o* / *t'a*
SK. *Stūpa*

92

THE SYMBOLISM of the small attribute stūpa, carried by certain divinities in the form of a pagoda, takes its inspiration from the symbolism of the great reliquary-stūpa.

The origins [2] of the stūpa go back to pre-Buddhist times. The stūpa at Sāñcī, clearly reveals a funerary intention; it is nothing more than an immense reliquary intended to contain a venerated relic of the historical Buddha. At Sāñcī, moreover, definite rules for ambulatory practices and for the veneration of the relic were early elaborated: the construction of the reliquary was a pious deed. It was, however, under the influence of Tantrism in the VI–VIII centuries that the "making of the stūpa" [3] was accomplished with the purpose of extracting the *vajra* (magical power), and the rites connected with this were analogous to those of the circumambulation of the reliquary. The basic texts of Tantrism speak of the stūpa, which on the material and metaphysical planes was identified specifically with the historical Buddha. In chapter XI of the *Lotus of the Good Law*,[4] for example, a marvelous stūpa is described:

"Then there arose a Stūpa, consisting of seven precious substances, from the place of the earth opposite the Lord, the assembly being in the middle, a Stūpa five hundred yojanas in height and proportionate in circumference. After its rising, the Stūpa, a meteoric phenomenon, stood in the sky sparkling, beautiful, nicely decorated with five thousand successive terraces of flowers, adorned with many thousands of arches, embellished by thousands of banners and triumphant streamers, hung with thousands of jewel-garlands and with

Plates

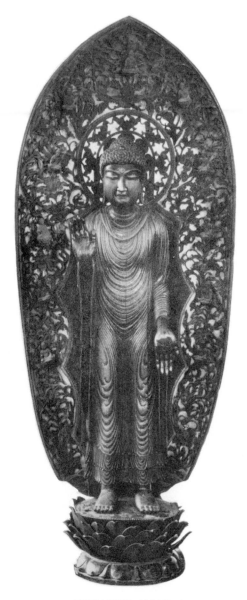

SHAKAMUNI. JAPAN

I

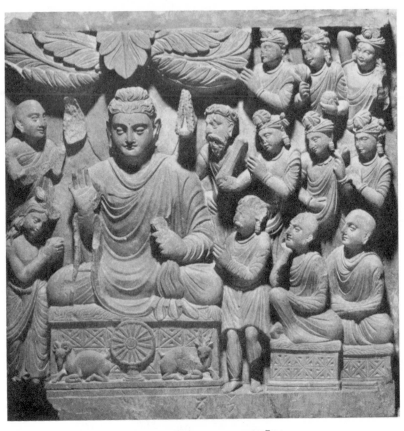

BUDDHA PREACHING. GANDHĀRA

II

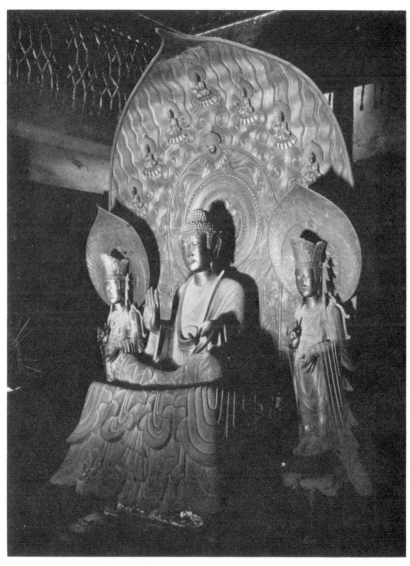

SHAKA TRINITY. JAPAN

III

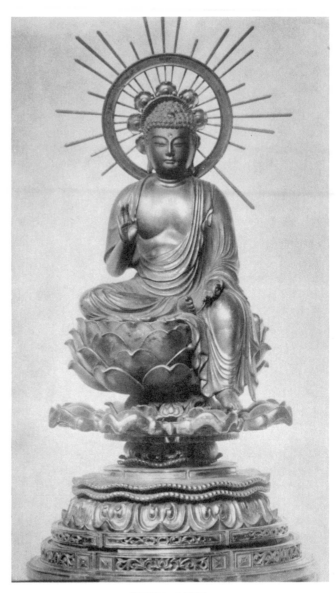

BUDDHA. JAPAN

IV

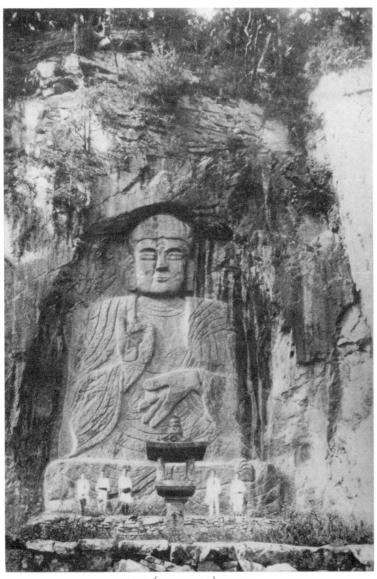

MIRJOK (MAITREYA). KOREA

V

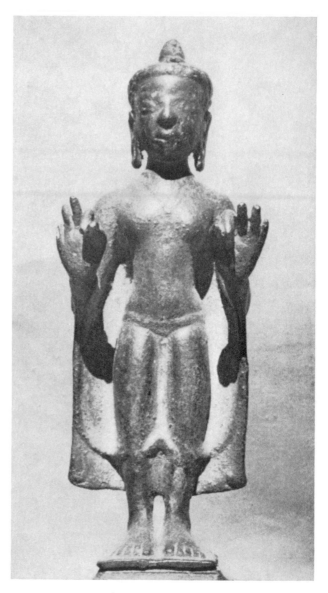

BUDDHA. THAILAND

VI

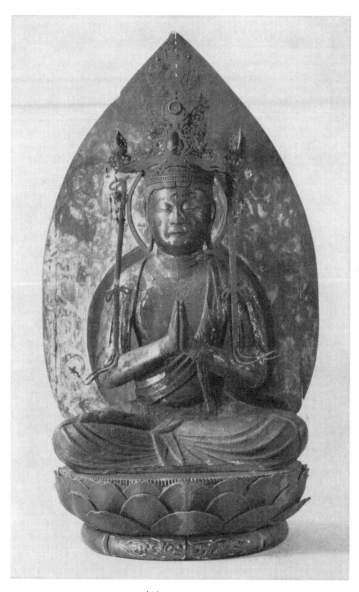

SEISHI (?) BOSATSU. JAPAN

VII

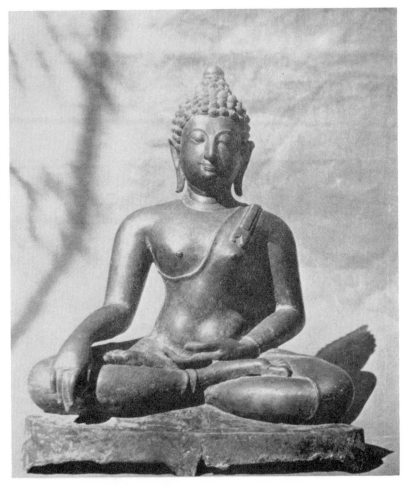

BUDDHA. THAILAND

VIII

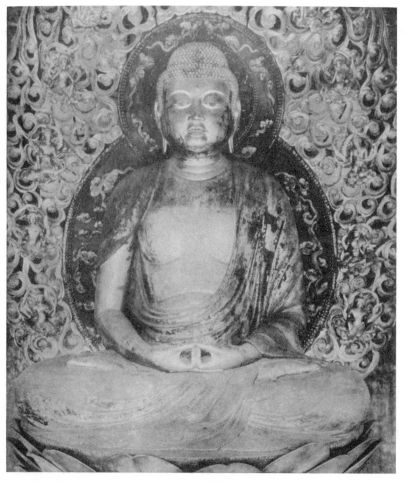

AMIDA. JAPAN

IX

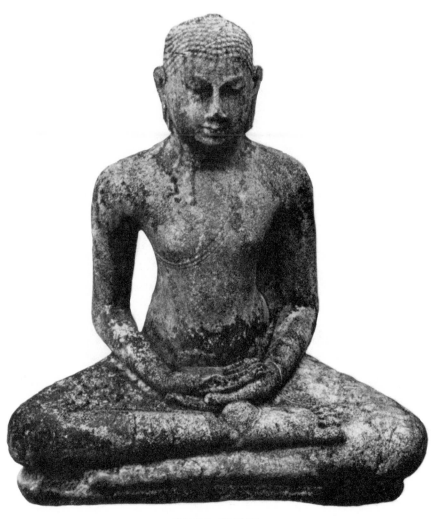

BUDDHA. CEYLON

X

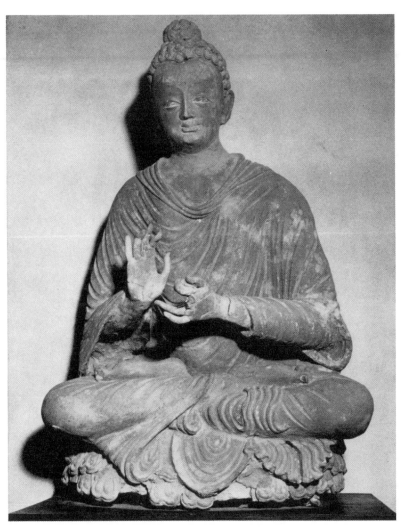

BUDDHA PREACHING. GANDHĀRA

XI

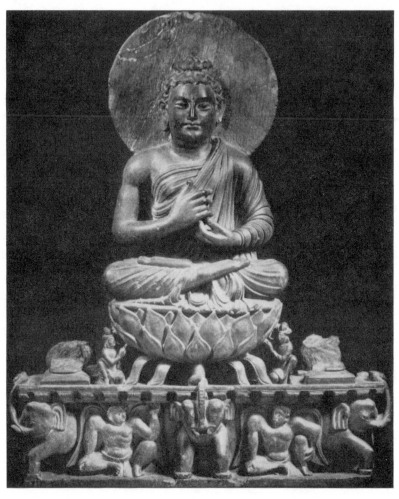

BUDDHA PREACHING. GANDHĀRA

XII

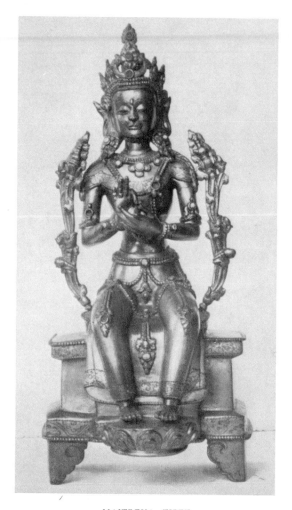

MAITREYA. TIBET

XIII

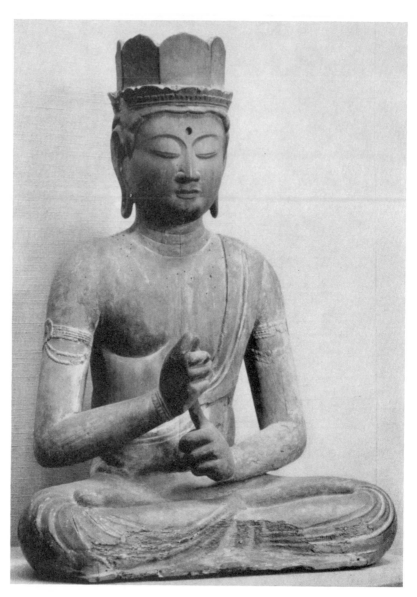

DAINICHI NYORAI. JAPAN

XIV

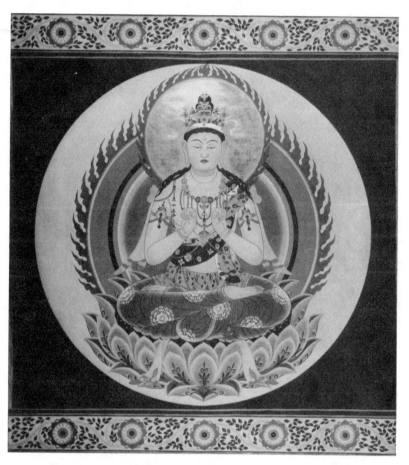

KONGŌGE BOSATSU. JAPAN

XV

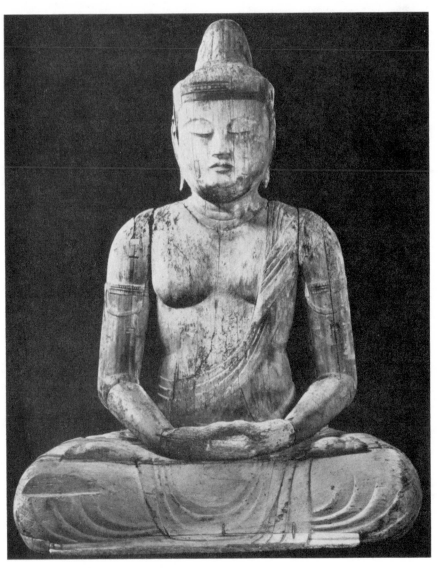

DAINICHI NYORAI. JAPAN

XVI

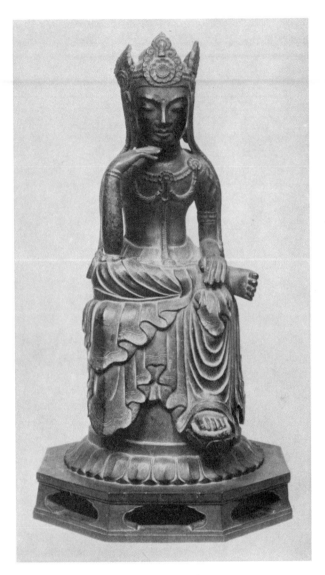

MIROKU. JAPAN

XVII

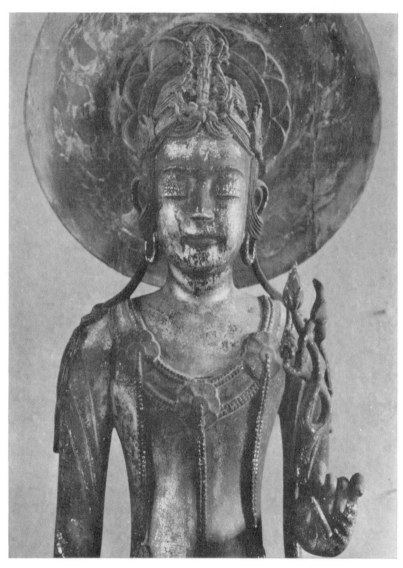

KANNON. JAPAN

XVIII

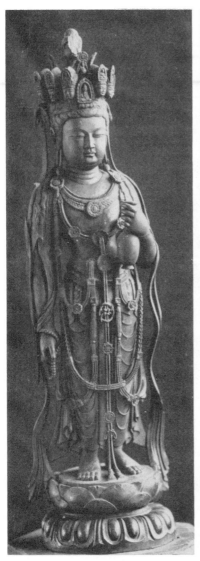
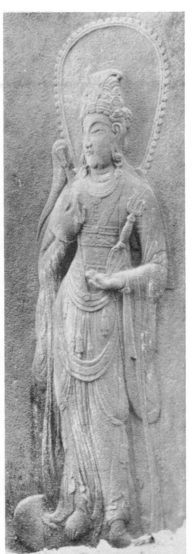

A. NINE-FACED KANNON. KOREA B. BODHISATTVA. KOREA

XIX

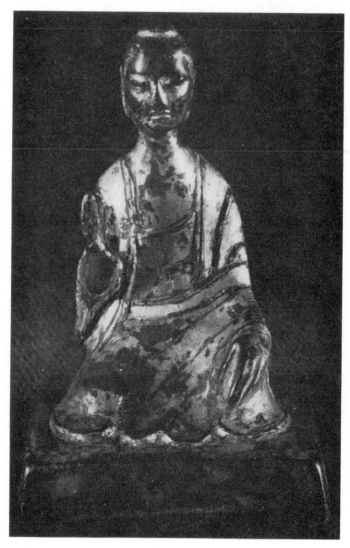

BUDDHA. CHINA

XX

BODHISATTVA. CHINA

XXI

A. AKṢOBHYA. TIBET

B. STŪPA. NEPAL

XXII

"KUDARA" KANNON. JAPAN

XXIII

KICHIJŌ-TEN. JAPAN

XXIV

A. THE MONK IKKYŪ. JAPAN

B. THE MONK SHINRAN. JAPAN

XXV

NYO-I-RIN KANNON. JAPAN

XXVI

hour-plates and bells, and emitting the scent of xanthochymus and sandal, which scent filled this whole world. . . .

"At the sight of that great Stūpa of precious substances, that meteoric phenomenon in the sky, the four classes of hearers were filled with gladness, delight, satisfaction, and joy. Instantly they rose from their seats, stretched out their joined hands, and remained standing in that position. . . .

"(A voice issues from the Stūpa, and, questioned concerning the person to whom it [the voice] belonged, the Bhagavat responds:) In this great Stūpa of precious substances, Mahāpratibhāna, the proper body of the Tathāgata is contained condensed; his is the Stūpa; it is he who causes this sound to go out. . . .

"Let my Stūpa here, this Stūpa of my proper bodily frame (or form), arise wherever in any Buddha-field in the ten directions of space, in all worlds, the Dharmaparyāya of the Lotus of the True Law is propounded, and let it stand in the sky above the assembled congregation when this Dharmaparyāya of the Lotus of the True Law is being preached by some Lord Buddha or another. . . ."

The important place of the stūpa was assured in traditional Buddhism, and in its turn, Tantrism lost no time in developing the iconographic symbolism. The introduction of bones in the stūpa endowed it, as it were, with a secret life; these sacred remains constituted at once material and spiritual relics. Since the reliquary contained a material part of the Buddha, its identification with the Buddha himself followed naturally. By simple extension, then, the edifice came to symbolize the spiritual body (dharmakāya) because it contained those material remains which represent the essence of the Buddha. Moreover, Buddhism, by adopting the notion of the universal sovereign,[5] compared the Buddha to the King of the Universe, and the identification of the stūpa with the body of the Buddha made it possible for this attribute to assume the symbolism of sovereignty.

Intended to hold specifically the reliques of the Buddha Śākyamuni, the building itself became, even in the beginning, the object of an

assiduous veneration. The stūpa naturally came to constitute an object of meditation precisely because it was identifiable with the supreme divinity. But this extension goes even further: the stūpa whose base represents the earth, and whose dome the heavenly spaces,[6] becomes, according to Mus, "the magical representation of the universe, a microcosm intended for meditation."

The form of the stūpa, according to the tradition, was imposed by the historical Buddha himself. Śākyamuni, in order to give the first model of a XXIIв] stūpa to his faithful, inverted his alms bowl (*pātra*) on top of his clothing folded square and thus formed the dome and the base of the edifice.[7] And

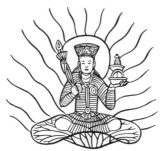

93 Bishamon holding stūpa

according to Combaz, the "production in architecture, in sculpture, in painting is accomplished at once on a material and on a metaphysical plane which may finally fuse: the sculptured stone is no longer the image of the god, it is the god himself, just as the edifice, erected by the architect, inspired by the gods, and conceived according to his religious and cosmological concepts, becomes the actual receptacle of the divinity."[8] The entire structure represents the universe; the base (Mount Meru) is surrounded by the heavenly dome, and both are connected by a central Diag. III] mast which plays the role of the cosmic axis.[9] Later, under Tantric influence, a sort of stylized stūpa appears, composed of geometric forms and bodies.[10] According to the Shingon explanation, this type of stūpa symbolizes the Buddha Dainichi, as supreme divinity, ultimate reality, "who, underlying all things, manifests himself in the Five Elements of the world and in nonrepresented conscience, because it is invisible like the sixth

DIAG. III. FIVE-STORIED STŪPA

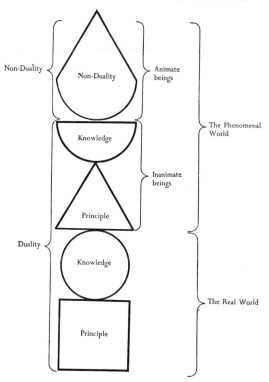

element." [11] The symbolism of the classical reliquary-stūpa is different from that of the five-storied geometric stūpa: the first emphasizes the cosmogony of Mount Meru as well as different series of Buddhist qualities; [12] the second puts the accent on the Esoteric concept of the duality-non-duality of Knowledge and Principle.

In the geometric stūpa, the various superposed forms are given an interpretation of a cosmic nature. The two geometric bodies [13] which form the base of the five-storied stūpa represent the fundamental elements (*hontai*) of the Real World (*jitsu-zai-kai*). The three others which are

superposed on these two basic forms represent the Transmutation Substances (*hentai*) of the Phenomenal World (*gen-shō-kai*). These interconnections emphasize the co-existence of the spiritual and phenomenal worlds, *kongōkai* and *taizōkai*.

Things are by their nature difficult to displace: thus the unmovable square, which serves as the base of the monument, constitutes an exact symbol of this concept. In the same way, the circle, which rests upon the square base and which may be easily turned, symbolizes perfectly the heart (*kokoro*) — for, according to the Shingon sect, *kokoro* is the abbreviation of the onomatopoeia *goro-goro*, which expresses the sound of the turning wheel. The *kongōkai*, the circle, is placed on the *taizōkai*, the square: thus, the spiritual is superior to the material, upon which it is nevertheless grounded. Together, these two bodies (square and circle) constitute the so-called "Form of the Real World."

The phenomenal is founded on the Real World and is symbolized by geometric forms (triangle, half circle), which are modifications of those representing the Real World (the square and the circle). Thus from two fundamental bodies are taken four modified shapes. One may discern two symbolic groupings among these five geometric forms: (1) "things" which are born (and which therefore die); (2) "things" which are not born (and which consequently do not die). The second group is represented by the triangle and the half circle — respectively *ri* (Principle) and *chi* (Knowledge). The first group is represented by a geometric body formed by the fusion of a triangle and a half circle (symbol of things which are born, and which die). In order to symbolize the highest degree, *ri* (triangle) and *chi* (half circle) are united in one single form, that of a half circle surmounted by a triangle. Thus the three upper bodies differ from the lower bodies by their form, but are identical by their quantity. The topmost body symbolizes the fundamental unity of the *kongōkai* and the *taizōkai*; the two bottommost bodies symbolize their separation, i.e., duality-non-duality.

Since the five-storied stūpa expresses the theory of the two worlds, it becomes an object symbolic of *taizōkai* Dainichi.[14]

170

Combaz' particularly interesting study on the evolution of the stūpa in Asia may furnish a number of details for the reader concerning the different aspects of the reliquary-stūpa. In the period between the II century b.c. and the VI–VII centuries of the Christian era, it may be noted that in all of India, the more or less flattened upper part of the edifice serves as a base for the superstructure. In Java, almost all stūpa take the form of an inverted bell, with the top almost horizontal and the lower edges slightly flaring.[15] In Burma, between the X and XIII centuries, the stūpa is like the one in Java. From the XII century on, there may be noted a tendency to raise the dome and to let the edges flare more. In Tibet, the hemispheric form takes the lead: the stūpa tends to be recessed at the bottom rather than flaring, and this shape follows Lamaism in its expansion through China, Mongolia, and Manchuria. In China, during the first centuries of the Christian era, the hemispheric form imported from India appears. In the VII–VIII centuries, a tendency may be noted to suppress the dome and to construct towers in story-like sections, which scarcely evoke at all the silhouette of the stūpa such as it had been known in India. In Korea and Japan it is the same. Yet the Japanese funerary monuments, formed by a high cylinder whose upper part is rounded, recall the original dome of the Indian stūpa.

The stūpa, as a symbolic object, is attributed most frequently to the Guardian Kings.[16] In Japanese sculpture, it figures regularly in the form of a pagoda (tō), whose aspect varies considerably.[17] Statues often hold a [92, 93] little stūpa of geometric forms, however — a type which lends itself easily to sculptural representation. Very often the mast, on Japanese pagodas for instance, is prolonged, and the attribute takes on a more slender silhouette. Sacred texts assign to the Guardian Kings a considerable choice of attributes,[18] of which the stūpa is one. Among these divinities the reliquary becomes the particular attribute of Tamonten: [19] he holds it almost invariably in his left hand. In India, especially, the stūpa constitutes the distinctive attribute of Maitreya.[20] According to the *Jikkanshō*, it is characteristic of (*taizōkai*) Dainichi, who holds it in his hands joined in *jō-in*.[21]

12 Rope

Kensaku 羂索

CH. *Lo-so*

SK. *Pāśa*

94

THE KNOT of the rope, which derives perhaps from the swastika, is supposed to be an angular knot, the mystic sign of the breast of Viṣṇu.[1] According to Williams,[2] the knot is one of the signs which figure on the feet of the Buddha. It represents his sacred entrails. In India, the slip knot must have been, however rare, one of the attributes of Avalokiteśvara.[3] It is also the attribute of Varuṇa, who uses it to bind demons: in sculpture it resembles a kind of ring fixed on a shaft by which it is held.

62, 63] *Kensaku* [4] signifies the rope or snare with which creatures are caught and bound. In Buddhism, this attribute symbolizes the love of the Buddha and Bodhisattva for all Sentient Beings, whom they catch and lead to salvation with the help of the rope. The *pāśa* may have three symbolic interpretations: [5] that of tying (in this instance, the four demons); that of attracting and holding, for the efficient Means of the Great Compassion may take away all illusion and cause the adept to enter into the *hokkai mandara*; and, last of all, that of *nirvāṇa*, the immovable. In order to illustrate the Three Studies,[6] the example of the robber and the rope is classical: (1) the thief is beaten (with the rope = *kai*, "Precepts"); (2) he is tied (by the rope = *jō*, "Concentration"); and (3) he is killed (by the rope = *e*, "Wisdom"). In contrast to the rope, the sword, mobile as the wind, is Wisdom, which can kill Evil: it is held in the right hand. The cord, on the other hand, immobile like void, is Concentration which can bind Evil: it is held in the left hand.

51] The rope is one of the fourteen basic attributes of Fudō, who uses it in order to tie demons and evildoers and thus to protect the Law. The

divinity almost always holds this attribute in his left hand,[7] more rarely in his right; [8] in the opposite hand he invariably holds the sword. Together sword and rope represent the indivisibility of knowledge and principle.

In Japan the rope is among the attributes of a type of Avalokiteśvara known as Fukūkensaku Kannon. The title refers to the fact that the snare (*kensaku*) is not empty (*fukū*), that is, the divinity is continually snaring Sentient Beings in order to lead them to salvation. This is one of the types of Kannon in the *taizōkai* section.[9] Esoteric (*kongōkai*) Asura carry the "stick of Yama" (*pāśa*) surmounted by a human head.[10]

The *pāśa* symbolizes the Buddhist precepts: [11] interdiction to kill, to steal, to be lascivious, to lie, to drink alcoholic beverages. A *vajra* may be attached to the end of the cord: in this case, the attribute is called *vajra-pāśa* (*vajra* rope), which is used to bind the hordes of Māra.[12]

95 Rope hand

13 Rosary

Nenju[1] 念珠

CH. *Nien-chu*
SK. *Mālā*[2]

96

THE ROSARY, which plays a very important role in lamaistic rites, attains its full development in Japan,[3] where its symbolism is considerably evolved.

The short rosary of eighteen beads, symbolizing the Eighteen *Arhat*,[4] is to be encountered considerably less frequently than the ordinary chaplet of 108 beads. (Rosaries may number also 9, 21, 42, or 54 beads. The total number of beads does not include the four *shitenno* beads, occurring at intervals of seven and fourteen and used to facilitate counting, as explained below.) The 108-bead form is in particular favor with the Shingon sect. The 108 beads symbolize the 108 passions (*bonnō*) or the 108 divinities of the *kongōkai*, and sometimes also the 108 Knowledges.[5] According to Williams, the 108[6] beads are meant to assure that the name of the Buddha be repeated at least one hundred times, the eight supplementary beads being present in order to make up for omissions or to replace beads which may be broken. But more probably 108 is chosen because it is traditionally an ideal number, a multiple of nine, which itself bears the greatest potential of variation.[6a] At the ends of the Tibetan rosary there generally are three beads somewhat larger than the rest. These symbolize the Buddhist trinity (Buddha, Doctrine, Community)[7] and indicate to the celebrant that the end of a complete cycle of prayers has been reached. The cord which passes through the beads represents the penetrating power of the Law.[8] When the celebrant begins telling the beads, the *jōmyō*, or counter bead, is

96]

174

DIAG. IV. ROSARY

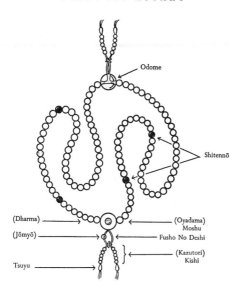

Odome

Shitennō

(Dharma)

(Jōmyō)

(Oyadama)
Moshu

Fusho No Deshi

(Kazutori)
Kishi

Tsuyu

slipped up the string; at the completion of a cycle it is slipped down. Sometimes several *jōmyō* beads occur.

Gonda Raifu explains the symbolism of the Shingon rosary in the following manner: "As a general rule, the rosary originally had an *oyadama*. The *kazutori* [see Diag. IV] includes ten beads and symbolizes the Ten Perfections. The two beads preceding the *kazutori* (usually called *tsuyu*, from the fact that they resemble drops of dew, *tsuyu*) symbolize the Double Marvellous Fruit which is Enlightenment (*bodhi*) and *nir-vāṇa*. This means that one is able, by ascending the chain of the Ten Per-fections, to reach this Double Fruit. The rosary of 108 beads has two *oyadama* by which it is 'divided' into two strands of 54 beads." [9]

In general, the 108-bead rosary may be considered as two strands of 54 beads. This, at least, is true of the 108-bead type brought to Japan from China by Kōbō Daishi. Hence there are two *oyadama*, each belonging

[Diag. IV

175

to one strand of 54 beads. In practice the fingers progress, in counting, from one *oyadama* to the other, at which point the direction is reversed and the counting is carried on back again to the *oyadama* from which one began. The counting never follows the 108 beads in succession.

The method of holding the rosary in Shingon ritual is the following: first, the *seppō-in* (*q.v.*) is formed by both hands. The rosary is then placed over the middle finger of the right hand and over the index of the left. The palms of the hands face each other. There are, of course, numerous formulas that may be recited by the aid of the rosary. One example will suffice: it is the frequently used *"Namu Daishi henjō kongō,"* "Homage to the great Teacher, Universal, Adamantine Illuminator." This formula is to be recited seven times, or three times seven times (i.e., twenty-one times) by counting to the second *shitennō* bead. During the ritual, the rosary when not in use is suspended from the left wrist, in a single strand, with the *oyadama* at the top. When it is in use — the times are indicated by the striking of a bell during the ceremony — it is held in the left hand, in double strand, with all the *kazutori* on the inside. When the rosary is being put away, it is folded into three loops with the two *oyadama* at the top. First, the top *kazutori* are folded inward and then the under *kazutori* are folded in over them.[10]

XIXA] Texts note the use of the rosary in pre-Buddhist India, where it was one of the attributes of Brahmā. In Buddhist India, the rosary constitutes a special attribute of Avalokiteśvara. Mallmann [11] states that its use by this divinity "is constant from Gupta art of Mahārāṣṭra [12] until the decline of the Sena style in Bengal." The origin of the rosary as an attribute of Avalokiteśvara would seem to be in the *Lotus of the Good Law*, where the Bodhisattva Akṣayamati, addressing the Buddha, speaks of a wonderful pearl necklace presented to the Bodhisattva Kannon.[13] Since the 108 beads represent the passions (*bonnō*) of the world, the rosary carried by Kannon signifies that the divinity herself by her compassion assumes these passions which bind the worshiper to the world, and liberates [14] him thus from the hindrance of desires. Since Kannon is the Bodhisattva emanating from the *dhyāni*-Buddha Amida, it is natural that the rosary should constitute

176

also a distinguishing symbol for this Buddha. Gonda Raifu establishes an identification between the Buddha Amida and the *oyadama* (mother bead) because Amida, by a sort of play on words in the reading of the ideographs, is the "mother" of Kannon.[15] Thus the *oyadama* is Amida, and the power of the State of Compassion (*taihi sammai*) characteristic of Kannon is precisely that virtue which permits reincorporation with the Buddha Amida. Hence the red cord, signifying the Compassion of Kannon, which runs through the *oyadama* (Amida), signifies this return or embodiment into the Buddha. It is the mediating power of the Bodhisattva which facilitates the access of Sentient Beings to Buddhahood.

Numerous holy men [16] carry the rosary. In Esoteric pictures of Kōbō [XXVв Daishi, the rosary which he holds in his left hand stands for Fudō Myō-ō and for the Matrix World (*taizōkai*). For the meaning of the *vajra* which he holds in his right hand, consult the section devoted to the *kongō* (pp. 184 ff.).

14 Scroll and Brush

O-kyō / Fude お經筆

CH. *Ching/pi*

SK. *Pustaka*

97

T HE SCROLL and the brush are generally represented together, but, like the bow and the arrow, they may figure separately. In the first case, they are arranged in opposite hands; [1] in the second, they are often carried by a left hand.

The scroll represents the sacred texts of the Buddhist canon, the depository of the Truth.[2] The single scroll represents then the whole of the *Tripiṭaka* and may be said, by extension, to stand for the entire Doctrine.

98] Mallmann speaks of the book which should be one of the objects carried by Avalokiteśvara in India: [3] such a book is made by binding together, by means of cords, the rectangular palm leaves which make up Sanskrit manuscripts. Mallmann has encountered in India only five multiple-armed statues of Avalokiteśvara in which one left hand holds a book (*pustaka*): the existence of others, however, may be postulated. The book as a symbol of the whole canon exists, of course, in China and Japan; but rather than the Indian *pustaka*, the scroll becomes a much more common symbol in these countries. It is probably a question of the transformation of "book" into scroll through the fact that, in China and Japan, it was in scroll form that the Buddhist canon regularly appeared. Consequently, for the Far East at least, the scroll rather than the book may be said to constitute a more immediately understandable symbol.

98 Tibetan and Indian books

In Japan, the scroll and the brush are held by the Guardian Kings [4] in order to symbolize the doctrine which they protect, sometimes by Kannon with multiple arms [5] and sometimes by dignitaries of a secular character.[6]

178

15 Sistrum[1]

Shakujō[2] 錫杖

CH. *Hsi-chang*
SK. *Khakkhara* [3]

THE KHAKKHARA spread throughout the Far East (China, Korea, Japan) by following the path of Buddhist penetration through Central Asia. As early as the V century, it may be seen at Tun Huang.[4] Its presence there indicates a Central Asian origin and refutes the older thesis of a Chinese or Japanese source for this attribute.

The historical Buddha himself commanded mendicant priests to provide themselves with a *khakkhara*. Being obliged to observe the rule of silence, the monk, in order to announce his presence, rings his sistrum in front of the door of the houses he visits. Moreover, Buddhism forbids harming any living thing. Thus the sistrum by its noise warns animals, insects, or birds of the approach of the priest, who in this way, may avoid killing inadvertently as he walks. In like fashion, the sistrum wards off dangerous animals from the path of the mendicant. Furthermore, its noise blurs the distractions of mundane life from which the monk ceaselessly tries to withdraw.[5] It is noted in the *Shibunritsu* (LII) that "the disciples of the Buddha, seeing snakes, scorpions, centipedes in the path of their wanderings and not being sufficiently emancipated from their material desires, were frightened and notified their master of this pass." The Buddha spoke, saying: "I permit you to take up the *shakujō* and to shake it." [6] According to another text, the *shakujō* is not limited to warning away dangerous creatures. Its use is threefold: against serpents, for the old, and for those who live on alms (*piṇḍapātika*). For the latter it is to be used when they beg; for the old, as a help in walking.[6a] The *Ubasokugo-kaiigikyō* reports that the *shakujō* "is to be shaken three times for getting

food, and on various [other] occasions. If three [times] produces no results, try five; if five is unavailing, try seven; if seven is useless, go on to another house." [6b]

The Buddhist sistrum is regularly made of a sort of hexagonal handle, usually of wood,[7] surmounted by a metal finial, which may be of various forms. In the finial, where the vital force resides, there are, on each side of the central axis, an even number (4, 6, 12) of rings. When the instrument is shaken, these rings in striking each other produce a resounding noise, whence the name "the stick which has voice (*ushōjō*)." The number of rings varies, theoretically at least, according to the station of the personage who carries the sistrum; this number is provided with a symbolism in relation to the bearer. Therefore ideally the mendicant priest carries a four-ring sistrum,[8] representing the Four Truths; [9] the Bodhisattva carries a sistrum with six rings [10] representing the Six Perfections; the Buddha(s) (that is, the *Pratyekabuddha* [11]) carry a sistrum with twelve rings representing the twelvefold chain of cause and effect. During the T'ang dynasty an all-metal, four-ring *shakujō* was used, but I-ching claims that this is not according to the original specifications.[12] In Japan at present, the *shakujō* commonly used has six rings in two sections or twelve rings in four sections.

Other names for the sistrum may replace that of *shakujō*. The *Shaku-jōkyō* [13] reports: "The Buddha said to the *bhikṣu* (mendicant monks): [6] 'You will take the *shakujō* because the Buddhas of past, future, and present all take it up. It is also called the *chi-jō* (Knowledge staff) because it reveals divine Knowledge: it is called as well *tokujō* basically because it accumulates merits (*kudoku*) [by avoiding killing]. It is the symbol of the holy man, the designation of the wise, and the true "banner" of the Law (*dharma*).' "

Mention may also be made of the magical use of the *khakkhara* for expelling demons. This application obtains especially in Tibet, where Tantrism favors such magical agency. The sistrum as "the stick which has voice" is actually the agent which expels baneful elements: thus it plays the role of protector of the Law by warding off enemies who would

attack it. The virtues of the "stick" are also efficacious on a purely magical plane, and in Japan the *khakkhara* is one of the "Sixteen Objects" indispensable for the bonze-magician, the Yamabushi, in whose hands it has much the same exorcising power as in Tibet.[14] Moreover, it is one of the eighteen objects which every Buddhist monk should carry. In China, the *shakujō* is used in the ceremony for the salvation of ancestors. It is carried by a monk who represents Jizō going through the Hells, forcing the demons to open the doors of cells where the damned are caught.[15] In rites, the *shakujō* is used at prescribed intervals: it is held in the right hand close to the head, with the thumb resting on the end of the nail which secures the finial to the handle. It is usually shaken three times, followed by a continuous, trembling movement which causes the rings to give out with a sustained, sonorous jangle. This series of movements is repeated two or three times.

Among the personages who carry the *khakkhara* may be mentioned Jizō,[16] whose benevolence it symbolizes; Monju,[17] whose knowledge it symbolizes; Kannon (with multiple arms),[18] whose compassion it symbolizes; and last of all Yakushi, who sometimes carries this attribute in his right hand, an alms bowl in his left.[19]

16 Sword

Ken[1] 劍

CH. *Chien*

SK. *Khaḍga* [2]

THE SWORD symbolizes more than the simple protection of the Doctrine. It is the emblem of the victory that Knowledge gains over error. It symbolizes thus the enlightenment of the world through Knowledge, which assures the annihilation of all untruth, all error. The sword constitutes an arm of war, and its use in a symbolic sense as an arm against evil is perfectly clear.[3] Moreover, it represents intelligence: the sword cuts the most complicated of knots in the same way that intellect penetrates to the very essence of the most abstruse doctrinary thought. Williams states that the sword is the emblem of knowledge and perspicacity: its goal is to sever doubts and confusion and to prepare thus for the reception of truth.[4]

The sword of wisdom (*e-ken*) is the characteristic symbol of Fudō,[5] who carries it in his right hand (the wisdom hand), while with his left hand he holds a rope (*saku*): [6] by means of these two weapons, he ties and kills Evil, which appears sometimes in the form of demons menacing the Buddhist Doctrine. From the sword are said to spring nine penetrating flames, which characterize this attribute as an arm of Fudō. The *e-ken*, the sword of wisdom, is also called the *chi no ken*, "Knowledge sword," or the *gōma no ken*, "demon-suppressing sword," and the rope (*saku*) is also called the *baku no nawa*, "rope of bonds." The ring and the rod at the end of the rope seem to have no iconographic importance, at least from the standpoint of the Shingon sect. In place of the sword, Fudō may also carry a *vajra*,[7] which indicates his adamantine determination and his force in destroying the illusions and the hindrances of the Nine

94⟧

51⟧

Realms.[8] Often the pommel of his sword is in the form of a *vajra*, bringing [50 together thus the symbolism of the hardness of the *vajra* and the protection represented by the sword.

There are other carriers of the sword: notably Monju, who holds the [63 sword of Knowledge (*ri ken*), which destroys ignorance. As a symbol of Monju, the sword is erect [9] on a lotus flower—a double symbol which represents the vow of the divinity to destroy evil. Kokūzō Bosatsu holds the sword in his right hand, the pommel reposing on his right thigh; in his left hand he carries a jewel.[10] It is also used figuratively for Amida and signifies this divinity's wisdom and discrimination.

17 Vajra

Kongō-sho [1] 金剛杵

CH. *Chin-kang-ch'u*
SK. *Vajra* [2]

101

I̶T IS DIFFICULT to determine with precision the origins of the *vajra*. Among the explanations advanced by certain iconographers, are, on one hand, the theory which postulates an Occidental origin, namely, that the *vajra* derives from the lightning bolt of Jupiter,[3] and, on the other hand, the theory which traces the origins to some ancient solar symbol.[4] Under any circumstance, the *vajra*, as an emblem, is found in several religious systems. Ancient Near Eastern divinities, for example, hold the pointed trident, which represents lightning,[5] while divinities in the same area [6] and at Elūrā, as well as Śiva in India, carry the double trident (cf. *viśvavajra* [7]). In the Ṛg-Veda, as in the Pāli canon, the lightning bolt (*vajra*) figures already as a weapon of the Hindu divinity Indra. Indeed, a legend tells of the Buddha who was supposed to have taken the lightning symbol from Indra in order to make of it a Buddhist emblem by bringing together the points of the rays.[8] Indra, as god of thunder and

102 Single and double tridents from the Ancient Near East

lightning,[9] holds a scepter-*vajra*, the weapon by which he puts the enemies of Buddhism to death: [10] hence the *vajra* also symbolizes the victorious power of the Law.

Esoteric Buddhism, notably the Shingon sect, lends to the *vajra* a diversified symbolism and endows it with various powers. It is first of all the emblem of hardness: like the diamond [11] (*kongō-seki*), it symbolizes the Law, which, similar to the diamond, is unshakable, indestructible, eternal.[12] It is also compared with the mystic Truth that may not be destroyed and with Knowledge which suppresses all the passions that bind Beings to this world. By extension, it symbolizes victorious power of Knowledge over illusion and evil influences; and, with this notion of power as a point of departure, it stands last of all as an emblem of sovereignty.[13]

103 Early Indian Vajra

The *vajra* represents the Absolute as well as the Dharma and Enlightenment, precisely because the Absolute is adamantine, indestructible, unmovable, and impenetrable like the Diamond. The *Vajraśekhara(-sūtra)* relates that "Void, the nucleus of all things, like a diamond, may not be demolished by the ax, nor be cloven, nor burned, nor destroyed." [14] The center and the four parts of the *kongōkai*, the Diamond World,[15] are consequently designated by the five points of the (*goko*) *vajra*. As Fujishima writes: "In the word *Vajradhātu* (*kongōkai*), literally 'diamond element,' *vajra* may be taken in two ways: from the point of view of solidity or from that of utility. In the first sense, it is compared to mystic truth, which always exists within the body and which may not be broken. In the second sense, it signifies the strength of Wisdom, which destroys the obstacles of passions. The *Garbhadhātu* (*taizōkai*), literally 'matrix element,' suggests the idea of containing. The state of things contained in the ordinary body of living Beings may be compared to the child contained in the womb of its mother." [16] Last of all, the *vajra* in śaktist cults becomes, as the counterpart of the lotus, the symbol of the male sexual member. The similarity of the single-pointed *vajra* to the lingam is at once apparent. Its symbolic relationship with the lotus has been mentioned above (cf. p. 160).

185

At its beginnings, the *vajra* may have been narrow at the lower end and divided at the upper end somewhat in the manner of a mallet or ax.[17] Foucher sees in this divided shape an association with the fork formed by the human legs, and, indeed, even in the *vajras* of modern Esotericism, it may be noted readily that the lateral arms are actually the most important, the center one being rather a kind of axis.[18] In Gandhāra, the pointed form, which may be seen at Sāñcī, "becomes a simple mass of arms which were grasped at the middle rather in the manner of dumb-bells." [19] In Japan, the *vajra* exists in several common types according to the use for which it is intended and the forces with which it is believed endowed. In Shingon practice, *vajras* with one, three, or five points, the *hō* (treasure)

69] -*sho*, and the stūpa *vajra* are most commonly used. *Vajra* bells are placed on the four corners of the Esoteric altar. The seven-point *vajra*, as well as the eight- and nine-point *vajra*, is exceedingly rare. An interesting example of a seven-point *vajra*, however, may be seen in the form of a finial on a XII-century Khmer *ghaṇṭā* now in the Santa Barbara Museum (California). The most common types are the following:

Toko-sho [20]

101, 51] The *toko-sho* or single-point *vajra* regularly consists of a four-faced blade terminating in a point (cf. the four faces of the sword blade). Coomaraswamy has said: "The point or end of the *vajra* corresponds to *aṇi*, the point of the axle-tree that penetrates the navel of the Wheel, Dante's *punto dello stello a cui la prima rota va dintorno*." [21] In the form of an arrow, unbreakable and adamantine, this *vajra* serves as scepter or weapon for the celebrant who, in the ritual, wields it in order to disperse evil influences. The *toko-sho* is used by priests of lower rank. It symbolizes the oneness of the Universe, of the *dharmadhātu*, the indentity of Buddha with all things. It is then the symbolic centeraxis of the cosmos, and symbolizes the Buddhist Doctrine from which all things proceed and to

which everything must return. He who holds the *toko-sho* is the symbol of Him who is in the center, who reigns as Universal Monarch. It is used in sūtra reading and stands for the Buddha section. It is one of the forty attributes of the Thousand-armed Kannon (*senju* Kannon) and one of the 108 attributes of Kongōzō Bosatsu. It stands as a special symbol of the Lotus section of the *maṇḍala* and is placed on the western side of the altar. Its single point symbolizes the "one and only universal dharma-realm, or reality, behind all phenomena."

105a
Two-pronged:
Niko-sho

Niko-sho and Sanko-sho

The *vajra* with two points [22] (*niko-sho*) consists of a handle symbolizing the vertical axis of the universe. This axis binds sky and earth, which are represented by the two identical extremities, "that is, as pure being, *Ding an sich, in principio*, and motionless, *pūraṇa apravartin, acala, abhedya.*" [23]

The term *vajra* used alone in Japanese Esotericism usually designates the three-pointed *vajra* (*sanko-sho*). Among the five sections of the *maṇḍala*, the three-pronged *vajra* stands for the karma section and is placed in the North. Among the Buddha, Lotus, and Diamond sections, it stands for the Lotus section. If, at the time of consecration (*kaji*), no *vajra* is available, the so-called *sanko-in* or three-pointed mudrā may be made to replace it. This gesture is formed by placing the two erect middle fingers together, while the two indexes stand separate, thus forming three points. Specifically the three-pointed *vajra* stands for the Three Mysteries. The fact that the points are all attached to a single handle emphasizes the unity and oneness of the Three Mysteries. It is commonly used for ritual consecrations (*kaji*).

[54, 72, XIXв

The attribute formed by crossing two *vajra* is called *katsuma kongō* (Sk. *karmavajra*) or *jūji kongō*, "crossed *vajra*." The *katsuma kongō* is regularly placed at the four corners of the Great Altar. The three prongs

105b
Three-pronged:
Sanko-sho

187

105c
Crossed: Karmavajra

stand for the Three Mysteries (act, word, thought) and are popularly thought to represent lifted hands. The crossing of the *vajras* signifies that the Three Mysteries apply to the four directions equally. The *katsuma kongō* is the convention body (*sammaya-shin*) of Shaka or Fukūjōju in the north. Placing this symbol in the four corners of the altar stands for the perfect understanding of the works of the Four Knowledges. It also designates inner assurance (*jishō*) and the saving of others. It corre-104] sponds to the wheel (*rimbō*) and represents the initial creative work of

104 Eight-spoked wheel (Hōrin)

the "exemplary principle"; it is closely related in form and in symbolism to the wheel. "Hence we find the spokes of the World-wheel not infrequently and quite naturally represented as *vajras*, extending from center to felly." [24] In the wheel whose eight spokes are formed by eight *vajra*, the eight points of contact at the felly represent eight earth points, while the eight heaven points meet and are fused in a common center. [25]

Shiko-sho

105d
Four-pronged:
Shiko-sho

In this *vajra* (*shiko-sho*) [26] the four prongs of the attribute are closed in such a way as to resemble the form of an unopened lotus bud. [27] The four-pointed *vajra* [28] may stand for various groups of four: the Four Periods—the Buddha's earthly life, the periods of correct law, the sem-

blance of the law, the decadence of the law; the Four Abodes — goodness of heart, joy, *samādhi* of the immaterial realm, *samādhi* of the infinite; the Four Buddhas; the Four Powers for attaining Enlightenment — personal power, power from others, power from past acts, power from milieu; the Four Attachments — desire, false views, false morals, ideas stemming from the concept of self; and so on. The *shiko-sho* may also symbolize the Five Elements. In this case, the axis or handle of the *vajra* constitutes a fifth prong, which represents the fifth element.

Goko-sho

The five-pointed *vajra*, the most common form, differs in Japan from the Tibetan *vajra* [29] of the same form. In Tibet, four prongs often surround an inner core, while in Japan five prongs are generally exterior. The points represent various series of five: the Five Elements — earth, fire, water, air, void; the Five Buddhas — Dainichi (Vairocana), Hōshō (Ratnasaṃbhava), Muryōju (Amitābha), Fukūjōju (Amoghasiddhi), Ashuku (Akṣobhya); the Five Powers which destroy obstacles — faith, which destroys doubt, zeal, which destroys remissness, memory, which destroys error, concentration, which destroys wandering thoughts, wisdom, which destroys illusion; and so on. (For other groups of five, the reader may refer to Soothill and Hodus, *A Dictionary of Chinese Buddhist Terms*, pp. 113–31.) This *vajra* is reserved for priests of the highest rank.

105e
Five-pronged:
Goko-sho

The *vajra* is a symbol of wisdom. The five points represent the Five Knowledges which symbolize the duality-non-duality,[30] the essence of the indivisible Buddha. The middle point stands for Buddha knowledge of the Absolute, while the outer four represent Buddha knowledge of the phenomenal. The middle point also represents Means (*hōben*). The fact that the outer four branches surround and encompass it indicates that the phenomenal must take refuge in the Absolute. The fact that both ends of the *vajra* are the same signifies that the Buddha World and the World of Beings possess in common the Five Knowledges and that there is no difference between them. The five-pointed *vajra* stands for the *kongō* section

of *maṇḍala*; it combines in one form the two types (*kongōkai* and *taizōkai*) of the Five Knowledges. The five terminal points fusing into the handle are actually united, although they are at the same time divided into five prongs: duality-non-duality. The points represent thus the Buddha and the elements associated with the Knowledges.[31] The middle prong stands for Dainichi and the *hōkkaitaishō-chi*, and the other four stand for the other four Knowledges and the remaining Buddhas. The four bands of eight leaves mean the Four Perfections, the Sixteen Bodhisattvas, the Eight Offerings, and the Four Acceptances of the thirty-seven divinities. The four jewels stand for the four Buddhas and the one in the middle for Dainichi. The bands which bind the eight leaves and thus divide them into two sections signify the greatness of the knowledge and wisdom worlds. The ten points stand for the Ten Perceptions. In Esotericism the *vajra* also symbolizes "the unity as well as the duality between material elements and Knowledge, the distribution of the manifestations of the Absolute among body, discourse, and thought. . . ."[32] Also to be noted is the value of this symbol as a weapon of defense and destruction; as such it removes guilty desires and clarifies knowledge of the supreme divinity.[33] This Knowledge prepares the hearer for Enlightenment: whence the expression *jōbodaishin*, "pure heart of *bodhi*," the first stage of the Shingon believer.[34] The *vajra* represents thus the strength of Buddhist Doctrine, which crushes all untruth and all vice:[35] when used by the Guardian Kings, who employ it in annihilating the passions, this *vajra* symbolizes vigor, determination, and perfection. In the *maṇḍala* it stands for the Diamond section.

Kuko-sho [36]

105f
Nine-pronged:
Kuko-sho

The symbolism of the nine-pointed *vajra* is not entirely clear. Legend attributes its use to Mahātejas,[37] guardian king of Buddhism, whose terrifying power gives him strength to protect the good and annihilate the evil. Nevertheless, Japanese texts do not mention this king, Mahā-

tejas, and the use of the nine-pointed *vajra* is more frequent in Tibet than in Japan. The Shingon sect, at least according to the information received by the present writer on Mount Kōya, does not utilize this form.[38] The nine-pointed *vajra* may stand for various groups of nine: the Nine Stages of Mental Concentration [39] during ecstatic contemplation; the Nine Realms [40] — desire, the four material realms, the four formless realms; the Nine Honorable Ones — Vairocana, the four Buddhas, and the four Bodhisattvas; the Nine Realities,[41] conditions in which Sentient Beings like to reside; the Nine Bonds that bind men to mortality — love, hate, pride, ignorance, (wrong) views, grasping, doubt, envy, selfishness; the Nine Truths — impermanence, suffering, void, no permanent ego, love of existence, the opposite of this, ceasing of suffering, *nirvāna, parinirvāna*; the Nine Kinds of Cognition — sight, hearing, touch, smell, taste, mind, mental perception, *bodhi*-consciousness, Buddha-consciousness; and so on. It is specifically used in worshiping Dai Itoku Myō-ō.

<div align="center">✻</div>

The *vajra* is carried by several divinities, of which the most important is doubtless Vajrapāni (Kongōshu or Shukongō),[42] "he who holds the *vajra* in his hand." In India, Vajrasattva, the "sixth" of the five *dhyāni*-Buddhas, is accepted as the "priest" of the other five. As such, he is represented holding the attributes characteristic of an official celebrant, that is, the *vajra* and the *ghantā*.[43] In Japan, the *vajra* is sometimes held in the hand, sometimes posed erect on the palm. It often figures in statues of the Guardian Kings [44] and of holy men: [45] in representations of [72 the first, it stands for strength and power against evil; in statues of the second, vigor and determination. It may be noted that in Esoteric pictures of Kōbō Daishi, the *kongō* which he holds in his right hand stands for Aizen Myō-ō, the god protector of the faithful, and for the Diamond World. The rosary which he holds in his left hand stands for Fudō Myō-ō and for the Matrix World. Sometimes, although less frequently, the *vajra* is held by a Buddha or a Bodhisattva: Ashuku, Amida, Fukūjōju, or Kaifuke-ō.[46]

18 Vase [1]

Byō 瓶

CH. *P'ing*

SK. *Kalaśa* [2]

106

THE VASE is one of the most ancient symbols of Buddhism. Its use as a receptacle in everyday life predestined this attribute to the double role it was to assume in Buddhist iconography: utilitary vessel [3] and mystic symbol. Gijō (I-ching) describes it thus: "The cover should be joined in one piece to the opening (of the actual body of the pot, and this cover should be) surmounted with a pointed top, about two finger (thicknesses) high (Sk. *aṅgula*); at the top (of this point) is pierced a little 107] hole, the size of a copper chopstick, and it is through (this aperture) that one may drink the water. On the side (of the belly of the jar) is opened another aperture, round, covered (with a spout) which rises vertically, about two finger (thicknesses) thick; the opening (of this spout is about the size) of a 'sapeke,' and it is through this opening that the water should be added (in order to fill up the jar). The capacity of the jar should be of two- or three-tenths of a bushel; a smaller jar would be useless. The two holes (the smaller upper aperture by which one drinks, and the larger lateral aperture used for filling the jar) may be closed by corks of bamboo or wood, or they may be wrapt in cloth or leaves, lest insects or dust penetrate (into the jar). . . ." [4]

The symbolism of this attribute is based on its use as a utilitarian receptacle. In the same way that a vase is useful by containing the liquid for which it is intended, Sentient Beings should strive to become a receptacle of the Truth. [5] The faithful worshiper, by making his heart empty like the interior of a vase, is capable of receiving and of containing the Truth of the Doctrine. But the emptiness or void which constitutes the

192

principle of the vase is an active and useful emptiness; for if this void within the belly of the vase did not exist the vase as such would cease to be and its usefulness would be unfulfilled. Like the vase, therefore, the emptiness of the faithful's heart should be a positive and active emptiness. As Glasenapp observes: "The comparison of the jar, in its fragile and impermanent form which is an illusion for our senses, but which has no

107 Two examples of Kuṇḍikā

substantial reality, with Self, the simple aggregate of masses, is common in Buddhist literature . . . ; or again, the jar serves to illustrate conventional reality (Sk. *saṃvṛti-sat*), as opposed to ultimate reality (*para-mārtha-sat*)." [6]

The vase is intended to contain the water (or the nectar) of life: as such, it constitutes a characteristic attribute of Kannon and holds in [XIXA, XXIII this instance the nectar of her compassion. The *Rokujūkegonkyō* mentions a *tendoku-no-kame*, a divine vase from which issue the desires of the heart,[7] for "the Enlightened (*bodhi*) heart is actually the *tendokubyō*, which grants the desires of all Beings." [8] The vase sometimes replaces the lotus, with which it is naturally associated. Sometimes it is present as a sign on the foot of the Buddha, and in this case it symbolizes the state of supreme intelligence (cf. Jar of Wisdom: consult n.2) which triumphs over death and rebirth.[9]

This attribute is accorded a very important use in the Esoteric cult.[10] [110 Here it is a question of large, bellied jars with big apertures. Five precious vases, representing the *gochi nyorai*,[11] that is, the Five *dhyāni*-Buddhas,[12]

are placed at the cardinal points of the altar. Flowers [13] are put in the vases which were previously filled with a mixture of the Five Grains (*koku*), the Five Medicines (*yaku*), the Twenty-four Kinds of Things,[14] and last of all perfumed water (*kō*).[15] Previous to Buddhism there is textual evidence that similar vases were used in the ceremony of royal investiture. They were filled with the waters of the Four Great Oceans, and these waters, symbolizing the extent of the royal terrain, were used in anointing the new sovereign (cf. *kanjō-in*).

108 Kobyō or
Bird's-head vase

Several divinities bear the vase as an attribute. Kannon, with two or more arms,[16] is the Bodhisattva with whom the vase is perhaps most frequently associated; it is, moreover, her most ancient attribute.[17] In India, as in Japan, the vase of Kannon (*kuṇḍikā*) is a more or less rounded receptacle, rarely pear-shaped, prolonged by a spout, frequently ending in a point and sometimes provided with a base.[18] The vase is sometimes surmounted by a bird's head; in this case, it is called *kobyō*.[19] The Bodhisattva holds the vase by the neck, most often in the left hand,[20] but frequently also it reposes on a lotus flower whose stem Kannon holds in her right hand. In China and in Japan, the vase of Kannon may be held in the hands of the divinity or it may be placed beside her. This arrangement was already extant in India. If this attribute is held or placed at her side, the divinity may carry a lotus or, after the VI century in China and consequently as early as the Suiko period in Japan, a willow branch,[21] with which she sprinkles the nectar of life that the vase is supposed to contain.[22]

89, 90]

When it is a question of the thousand-armed (*senju*) Kannon, the vase, according to the Esoteric interpretation, is symbolic of Brahmā: "it figures in conformity to the disciplinary prescriptions relative to the water jar with or without the lateral spout." [23] Kannon often holds a vase (*kebyō*) in which stands a lotus bud. These two attributes appearing together symbolize the two worlds, the material (*taizōkai*) and the spiritual (*kongōkai*), and the unity which exists between them.

The vase is also associated with Miroku. For this divinity it constitutes a symbol subsidiary to the wheel, and represents the Convention Body (*sammaya-shin*).[24] It is most often supported by a lotus flower at

the level of the left shoulder of the divinity; it is more rarely carried in the hand. In the case of Miroku, the vase (*amṛta-kalaśa*) contains the nectar of immortality. It is possible, however, that even in India, this nectar vase, "emblem of royal divinities such as Indra and Maitreya, may not have been, in ancient times, differentiated from the water vase (*kamaṇḍalu*)." [25] At a later date, in Pāla-Sena art, Maitreya carries the *kamaṇḍalu*, but this manifestation is very late.

109 Unction vase 110 Ritual vase

The vase is also an attribute of the god Brahmā, who holds it in his left hand. The divinity is said to have used it, when he created the Receptacle world, to fill (this receptacle) with all things.[26] Sometimes Amida carries the nectar vase (*amṛta-kalaśa*), which has become, in this instance, a covered vessel, in which is found a so-called Aśoka branch.[27] Between the vase and the cover slip strands of beads, which fall in garlands around the vase. The beads represent sacred cachets used in the ceremony of longevity.

195

NOTES

NOTES

ABBREVIATIONS *and* REFERENCES
are explained in the BIBLIOGRAPHY.

PRELIMINARY

1 The character *in* 印 has been successively translated by "seal" (the traditional Japanese rendition), "sign," "gesture," "ritual" or "symbolic gesture." None of these translations can claim to exhaust the meaning of the ideograph. The Sk. term *mudrā* is general, while the Japanese word *in*, in the sense of "seal," "sign," or "symbolic gesture" refers chiefly to rites. Both, however, are used in connection with iconography. It has been decided in the following text to use the term "mudrā," treated in roman type, as if English. However, when syntactical necessity has dictated the use of "gesture" or "symbolic gesture," these terms have always been within the meaning of "mudrā."

2 Toki, *Si-do-in-dzou*, subtitled "gestures of the officiating priest in the mystic ceremonies of the Tendai and Shingon sects." The *Si-do-in-dzou* gives a design of each mudrā as it appears in the ceremonies, the name in Chinese characters, and the Sino-Japanese phonetic transcription. Beside each design is a short paragraph identifying the mudrā, more or less superficially, with respect to its use in the cult.

3 *Mahāmaṇivipulavimānaviśvasupratiṣṭitaguhyaparamarahasyakalparājadhāraṇī* (*T.* 1007, XIX, 661a–63a; N. 536; anon. tr. *ca.* 502–557). [See Bibliography for *T.* and N.]

4 Toganoo, *MK*, p. 483, li. 15: "Probably the first sūtra explaining the mudrā, the *Murimandarajukyō* gives only sixteen gestures. One century later, according to the *Daranijikkyō* (*T.* 901, XVIII, 785ff.), translated by Atigupta [?] in the VII century, the mudrā have increased to more than three hundred."

The *Jayākhyasaṃhitā* (*IC*, p. 569, § 1169) enumerates fifty mudrā. The *Jayākhyasaṃhitā* (cf. Renou, *LS*, p. 53a) is "one of the principal and one of the oldest Viṣnuite *saṃhitā* . . . containing important elaborations on practices." It dates perhaps from the V century. Mention of other mudrā is found in the *Dakṣināmūrtisaṃhitā*, the *Rāmapūjāsaraṇi*, the *Nāradapāñcarātra*.

Bhattacharyya, in the introduction of *Two Vajrayāna Works*, places among the first Tantric works which contain numerous examples of mudrā, maṇḍala, and mantra (1) the *Mañjuśrīmūlakalpa* (*T.* 1191, XX, 835ff.) and (2) the *Guhyasamāja* (*T.* 885, XVIII, 469ff.). The first, dating probably from the II (?) century A.D., and the second, from the III (?) century, presuppose a considerable earlier literature.

5 Toganoo, *MK*, p. 483. More than 300 mudrā are found in the *Daranijikkyō* (*T.* 901, XVIII, 785ff.; *Dhāraṇīsamuccaya* [?]), dating from the VII century and attributed to Asaṅga. It was translated by Ajikuta (Sk. Atigupta [?] or Atikūṭa [?]; in Jap., Mugoku-kō; *BD* 23a) and includes not only the *shu-in* (i.e., "hand gestures") but also the names of symbolic objects. Neither the *Daranijikkyō* (*BD* 1182c) nor the *Murimandarajukyō* figures in the list of sūtras used in the VII and VIII centuries in Japan (cf. de Visser, *ABJ*, pp. 3–5).

Cf. *Dainichikyō*, ch. 9 (R. Tajima, p. 121): when the Shingon officiating priest performs a consecration (*kaji*) by means of the mystic mudrā of the Tathāgata, he assimilates himself with the *dharmadhātu* body of the Buddha. This chapter enumerates the 31 mudrā and mantra of the Tathāgata and the 57 mudrā and mantra of all the divinities beginning with the Bodhisattva Maitreya, as well as the 45 mudrā belonging to the other divinities. Cf. also R. Tajima, ch. 14, "Les huit mudrās ésotériques."

6 Buhot, *Les Arts de l'Extrême-Orient*, p. 35, distinguishes six mudrā: *bhūmisparśa, dharmacakra, vitarka, dhyāna, abhaya, vara*. Mallmann, *Intro.*, p. 262, distinguishes five: *abhaya, vara, añjali, dharmacakra, tarjanī* (for Avalokiteśvara). Sirén, p. 134, distinguishes seven mudrā: *dhyāna, varada, abhaya, vitarka, dharmacakra, bhūmisparśa, añjali*. Takata, *Indo nankai no bukkyō bijutsu*, pp. 46–47, gives five: *sokuchi-in, tembōrin-in, jō-in* (*yuga sen-in*), *semui-in, segan-in*, of which the last three are the most common in India. These five are said to form the basic mudrā of Esoteric Buddhism. In Esotericism they become the characteristic gestures of the Five Buddhas of the *kongōkai* — with the addition of the *chi ken-in* (*bodhiśrī-mudrā*) characteristic of Dainichi. Bose, *Principles of Indian Śilpaśāstra*, p. 59, enumerates 25 "sorts" of mudrā.

Of the repetition of the mudrā, Steinilber-Oberlin (*The Buddhist Sects of Japan*, p. 117) says: "a seal may vary in signification according to the circumstances in which one forms it . . . because the sense of a seal varies according to the words which are pronounced by the officiating priest and the meditation to which he abandons himself."

7 Specialized works dealing with mudrā:

1 Gonda and Ōmura, *Butsuzō shinshū*. Two volumes (text and plates), giving a choice of passages from sūtras concerning the specifications of statues, attributes, and mudrā.

2 Gonda, *Shingon mikkyō hōgu benran*. One volume of text and one of plates, devoted to explaining particularly the paraphernalia of Shingon ceremonies.

3 Toki, *Si-do-in-dzou*. The French translation of a Japanese text, consisting of notes on ritual gestures used in Shingon and Tendai ceremonies.

4 *Daizōkyō zuzō*, VIII. This volume includes some fourteen separate works in which mudrā are illustrated. Particularly useful for the identification of mudrā in general and especially of uncommon mudrā.

5 The *Asabashō*, comp. by Shōchō (1205–82), a contemporary of Nichiren (1222–82), appears in the collection *Dainihon bukkyō zensho*. It concerns the ceremonies and the traditions of the Tendai sect. The author was the abbot of the Miidera. The *Asabashō* was subsequently reproduced a number of times. The copy at the Musée Guimet, which was originally consulted for this study, is by the hands of several copyists, the last of them the priest Teido, who began his work in March 1811 and finished it in 1812. This text includes 102 volumes (originally 228). The manual, though providing few figures, and these poorly executed and often indistinct, has the advantage of furnishing texts relating to the making of statues. The *Dainihon bukkyō zensho* edition is much clearer.

6 *Jikkanshō*, also called the *Sonyōshō*. In 10 vols., by the monk Eju, of the Kamakura period. The Musée Guimet possesses a reproduction in collotype by the Dainihon bukkyō zensho kankōkai. The text may now be in the possession of the Jōraku-in, Kyoto. This volume, as well as that of Gonda and Ōmura (No. *1*, above), gives a great number of images.

7 Akiyama, *Buddhist Hand-Symbol*. This small volume gives illustrations of the principal gestures. Short explanations are provided.

8 *Kakuzenshō,* 7 volumes, in *Dainihon bukkyō zensho,* Vols. 45–51.

9 *Shoson zuzōsho,* 11 volumes. This work is cited by Eliot, *Japanese Buddhism,* p. 347. Unfortunately, it has not been possible to consult it.

DEFINITION OF TERMS

1 "Mudrā, Muddā," p. 280.

2 *Elements of Hindu Iconography,* I, i, p. 14.

3 Sk. *udāna,* furthermore, is translated "grips." Woodward, in *The Book of Kindred Sayings,* part IV, p. 267, n. 1, records *muddika* as "faultless reckoner," "one skilled in interpreting finger-signs," and "reader of symbolic gestures." *BD* 108b supports this rendition by citing the *Daijōgishō* 2 (*T.* 1851, XLIV, 507b, li. 22–24), which in turn reports that *udāna* means *in,* that is, "mudrā." According to Soothill (p. 456a), *in* corresponds to Sk. *uddāna,* which he translates "fasten, bind, seal." Cf. *udāna* in Eitel, p. 183; and in Monier-Williams, *Sanskrit-English Dictionary,* p. 188a.

4 See n. 2 in preceding section.

5 *A Dictionary of Chinese Buddhist Terms,* s.v. *yin,* p. 203a-b.

6 *The Gods of Northern Buddhism,* p. 171.

7 Eitel, p. 101.

8 Mudrā are utilized to a certain extent by other sects than Shingon, e.g., Tendai, Sōtō Zen, Jōdo, Shin. It is the Esoteric sects, however, which accord the most importance to gestures.

9 "Mudrā = Schrift (oder Lesekunst)?" pp. 731–34.

10 *South Indian Bronzes.* For this author, mudrā seems to be the position of the fingers, and *hasta* the movement or position of the arm. Auboyer ("Moudrā," p. 158b, n. 10) states: "The distinction between *mudrā* and *hasta* appears to be relatively modern. It is, however, accepted. *Mudrā* regularly designates ritual gestures and gestures appearing in Buddhist and Tantric iconography. *Hasta* is used rather in the domain of aesthetics and of Hindu religions."

11 *A Catena of Buddhist Scriptures from the Chinese,* p. 410.

12 This information on the etymology of the word mudrā has been taken from the article by Przyluski, "Mudrā."

13 F. Hommel, "Pali *muddā* = babylonisch *musarū* und die Herkunft der indischen Schrift." One may note the existence in Hindi of *mudrā* and of *mundrā*; in Khas, the seal is called *munrō;* in Sindhi, *mundrī.* The nasalization must be very old (Przyluski).

O. Franke notes (p. 733): "Only after a possible future proof of my hypothesis will it perhaps be time to consider whether the word *mudrā* indicates Egypt; compare the Old Persian *mudrāya* and the Hebrew *misraim* for Egypt. Weber, in his monograph 'Die Griechen in Indien' (p. 5 of the separatum) has already indicated, for the meaning of 'seal,' a possible relationship with *mudrāya.*

". . . one should further suppose that in Sanskrit, because of the non-use of writing, the meaning of the word was restricted to 'seal' and the meaning 'writing' was perhaps completely lost."

14 This hypothesis is rejected by Lüders: "Die Śākischen Mūra," p. 742, n. 3.

15 Cf. Renou, *Dict.* p. 571a. Bhattacharyya (*An Introduction to Buddhist Esoterism,* p. 152, n. 2) adds: ". . . an appetiser (for more drink), and the woman (as in *mahā-mudrā*). . . ."

Cf. also L. Finot, "Manuscrits sanskrits de Sâdhana's retrouvés in Chine," p. 17.

16 That is to say, Hindi, Marathi, Bengali, Kanarese (Przyluski, "Mudrā," p. 715). Note Persian *muhr,* "seal," hence "gold coin," and Khotanese *mūra,* "coin," deriving from

201

an old form, *mudrā*, "seal." In Sk., *mudrā* as "coin" occurs in the commentary of Hemacandra (1089–1172) 3, 81, by Mahendra (ibid.).

17 Przyluski, "Mudrā," p. 715.

The notion of finger-pose is not always used in a religious sense. In Pāli, for example, *mudrā* becomes the art of calculating with the help of the fingers. R. Franke translates, consequently, by *"Finger-rechnen"* (*Dīghanikāya*, pp. 18–19, n. 9) and Rhys Davids (tr., *The Questions of King Milinda*, p. 91) by "the art of calculating by using the joints of the fingers as signs or marks." For a text (that of *Yājñavalkyaś.*, 25) concerning the inutility of recitation without gestures, see Przyluski, "Mudrā," p. 717. Edgerton (II, p. 435a, s.v. "mudrā") calls *mudrā* the "art of calculation," "hand-calculation," "always in the list of arts learned by a young man, and associated with mathematical terms."

18 Przyluski, "Mudrā," p. 716: "Going back to the Vedic times, however, one finds the word and the gesture on one plane, and being given the same magical or religious importance. The Vāj. Prāt., I, 124, notifies that the accents were indicated by moving the hands upwards, downwards, or laterally. Later texts mention gestures which marked the accents and explained the sense also."

"Grammatical" gestures are referred to in the *Pāṇinīya-śikṣā*, pars. 52–55. Here *hasta* is used to mean this kind of gesture, and the text speaks of reciting "with and without a show of hands."

19 Ibid., p. 719: "At DhA., II 4, *muddikā* (from *muddā*) is used with the meaning of authority."

20 Cf. Auboyer, "Moudrā," p. 153b.

21 Przyluski, p. 717: "*Mudrā*—or more usually *mahāmudrā*—has in the Tantras, besides the ordinary sense, that of 'woman,' when a woman is associated to the rites. For instance, in the *Abhiṣeka*, the master and disciple both have their *mudrā*; and, however discrete the expression may voluntarily be, the context does not leave any doubt upon the part which these assistants play. Vajravārāhī is given the name of Mahāmudrā, in the quality of Heruka's first wife (*Agramahiṣī*). (V.S., *Mūlamantra*, pl. 61—according to Finot ["MSS. sanskrits"], p. 17)." Zimmer (*Philosophies of India*, p. 591, citing Woodroffe, *Shakti and Shākta*, pp. 569–70) notes *mudrā* with the meaning of "parched grain."

22 Auboyer, p. 153. Also seal, (seal-)ring, passport, sign, image, lock, the closing of the eyes or of books.

23 Cf. *BD* 1590b-c for the first two groups of meanings. *In*, more precise and delimiting, necessarily excluded the meaning of *śakti*.

24 Cf. Glasenapp, *MB*, pp. 152ff. In Tantric texts *mudrā* is used for *śakti*.

25 *Kei-in* is used especially by the Shingon sect; *sō-in* by the Tendai. But according to the *Mikkyō daijiten* (I, 105b), *kei-in* is also called *sō-in*, which supposedly is to represent a specific form (either the sword, the wheel, the lotus, etc.) held in the hand of the divinity: this distinguishing symbol is what is known as the *sammayagyō*, Convention Form. Consult Soothill, p. 67a for an explanation of *sammaya*. Mochizuki, *BD* (1954), 176f., treats *kei-in* as a generic term for the Sk. *mudrā*.

Shu-in, according to some authorities, signifies the symbolic gestures formed by joining the two hands (cf. *chi ken-in, mida jō-in*, etc.) in contrast to those gestures which are formed with one hand alone (cf. *semui-in, segan-in*, etc.). In all these compounds, the vocable *in* represents the notion of sign, of seal in the Esoteric sense and in the ritual sense, or that of sealing the magic of the words, of insuring the efficacy of the formulas of the rite. It is in this sense that seal may be explained as capable of demolishing all error and guaranteeing the authenticity of the words.

Gale, in *Korean Folk Tales*, p. 164, writes: "Yee answered, 'Hungry, are you? Very

well, now just move back and I'll have food prepared for you in abundance.' He then re-peated a magic formula that he had learned, and snapped his fingers. The three devils seemed to be afraid of this. . . ."

Kei (pact) in *kei-in* means the contract made between the believer and the divinity. *Mitsu* (mystery; Sk. *guhya*), in *mitsu-in*, signifies the Esoteric virtue of the mudrā. *Sō* (to help; appearance) in *sō-in* would seem to indicate the power to help, or more still, the fact that the *in*, "appearing" as a symbol, represents the words pronounced by the faithful.

The *in* which express the deeds and the works of the historical Buddha are called *komma-in*, Deed Seals. The translation given by the *Hō.* is *"sceaux d'acte."*

26 Soothill, pp. 157b and 193b.

26a Liebenthal, "Chinese Buddhism during the 4th and 5th Centuries," p. 54.

27 The importance of the seal is universally manifest as much in early times as in the present day; stamping and impressing any document confer upon it its legal quality. There is the story of the impatient Caligula who went to Capri to seize with his own hands the imperial seals from the dying Tiberius. Buddhism gives us the story of Prince Kunāla, whose beautiful eyes inspired in his mother-in-law, the queen, a most incestuous love. Lost in contemplation, he paid no attention to her advances. The queen then, taking ad-vantage of the absence of the king, seized the royal seals and ordained that the eyes of the unhappy prince be gouged out.

Cf. the drama in 7 acts (V or VII–IX centuries), *Mudrārākṣasa*, "Rākṣasa and the Seal" (by Viśākhadatta), which tells of the rivalry of the Nanda and the Candragupta, respectively advised by the ministers Rākṣasa and Cāṇakya. A ring bearing the seal of Rākṣasa falls into the hands of an enemy, who uses it against him.

The magico-religious quality of the gesture is brought out by the story of Ryūkai, a priest of the Hossō sect at the Gangō-ji (temple), who died while making the *muryōju-nyorai-in* (mudrā of the Tathāgata Amida) with his right hand: when his body had been burned there remained only the mudrā (de Visser, *ABJ*, p. 340).

Cf. Reischauer, *Ennin's Travels in T'ang China*, pp. 236 ff. Liebenthal, "Chinese Buddhism during the 4th and 5th Centuries," p. 54: "Prestige is in China more important than in other countries. There it is called 'face.' Originally it meant the possession of emblems and rites which bestow magical power on the owner. The emperor had 'face,' and his deputies shared his 'face' because they were authorized to carry his emblem and seal." Also, for mudrā in China, cf. Lloyd, *The Creed of Half Japan*, pp. 122ff. In Japan there is the story of Emi no Oshikatsu (Fujiwara no Nakamaro) who stole the imperial seal for the issue of commissions to raise troops against Dōkyo: cf. Eliot, *Japanese Buddhism*, p. 226.

28 Toganoo, *MK*, p. 470; in the *Zōagongyō*, 25 (*T.* 99, II, 181b, li. 3–4) one reads: "Then the king, having heard these words . . . , wrote them all on paper. He closed it and affixed his seal, which was the imprint of his teeth." This idea of authenticity, as concerns the Law, is brought out in the *Zōagongyō*, 10 (*T.* 99, II, 64b ff.), the *Dainehangyō*, 12 (*T.* 374, XII, 433 ff.), and the *Daibibashanaron*, 126 (*T.* 1545, XXVII) etc. —all noted in Toganoo, *MK*, p. 471.

29 Ibid., p. 471. Toganoo affirms that in the mudrā called *hō-in zammai, nyū-in zammai, sōji-in zammai*, etc., mentioned among the 108 *sammai* (composing of the mind) of the *Daihannyakyō*, 41 (*T.* 220, V, 227c ff.), *in* expresses veracity and the lack of vain words and of error: *in* here takes the meaning of "seal."

Cf. *sambō-in*, mudrā of the Three Dharma, which guarantees that there will never be any error in perfecting the essence of Buddhist doctrine. Soothill (p. 61b) adds that the *sambō-in* (or the *san-in*) signifies the three signs or "proofs" of a Hīnayānist sūtra: non-permanence, non-personality, nirvāṇa.

Toganoo mentions the *butsu-in*, which represents the virtues of the Buddha and has the qualities necessary to assure "rectitude" (avoidance of error). According to the *Daichidoron*, 47 (*T.* 1509, XXV, 396b ff.), this mudrā means: (1) not coveting; (2) not desiring; (3) freedom from adherence [to error].

30 According to *BD* 90c, li. 16–17. Cf. *Hizōki* (*BD* 727c, li. 8).

31 *Si-do-in-dzou*, p. 5: "The word '*in*' (seal) is understood as having the sense of 'sign of a firm resolution' just as one seals a solemn contract with a cachet."

32 Auboyer, "Moudrā," p. 156b.

33 Ibid., p. 156a.

34 As in such sūtras as the *Kongōchōkyō* (*T.* 865, XVIII, 207a ff.), noted in Toganoo, *MK*, p. 473.

35 This is according to Atigupta, who translated the *Daranijikkyō* in the VIII century (Toganoo, *MK*, p. 472).

Toganoo (*MK*, p. 475) notes that — according to the *Kambutsusammaikyō* (*T.* 643, XV, 645c ff.) — as time passed, more and more emphasis was placed on the contemplation of the image of the Buddha. This applied not only to the statues and to the images of the Buddha but also to the objects which he held in his hand and which represented his essence. The same idea is taken up in the *Murimandarajukyō* (*T.* 1007, XIX, 657c ff.).

For the term *in-gei* applied to these objects, cf. *Daihannyakyō* (*T.* 223, VIII, 217a ff.); *Kegongyō* (*T.* 278, XIX, 395a ff.), and also the *dhāraṇī* of the Shingon sect.

Toganoo, *MK*, p. 473, would see the *in* divided into three classes according to the gradually expanding meaning of the term: (*1*) hand gesture only; (*2*) hand gesture and attributes; (*3*) hand gesture, attributes, images, germ syllables (*bīja*), and mystic formulas (*dhāraṇī*).

36 Toganoo, *MK*, p. 472: according to the *Daranijikkyō* (*T.* 901, XVIII, 785a ff.; *BD* 1182c, tr. Atigupta [?], VII century A.D.).

37 Ibid., p. 473. In the *Kongōchōkyō* (*T.* 865; also *T.* 874), the meaning of *in* is very wide. First, *in* meant only *shu-in*, "hand gesture," but little by little, it took on the meaning of attribute and of magical formula (*dhāraṇī*), and even of Buddha images.

ORIGINS AND FIRST REPRESENTATIONS

1 Toganoo, *MK*, pp. 473–82. Foucher, *AGBG*, p. 326, mentions the spontaneous nature of the gestures.

2 Renou, *IC*, p. 570.

3 Buhot, *Les Arts de l'Extrême-Orient*, p. 352, writes that the gestures were "fixed." The expression is perhaps too strong in view of the undefined usage which characterized the first gestures in Gandhāra, at Mathurā, and Amarāvatī.

Kaneko Ryōun, in "Butsuzō no in," p. 2, believes that the iconographic mudrā very likely developed from gestures used in (Esoteric) ceremonies.

4 Chs. 32–34.

5 Cf. the study on this Tibetan text by Tucci, "Some Glosses upon the Guhyasamāja."

6 Glasenapp, *MB*, pp. 99–100. "The practice of assigning to the fingers a prescribed form during the performance of holy acts goes back in India to very ancient times" (p. 97).

7 After Coomaraswamy, *Mirror of Gesture*, p. 16. Ghosh, ed., *The Nāṭyaśāstra* (pp. 4–5) also gives a translation of this passage.

8 For more detailed information, cf. Renou, *LS: Veda*, pp. 140–41; *Ṛg Veda*, pp. 103–4; *Yajur Veda*, p. 148; *Sāma Veda*, p. 106; *Atharva Veda*, p. 19. Consult also Renou, *IC*, pp. 270–88.

9 Ghosh, *The Nāṭyaśāstra*, p. LXXXI: ". . . the available text of the Nāṭyaśāstra existed in the second century after Christ, while the tradition which it recorded may go back to a period as early as 100 B.C." Cf. also Ghosh, ed., and tr., *Abhinayadarpaṇam*, and Renou, *LS*, pp. 81b–82a. Concerning the *Nāṭyaśāstra*, see also Renou, *LS*, pp. 81 ff.

10 *IC*, p. 570.

11 Ibid., p. 569, § 1170.

Concerning the hand and its use in Vedic recitation, see Ghosh, tr., *Pāṇinīya Śikṣā*, sect. 52–55, pp. 76 ff.: "If anybody reads (the Veda) without a show of hands and does not observe proper accents and places of articulation, Ṛk, Yajus and Sāman burn him and (on death) he attains rebirth as an inferior animal (54).

"And a person who reads the Veda with a show of hands, observes proper accent and places of articulation and knows the meaning of what he reads is purified by the Ṛk, Yajus and the Sāman and is placed high in the realm of Brahman (55)." Here *hasta* is used to designate the "show of hands."

12 *IC*, p. 569.

13 Toganoo, *MK*, p. 476.

14 Ibid. See also *IC*, p. 594, § 1219, "Pañcattatva."

15 Auboyer, "Moudrā," p. 153. The quotation from *jātaka* no. 546 is based on the tr. of Cowell, VI, p. 364.

Concerning the raised fist, Coomaraswamy believes that it is a question of a prototype of the more modern *śikharamudrā* (cf. his "Mudrā," p. 280).

16 Coomaraswamy, *EBI*, pp. 10f.; figs. 4–10.

17 For the interdiction of representing the body of the historical Buddha, cf. Soper, "Early Buddhist Attitudes toward the Art of Painting"; and *Hō.*, p. 210a, s.v. *Butsuzō*, and its Supplément, p. III.

Coomaraswamy notes: "In Pāli texts there is no express tradition prohibiting the making of anthropomorphic images of the Tathāgata" (EBI, p. 4). In a note (4, p. 63) he speaks of an interdiction of this kind in 48 of the Vinaya of the Sarvāstivādin.

Cf. Waley, "Did Buddha die . . . ," p. 352.

18 Soper ("Early Buddhist Attitudes," p. 148a) translates from the *Jūjuritsu*, (Sk. *Sarvāstivādavinaya* [?], N. 115, T. 1435): "The Elder then said, 'Lord of the World, since it is not permitted to make a likeness of the Buddha's body, I pray that the Buddha will grant that I make likenesses of his attendant bodhisattvas. Is that acceptable?'"

Consult the translation of T. 1435 (pp. 351c–52a) in *Hō.*, p. 212a, and the very important note in the *Supplément au troisième fascicule*, n. for p. 212a (50).

The *Komponsetsuissaiububinayazōji* (Sk. *Mūlasarvāstivāda*, N. 1121; T. 1451, XXIV, 252a, li. 25; cf. tr. Soper, p. 148b): "The Buddha said, 'It is permissible to use scented paste and spread it where you will; but you cannot make drawings that have the form of living creatures without falling into the sin of transgression against the Law. If you draw corpses or skulls, however, there is no offense.'"

Yet there exist passages which justify the making of images; most particularly the *Kengukyō*, tr. Ekaku (according to Soper = Sk. *Damamūktanidānasūtra*, N. 1322, T. 202, IV, 368–69). In this text, it is a question of King Po-sai-ch'i, who causes 84,000 statues of the Buddha to be made after the model constructed by the *Puṣya* Buddha (cf. Soothill, p. 188a). These statues were sent to the "various minor frontier lands," one for each country,

so that the inhabitants might insure their ultimate salvation by worshiping the Buddha. See tr. by Soper, p. 149b.

Coomaraswamy, *EBI*, p. 6, notes that later traditions represent the Buddha himself as having instituted the use of anthropomorphic images; cf. *Divyāvadāna*, p. 547.

19 Soper, "Roman Style in Gandhāran Art"; Rowland, "The Hellenistic Tradition in Northwest India"; and idem, "Gandhāra and Early Christian Art."

20 Cf. the illustrated text by Tagore, *Some Notes on Indian Artistic Anatomy*; Coomaraswamy, *The Transformation of Nature in Art*; and Bagchi, "On the Canons of Image-making, *Piṅgalāmata*, Chap. IV." For the principles and their interpretation, consult Bose, *Principle of Indian Śilpaśāstrā*, pp. 16–55 (p. 27).

21 For the 32 great signs characteristic of a Great Man, and the numerous secondary signs, cf. Burnouf, *Le Lotus de la bonne loi*, p. 553f.

22 Akiyama, *Buddhist Hand-Symbol*, Introduction; Mochizuki, *BD* 177.

23 Cf. Foucher, *L'Art gréco-bouddhique du Gandhâra*, II, p. 326; also see I, figs. 198, 210, 245 (gift); 194, 212 (homages); 251 (welcome); 255, 271–75 (subjugation); 233, 243 (predication); 220 (turning the wheel of the Law).

24 Toganoo, *MK*, p. 474.

THE CONTRIBUTION OF TANTRISM

1 Shingon, which derives from a branch of Tantrism, maintains that the essence of the Doctrine can be apprehended only by those initiated into the Mysteries. Hence, this type of Buddhism is called *mikkyō*, "mystic, or esoteric, doctrine." The Mysteries are largely transmitted orally. The traditional teachings of Śākyamuni, transmitted by and studied in the canonical literature, are accorded lesser importance in Shingon. This traditional type of Buddhism is called *kengyō*, "apparent doctrine."

2 Eitel, *Handbook of Chinese Buddhism*, p. 209a.

3 Vajrabodhi (Kongōchi), 670–741, of Central Indian origin, embarked from Ceylon for China in 717, arriving at Canton in 719, at Loyang in 720. (Cf. *Hō.*, fasc. annexe, p. 143a and b, s.v. Kongōchi.)

4 Amoghavajra (Fukū), 705–74, born in Ceylon, having accompanied Vajrabodhi to China, established himself at Ch'ang-an in 756. (Cf. *Hō.*, fasc. annexe, p. 135a, s.v. Fukū.)

5 Kūkai (posth. Kōbō Daishi), born 774 in Sanuki, traveled to China from 804–6 (var. 807); resided at Kyōto as early as 809, died in 835. (Cf. *Hō.*, fasc. annexe, p. 144a, s.v. Kūkai.)

Eliot, *Japanese Buddhism*, p. 337: "He [Kūkai] spent two years (804–806) in studying it [the Shingon doctrine] under Hui-kuo, the celebrated abbot of the Ch'ing-lung temple at Ch'ang-an." Cf. also Steinilber-Oberlin, *The Buddhist Sects of Japan*, pp. 94ff.

6 Hui-kuo, born 746, disciple of the Zen master Ta-chao (Daishō) and later of Fukū; traveled 776–77, died in 805. (Cf. *Hō.*, fasc. annexe, p. 142b, s.v. Keika.)

7 Hossō, Tendai, Kegon, and Shingon derive from the *Yogācārya*.

8 *Si-do-in-dzou*, p. 4, states that the three Mysteries essential for attaining *bodhi* are: (1) *kan-nen*, meditation on the great laws of Buddhism; (2) *shin-gon*, exact recitation of the mystic formulas; (3) *shu-in*, "hand-seal." Fujishima, *Le Bouddhisme japonais*, p. xxiv, gives: body, word, and thought. See Steinilber-Oberlin, *Buddhist Sects*, pp. 116ff. According to the *BD* 664b, *san mitsu* are: *1 shimmitsu*, mudrā; *2 go mitsu*, dhāraṇī or mantra; *3 i mitsu*, meditation (concentration). Also cf. Soothill, p. 63b.

In Sk. the term (Three) Mysteries is rendered by *guhya*, which Renou (*Dict.*, p. 232a) explains as: "[1] a.v., qui doit être caché, secret, confidentiel, mystérieux, mystique; [2] nt. secret, mystère, organe sexuel." *Kāya guhya*, symbolic means of expressing a fundamental truth; *vāg guhya*, word, mystic formulas; *mano guhya*, "mental": meditative concentration.

9 Glasenapp, *MB*, p. 91.

10 *Tantra*: mystic formularies (Getty). Cf. Renou, *LS*, p. 127: "les textes ou portions de textes les plus anciens peuvent remonter aux VIIe ou VIIIe siècles."

Cf. Renou, *IC*, pp. 423–29. A *tantra* is composed of four parts (p. 424): *1 Jñāna*, Knowledge of the divinity; *2 Yoga*, Concentration; *3 Kriyā*, Cult practices, making of images, construction of temples, etc.; *4 Caryā*, "methods" of worship.

The *tantra* seem to put the emphasis on the practical parts at the expense of "speculation" (cf. ibid., p. 424, § 846 for the "Five Subjects," etc.), for Tantrism aims at a *sādhana*, at a "practical realization" (p. 425). Concerning the age of the *tantra*, cf. ibid., p. 427, § 852; Glasenapp, *MB*, p. 20. For a general, basic study, cf. Avalon, *Principles of Tantra*.

11 Renou, *IC*, p. 428, § 856, mentions the *Uddhārakośa* of Dakṣināmūrti, as well as the "lexicons designed to translate the words or phonemes used with an esoteric value; some of them also describe the mudrā."

Bhattacharyya, *An Introduction to Buddhist Esoterism*, p. 49, mentions the *Mañjuśrī-mūlakalpa*" . . . with all the paraphernalia of worship and an immense number of mudrās, mantras, and dhāraṇis."

12 Glasenapp, *MB*, p. 20.

13 Concerning the origins of Tantrism in primitive magic both pre-Buddhist and Buddhist, cf. ch. I–IV of Bhattacharyya, *Introduction*; cf. also p. 49, li. 10–13.

14 *IC*, p. 368, § 745.

15 Ibid., p. 369.

16 Ibid., p. 370, § 748.

17 Ibid., p. 370, § 749.

18 Ibid., p. 371, § 750.

19 Ibid., p. 372, § 752.

20 Ibid., p. 596, § 1223.

21 Ibid., p. 598, § 1226.

22 Ibid., p. 610, § 1250.

23 Ibid., p. 611, § 1251.

24 Glasenapp, "Tantrismus und Śaktismus," p. 122: "Many Tantric rites derive from earlier times: the teaching of magic charms relating to *dhāraṇī* and *parittā* may be traced back to the Atharva Veda. The mystic sounds and syllables which the mantras and śāstras teach are already found in the Yajur Veda. And also for many ceremonies it is possible to posit precursors, some already in the Veda, most in the Purāṇas and in the rich literature that came into existence in the millennium between the end of the Brāhmaṇa period and the rise of Tantrism."

25 *IC*, p. 369.

26 Compare the interdependence which exists in Yoga practices and which is summarized in the phrase *shinkuisōō* (Nakagawa's reading), that is, the relationship between the hands (mudrā), the mouth (mantra), and the mind (yoga) — Eitel, p. 208b.

27 The term *shin-gon* signifies the true word and emphasizes the importance of the true, the right, and, consequently, the efficacious word, which is indispensable in order to attain final identification with the divinity.

Toganoo, *MK*, p. 430, part II, notes that *shin-gon* translates Sk. *mantra*, composed of

man, "sacred thought," and *tra,* suffix meaning "to fill (like a container) with (i.e., sacred thought)."

28 *The Saddharma Puṇḍarīka, or The Lotus of the True Law,* tr. H. Kern, pp. 370f. Cf. French tr. by Burnouf, pp. 378f. For the variants of the magical formulas established by this chapter, cf. Burnouf, pp. 418f., notes.

29 Cf. Getty, p. 168: *dhāraṇī,* "litanies." Eitel (p. 43b): mystic forms of prayer, often couched in Sanskrit.

Dhāraṇī is a feminine form of *dhāraṇa.* It is an agent substantive coming from the root *DHṚ-,* meaning "that which holds, keeps, preserves, protects." In the feminine, this word is a generic term for the magic formulas of the *Mahāyāna.* Cf. *IC,* § 2003.

Renou *LS,* p. 37b, s.v. *dhāraṇī):* "protective charm, used in reference to Buddhist texts, which are generally brief, and employed directly or indirectly for magical purposes." Glasenapp (p. 21) traces the translation in Chinese of these "anathema formulas" to the III century A.D., mentioning particularly Shih-ch'ien and Shrīmitra.

Toganoo, p. 429, writes that in Southern Buddhism, the *dhāraṇī* were called *parittā,* "things which protect."

30 *Charme (Hō.);* spells (Getty); short magic sentences—generally ending with meaningless Sanskrit syllables (Eitel, p. 96b). Renou, *LS,* p. 74b, s.v. *mantra* = "('pensée') nom générique des formules chantées . . ." Cf. *IC,* p. 565, § 1161.

E. Conze, *Buddhism,* p. 183, says: "To pronounce a *mantra* is a way of wooing a deity and, etymologically, the word mantra is connected with Greek words like 'meimao' which express eager desire, yearning and intensity of purpose, and with the old High German word Minn-ia, which means 'making love to.' "

31 Glasenapp, p. 95.

32 Ibid., p. 95. Cf. *Hō.,* p. 40b.

Glasenapp notes that this formula was actually at the origin of *oṃ maṇi padme hūṃ.* In the first, Akṣobhya was in the vocative. In the second, which addresses the goddess Maṇi-padmā, *maṇi padme* is the vocative form of this name, and would mean in this instance "oh, lotus jewel." Later the following meaning was given: "*oṃ,* jewel (*maṇi*) in the lotus (*padme* —locative), *hūṃ*" (cf. Eitel, p. 11a), and this is the traditional one. Cf. Eliot, *Japanese Buddhism,* p. 123, n. 1. Renou, *Dict.,* § 2338, notes that this form does not appear to be attested before A.D. 1000.

Mathews gives (p. 6, No. 31) the Chinese ideograms used to transcribe *oṃ maṇi padme hūṃ.* Tibetans use the script known as *lantsa* for this formula (Glasenapp, p. 102). According to the Tibetan explanation, *oṃ,* which is composed of *a* plus *u* plus *m,* symbolizes the Buddhist trinity, that is, the Buddha, his doctrine, and the community. This same *aum,* when there was still the great void (*mahāśūnyatā*), by manifesting itself was able to produce with its own volition the Ādi-Buddha (Getty, p. 2). *Hūṃ* is supposed to be able to chase away demons, while the two words *maṇi padme* confirm the fact that a jewel (the Buddha or his doctrine) has appeared in (*sic*) the lotus (the world) (Getty). Cf. also Bousquet, *Praśna Upaniṣad,* p. 9.

Note in Japan the following examples of *mantra:* the six-syllable *a-ba-ra-ka-ki-un,* in which *a* = *oṃ* and *un* = *hūṃ* (Getty, p. 172); *abanrankanken* (Sk. *avaṃraṃkaṃkhaṃ*), one of the three formulas of Vairocana, used by the Shingon sect (*Hō.,* p. 5); *arahashana* (*Hō.,* p. 34a); and *arorikya,* formula of Tarakannon (*Hō.,* p. 37). Concerning the question of the origin of this last formula, see Tucci, "Some Glosses upon the Guhyasamāja," pp. 345ff.

33 For other relationships, cf. *IC,* p. 566, § 1162.

34 Cf. *IC,* § 1162, for other interpretations.

35 Ibid., p. 567, § 1164: *bīja* signifies " 'semen': that is, that which contains in 'seed' the corporeal form of the god or that which is the 'seed' of materialization, the deeper sense of which is given only to the initiate."

36 Ibid., p. 569, § 1168, "Les Nyāsa." "The use of the *nyāsa* recalls the ritual practice of contact, frequently attested in Brāhmaṇa and Kalpasūtra literature; it is even possible that the Śatapatha-Br. may note forms of touching analogous to the *nyāsa* (Avalon)."

37 On the *maṇḍala:* Toganoo, *MK;* Gonda Raifu, *Mandara no tsūgi;* Tucci, *Teoria e pratica del mandala;* J. Oda, "Shingon mikkyō no mandara shisō ni tsuite" (Concerning the concept of the *Maṇḍala* in Shingon Esotericism); see Renou, *LS*, p. 74.

Maṇḍala:

"A magic circle geometrically subdivided into circles or squares painted with Buddhist symbols or divinities" (Getty, p. 171).

"An esoteric diagram, consisting of a series of circular or quadrangular zones surrounding a mysterious center, residence of the divinity. The one who meditates on a *maṇḍala* must 'realize' through meditative effort and prayer the divinities belonging to each zone. Progress is toward the center, at which point the person meditating attains mystical union with the divinity" (Auboyer, "Moudrā et hasta").

"Magic circles used in sorcery" (Eitel, p. 94a); "psycho-cosmograms" (Tucci).

One may add to these definitions: the disposition not only of symbols but also of objects, such as vases, bronze containers, or statues on an altar. Cf. the numerous dispositions in the *Jikkanshō* and the *Asabashō.* For the *Ninnō-mandara,* see de Visser, *ABJ*, p. 161.

38 In Japan the term Ādi-Buddha does not figure. Ādi-Buddha = first (*ādi*) Buddha; hence, spiritual essence, Dante's "love" as creator. Vairocana is accepted as being supreme in Shingon; Amida and the other three *Dhyāni*-Buddha being only so many manifestations of Dainichi. It must be added that for Amidist sects, Amida is the supreme Buddha; Vairocana and the other three *Dhyāni*-Buddha being, in their turn, only so many manifestations of Amitābha.

39 These *mandara,* called in Japanese *shuji mandara,* are particularly esteemed in Japan. See Renou, *IC*, p. 567, s.v. *Bīja.*

40 Auboyer, "Moudrā," pp. 157b–158a. Auboyer refers the reader to Finot, "Manuscrits sanskrits de Sâdhana's retrouvés en Chine." N.B. The transcription of the Sanskrit words in this passage has been changed according to Finot, p. 69.

41 I.e., with Vairocana, in Japan. In China and in Japan Vairocana is recognized as the founder of Tantrism, for it is he who is said to have transmitted the doctrine to Vajrasattva. Northern Tibetan Buddhism, however, does not associate Vairocana with the creation of Tantrism.

42 Auboyer, p. 157b. According to the *BD, in-gei* represents the virtue of the *dharmadhātu.* Tajima, *Dainichikyō,* ch. 9, p. 121, says that when the Shingon worshiper performs his own consecration (*kaji*) by means of the mystic mudrā of the Tathāgata, he is assimilated into the body of the World of Essence (*hokkai*).

"Great importance is attached to the practice of *mantra, mudrā* and *maṇḍala* in the Vajrayāna, and hence a great mystic value is attached to the various manifestations of sound, which, according to these teachers, could be visualized in the forms of gods and goddesses. When these divinities appear before the mystic, they form a *maṇḍala* in which they take their proper seat according to various dispositions, and the mystic, who is now speechless, carries on his worship with the help of the mudrā which is now his only language" (Majumdar, *The History of Bengal,* I, p. 420).

43 *BD 56.*

44 Toganoo, *MK*, p. 472, referring to *Dainichikyō* (*T.* 848, XVIII, 33a, li. 14).

45 Ibid. The attributes (lotus, stūpa, etc.) represent the original vows of the Buddha and the Bodhisattva. These attributes may be either objects which the divinities hold in their hands or designs made by the priest on the ground, on silk, on paper, etc. The attributes as well as the designs symbolize the understanding of the Buddha and the Bodhisattva. See part IV of the present study.

46 After Eitel, p. 209a–b.

47 For the role of the mudrā in Hindu dancing, cf. Chatterji, *La Danse hindoue;* and La Meri, *The Gesture Language of the Hindu Dance.* In an introduction to the latter, Heinrich Zimmer writes (p. xvi): "Both [hands and postures] are meant to evoke the visual presence of divine apparitions in the mind of the initiate and to transform his inner being, through suggestive auto-magic, into the essence of the godhead."

48 Auboyer, "Moudrā," p. 160a.

RITES

1 Glasenapp, *MB*, p. 28.

2 See mudrā in the *Pañcattatva IC*, p. 594, § 1219): mudrā is one of the five "m" which serve to bring the *śakti*, "the divine energy" close; it corresponds to the element earth. "The oldest reference [to this rite] according to B. Bhattacharyya would be that given by the tantra *Guhyasamāja.*"

3 De Visser, *ABJ*, pp. 167ff. The *Ninnō* [*gokokuhannyaharamittakyōdarani*] *nen-jugiki* (*T.* 994, XIX, 516a–517c), explains how benevolent kings protect their countries. Tr. A.D. 402–12 by Kumārajīva (Sino-Jap. Kumarajū) and utilized in Japan as early as the VII century. See also the list of sūtras in de Visser, *ABJ*, pp. 3–5.

4 See *āsana*, pp. 121ff.

5 That is, the *shōjō-in*, which alone possesses the power of giving purity.

6 *Añjali* (?) *mudrā.*

7 According to de Visser, *ABJ*, pp. 168–73. Cf. *BD* 94, 944—the mudrā of the *jūhachidō.*

8 *Butsubu sammaya-in.* These Buddhas and Bodhisattvas confer on Sentient Beings their magical powers by means of tantra and mudrā. They do this in order to make them understand the oneness of the original essence of the Buddha and Sentient Beings. These powers permit Sentient Beings to subtract themselves from the anxieties brought about by the Six Senses. The two hands are held near the heart, folded and clenched as fists, the two thumbs upright, side by side. (De Visser, p. 168).

9 *Bosatsubu sammaya-in.* Like the preceding mudrā except that the left thumb is folded into the palm. (De Visser, p. 169.)

10 *Kongōbu sammaya-in.* It is said that these saints (the *Vajra*), having received the majestic spirit of the Buddha, are able by means of the power of their own vow, to protect and support a country and its inhabitants and to save them from calamity and danger. It is like the preceding mudrā except that the left thumb is raised and the right thumb is folded into the palm.

11 *Goshin-in.* This is the Consecration of the Five Places (*gosho kaji*). With the fingers that form the mudrā one touches the forehead, the right and left shoulders, the heart, and the throat, which represent respectively Dainichi (Mahāvairocana). Hōshō (Ratna-

saṃbhava. Fukūjōju (Amoghasiddhi), Ashuku (Akṣobhya), and Muryōju (Amitāyus) — according to another version Amida and Dainichi are the first and the last. The *vajra* and the bell are sometimes used. They represent the mystic assistance of the Buddha whose power the worshiper has received. (De Visser, p. 170.) The mudrā is made above the head and this act symbolizes the protection of the whole body by the Adamantine Armor. The gesture causes the body to emit an unbearable brilliance that blinds demons and those who cause pain.

12 *Byakujo-in* is made above the head.

13 *Shōshoshōshukōdan-in* (de Visser, p. 171).

14 *Ken'aka kōsui-in. Aka* (Sk. *argha*) means offering. This mudrā is made above the head and symbolizes thus that all the Buddhas and all the Bodhisattvas of the *hokkai* (*dharma-dhātu*) will protect the celebrant. (De Visser, p. 171.)

15 *Kenhōza-in.* The celebrant holds his two hands in front of his heart free from passions, joins the palms, the thumbs touching the little fingers, bends them a little, and extends the rest of the six fingers. (De Visser, pp. 171f.)

16 *Fukuyō-in.* The worshiper joins the palms in such a way that the fingers are entwined, those of the left hand tightening on those of the right. He holds his hands in front of his heart.

17 *Hannya haramita kompon-in.* The two hands are joined back to back; the two indexes are united, the little fingers folded into the palm, the thumbs pressed against the ends of the other two fingers. The celebrant reads a tantra.

De Visser, pp. 172–73, says: "*Prajñā-pāramitā, the Bodhisattva, is the mother of all the Buddhas.* As to her image, she is sitting cross-legged upon a white lotus flower, the colour of her body is that of yellow gold; she wears a precious necklace and her whole body is grave and majestic. On her head she wears a precious crown, with white silken bands hanging down on both sides. Her left hand is held near her heart and carries a '*Hannya bonkō*' (i.e. the *Prajñā- pāramitā-sūtra* written on palm leaves) (leaves of the *tāla*, the Lontarus domestica). Her right hand is held near her breasts, making the mudrā of explaining the Law (*seppō-in*), the thumb pressing the top of the 'nameless finger' (the ring-finger)." (N.B. A variant reading of *bonkō* is *bonkyō.*)

18 Concerning the rite of the "Lois mystérieuses," see Steinilber-Oberlin, *The Buddhist Sects of Japan*, pp. 117f.

19 Ibid., pp. 119–27.

20 De Visser, p. 81: The *Ānanda-paritrāṇa-dhāraṇī-preta-kalpa-sūtra* (N. 985; T. 1318, XXI, 468c ff. — *Enkugikikyō*) affirms that by means of the mudrā and magic formulas, the *preta* are invited, their crimes invoked, and their *karma* fixed. Cf. ibid., p. 83, "the Kalpa for the distributing of food to the *pretas*" (N. 1467, 2).

21 Mochizuki *BD* 177b–c.

22 *BD* 90: R.H. (*satori*), Sk. *prajñā*. L.H. (*jō*), Sk. *samādhi*. Toganoo, in *Mikkyō shisō to seikatsu*, gives the following:

L.H.	R.H.
World of *Satori*	World of Illusions
Beings	Buddha
Quietude	Movement

23 Cf. Mochizuki, *BD* 177.

24 *BD*, 90c quotes this text. *Fudarakaieki* = *Fudarakukaieki* (*T*. 1067, XX, 129b, li. 21ff.), tr. by Fukū (Amoghavajra). Fudara is probably a proper name, Potaraka (Eitel, p. 117b). It is the place where the palace of Avalokiteśvara is located. There is an allusion to this palace in Burnouf, *Introduction à l'histoire du bouddhisme indien*, p. 542; likewise on page

57a of the *Hō*. Potala is also the name of the quarters of the Dalaï-lama situated on the dMar-po-ri, the Dalaï-lama being an incarnation of Avalokiteśvara (Hackin, *Guide*, p. 67).

On the subject of Potala, cf. Tucci, "A propos d'Avalokiteśvara," pp. 179ff., and Eliot, *Japanese Buddhism*, p. 124.

25 According to Mochizuki, table, p. 177.3. The Five mystic Sanskrit signs and the Five Elements in Sanskrit letters are deleted from the table in Diag. 1.

Cf. the hands posed on a lotus (Tun Huang) in Sir M. Aurel Stein, *Serindia*, IV Pl. XCIX, ch 00153 — text, II page 968b. Also cf. the hands in the *Daizōkyō zuzō*, VIII, plates following pp. 298 and 315.

CLASSIFICATION

1 Toganoo, *MK*, p. 485. Cf. *Dainichikyō* 6, (*T.* 848, XVIII, p. 44a, li. 17ff.).

2 Mochizuki, *BD*, 177a, li. 4ff.; *Dainichikyō* (6) and *Daisho* 20 (*T.* 1796, XXXIX, 783b, li. 15ff.) (tr. Ichigyō [I-hang], 683–735, disciple of Kongōchi [Vajrabodhi]). See *Hō.*, fasc. annexe, p. 140a, s.v. Ichigyō.

3 Toganoo, *MK*, p. 485.

4 In certain cases, mudrā imitate cult objects, such as the *vajra*, the vase, the bell, and others.

5 Toganoo, *MK*, p. 485. Cf. *Daisho* (*T.* 1796, XXXIX, 741b, li. 5–6).

6 Diagrammed in Toganoo, *MK*, p. 486.

7 See Soothill, p. 123a. There is also a reference to the Five Knowledges of the Vairocana group, etc.

8 The so-called pact-signs (*kei-in*) of the *Daisho* are termed convention-form mudrā (Toganoo, *MK*, p. 485).

9 In the *Tantrārthavatāra-vyākhyāna* (Toganoo, *MK*, p. 486).

10 Toganoo, *MK*, p. 486. Vajra (ṛṣi?); Jap. Kongōsen: dates uncertain.

11 Toganoo, *MK*, pp. 487–8, indicates the *Daisho* 15 (*T.* 1796, XXXIX, 732c ff. [?]). Cf. Kūkai's remarks about attitudes and mudrā in de Bary (ed.) *Sources of the Japanese Tradition,* p. 142.

12 *Kongōchōkyō* 3 (*T.* 865, XVIII, 220a ff.).

13 *Daisho* (*T.* 1796, XXXIX, 741b, li. 5).

14 Toganoo, *Himitsu jisō no kenkyū*, p. 275.

15 *Murimandarajukyō* (*T.* 1007, XIX, 661a–63a). Toganoo in *Himitsu jisō*, p. 275, says that 19 *shu-in* are explained, but as far as I can see the sūtra itself mentions 16.

16 Śubhākarasiṃha, from Central India. In 716 he arrived at Ch'ang-an, where he resided at the Hsing-fu and the Hsi-ming temples. In 724, he went to Loyang, where he worked and died in 735 at the age of 99.

17 *Daisho* (*T.* 1796, XXXIX, 715c). *Dainichikyō* (*T.* 848, XVIII, 24a–30a).

18 Cf. *BD* 231b–c for a list of the *jūni gasshō*. This list differs slightly from that given in the text: the *kenjisshin* becomes the *kenjitsu gasshō*; the *mikairen* becomes the *nyorai kairen gasshō*; the *kongō* becomes the *kimyō gasshō*. The others are the same.

The *Daisho* 13 (*T.* 1796, XXXIX, 715c [?]) "gives a list of twelve Seals made by joining the hands; the 6th, the 11th, the 12th are called adara" (Sk. *ādhāra*) — *Hō.*, p. 9a.

Toganoo, *MK*, p. 485, indicated the four kinds of *ken-in* (*shishu-ken*). There are mentions also of the six *ken-in*: Akiyama, p. 53, and *BD* 1824, s.v. *rokushu-in*.

19 For the Lotus clasp (*renge gasshō*) in the Nichiren sect, cf. Smidt, "Eine populäre Darstellung der Shingon-lehre," VII, pp. 117ff.

20 Cf. *Daisho*, 13 (*T.* 1796, XXXIX, 714c).

21 Toganoo, *Himitsu jisō*, p. 276.

22 The *kongō ken-in* (*BD* 479c) is formed by presenting the two closed fists in front of the breast. Cf. the figure in *BD* 479c. This *kongō-ken-in* is actually the upper hand of the *chi ken-in*, q.v. For an example of this fist used in the outer Diamond Section of the *taizōkai*, see *BD* 1102a. See also Miyano (comp.), *Shingon mikkyō zuin-shū*, II, 8a.

23 Cf. *Kongōchōkyō*, *T.* 865, XVIII, 221c.

24 *Daisho* (*T.* 1796, XXXIX, 715c). See also *Jishoki* (*T.* 957, XIX, 322b).

25 Toganoo in *Himitsu jisō*, p. 277, quotes the *Kongōchōkyō* (*T.* 865, XVIII, 241b).

26 The *gebaku ken-in* (*BD* 439b), one of the Four Clasps: *gebaku* means "exterior bonds." Since the ten fingers remain on the outside, this gesture is also known as *shizaige-ken*, "fingers remaining outside the fist," or *kengobaku* or *kongōbaku*. It represents the perfect form of the Ten Virtues. Cf. Soothill, p. 48a.

27 *Kongōchōkyō* (*T.* 865, XVIII, 220c).

28 Ibid., p. 221a.

29 Gonda Raifu, *Mikkyō okugi*, p. 80, as noted in Toganoo, *Himitsu jisō*, p. 278. I have not been able to consult Gonda's book.

30 Toganoo, *Himitsu jisō*, p. 278.

31 *Kongōchōkyōryakushutsunenjukyō* (*T.* 866, XVIII, p. 237b).

32 Toganoo, *Himitsu jisō*, p. 278.

33 Ibid., p. 279.

34 *BD* 1548a.

35 *BD* 1357a.

36 The *kenjisshin* (*BD* 416c) represents the Sk. *hṛdaya* (Sino-Jap. *karida* or *kiridaya*). It is one of the Four Hearts of *tathatā* (*shinnyo*). In the *Daisho* 13 (*T.* 1796, XXXIX, 714c, li. 10ff.) the following is noted: "The first handclasp: it represents unshakable sincerity. The ends of the ten fingers, facing each other, are a little separated and a little open. This is called Nekona Gasshō or Kenjisshin Gasshō." Cf. *nebina gasshō* in *BD* 1376c. Smidt ("Eine populäre Darstellung der Shingon-lehre," VII, 116) notes the following: "The gasshō of the Zen sect is the gasshō called Kenjitsushin [*der Festen Seele*]. As the hands are held joined and pressed together, thus does man concentrate himself on inner meditation. This expresses very well the Zen precept: *Jikishijinshinkenshōjōbutsu* — to become Buddha, whereby, beginning with the most precise knowledge of the nature of his own soul, man perceives the original nature of the human soul."

37 The *koshin gasshō* (*BD* 465c) is formed according to the *Daisho* 13 (*T.* 1796, XXXIX, 714c, li. 12–13), by joining the ends of the ten fingers and leaving a little space between the hands. The Sanskrit is *sampuṭa*, and the Japanese given here in the text is simply a transliteration of this word. The word "empty" in the name means "empty of passions."

38 Also commonly called the *mikairen gasshō*. Cf. *BD* 301a.

39 Also commonly called the *shōkatsuren gasshō*. Cf. *BD* 1633a.

40 Also commonly called the *kenrō gasshō*. This name indicates clarity and lack of dissimulation just as the Lotus (of the good Law) is clear and pure. It is not mysterious (*BD* 1373c). Cf. *BD* 149a.

41 Commonly called the *jisui gasshō*. Cf. *BD* 23a.

42 Commonly called the *kimyō gasshō* as well as the *kongō gasshō*. Cf. *BD* 1429b–c.

43 *BD* 1681a. Called in Japanese *hansha gasshō* (*BD* 1621b).

44 *BD* 1490c–91a. Called in Japanese *hanjakugoshochaku gasshō*.

45 In Japanese *ōchūshi gasshō*.

46 The *fukushukōge gōshō* (*BD* 1513a).

47 *Fukushu gasshō.*

48 The exposition of the Twelve Handclasps is based largely on Toganoo, *Himitsu jisō*, pp. 279–81.

GENERALITIES

1 Cf. *BBK*, p. 506.

2 *Abhaya, dhyāna, bhūmisparśa, dharmacakra* (this last is rather rare) –cf. Foucher, *AGBG*, p. 328.

3 Ibid., pp. 485–86, fig. 243. The Buddha (Lahore Museum, No. 5, from the stūpa of Sikri) makes the *semui-in*, but he is teaching, for here it is a question of the predication to the Trayastriṃśas gods.

The evolution of the mudrā which was to take over definitely the role of expressing the Predication of the Law is impossible to reconstruct. Does it derive from this gesture of the raised hand? The raised hand designates the episode of the elephant: other gestures came to represent the Enlightenment, the Meditation, the Charity, etc. According to the *BBK*, p. 505, the raised hands of the *semui-in* (sometimes both hands are in *semui-in*) may have been brought together to form the *tembōrin-in*. This thesis lacks sculptural proofs and since no sculpture exists to show the intermediary forms of the gestures, it is likely to remain hypothetical.

4 *BBK*, p. 506.

5 Ibid.

6 Cf. the east wall of the Hōryūji and the central statue of the Taemadera.

For Wang Hsüan-ts'e's travels see S. Lévi, "Les Missions de Wang Hiuen-ts'e dans L'Inde" and "Wang Hiuan-tsö et Kaniṣka." See also P. Pelliot, "A propos des missions de Wang Hiuan-ts'ö" and "Autour d'une traduction sanscrite du Tao Tö King."

7 Grünwedel, *Mythologie des Buddhismus*, p. 20.

8 Sirén, p. 136.

9 In India, Vairocana (Dainichi) makes the *dharmacakramudrā* (*tembōrin-in*); Ratnasaṃbhava (Hōshō), the *varadamudrā*; Amitābha (Muryōju, Amida), the *samādhimudrā* (*Jō-in*); Amoghasiddhi (Fukūjōju), the *abhayamudrā* (*semui-in*); and Akṣobhya (Ashuku), the *bhūmisparśamudrā* (*sokuchi-in*).

10 Sirén, p. 11.

11 Ibid., p. 132.

12 Davidson, *The Lotus Sutra in Chinese Art*, p. 24.

13 Cf. Bagchi, "On the Canons of Image-making: *Piṅgalāmata*, ch. IV."

14 Davidson, p. 45; cf. also n. 1.

15 Sirén, p. 132. Cf. the *an-i-in*, which is an excellent example of this phenomenon.

16 See, for example, the Tamon-ten, Brunoff, ed., *Histoire de l'art du Japon*, Pl. XVI.

17 Sirén, p. 133.

SEGAN-IN

1 Tib. *mch'og-sbyin* (Waddell, p. 337); *phyag-gyas-sbyin.*

2 Also: *yogan-in, mangan-in* (*BD* 1025c); cf. *BD* 1186b, *danaharamitsu.*

3 *Dainichikyō*, 4 (*T.* 848, XVIII, 25a, li. 17ff. *Dainichikyō*: tr. Zemmui (Sk.

Śubhākarasiṃha); from Central India, arrived at Ch'ang-an in 716; died in 735; see *Hō.*, fasc. annexe, p. 152a, s.v. Zemmui. Tr. also by Ichigyō (Ch. I-hang) 683–727, disciple of Zemmui and of Kongōchi (cf. *Hō.*, fasc. annexe, p. 140a, s.v. Ichigyō. On this same detail, see *Kokuyaku Daizōkyō*, Vol. I, 117–118 (*Dainichikyō mitsuin-bon, 9*).

4 According to Rao, I, i, p. 14, figs. 4, 5, and 6. See *Varahasta* in Gangoly, *South Indian Bronzes*, Pl. XXIII, and Anand, *The Hindu View of Art*, Pl. XV.

5 See Gonda and Ōmura, *Butsuzō shinshū*, p. 7; the *segan-in* at the level of the breast.

6 See Warner, no. 18 (Yakushi); no. 23 (Shaka Trinity).

7 Gonda and Ōmura, p. 7, cite: the *Shushinjitsukyō* (*BD* 1035b), abbr. of *Shobutsu-kyōgaishōshinjitsukyō* (*T.* 868, XVIII, 276a, li. 4ff.—tr. Hannya (Sk. Prajña), from Kashmir; worked in Ch'ang-an ca. 785–810): "The left hand holds the *kesa* while the five fingers of the right hand are extended, the palm up (turned outward)."

8 See *BD* 1025c.

9 See Codrington, *Ancient India*, Pl. 34, fig. A: the left hand in *segan-in* (?). Cf. the traditional form: Pl. 37, fig. C.

10 *BD* 1025c. (*Dainichikyō*), *Jikkanshō* (1, 7), *Asabashō* (47, 48), Gonda and Ōmura (p. 11), Auboyer, Burgess ("The right hand of charity," p. 25) all call the *segan-in* a gesture of the right hand; Rao (p. 14, *varadahasta*) considers it as a gesture of the left hand.

11 Bhattacharyya, *IBI*, p. 189.

12 See Sirén, Pls. 35, 38, 41, 227.

13 See Koizumi, no 55: Nyo-i-rin Kannon makes the *an-i-in* and the *segan-in:* her attitude is that of meditation.

14 Cf. *Asabashō*, 48 (painting): Fukūkensaku Kannon with 8 arms, makes the *segan-in* (third hand left and right) and the *kongō gasshō* (second hand left and right), and carries the sistrum (*shakujō*), q.v., the whisk, the lotus, and the rope.

15 See Grousset, *Les civilisations de l'Orient: le Japon*, p. 44, fig. 30. This statue dates from the XII century.

16 Sirén, Pl. 182.

17 Brunoff, ed., *Histoire de l'art du Japon* in which Pls. V and X seem to show an evolution of this variant.

18 Cf. the Amida Trinity, in *Hō.*, Pl. IV, fig. 1.

19 See Hackin, *Guide*, p. 77: *segan* is synonymous to Buddha (*Hō.*, p. 193b).

20 *IC*, p. 627: *varada* means that which grants wishes, gives gifts; *da* = "which gives," from the root *DĀ-*, to give.

21 Soothill, p. 303b.

22 In India it is seen in statues of Maitreya, Mañjuśrī, Vajrapāṇi, Tārā, Viṣṇu, Śiva, and others.

23 Mallmann, *Intro.*, p. 263. This gesture is seen "in Magadha and more rarely in Mahārāṣṭra, where it seems generally to characterize the end of the style."

24 Ibid. Its presence may be noted in the 2-armed statues of Lokanāthā, Khasarpaṇa, and Siṃhāsana-Lokeśvara of Ratnagiri.

25 See Koizumi, no. 27, 6 (left hand): *Asabashō*, 48: Fukūkensaku Kannon with 8 arms (right and left).

26 See Koizumi, no. 55.

27 See *Asabashō*, 47: Jūichimen Kannon with 4 arms (right hand).

28 Mallmann, *Intro.*, p. 263: *Kāraṇḍa-vyūha:* second scene.

29 Cf. the Five Great Buddhas in Cave X at Yün Kang (V century) in Sirén, Pl. 38. They are making the *segan-in* with the left hand.

30 See *Jikkanshō*, I: (*kongōkai*) Hōshō, as well as (*taizōkai*) Kaifukeō makes this gesture with the right hand. Cf. Gonda and Ōmura, p. 7. This is one of the "Act Seals" of the Five Buddhas (*gobutsu komma-in*), the seal of the Gift, corresponding to Vow pertaining to Ratnasaṃbhava in the Matrix World (*Hō.*, p. 195b).

31 Cf. Warner, no. 17: Roshana (Asuka-dera) makes the *segan-in* with the left hand.

32 Ibid., no. 23: Shaka Trinity of the Kondō (Hōryūji). Shakamuni makes the *segan-in* with his left hand (*semui-in* with the right): the little finger and the ring finger are slightly bent. Fugen and Monju are on either side, carrying jewels in both hands. Note also the statue of Shakamuni (*semui-in*, right hand; *segan-in*, left hand) on the outside of Cave XIII, Yün Kang: the index points to the earth (Sirén, Pl. 41); also Cave IX (Sirén, Pl. 35) and Buddha, Northern Ch'i (Sirén, Pl. 227).

33 See Gonda and Ōmura, p. 9, fig. 13, Hōdō Nyorai (right hand): and Warner, no. 107 (?).

34 Warner, no. 18: Yakushi in the Kondō (Hōryūji), left hand in *segan-in* (?). Cf. also *Kokka*, no. 153, VII: central statue of the Yakushi-ji (Nara): the note in *Kokka* says of the right hand: "The raised thumb and index finger being symbolic of peace and tranquillity."

The Twelve Vows of Yakushi Nyorai (Sk. Bhaiṣajyaguruvaiḍūrya-tathāgata) are the following. The Bodhisattva desires:

1 To enlighten with his own light the whole world; he desires that every being attain deliverance.
2 That his body be luminous.
3 By means of Wisdom, to propagate infinite love.
4 To lead Hīnayānists to the Mahāyāna.
5 To give the precepts to beings in order that they may obtain salvation.
6 That the ill become well.
7 To cure the poor and the sick by the power of his name.
8 That women be reborn in the body of a man in order to obtain salvation.
9 To guide back to the right way those who have strayed.
10 To save without difficulty and without mishap.
11 To save from hunger and thirst.
12 To give to those beings not clothed vestments and incense.

35 See Grousset, *Les Civ. de l'Or.: le Japon*, fig. 30: Kichijō-ten of the Jōruriji (Kyoto): *segan-in* in the right hand. See also *ZZ*, Pl. 25: Kichijō-ten of the Rokumaji.

SEMUI-IN

1 Cf. *Abhayaṃda*, a name of Avalokiteśvara: "he who causes fear to cease." *IC*, p. 525: *a* = privative prefix; *bhaya* = "fear, terror, fright, alarm, peril, danger, distress"; (from the root *BHĪ-*); *da* = "[he who] gives," (from the root *DĀ-*).

2 L'Orange, *Studies on the Iconography of Cosmic Kingship in the Ancient World*, pp. 140–41. Fig. 100 shows the *magna manus* depicted on coins. In Arabian literature, Albiruni tells us "Ardshir Balman was called Longimanus, because his command was omnipotent, wherever he liked, as if he were only to stretch out his hand to set things right."

3 L'Orange, p. 147: "It is from the orientalized world of gods of the third century

A.D. the gesture has been transferred to the emperor." According to L'Orange, it was only in Severan times that oriental cults from Semitic Syria became established at Rome.

4 Cumont, *Fouilles de Doura Europos*, pp. 70ff.; quoted in L'Orange, p. 157, n. 2.

5 L'Orange, fig. 63, p. 92.

6 Ibid., pp. 159ff.

7 Ibid., fig. 116, showing Christ in the catacomb of Callistus with right hand raised, palm turned toward Lazarus. In a mosaic at St. Costanza in Rome (ibid., fig. 117) Christ is depicted making this sign as the all-powerful Cosmocrator.

8 Ibid., fig. 119.

8a Hastings, *Encyclopaedia of Religion and Ethics*, VI, 493.

9 *BD* 1036c: *Shugokokkaishudaranikyō* (*T.* 997, XIX, 530c, li, 28ff.); tr. Hannya (Sk. Prajña) and Munishitsuri (Sk. Muniśrī), the latter being an Indian monk from Nālanda, arrived at Ch'ang-an in 800, died in 806. This passage also occurs in the *Kokuyaku Daizōkyō*, Vol. L, 117.

10 Cf. Diagram II.

11 *BD* 1036; *Dainichikyō*, 4 (*T.* 848, XVIII, 25a, li. 12).

12 Rao, p. 14; cf. figs, 1, 2, and 3. Takata (*Indo nankai no bukkyō bijutsu*, p. 46) gives the same description. Bose (*Principles of Indian Śilpaśāstra*, p. 59) notes to texts that describe the *vara* and *abhayamudrā*: *Mayaśāstram* (the text of which he gives in Sk.) and *Pratimā-māna-lakṣaṇam*.

13 *BD* 1036c, *Senkōgengyō* (Senkōgen = Kannon with 1,000 arms – *T.* 1065, XX, 122a, li. 23ff.

14 *Kōōbosatsudaranikyō* (*T.* 1401, XXI) cited in *BD* 1036c. This sūtra was translated by I-ching (635–713). It contains rules for the making of images and for the composition of *dhāraṇī*. Cf. Soothill, p. 252b. The sūtra is also called the *Kōōkyō*, abbr. of *Daikongōkōdaranikyō* (*T.* 1401, N. 868).

15 Cf. *Asabashō*, 7: Kannon.

16 The Five Destinations (*gati*; Tajima translates "Orientations") are: (1) gods, (2) men, (3) animals, (4) *preta*, (5) infernal beings; sometimes a sixth is added: *asura*. Cf. Soothill, p. 125a–b.

17 Cf. *BBK*, p. 506.

18 Bhattacharyya (*IBI*, p. 189) distinguishes the *abhayamudrā*, the simple raised hand, from the *capeṭadānamudrā*, "the right hand menacingly extended upwards just as we do in dealing a slap."

19 Foucher, *Iconographie bouddhique*, pp. 68–69.

20 Cf. Kramrisch, *Indian Sculpture*, p. 161, fig. 41 and fig. 59. The *Si-do-in-dzou*, p. 43, notes that the ritual usage requires that the ends of the fingers be at the level of the priest's head. Cf. Warner, Pl. 69.

21 Cf. Sirén, II, Pl. 182.

22 This gesture is by far the most common on Gandhāran statues, as well as on those of Mathurā and Amarāvatī, where the mudrā assumes a multiple use. This double gesture is present in Brahmanism: cf. the Skanda, Musée Guimet (Milloué, *Petit Guide illustré au Musée Guimet*, p. 71).

23 Kaneko in "Butsuzō no in," uses this same nomenclature, i.e., "*yogan-semui-in*."

24 Cf. Toganoo, *MK*, p. 483, li. 5–9: This legend is attested in several texts: *Hokkuhiyukyō*, 3 (*T.* 211, IV): *Abidombibasharon* (*T.* 1546, N. 1264): *Daibibasharon* (*T.* 1545).

25 Glasenapp, *MB*, p. 144: "When Devadatta threw a maddened elephant against

the Buddha, far from killing or wounding this animal, the Sublime One tamed it by causing his own benevolence to enter into it: as a result the elephant, falling at his feet, worshiped him." Cf. fig. 15 in Grousset *Les Civ. de l'Or.: L'Inde.*

26 Foucher, *AGBG*, p. 541, fig. 510: the subduing of the elephant at Amarāvatī. For the subduing of the maddened elephant and the different versions of the legend, Foucher (*La Vie du Bouddha*, p. 289) sends the reader to Hsüan-tsang, in: Julien (tr.), *Mémoires sur les contrées occidentales,* II, 16; Beal (tr.), *Si-yu-ki: Buddhist Records of the Western World,* II, 150 (cf. n. 39); and Watters, *On Yuan Chwang's Travels in India,* II, 149. Also cf. Foucher, *Iconographie bouddhique,* II, pp. 169–70 and Pl. X, 5.

27 The legend of the lions is attested in the *Zappōzōkyō* (cf. *Zappōzōkyō* [8], *T.* 203, IV, 488c ff.). This text was translated by Kikkaya (Kiṃkārya?) and Don'yō.

28 Toganoo refers the reader to the *Butsuhongyōkyō* (*T.* 192, IV, 93c), but this text makes no mention that I can discover of the five colors. Also reference is made in this text to the arm (or elbow) rather than specifically to the hand as the part of the anatomy from which the rays are supposed to emanate.

29 The passage from Foucher is cited according to Hackin, p. 81: cf. also fig. 15 in Grousset *L'Inde.*

Note the ivory plaque from Bégram, at present in the Musée Guimet (there identified as "chantier no. 2," I–II cent. B.C.). It represents a lion which affronts an elephant and tames it by making the *semui-in* (*abhayamudrā*). Should these plaques bear witness to the existence of this version of the legend in the I–II centuries A.D.?

30 The legend attributes the *semui-in* to the right hand. It may be noted, however, that two-handed statues in *semui-in* are not lacking (cf. *Asabashō,* 47: Kannon with 11 heads and 4 arms; cf. also the bronze statue of a standing Buddha [Siam, XV–XVI centuries] in the Musée Guimet). It is doubtless question of a simple repetition of the *semui-in* of the right hand rather than a left-handed *semui-in.*

31 Foucher, *AGBG*, pp. 327–28.

32 Cf. no. 1.

33 According to the *Hō.*, *mushoi* = "assurance" (Sk. *vaiśāradya*).

34 Soothill, p. 178a: Buddha = omniscience, perfection of character, overcoming opposition, ending of suffering. Bodhisattva = powers of memory, of moral diagnosis and application of the remedy, of ratiocination, and of solving doubts.

35 Cf. *BD* 1722a.

36 Ibid.

37 Ibid. Cf. the translation of de Visser ("The Arhats in China and Japan," p. 96): "Exhaustion of leaking"; that is, *āsravakṣaya;* according to Kern, "the destruction of defiling passions."

38 *BD* 1722a and 1031c.

39 *BD* 1722a and 1032a.

40 According to Tajima, pp. 108ff., the first member of this double way is the *"trikalpa (sangō)* which consists of going beyond the three sorts of attachment of the passions."

In Sk., the Six Fearlessnesses are *sannirbhaya, kāyanirbhaya, nairātmyanirbhaya, dharmanirbhaya, dharmanairātmyanirbhaya, sarvadharmasamatānirbhaya.*

41 *Si-do-in-dzou,* p. 42.

42 Sirén, p. 134: *"sceau de l'Assurance."*

43 Foucher, *AGBG*, p. 68: *"la mudrā qui rassure":* Abhayapāṇi = *"celui qui a à la main l'Absence de Crainte."*

44 Cf. Soothill, p. 381, *abhaya* = fearless, dauntless, secure, nothing and nobody to fear: also *vīra*, courageous, bold.

45 Rao, p. 14: "the protection-affording hand-pose."

46 Foucher, pp. 485–86: cf. fig. 243, p. 485 (Lahore Museum, no. 5 Stūpa of Sikri). The Buddha (Musée Guimet, no. 17478, Afghanistan, III–IV century) forms the *semui-in* with the right hand; on the palm may be seen a wheel, which indicates that this gesture symbolizes the Teaching.

47 Cf. Davidson, *The Lotus Sutra in Chinese Art*, p. 30 and Pls. 3 and 4. The *semui-in* occurs in various stelae as well: cf. ibid., p. 35.

48 Ibid., p. 67.

49 Ibid.: "There is an obvious confusion here between literary and artistic traditions."

50 *Dīpaṃkara* is the most ancient of the 24 Buddhas, predecessors of the historical Buddha. The name *dīpaṃkara* appears to mean "maker of lamps (*dīpa*) or of lights" (Buhot, "La Pluralité des Bouddhas," p. 34).

Cf. Eitel, p. 50, who translates "The Fix-Light Buddha"; and Doré, *Recherches sur les superstitions en Chine*, pp. 67ff.

51 The meaning of holding the *kesa* (stole) is difficult to ascertain. It would seem, according to modern explanations by Shingon priests whom the author has interviewed on the subject, that holding the stole signifies "honoring the Law," for *kesa* is equated to Law.

51a Price, tr., *The Diamond Sūtra*, p. 24.

52 Cf. the Ashuku of the Hōryūji (*ZZ*, Pl. 42), who holds a fold of his stole in the left hand.

53 Mallmann, *Intro.*, p. 261, n. 2: "We have not found in India one single image of a two-armed Avalokiteśvara in which the god is represented with both hands raised. There exist relatively few in which the two hands are lowered."

54 Ibid., Pl. VI.

55 Ibid., p. 261.

56 Cf. Bachhofer, *Early Indian Sculpture*: Pl. 8, Bodhisattva of Katra (Mathurā), *ca.* A.D. 100; Pl. 82, Buddha-Bodhisattva (fragment), Mathurā, *ca.* A.D. 80–100; Pl. 129, Amarāvatī (end of the II century).

57 *BD* 1036. The terms *Semuibosatsu* and *Semui-sha* are equivalent to Kannon.

58 *Saddharma Puṇḍarīka*, tr. H. Kern, p. 412. According to Stael-Holstein, in this chapter is found the oldest explanation of the name of Avalokiteśvara: Mallmann (*Intro.*, p. 65) sends the reader to Staël-Holstein, "Avalokita und Apalokita."

59 Mallmann, *Intro.*, p. 262, cf. Pl. IIIb.

60 Ibid., Pl. IIIa.

61 Cf. Koizumi, no. 6: Kanzeon (bronze).

62 Cf. Warner, no. 49: Nyo-i-rin Kannon (Imperial Household Collection).

63 *Hō.*, Pl. VIII.

64 Cf. Batō Kannon, in *Hō*, pp. 58–61.

65 Cf. Ibid., p. 72, fig. 35.

66 *Yakushinyorainenjugiki* (*T.* 924, XIX, 29b, li. 19ff.): *BD* 1752a. Tr. by Amoghavajra (Fukū) before 774, the year of his death. This text is cited by Gonda and Ōmura, p. 15, li. 9ff.

67 The medicine receptacle is the lapis lazuli of twelve angles and represents the Twelve Vows of Yakushi (*jūnijōgan*). For the Twelve Vows, cf. Soothill, p. 473a; de Visser, *ABJ*, p. 534.

68 The *kessankai-in*, mudrā of "tying the Three Worlds," is so called because this gesture, by binding Sentient Beings, prevents them from falling into fear or calamities. The Three Worlds (Sk. *triloka*) are: (1) Desire World (Sk. *kāmadhātu*); (2) Form World (Sk. *rūpadhātu*); (3) Formless World (Sk. *arūpadhātu*); cf. Soothill, p. 70b.

69 Gonda and Ōmura, p. 15; cf. fig. 17.

70 Ibid., p. 15: Yakushi Nyorai.

71 Cf. the famous statues in bronze of the Kondō (Hōryūji) from the beginning of the VII century — Warner, no. 18.

72 Cf. Warner, no. 30: Yakushi of the Hōrin-ji, wood, Suiko period; *Kokka*, no. 166, VI: Kō-Yakushi of the Shin Yakushi-ji (Yamato); the right hand is in *semui-in*, and the left hand, pendent, holds a medicine bowl (*c.* 673–85, Hakuhō period).

73 Cf. *Kokka*, no. 96, V: the central figure of the Yakushi-ji (Nara), VI–VII centuries; no. 153, VII: Yakushi-ji, VII–VIII centuries; no. 159, VI: Kōzan-ji, Kyoto, VIII century.

74 Cf. the Yakushi of the Hokkai-ji (Yamashiro). The medicine bowl is resting on the hands joined in *hokkaijō-in*. But according to de Visser (p. 565) this statue is perhaps late. The same form is found in the maṇḍala of the XII century depicted in *Kokka*, no. 32, I.

75 Cf. Warner, Pl. 107.

76 Getty (Addenda, p. 40) maintains that the mudrā in which the end of the thumb and the end of the index are brought more or less close together is the most common in Korea. The one that shows the thumb and the ring finger close together is very rare.

77 Cf. *Hō.*, Pl. IV: the Amida trinity.

78 *BD* 1705a, s.v. *mushofushi-no-in*.

79 If, in the gestures of statues of Shakamuni in *segan-semui-in*, the indexes are bent inward, the statue belongs to the Shingon sect (Getty).

Cf. Sirén, no. 41, Shakamuni, Yün Kang (outside of Cave XII); Warner, no. 23: Śāka Trinity (Kondō, Hōryūji). The Shaka of the Musée Guimet, Japan, XVI century, forms the compound gesture of the *segan-semui-in*; the thumbs and the indexes touch and the fingers are slightly bent; the same is the case of the Buddha statue (bronze) of the Musée Guimet, China, XVI century.

80 Cf. Warner, no. 17; Roshana (Asuka-dera).

81 *ZZ*, Pl. 86.

82 Elisséeff, "Mythologie du Japon," p. 412.

83 Cf. Sirén, Pls. 26, 30, 35, 38, 44, 50, 51.

AN-I-IN

1 Both the Sanskrit designation and the symbolic prototype of this gesture are in default. The *vitarkamudrā* corresponds to the designation *seppō-in* and signifies "argumentation," "reasoning."

2 According to Sanskrit texts, this designation, although common, should be admissible only to designate the so-called *vitarkamudrā*. Mallmann has brought to my attention that *vyākhyānamudrā* designates rather the *dharmacakramudrā*. The justification of the term *dharmacakra* may be found in the fact that the most frequent form of *tembōrin-in* consists of two *an-i-in* (i.e., *seppō-in*) juxtaposed. It remains to be noted whether the *vyākhyānamudrā* is a gesture made by the two hands or if it is a gesture of one hand alone. Majumdar (*The History of Bengal*, p. 475) reports: "*Vitarka* (discussion) or *Vyākhyāna* (explanation) — in which the 'tips of the thumb and the fore-finger are made to touch each other. The palm of the hand is made to face the front' (Rao)."

3 L'Orange, *Studies on the Iconography of Cosmic Kingship*, p. 171.

4 Ibid., p. 175.

5 Cf. ibid., p. 181, n. 2, for Quintilian's description of this gesture.

6 It is present in early Christian art and through the Middle Ages on.

7 Cf. L'Orange, fig. 120. The so-called *benedictio graeca* corresponds in form to the *kichijō-in*.

8 L'Orange, pp. 175–76.

9 This gesture changed in the Middle Ages from characterizing a confessor Christ to denoting a benedictory Christ (L'Orange, p. 183).

10 Ibid., p. 187.

11 Ibid., pp. 194–95.

12 *An-i-shōshu-in* (Mochizuki, *BD*, p. 78): "gesture of consolation and of gathering in." From *an-i* or *i-an*, console, pacify, relieve, encourage, calm, tranquillize.

13 Linossier, "L'Iconographie de la descente d'Amida," p. 118. The author calls this mudrā "the gesture of tranquillity." This form is less frequent than the two others.

14 Cf. Brunoff, ed., *Histoire de l'art du Japon*, Pl. XXV.

15 Cf. *an-i-in*, which figures in Pl. 26 of the *ZZ*: the right hand is in classical *an-i-in*: that is, the index and the thumb are joined, while the left hand, lying on the left knee, palm up, makes the *an-i-in* with the thumb and the index.

16 Mochizuki, *BD*, Pl. 17. For this gesture in Central Asia, cf. the Tokharan monk in Ernst Waldschmidt, *Gandhāra, Kuṭscha, Turfan*, Pl. 21a, as well as Pls. 52, 55a and b.

17 Auboyer, "Moudrā," p. 156. Cf. Codrington, *Ancient India*, Pl. 31a.

18 Foucher, *Etude sur l'iconographie bouddhique*, p. 68.

19 *BBK*, p. 506.

20 Mochizuki, *BD*, Pl. 17: Mochizuki, in describing this gesture, really makes the description of the compound gesture *segan-semui-in*.

21 *ST*, II, Pl. 6.

22 Rao, p. 16 (joining the thumb and the index). Mudrā of explication or of exposition. This author calls it (p. 16) *vyākhyānamudrā* and *saṃdarśanamudrā*, and for him the *jñānamudrā* is formed by joining the ends of the thumb and the middle finger and by turning the palm toward the body.

23 *Vyākhyānamudrā. Vyākhyāna* means "detailed exposition or explanation" (*IC*, p. 706a).

24 Buhot, *Les Arts de l'Extrême-Orient*, p. 352: *ST*, II, Pl. 6.

25 Sirén, p. 134: the open hand "in *abhayamudrā* except that the index or the middle finger touches the end of the thumb." Cf. Getty, p. 201.

26 Ibid., p. 181.

27 Foucher, after examining two Nepalese miniatures which recall the Avalokiteśvara that Mallmann ("Notes sur les bronzes du Yunnan," p. 578) speaks of, "was not able to determine on either one of them whether the gesture which was reproduced was the *abhaya* or the *vitarkamudrā*." Cf. Foucher, *Iconographie bouddhique*, p. 193, no. 20 (Siṃhala-dvīpe-ārogaśālā) and p. 212, no. 28 (same).

28 One may in fact note a similarity of form between the *segan-in*, mudrā of the gift of the Vow, and the *an-i-in* — a contamination analogous, moreover, to that which exists between the *semui-in* and the *an-i-in* (cf. *Nihon no chōkoku*, III, 8).

29 Cf. also the Bodhisattva (?) from Central Java which seems to make the *an-i-shōshu-in* (Hackin, *La Sculpture indienne et tibétaine du Musée Guimet*, Pl. XL).

30 Mallmann, "Notes sur les bronzes du Yunnan," p. 578.

31 Cf. *Daizōkyō zuzō*, VIII, p. 24.

32 Ibid.: cf. fig. 44, p. 36, for another gesture of this same designation.

33 Cf. *Hachidaibosatsumandarakyō* (*T.* 1167, XX, 675c li. 18). This text is rendered in modern Japanese in Mochizuki, *BD*, p. 78a, li. 4.

34 Eitel (p. 189a) notes a transcription. Tib., *byan-chub-mch'og*.

Waddell (p. 337, cf. fig. on page 336: Vairocana): "The best Perfection . . . Index-finger and thumb of each hand are joined and held almost in contact with the breast at the level of the heart." Burgess, "Buddhist Mudras," p. 25a: "The Uttara-bodhi-mudrā (. . . byan-chūb) ascribed to Vairocana Buddha . . . is apt to be confounded with the Dharma-chakra mudrā." Getty (p. 179) gives the description of another mudrā under the heading of *"uttara-bodhi"* (Sino-Jap. *renge-no-in*). For *"Uttara,"* see *IC*, p. 138a. Also, see Gordon *Tibetan Lamaism*, p. 23.

35 Cf. Waddell, fig. p. 5; Williams, pp. 196, 197. Waddell (p. 337) distinguishes what he calls "the preaching" of the *abhayamudrā:* the first presents the thumb inflected. When the thumb and the ring finger touch this form is called the "triangular pose." The *abhayamudrā* presents the hand raised, the fingers up.

36 Cf. Mallmann, "Notes sur les bronzes du Yunnan," Pl. I, facing p. 596. But Mochizuki, *BD*, p. 78 (or Pl. 17) shows the two hands each forming a circle. According to Chapin ("Yünnanese Images of Avalokiteśvara," Pl. 144), in the statues of Avalokiteśvara, this bastard gesture of compassion, a characteristic quality of this divinity, may have been attributed by the image-makers to the left hand, which had lost its attribute (lotus?).

Cf. the two statues of Avalokiteśvara at the Musée Guimet: M.A. 18, gilt bronze, end XII–beginning XIII century (*an-i-in* in the right hand; *shōshu*, "gathering in," in the left hand); M.A. 1039, XIV–XV cent. (?) has the same disposition of the hands.

37 Mochizuki, *BD*, p. 78: "An-i-in means the 'seal' which consoles all Beings: *an-i-shōshu-in* is also said." The same designation is used in Chinese: cf. Chapin, "Yünnanese Images," pp. 144–45.

38 Mochizuki *BD*, p. 78.

39 According to Demiéville, *shōshu* (Ch. *shê-ch'u*) would correspond more exactly to the Sanskrit *saṃgraha* "gathering in." The *an-i-shōshu-in* is probably not of Indian origin, and consequently the term created to designate it does not have any exact Sanskrit equivalent: it is simply the "gesture which gathers in — or which assembles — (Sentient Beings) in order to appease (them) and to console (them)." Cf. Mallmann, "Notes," Pl. 578.

40 Chapin, "Yünnanese Images," p. 145, n. 30 (based on the *Bukkyō daijii* 4.2963).

41 This position goes back, like the others, to an Indian prototype; cf. Foucher, pp. 487–88, fig. 243.

42 Cf. Shaka "Teaching the Law," Pl. 53 of the *BD*.

43 Foucher, *Iconographie bouddhique*, p. 68.

44 *Vitarka:* here "reasoning, reflection" (*IC*, p. 653b).

45 *Hō.*, 85a, s.v. *Bitaka*. An older translation = *kakkan*. According to Soothill, p. 481a, "awareness and pondering, acts of intellectualization . . . both of them hindrances to abstraction, or dhyāna."

46 Foucher (*AGBG*, pp. 487–88, fig. 342): the right hand is in *semui-in* (here = Teaching), and the left hand is in *vitarka* (Argumentation-Teaching).

47 *Amida butsu seppō-in:* cf. *Daranijikkyō* 2 (*T.* 901, XVIII, 800c, li. 4ff.). Both hands are held in front of the breast.

48 Also *chi Kichijō-in* (*BBK*, p. 5076); Sk. *śrīmudrā*; Ch. *chi-hsang-ying*.

49 Sk. Lakṣmī (*BD* 1776b).

De Visser, *ABJ*, p. 309: Kichijō-ten = Goddess of felicity = Kudoku-ten, "Devi of Blessing Virtue." She is the younger sister of Bishamon-ten (Vaiśravaṇa).

De Visser, p. 309, sec. 16-17 of the *Kongōmyōsaishōōkyō* (*T.* 665, XVI, 440a, sec. 16-17). Śrī is worshiped for abundant harvest as well as for good fortune.

Kichijō-ten or Kudoku-ten is the daughter of Tokushaka (Takṣaka, king of the Nāga, one of the four kings called Ryū-ō, dragon kings) and of Kishimo (Kareitei, Sk. Hārītī, mother of the demons: cf. Eitel, p. 62b). She was early assimilated into the Buddhist pantheon. In Japan, Kichijō-ten is a benevolent goddess of a very active popular cult. Buddhist texts put Kichijō-ten at the head of the *deva*, who, having heard the doctrinary explanations of the Buddha, were content. They promised to devote themselves completely to the protection of the sūtras and to bring it about that those who would keep them (i.e., the sūtras) should be exempt from pain and capable of attaining eternal happiness (de Visser, p. 309, sec. 22 of the *Kongōmyōsaishōōkyō*, *T.* 665, XVI, 444c-446c). This cult appears in Japan as early as the VIII cent. It possesses its own rites and ceremonies for the goddess Kichijō (cf. de Visser, pp. 309-10).

Cf. *ST* VI: Śrī, wood, Jōruriji (Kutaiji), Tō-no-o, Yamashiro. Compare with *ST*, I: the image of Kichijō-ten of the Yakushi-ji.

50 *Daisho en'okushō* (15) is cited in the *BD* 243a.

51 *Kudoku* means "virtue achieved," "power to do meritorious works." See Soothill, pp. 167b-168a.

52 Gonda and Ōmura, p. 14.

53 *Kokuyaku Daizōkyō, Daisho* (9), Vol. L, 115.

54 Cf. *Hō.*, p. 30a (Amida of the 9 classes); and Demiéville, "Les Versions chinoises du Milindapañha," p. 236.

55 Waddell, p. 337, 8. (Tib. = *pa-dan rtse gsum*). Cf. Getty, p. 181, s.v. *Vitarka*.

56 Getty, p. 181. Waddell, p. 337, 8.

57 Cf. *ST*, II, Pl. 6: Bronze statue of Shakamuni. The text gives the esoteric interpretation.

58 Cf. *ST*, I, Shakamuni of the Kanimanji, Kyoto (bronze), right hand: this gesture is very frequent in Outer India (cf. statue 18891 of the Musée Guimet, Khmer, VIII cent.); as well as in China (cf. Sirén, no. 30: here the thumb and the index [left hand] are raised but do not touch, the other fingers being flexed toward the palm). According to Sirén, the Buddha is seated in the "attitude of Predication" (p. 16), indicated by the presence of the gazelles and the three wheels.

For Buddhas there are three states:

1 *Dharmakāya* (*hosshin*, Essence Body) Buddha who, freed from all that is human, has entered into *nirvāṇa*. In *nirvāṇa* personality disappears; only the thumb touches the index.

2 *Sambhogakāya* (*hōjin*, Fruition Body) Buddha, as chief of the Bodhisattvas, communicates with them; the thumb touches the middle finger.

3 *Nirmāṇakāya* (*ōjin*, correspondence body) Buddha takes on human form in order to preach; the thumb touches the ring finger.

59 Koizumi, no. 31: Amida Nyorai; right hand raised, the left hand reposes in the lap, the thumb and the index joined: cf. also no. 46.

ST, I: Amida of the Zenrin-ji, Kyoto (Fujiwara period), the two hands are in front of the breast, the thumb touching the index and forming two *an-i-in*, which are, to a certain extent, here, the "seal of welcoming" of Amida.

60 *Hō.*, Amida, p. 29a.

61　The idea of the 9 classes of Amidas seems to date from the middle of the Heian period. The concept is set forth in the *Kammuryōju [butsu] kyō* (*T.* 365, XII, 340b ff.). In describing the hand positions of the 9 classes of Amida, the left hand is said to be in *segan-in* and the right in *semui-in* with the appropriate fingers touching.

The *an-i-in* of the Amida of the 9 classes (*kuhon* Amida; cf. *Hō.*, p. 30a and Demiéville, "Les versions chinoises," p. 236, and *Butsuzō- "ikonogurafī,"* p. 16) may be seen on the 9 Amida statues of the Kuhon-butsu Jōshin-ji, Tokyo.

It should be noted that this iconography was not really established until the end of the XI cent., although the *kuhonmandara*, Circle of the 9 Classes, was introduced from China by Eun in 847 (cf. *Hō.*, p. 29a).

N.B. For the other mudrā of the Amida of the 9 Classes, cf. the present text, s.v. *jo-in* (*infra*). It must be noted that the Amida of the 9 Classes of the *Hō.*, p. 28, fig. 13, form another and different series of mudrā. Variant listings are also noted in the *Butsuzō- "ikono-gurafī,"* p. 16.

62　Cf. *Hō.*, p. 29a: *Daishūkōyō* of Kōken (pub. 1739).

63　Mochizuki, *BD*, p. 78. *ZZ*, Pl. 31: the two attendants of Amida show the *an-i-shōshu-in* (left hand raised in *an-i-in*, right hand making the gesture of "gathering in."

64　Cf. *ZZ*: Pl. 54 represents Yaku-ō *bosatsu* and Yaku-jō *bosatsu* forming the *an-i-in* with the right hand, "assembling and welcoming" with the left.

Cf. Bashi, an adept in Esotericism, according to the *Himitsu jirin* (870): "The right hand is raised, the palm in front, the thumb and the index form a circle" (*Hō.*, pp. 56–57). Cf. the *vitarkamudrā* of Śiva as master of Science, South India (Musée Guimet, 18519).

65　Koizumi, nos. 22, 55. Sirén, no. 575, Kuan-yin (Sung) with the right hand in *vitarka* (thumb and middle finger).

66　Cf. Gonda and Ōmura, p. 54; Miroku makes the *daiji-sammai-no-in.*

67　*Hō.*, p. 118b. According to the *Hizōki*, Brahmā holds a lance with one of the right hands, with the other he makes the *an-i-in* ("Seal of the Gift of Security").

68　Cf. *Nihon butsuzō zusetsu*, Pl. 22.

69　Ibid., Pl. 99.

70　Ibid., Pl. 85.

71　Cf. *Kokuyaku Daizōkyō*, vol. on iconography, fig. following p. 124.

KONGŌ-GASSHŌ

1　*Gasshō* or *gasshu*, Sk. *praṇāma.* The *kongō-gasshō* is the seventh of the Twelve *gasshō.* Soothill, p. 203, calls this gesture "the mother of all manual signs." See Miyano, *Mikkyō zuinshū*, II, p. 8. *BD* 1102 calls this gesture the *bashari-in* (i.e., *vajramudrā*). It is made by *taizōkai* Taishaku (Indra).

Bhattacharyya, p. 189: *añjali, sarvarājendra, saṃpuṭāñjali.*

2　*Daisho* 13 (*T.* 1796, XXXIX, 715c): *BD* 478a.

3　*Kimyō-gasshō:* the joined hands symbolize the act of taking refuge in the Buddha.

Kimyō issaichi, "I entrust myself (vow myself) to the Omniscient." Cf. Sk. *namaḥ sarvajñāya siddhaṃ*, "Adoration to the Omniscient according to the *siddha.*"

4　*BD* 247c, li. 1: Sk. *praṇāma.*

5　Sk. *namo añjalikarmamudrā; namaskāra*, "prayer" (Getty, p. 54). *BD* 805a–b.

6　According to Ono Kiyohide *Kaji kitō oku-den:* cf. Pl. following p. 5.

7　According to the *BD* 231c, under the heading *"gasshō shashu."* In Esotericism, these two gestures seem to be equivalent. Mochizuki, *BD* (Pl. 17) under *"kongō-gasshō,"*

shows the ends of the fingers interlocked; the author calls the hands joined against each other *"kenjisshin-gasshō."*

8 *Gyōbokanyōshō* (1, quoted in *BD* 247b). Cf. *Rengebushinki*, quoted in *BD* 247b: *"kimyō-gasshō* or *kongō-gasshō* are said."

9 *Jūhokkai (Hō.*, p. 135a). In the system of the Ten Essence Worlds of the Tendai school, laymen belong to the six lesser Worlds (hells, dead, animals, *asura*, men, gods), and Saints belong to the four Higher Worlds (auditors, Buddhas-for-self, Bodhisattvas, and Buddhas . . . (p. 135b). The Shingon school divides the laymen between the hells, the dead, the animals, the men, and the *asura-deva*, while the Saints are auditors, Buddhas-for-self, Bodhisattvas, and Buddhas.

According to the *Kokuyaku Daizōkyō (Dainichikyō)*, Vol. L, 115, the *kimyō-gasshō* is equivalent to the *kongō-gasshō*. The drawing here shows the two hands joined, the tips of the fingers interlocked, right thumb over left.

10 Mochizuki, *BD*, Pl. 17. Cf. the *(kenjitsu-)gasshō* of the Zen sect Smidt, p. 116 (Pl. VII, fig. 4).

11 *BD* 231b.

12 Foucher, *Beginnings of Buddhist Art*, Pl. XXVIII (2).

13 Smidt, p. 116: The *kongō-gasshō* corresponds to the *kongōkai*, the *renge-gasshō* to the *taizōkai*, because the Shingon sect is a system of the *kongōkai* and the Tendai a system of *taizōkai*.

14 Ibid., p. 117ff. The author notes that the "Jōdo and Shin sects have only the *koshin-gasshō*, without the crossed thumbs of the *kongō-gasshō*, a crossing which the Jōdo sect identifies with the *koshin-gasshō* of the other fingers. This is the *renge-gasshō* of Amida Nyorai."

15 *BD* 1214c: by "contemplating one's fundamental nature and becoming Buddha" it is meant that one attains the state of Buddha by rejecting all literary help, by examining directly the (human) heart, and by penetrating into and by perceiving the fundamental nature of the heart (according to the *Goshōron*). Cf. Eliot, *Japanese Buddhism*, p. 160.

Smidt, p. 116: "To become Buddha, whereby one perceives the essence of the human soul, through the most exact knowledge of the nature of one's own soul."

16 Cf. tr. of the *Gyōbōkanyōshō* (1), quoted in *BD* 247b.

17 *BD* 247b, li. 2–4. *Kimyō* = Sk. *Namas, namaḥ, namo (namu)*. Note the expression *Namu Amida Butsu (Hō.*, p. 198a).

18 Cf. *Asabashō*, 48: Fukūkensaku Kannon.

19 Cf. *BD* 1681a.

20 Mallmann (p. 263) notes that the particular intention of this gesture is confirmed by the name *Sarvarājendra*, "sovereign of all the kings."

21 Ibid., p. 263: "among the Indian forms of Avalokiteśvara, only Ṣaḍakṣrī-Lokeśvara holds his main hands in *añjalimudrā*. We have not met with this gesture in any human Avalokiteśvara."

22 Cf. Sirén, Pl. 473: *Bhikṣu*.

23 Koizumi, no. 51: Monju; Sirén, IV, 503, Bodhisattva at T'ien Lung Shan; *Nihon no chōkoku*, V, 32: Fugenbosatsu.

SOKUCHI-IN

1 *IC*, p. 872: *bhūmi*, "earth"; *sparśa*, "touch," from the root *SPṚŚ-* "to look for, to put one's hand on." *Sparś* is glossed in Jap. by *fueru (sawaru)*, "to touch, feel, contact";

bhūmi = *chi*, "earth, that which may produce," "that which serves as a base." Cf. *BD* 1189c, li. 20 and Soothill, p. 336b, "that on which it relies."

2 The divinity which makes the *sokuchi-in* should be seated in *vajraparyaṅka* (cf. *āsana, infra;* Bhattacharyya, p. 190. Sirén (p. 135) maintains that the attitude which should accompany this gesture (for China, at least) is that of the *padmāsana.*

3 Takata, *Indo bukkyō-shi*, Pl. 10, following p. 170, shows the right hand, palm out, in *sokuchi-in*, and Pl. 19 (Ajaṇṭā, Cave 7, no. 1) shows the same disposition. The author calls these gestures mudrā of the demons' defeat. Also cf. Mochizuki, *BD* (1954), 3139c.

4 *Hō.*, p. 40b, under Ashuku.

5 According to *Kongōsattaki* (Kongōsatta = Vajrasattva; *BD* 481b), cited in Gonda and Ōmura, p. 6. Cf. *Shōshinjitsukyō* (*T.* 868, XVIII, 275c, li. 26ff.): *BD* 1035b.

6 Gonda and Ōmura, p. 6. Getty (p. 165) writes: "The right arm is pendent over the right knee, the left hand lies on the lap, palm upward."

7 Cf. *Hō.*, p. 40b: also fig. 19, p. 40.

8 *An*, "restrain, repress, consider, investigate, mass."

9 Toganoo, *MK*, pp. 482–83, notes that mention is found of this story in *Fuyōkyō* (*T.* 186, III, 483ff.) and in *Hōkōdaishōgonkyō* (*T.* 187, III, 539ff.) — i.e., the *Lalitavistara.* Also cf. Foucher, *La Vie du Bouddha*, pp. 183–84.

In the *Fuyōkyō*, it is explained that the Buddha indicates the earth, but the gods of the earth are not mentioned. The *Hōkōdaishōgenkyō* mentions the apparition (Toganoo, *MK*, p. 483, n. 1) of the gods.

9a Cf. Warren, *Buddhism in Translations*, pp. 80–81. But not all texts mention Vessantara. The *Mahāvastu*, for example, is completely silent on this subject. Cf. Rowland's review of *The Life of the Buddha.*

10 Also *gōma-sō* (*BBK*, p. 506).

11 Note also the raised index, at the level of the eyebrow, which expresses the anger that vanquished the demons (cf. *Si-do-in-dzou*, p. 73; cf. *fuma-in* of the *Taizō inzu* (Vol. I) in the *Daizōkyō zuzō*, VIII, p. 189, fig. 46: cf. *Himitsu jirin*, p. 960.

In India this form of the raised index constitutes the *tarjanīmudrā*, a mudrā of warning or of menace. If a lasso is found attached to the index, the gesture is called *tarjanīpāśa:* if the hand holds a *vajra* (the index raised as usual) the gesture is called *vajratarjanī* (Bhattacharyya, p. 197: cf. Mallmann, *Intro.*, p. 265). If the stiffened finger indicates an object on the ground, the gesture is called *sūcī hasta* (Rao, I, 1, pp. 14ff.).

12 Mārarāja, god of lust, sin, and death, who may assume many monstrous forms and who sent his daughters to seduce or to frighten the "saints on earth" (Eitel, p. 97a).

13 Evil spirit (cf. Eitel, p. 202b).

14 *Si-do-in-dzou*, p. 73. Cf. *Shugokokkaishukyō* (*T.* 997, XIX, 530b, li. 22).

15 Conze, *Buddhism*, p. 35.

16 Burgess ("Buddhist Mudras," p. 25a) writes: "The Bhūmisparśa (Bhūmisprś) or Dharmasparśa mudra — the 'earth-pointing' or 'witness' attitude of Śākya-Buddha and Akshobhya. . . ."

17 Foucher, *Iconographie bouddhique*, p. 69.

18 Glasenapp, *MB*, p. 98.

19 Foucher, *Iconographie bouddhique*, p. 69.

20 Gonda and Ōmura, p. 6.

21 For texts concerning the *nōsaibuku-in, kama-in*, and *nōmetsu-binayaka-in*, cf. *Hō.*, p. 40, s.v. Ashuku.

22 Sirén, p. 136: *"mudrā de l'Ensorcellement."*

23 *Hō.*, p. 195b. The *sokuchi-in* corresponds to Akṣobhya of the Diamond World (*kongō-kai*): in the Matrix World (*taizōkai*) it corresponds to Dundubhiṣvara.

24 According to the *Shōshinjitsukyō* (cf. n. 5, *supra*), text cited in Gonda and Ōmura, p. 6, li. 2.

According to Gonda and Ōmura, p. 6, li. 9–10, the act of holding the *kesa* indicates the defeat of the demons.

25 After the *Shōshoyugaki* (*T.* 1120a) cited in Gonda and Ōmura, p. 6, li. 3ff. Cf. *BD* 846c.

26 Cf. *Jikkanshō*, I (*kongōkai*) Ashuku makes the *sokuchi-in* with his right hand: the left hand holds a section of his robe. The five-pointed *vajra* (*goko-sho*) is assigned to him as an attribute — which would explain the presence of the *kongō ken-in* made sometimes with the left hand.

27 Gonda and Ōmura, fig. 15 (p. 10): Tenkuraion [Ku-on] (= Fudō.) Cf. *BD* 1246c.

28 *Hō.*, p. 40a, s.v. Ashuku. Cf. also *Kokuyaku Daizōkyō*, section on images and symbolism, p. 12.

29 Mochizuki, *BD* (1954), 3139c.

30 Cf. Sekino, *Chōsen no kenchiku to geijutsu*, Pl. 17: Buddha; and Pl. 21: Amida Nyorai.

JŌ-IN

1 *Dhyānamudrā* (Eitel, p. 49a–b, "abstraction," "contemplation," "exercises in reflection"); also *jñānamudrā*, *padmāsanamudrā*, *samādhimudrā* (Burgess, "Buddhist Mudras," p. 25); *Hō.*, p. 16a: "*Extase où est éliminée l'obstruction des passions.*"

Majumdar, *The History of Bengal*, I, p. 475, describes the *jñānamudrā* thus, citing Rao: "The tips of the middle finger and the thumb are joined together and held near the heart, with the palm of the hand turned towards the heart."

2 Cf. Eitel, p. 140b: "Abstract meditation, resulting in physical and mental coma and eventually in *nirvāṇa*."

Toganoo, p. 478, notes that this idea of concentration, such as it is manifest in Buddhism and notably such as it is symbolized by the *jō-in*, comes from the practice of concentration, i.e., yoga (*yugasammai*).

3 A considerable number of interchangeable appellations are classified under the general heading of *jō-in* (Mochizuki, *BD* [1954], 3679b–c): *sammai* (*-in*) (transcription of the Sk. *samādhi* [*mudrā*] (*BD* 661c), cf. Eitel, p. 140a; *zen* (*na*) *-in* or *zenna haramitsu*; *hokkai jō-in*; *nyū jō-in*; *baku jō-in*; *daiichi saishōsammai* (*no*) *-in* (according to the *Shugokyō*, *T.* 997, XIX, 581c ff.); *zenharamitsu bosatsu-in* (according to the *Senjuki*, *T.* 1056, XX, 72a ff.); *shakamuni daihachi-in*, and *nyoraihachi-in* (according to the *Daisho*, *T.*, 1796, XXXIX, 714a ff.), cited in Mochizuki, *BD* 1993a. Other designations are mentioned in the text. The word *jō-in* may be accepted as the generic term which designates any mudrā of concentration.

Waddell (p. 337) writes "The Impartial or Meditative Pose"; Sirén (p. 134), "*Sceau de la méditation.*"

4 The manner of crossing the legs may vary: if the left leg is crossed over the right, this is the attitude which should evoke the suppression of the demons, the episode which is associated with the meditation under the *bodhi* tree; the inverse indicates benediction. The same is the case for the position of the hands.

5 Gonda and Ōmura, p. 8, li. 3, *Shōshinjitsukyō* 2 (*T*. 868, XVIII, 276a, li.12): the gesture thus formed is called the *hokkai jō-in* (which signifies that Amida and Dainichi are identical). This denomination may in fact designate the *jō-in* of the three types.

6 Cf. Sirén, Pl. 16, 35.

7 Cf. a continental prototype. Bachhofer, *Early Indian Sculpture*, Pl. 157 (Taxila, V century).

8 Cf. the statue of Muni Suvrata (20th Tīrthaṃkara of the Jains, Musée Guimet 5343.

9 Cf. Sirén, No. 615, Yuan dynasty: No. 264, 383.

10 Cf. Grousset, *L'Inde* (1949), fig. 66: Musée Guimet, No. 17, 483 (Angkor Vat, XII century).

11 Mochizuki, *BD*, Pl. 17, calls this gesture the *hokkai jō-in* (the two thumbs join). When the two thumbs rise and form the mystic triangle by joining, he calls this gesture *yakkon-in*, gesture of the medicine bowl (of Yakushi). The *Hō.*, p. 243b, speaks in the article on *byō* of a "boîte à médicaments": the phial of Kannon (*byō*) "qui ne semble pas avoir la même destination" is mentioned. Cf. *ZZ*, Pl. 24.

12 Cf. Sirén, 43, 44.

13 Cf. *ST*, I, The Mysterious Five (*kakemono*); V. Kwanshin (Tōshōdai-ji, Nara); VI, Ashikaga Yoshimasa: Koizumi, 25.

14 Sickman, *University Prints*, 0–184, Lohan (T'ang).

15 Mochizuki, *BD*, Pl. 17.

16 On the example of the *Kanjizaiōshugyōhō* (*T*. 932, XIX, 77b, li. 21ff.): ". . . the two hands lie [in the lap], the palms up, touching, the two indexes back to back and erect, the two thumbs touching the tips of the indexes" (Gonda and Ōmura, pp. 7–8).

17 See Miyano, *Shingon mikkyō zuinshū, taizōkai* (1), p. 3a, fig. 8. Ibid. (p. 2a, sect. "*Taizōkai nenjushiki*") notes that the hands are flat; the right rests on the left.

18 Getty (p. 168) states that in Japan the fingers are tightly locked, with the exception of the thumbs and the indexes, which touch at the ends, forming thus the so-called "triangular pose." Mochizuki, *BD*, Pl. 17, calls this gesture the *mida jō-in* (Amida's concentration mudrā).

Cf. *Asabashō* 30: divers Amida in *padmāsana* and in *jō-in*. Here is seen the variant in which all the fingers follow the curve formed by the index.

19 China: cf. Sirén, IV, Pls. 597–598: Śākyamuni in meditation; Japan: Kamakura Daibutsu (*ST*, VI); Amida of the *Hōnen-in*, Kyoto (*ST*, I); see also *ZZ*, Pl. 72, 1232.

20 Soothill, p. 254b. Hence the name *jogaishō-jō*, "ecstatic concentration in which the Obstruction (of Passions) is eliminated" (*Hō.*, p. 16a).

21 Cf. *Yogātchārya* (Eitel, p. 208b).

22 From *dhyāna*, spiritual contemplation exempt from all obstacles of the senses.

23 Cf. Soothill, s.v. *jō* (concentration), p. 254b.

24 Mus, p. 586: "This (*dhyāna*) mudrā was used to represent the Buddha in his meditation and under the tree."

25 Liberator of the serpents: this is the mystic gesture of Batō Kannon and emblematic of the lotus flower (Getty, p. 39).

26 The *uttarabodhimudrā*, the gesture of perfect enlightenment, is not usually considered to be a *jō-in*. This mudrā is formed by crossing the fingers at the level of the breast, the palms down, the indexes raised and touching the thumbs at the ends. In Japan, the middle fingers may also be raised.

Cf. *uttarabodhi* in Gordon, *The Iconography of Tibetan Lamaism*, pp. 22, 23. In Tibet, Gordon notes this to be the mudrā of the historical Buddha as Liberator of the Nāgas and that of Nāmasaṅgīti. Waddell, on the other hand, notes a different mudrā under this designation. In *The Buddhism of Tibet*, p. 337, he reports: "The best Perfection (Skt., Uttarabodhi). Index-finger and thumb of each hand are joined and held almost in contact with the breast at the level of the heart." This is obviously a kind of *tembōrin-in*, associated with Vairocana (Dainichi). See *tembōrin-in*, note 53.

27 Mus, p. 586.

28 *IC*, p. 569, ¶ 1169: "the *yonimudrā*, used in the *pūjā* in honor of Durgā, symbolizes the feminine organ: the fingers are brought together to circumscribe the figure with a triangle." Yoni (Renou, *Dict.*, p. 594) = matrix, uterus; fig., place of birth, source, origin, homeland; race, caste.

In Japan the triangle symbolizes the flame, the third element, which destroys impurity.

29 Getty, p. 177, according to Beal. She adds: "When seated in dhyāna-mudrā the Buddha forms a perfect triangle resting on its base and it is believed by Buddhists to have been his attitude in the womb of his mother. In the Garbhadhātu maṇḍala, the triangle rests on its base, and, according to the esoteric doctrine, is the form which is symbolical of material essence. The triangle with the point below is the symbol of the highest form of spirituality — the spiritual essence of Ādi-Buddha." Cf. Soothill, p. 312b.

30 Steinilber-Oberlin, *The Buddhist Sects of Japan*, p. 119.

31 Auboyer, "Moudrā," p. 156a.

32 Mochizuki, *BD*, 1993a and b; *Si-do-in-dzou*, p. 22.

33 ". . . the Wisdom-circle is an extent ideally equivalent to that of the whole Universe, and is gnosis realised as such. Now the meaning of a circle is with respect to its centre, which is a mathematical, and undimensioned point, not with respect to its actual extension in physical space" (Coomaraswamy, *EBI*, p. 42).

34 Smidt, p. 114, writes: "The *honzon* of the Jōdo sect is Hosshin Amida, who makes the *jō-in* composed of a wheel of the Law made by each hand by joining the thumb and the index to make a circular shape.

35 Cf. *Daisho* 13 (*T.* 1796, XXXIX, 714a ff.).

36 According to *BD* 1222c, s.v. *jō-in*: 1 *Butsubu no jō-in*; 2 *Rengebu* no *jō-in*; 3 *Kongōbu no jō-in*.

37 *BD* 1222c or *jū jō-in* of *taizōkai* Dainichi.

38 *BD* 1594c: cf. *BBK*, 447; the right hand rests on the left, the two thumbs slightly separated, the palms turned up. The joining of the thumbs, however, is typical of this mudrā when it belongs to the *taizōkai*. According to the *BBK*, the thumbs of this type, when closed, represent the *taizōkai*, when slightly separated, the *kongōkai*. Cf. *taizōkai* Dainichi, *Jikkanshō*, I; the thumbs touch, the right hand rests on the left.

39 Gonda and Ōmura, p. 3, cites the *Ryakushutsukyō* (*T.*, 866, XVIII, 223c ff.) and the *Sonshōbucchōshuyugahōgiki* (*T.* 973, XIX, p. 368b ff.); see Mochizuki, *BD* (1954), 367b, for other texts.

40 Gonda and Ōmura, p. 3; the figure shows this form of *hokkai jō-in* in which all the fingers are flat. Cf. figs. 3 and 4 on p. 4.

41 *Ri* (Principle) = *taizōkai* (*BD* 1813a). Cf. the discussion of this term by Bodde, "Chinese Philosophic Terms," p. 238. *Chi* (Knowledge) = *kongōkai* (*BD* 1787b). The oneness of *chi* and *ri* = *ri-chi fu-ni* (*BD* 1813). Cf. *BD* 1339c.

42 Gonda and Ōmura, p. 4, according to the *Hizōki* of Kōbō Daishi.

43 Form of Type C, cf. *Hō*, p. 29, fig. 14: "This is the Seal of the first of the 9 Amida of the 9 Classes. . . . Sometimes the indexes are not raised and the Seal has but one circle, closed by the thumbs, and not two."

Smidt, pp. 114ff., adds the *hosshin* Amida (*honzon* of the Jōdo sect). Cf. fig., p. 7, Gonda and Ōmura, pp. 7, 8: according to the *Kanjizaiōshugyōhō* (*T.* 932, XIX, 77b, li. 21ff.): see note 16 of this section.

In India, before the Gupta period, the iconography of this mudrā as a gesture of Amida had not yet been established and what is more, the connection between the Sukhāvatī and Amida was not absolute. ". . . in fact, we know of some texts in which Buddha is preaching in the Sukhāvatī instead of Amitābha: those who wanted to represent Buddha preaching in the Sukhāvatī must have, therefore, attributed to him the *dharmacakramudrā* rather than the *samādhi-mudrā*" (Tucci, "A propos d'Avalokiteśvara," p. 178).

44 *Myōkanzacchi* (Sk. *pratyavekṣaṇājñāna*), *Hō.*, Suppl., p. *II*, first fasc. See Mochizuki, *BD* (1954), 379b, for this posture.

45 "From the point of view of Diversification" (*Hō.*, p. 28a).

46 *Hō.*, p. 28a.

47 *BD* 1727c, s.v. *myōkanzacchi.*

48 Ibid.

49 Cf. *myōkan*, Soothill, pp. 76–77. According to a verse from Nāgārjuna on the unreality of all phenomena, the result of the chain of cause and effect, the Middle School of the Tendai Sect proposes a meditation comprising three states. This is the theory of the San Dai or Three Dogmas (*BD* 645a–c).

1 *Kū* (*śūnya*): everything, as a result of causality, is of an unreal nature: this is a state of transcendental universality; spatial; free from subjectivity; a synthesis of all Buddhist thought.

2 *Ke* ("fictive"): things of unreal essence are real by their fictive forms: temporal existence; imminence; all *dharma* are temporary; identity of the human mind and the absolute.

3 *Chū* (the Middle Way): but both 1 and 2 are really one: this is the Way of synthesis; identity of the human mind with the universe stresses logic and a system with a systematic approach.

50 Cf. *Hō.*, p. 29a.

51 Mochizuki *BD* (Pl. 17) uses for *hokkai jō-in* the name *mida jō-in:* cf. p. 177ff. Cf. *Jikkanshō*, I, (*kongōkai*) Muryōju in *sammaji-in.*

52 De Visser, *ABJ*, p. 340, under the heading of "Amidism in Japan in the 10th and 11th centuries A.D.," tells the story of a priest by the name of Ryūkai, of the Hossō Sect, connected with the Gangōji. The priest died making the *muryōju nyorai-in* (cf. *BD* 1720c: this is the *nyū jō-in* of the *Rengebu:* Muryōju Nyorai = Amida) with his right hand: when his body was burned only the mudrā remained (according to the *Nihon kiryaku, Zempen*, ch. XX, p. 737).

53 *Hō.*, p. 30a. For other gestures of the Amida of the 9 Classes, cf. *an-i-in, supra.* It may be noted that the Amida of the 9 Classes in the *Hō.*, p. 28, fig. 13, make a different series of mudrā.

54 *BD* 1445a.

55 Cf. Shakamuni (Sirén, 16); Buddha (Sirén, 44); Dainichi (Koizumi, 25); Kamakura Daibutsu, Amitābha (*ST*, VI).

56 Cf. the Hōryūji Monju (N.B. fingers are curved) of the Nara Museum collection, no. 140; and the Hokkai-ji (Yamashiro) Yakushi. The mudrā of Yakushi is traditionally

the *semui-in*, but the divinity carries here his medicine bowl placed on his hands joined in *jō-in* (probably a late form). This same form appears in a *mandara* of the XII century (*Kokka*, XXXII, 1). This mudrā may also be called the *yakkon-in* or the gesture of the medicine pot (cf. Kaneko, "Butsuzō no in," p. 2).

Cf. Getty, p. 7. This position of the hands serves as a support for the wheel of Dainichi Nyorai, who, as a divinity of the polar star (myoken), holds a wheel in his hands in *dhyāna-mudrā* (Getty, p. 33; Milloué, *Petit catalogue illustré au Musée Guimet*, p. 154). Moreover, the *jō-in* serves often as a support for a symbolic object: Dainichi, the wheel (cf. *temborin-in*); Yakushi, the medicine bowl; Shakamuni, the alms bowl (cf. *Hōhachi-in*, according to the *Jikkanshō*, VII). Concerning the mystic Yakushi and his relation to the *hokkai jō-in*, see de Visser, *ABJ*, p. 565-66.

57 Cf. Kanshin, Tōshōdaiji, Nara (*ST*, V). Ashikaga Yoshimasa, Jishōji, Kyoto (*ST*, V; Yoshimasa became a priest under the name of Dōtei in 1473). Cf. also the two Chinese Lohan (Sickman, *Univ. Prints*, 0-184, 0-202).

58 Cf. the X-century Viṣṇu in *dhyānamudrā*: Codrington, *Ancient India*, Pl. 73.

TEMBŌRIN-IN

1 *Dharma* (law) *cakra* (wheel). Coomaraswamy (*EBI*, p. 25) writes: "Word-wheel (and World-wheel) or Wheel of the Law or Norm." According to the Shingon sect, "Word-wheel" and "World-wheel" are closely connected (cf. ibid., p. 30). For *cakri* and *cakra*, cf. ibid., p. 27.

Other Sanskrit designations: *vyākhyānamudrā*, *dharmacakrapravartanamudrā*, *saṃdarśana-mudrā* (?). Majumdar (*The History of Bengal*, p. 475) says that the *dharmacakramudrā* "is a combination of *jñāna* and *vyākhyānamudrās*, the left hand being in the former and the right in the latter poses."

Tib.: *Tabdong shesrap*, "the Union of Wisdom with Matter" (Getty, pp. 30, 168). Burgess ("Buddhist Mudras," p. 25a-b) writes that "this attitude typifies 'the unity of wisdom with matter,' . . . or the assuming of the material forms by the Buddha and Bodhisattva for the purpose of spreading the right understanding among animated beings." Waddell (p. 337) gives *ch'as 'k'or-bskor*; Burgess (p. 25) *thabs-sches* and *thabs-dan-shes-rab*.

2 Foucher, *Iconographie bouddhique*, Part I, p. 331. Takata (*Indo nankai no bukkyō bijutsu*, p. 46) adds that the *temborin-in* is formed first by joining the two hands, later by one single hand: it is probably a question, in this instance, of the *vitarkamudrā*.

3 *BBK*, p. 72. Auboyer ("Un aspect du symbolisme de la souveraineté dans l'Inde," p. 90) writes: "As for the *dharmacakramudrā*, it does not seem to appear in the iconography of India before the Gupta period."

In India, Śiva as Dakṣiṇamūrti makes the *temborin-in* which is named in this instance "the mudrā of reasoning."

Bachhofer, *Early Indian Sculpture*, Pl. 23: "*Prasenajit* post of the Southern Gate"; to the right center is one of the first examples of *temborin-in* with one hand: made by a "founder" — middle II cent. B.C.

4 *BBK*, p. 252: this variant exists as early as the time the gesture reached Japan: its use declined in the following centuries. The meaning of holding a corner of the *kesa* is not entirely clear; consult, however, n. 51 under the heading "*Semui-in*."

Cf. Gupta, *Les Mains dans les fresques d'Ajanta*, p. 15; Foucher, *Beginnings of Buddhist Art*, Pl. XXI; this same author writes in *AGBG*, pp. 328-29: "It is to be noted that in

Gandhāra the right hand is always represented above, with the little finger usually grasped between the thumbs and the left index."

5 Cf. Hackin, *Guide*, Pl. IIIb, and Foucher, *AGBG*, figs. 405, 407, 426, 456, 459, 555, and 567.

6 Cf. Hackin, Pl. XV; cf. a variant, Pl. XXIII; cf. Getty, Pl. XIV.

7 Sirén, p. 134.

8 Mochizuki, *BD*, Pl. 17: *BBK*, p. 362: *Hō.*, Pl. II and fig. 15 (p. 29a); Pl. IV, 2: *Si-do-in-dzou*, p. 9.

9 Getty, Pl. XV, a, b, and c. The variant (the fingers crossed and entwined: Pl. XI, fig. 4) is classified under the designation of *temborin-in* in the *taizō inzu* (I), in the *Daizōkyō zuzō*, VIII, p. 183, fig. 11. Cf. Takata, *Indo nankai no bukkyō bijutsu*, p. 46.

10 Cf. *BBK*, pp. 505–6: the esoteric symbolism of this gesture is based on the Table which comprises Diag. I. See design in Mochizuki, *BD*, Pl. 17.

11 "Dharmatchakra, lit. the wheel of the law. The emblem of Buddhism as a system of cycles of transmigration, the propagation of which is called Tembōrin, lit. turning the wheel of the law" (Eitel, p. 47b). Cf. *BD*, 1257a.

As for the wheel, it is probably a question of a chariot wheel. Cf. Coomaraswamy, "The Persian Wheel," 283.

12 Cf. Foucher, *Beginnings of Buddhist Art*, Pl. I, figs. 1, 2. See Toganoo, Pl. 37.

13 *Si-do-in-dzou*, p. 9. Williams (p. 392) writes: "and the turning of the wheel of the Law was probably connected with the Vedic sun-worshiping ceremonies in which a chariot wheel was fastened to a post and turned towards the right, i.e. following the path of the Universal Law which directed the sun in its orbit." Cf. P. E. Dumont, "The Indic God Aja Ekapād, the One-legged Goat," pp. 326ff.

14 Vairocana: from *virocana*, "who illumines, who lightens; masc., sun, sun god, Viṣṇu; moon" (Renou, *Dict.*, p. 672b, s.v. *virocana*).

15 Dainichi Nyorai as god of the polar star holds a wheel in his hands, which are joined in *dhyānamudrā* (cf. Getty, p. 33). "Mio-ken, The Polar star, was a type of the eternal because apparently it never changed with time. It was the earliest type of supreme intelligence . . . which was unerring, fast and true . . . a point within a circle from which you could not err. . . . It was called the eye upon the mountain, the radiating centre of light surmounting the triangle" (Getty, p. 33 n. 1), quoting Churchward, *The Signs and Symbols of Primordial Man.*

16 Glasenapp, *MB*, p. 87: "Vairocana is then the *Buddha solaris* who dissolves the shadows of doubts."

17 Combaz, "L'Evolution du stūpa," IV, 110: wheel = sun, revolution of the year, creation of the Law, the Law, the Buddha (p. 111). For a bibliography of Indian works concerning the revolution of the year, cf. Coomaraswamy, *EBI*, pp. 25ff.

18 Ibid., p. 25.

19 Ibid., Pl. I, figs. 2 and 3; ca. A.D. 200.

20 *Aitareya Brāhmaṇa*, VIII, 2, cited by Coomaraswamy, p. 28. Cf. ibid. for the chariot of the sun conceived as a three-wheeled carriage (*tricakra*): cf. "Principial and Existential Wheels," p. 30.

21 Ṛg Veda, V, 29, 4; and X, 89, 4, cited in Coomaraswamy, p. 28.

22 *Cakra-vartin*: lit., the one who has, who possesses the rotation of the wheel. For the etymology of *cakravartin*, cf. Senart, *Essai sur la légende du Bouddha*, p. 7: "gifted with, possessor of the *cakravāla* — in other terms — "he who is limited only by the extreme limit of the world, who, in other terms, possesses it completely."

In Pāli, *cakkavattī:* (cf. Eitel, p. 172a). The wheel is one of the principal symbols of Viṣṇu (as king of the universe) as well as of Śiva.

The term *cakravartin* does not exist in the Veda, but one meets there the notion of a supreme Force, so that the idea of the universal king may hardly be considered as an innovation of Buddhism (cf. Coomaraswamy, *EBI*, p. 27).

The *cakravartin*, according to Eitel (p. 172), is the military conqueror of a part or of the totality of the universe. Great sovereigns took this title for themselves.

For the myth of the *cakravartin*, cf. Przyluski, "La Ville du cakravartin," *Rocznik Orjentalistzczny.*

23 Cf. Eitel, p. 171a: *tchakra*, Tib. *khor lo.* Cf. Soothill, p. 469b. For the Brahmanic wheel (*bonrin*) see *Hō.*, p. 120a, b.

24 Glasenapp, *MB*, p. 103. The wheel, originally an arm of the sovereign of the world (*cakra-vartin*, "he who makes the wheel turn"), with which he subjects the whole world, is mentioned in the ancient *Dīghanikāya* (14, 1, 30) as being the first of the precious things (*ratna*) of the universal monarch.

25 *BD* 1259a, s.v. Tenrin-ō, li. 22. Cf. Foucaux, *Histoire du Bouddha Sakya-Mouni*, pp. 14–15: "La roue qui 'vient.' "

26 *BD* 1257a gives two ideas for *cakra:* 1 that of revolution; 2 that of crushing.

27 Auboyer, "Moudrā," p. 156b.

28 Williams, p. 392.

29 Combaz, "L'Evolution du stûpa," p. 110: "Buddhistically speaking, the Buddha by turning the wheel . . . recreated the Law of the world for a new *kalpa.* . . ."

30 Cf. Coomaraswamy, *EBI*, p. 27. Bousquet (*Praśna Up.*, VI, 6) translates: "Celui en qui les seize parties sont fixées, tels les rayons dans le moyeu du char, celui-là, je le connais comme étant l'Etre que l'on doit connaître."

In Pāli texts and later Sk. texts the "Person" is called *cakkavattī (cakravartin).*

31 Coomaraswamy, pp. 26–27.

32 Williams, p. 392.

33 Foucher, *AGBG*, fig. 475, 2–b (Sāñchī and Amarāvatī).

34 Coomaraswamy, p. 33.

35 Foucher, p. 432; at Lahore, no. 134, the wheel stamps the front of the socle . . . : "we do not see particularly that the Master had yet adopted the gesture which would later become the characteristic mudrā of his predication."

36 *Hō.*, p. 188a, s.v. *Bussokuseki*; cf. the figure (Yakushiji) on this same page. The wheel with 1,000 spokes appears on the famous engraved stone at Pāṭaliputra which Hsüan-tsang describes (*Daitōsaiikiki*, *T.* 2087, LI, 867b ff.). Cf. Beal, *Si-yu-ki*, II [Bk. VIII], p. 90.

37 The wheel with 64 spokes at Amarāvatī (Coomaraswamy, *EBI*, Pl. I, figs. 2, 3). Cf. the wheel of life which figures in Przyluski, "La Roue de la vie à Ajaṇṭâ," Pl. 319. The Ajaṇṭā wheel had eight divisions (hence spokes). Cf. Waddell, "The Buddhist Pictorial Wheel of Life," p. 134.

According to Hsüan-tsang, the diamond throne of the Buddha reposes on the felly of a 1,000-spoked wheel (Getty, p. 166).

38 Auboyer, "Moudrā," p. 156b.

39 Cf. Coomaraswamy, *EBI*, Pl. VI, fig. 25.

40 Cf. the sudarśanacakra (Musée Guimet): *Revue des Arts Asiatiques*, V (1928), Pl. XVIII, fig. 1.

41 Fragments remain at Sāñchī and at Mathurā.

233

42 Getty (p. 167, s.v. *cakra*) writes that in the middle of the calyx is found a Nepalese Yin-Yang.

43 The Type C form of *jō-in* is actually composed of two wheels of the Law, constituted by the junction of the thumb and the index of each hand. This is the mudrā of hosshin Amida, *honzon* of the Jōdo sect (after Smidt, pp. 114ff.).

44 The iconographic representations of Gandhāra, are used indeterminately. The *tembōrin-in* is not the only mudrā there to express the crucial moment of the Buddhist legend.

45 There is confusion here with the *seppō-an-i-in*. The *seppō-in* designates simply the hand which forms the mystic circle. It is nevertheless evident that this denomination is applied also to the *tembōrin-in* which is actually two *seppō-in* juxtaposed.

46 Auboyer, "Moudrā," p. 156.

47 Cf. also the *tembōrin-in* in China: Sirén, III, Pl. 442. According to the *Jishibosatsuhō* (*T.* 1141, XX, 595c, li. 9ff.): "In the middle is placed the bodhisattva Jishi as the central divinity. On his head he wears the crown of the five *tathāgata*. In his left hand he holds a lotus in which is placed an essence-world stūpa (*hokkai tō-in*). With his right hand he forms the *seppō-in*, and he is seated in the full lotus posture (*kekka fuza*).

48 That is to say, the Shingon sect (*Hō.*, p. 29a).

49 Cf. the famous Hōryūji mural (*Hō.*, Pl. II, as well as Pl. IVb). Mochizuki, *BD*, p. 177b (li. 27) speaks of the *Taemandara no honzon* in *seppō-in* (Jōdo sect), (*BD* 115c). Sirén, p. 138, writes that, in China, "the bhūmisparśa and the dharmacakra mudrā are never present, that we know of, in the statues of Amitābha." This is universally true.

50 Soothill, p. 56b, s.v. *jōguhonrai:* "Above to seek *bodhi*, below to save all."

51 Smidt, pp. 114ff. This is symbolism proper to the Shin sect (p. 117) whose *hosshin* Amida occupies the position of *honzon*. The author calls this gesture *tempōrin-sō* or *seppō-no-sō.*

52 Ibid., *gekeshujō*, "den göttlichen Gewinn, den die Erdgeborenen von der Wandlung des Butsu haben."

53 *Si-do-in-dzou*, p. 9: here the *tembōrin-in* figures under the heading of *taizōkai. Hō.* (p. 148b) mentions the Five Bucchō, of which Sitātapatra is one, as being the "Kings turning the Wheel."

54 Getty, p. 30. The system of the Ādi-Buddha (first Buddha; creative force, source of the Five *dhyāni*-Buddhas, born of the action of the Five Knowledges (*jñāna*) and the Five Concentrations [*dhyāna*]) does not exist in Japan. For the Amidist sects, Amida is the original Buddha (*ichibutsu*); for the Hossō, Tendai, Kegon, and Shingon sects, the supreme Buddha is Dainichi (Vairocana). These two supreme Buddhas are not supposed to have "created" the four other *dhyāni*-Buddhas. The *dhyāni*-Buddhas are but manifestations of the supreme Buddha, either Amida or Dainichi. According to Tantric Buddhism, the *dhyāni*-Buddhas would derive from the Five Elements which, in principle, are eternal; these Elements constitute the Being when they are fused together by action (Bhattacharyya, *Introduction to Buddhist Esoterism*, p. 129).

55 *Ōjin* = Transformation Body (*nirmāṇakāya*): *ōjin-seppō-in*, the mudrā of the explanation of the Law of the Transformation Body. *Nirmāṇakāya*, one of the three bodies, may vary in meaning: a) an incarnation of the Buddha (*kesshin*, metamorphosis body); b) the Buddha as Reality; and c) sometimes the Enjoyment Body (*hōjin, juyōshin*, Sk. *sambhogakāya*) or the body which is given to him for his own use and enjoyment. Thus this gesture is called the *hōkenishinseppō-in*, mudrā of the explanation of the Law of the Two Bodies (that of Enjoyment and that of Transformation).

56 Cf. Gonda and Ōmura, p. 10, fig. 16: Shaka Nyorai.

57 Ibid., p. 14.

58 "One's own assurance of the truth" (Soothill, p. 131b).

59 "External manifestation, function or use" (Soothill, p. 184a). Cf. fig. 16 in Gonda and Ōmura.

CHI KEN-IN

1 The gesture of the right hand in this mudrā is called *kenrō kongō ken-in*, adamatine diamond fist or simply, *kongō ken-in*, diamond fist. The Sanskrit designation would derive from the use of this mudrā in the *vajradhātu* (*kongōkai*) *maṇḍala*. Getty (p. 30) calls this gesture the mudrā of the Six Elements (Pl. II, fig. a; LXII, fig. d).

2 Cf. n. 1 under "*an-i-in.*"

3 Takata (*Indo nankai no bukkyō bijutsu*, p. 47) gives this Sanskrit reconstruction for the *chi ken-in*. For *bodha-* read better *bodhi-*.

4 Pl. XIII. For different forms, cf. Getty, Pl. II, fig. a and Pl. LXII, fig. d.

Names also used are *rokudai-in*, the mudrā of the Six Elements (Getty, p. 33; and Elisséeff, *Mythologie asiatique*, p. 406, gives this same designation); *kakusho-in*, mudrā of the victory of Enlightenment (peculiar to Dainichi Kinrin; *BD* 185b); *nyorai ken-in* (according to the *BD* 1357a and the *Kaji kitō oku-den* by Ono Kiyohide, fig. following p. 5).

5 The *Kongōchōrengebushinnenjugiki* (cited by Gonda and Ōmura, p. 2: *T.* 874, XVIII, 313a, li. 4–5 [?]), under the heading "Act Seals" (*komma-in*), calls the *kongō ken*, the mudrā of the entrance into Knowledge (*nyūchi*).

Cf. the two *kongō ken-in* (*Si-do-in-dzou*, p. 118): the right hand, World of the Buddhas, represents "the spirits of all living beings in whom the Buddha Intelligence exists in a perfect state; the left hand, Material World, moves the bell (which may be present only in thought) in order to disperse the illusions and the errors of (sentient) beings."

6 According to the *Kongōchōrengebushinnenjugiki*, the text indicates that the right hand in *kongō ken* held the extremity of the left index, the left hand reposing in the lap (Gonda and Ōmura, p. 2). Cf. Glasenapp, *MB*, Pl. I, Vairocana, XII century.

7 Cf. *Mikkyō daijiten*, II, 690, s.v. *kongōshi*.

8 Statues exist in which the index penetrates almost entirely into the right fist.

8a Mochizuki, *BD* (1954), 3571a (both quotations).

9 Incantation (Sanseido Dictionary); *bénédiction* (Hō.); *consécration* (S. Lévi, Tajima). The *kaji* are the means (*dhāranī, mantra*) by which one may be identified with the Buddha; Sk. *adhiṣṭhāna*. According to Soothill (p. 167b), *kaji* is defined as "dependence on the Buddha, who confers his strength on all (who seek it), and upholds them; hence it implies prayer, because of obtaining the Buddha's power and transferring it to others."

10 *Shōshinjitsukyō* (*T.* 868, XVIII, 275c, li. 2–16). Gonda and Ōmura cites this text on p. 2, li. 8ff. Also see Mochizuki, *BD* (1954), 3571a.

11 Getty, p. 168 s.v. *dharmacakramudrā*; *BBK*, p. 507.

12 Foucher, *AGBG*, fig. 555.

13 Cf. Bachhofer, *Early Indian Sculpture*, Pl. 153: the Buddha of Sahri-Bahlol.

14 *BD* 1357a. Gonda and Ōmura (p. 41, fig. 121) shows Daijō Kongō making the *chi ken-in*; he is seated on a lotus and bears various attributes in the hands.

15 *Ādi.* Cf. *svayambhū* (Eitel, p. 168a).

16 Vairocana of the *taizōkai* makes the *jō-in* (*dhyānamudrā*). Cf. Gonda and Ōmura, p. 3, *Sonshōbucchōshuyugahōgiki* (*T.* 973, XIX, 376a, li. 1–3 [?]).

17 *Hokkegisho* 12 ((*T.* 1721, XXXIX, 621ff.). Tr. by Kichizō (Chi-ts'ang), Sanron

sect, born at Nanking in 549 of a family of Parthian origin (cf. *Hō.*, fasc. an., p. 142b, s.v. Kichizō).

18 Getty (p. 32) writes: "earth, little: water, ring: fire, middle: air, index: ether, thumb." The fingers represent also the Five Aggregates, the Bodhisattvas, the Roots.

19 Eitel, p. 198: also used are *rokunyū*, the Six Entrances (*ṣaḍāyatana*; cf. Soothill, 132b); *rokuroku*, the Six *guṇa* (p. 39b): *1 cakṣuḥ*, eye, view; *2 śrotra*, ear, hearing; *3 ghrāṇa*, nose, smelling; *4 jihvā*, tongue, tasting; *5 kāya*, body, touching; *6 manas*, mental.

20 Getty, p. 30. Cf. Elisséeff, "Mythologie du Japon," p. 406: "the index of the left hand represents the intellectual element (*chi*)." *IC*, p. 426, § 851: "There is also . . . a theory of sexual union in the form of a flame which penetrates the body of the woman."

21 Getty, p. 30: "The six fingers represent the Six Elements which, when united, produce the sixfold bodily and mental happiness." Cf. also Elisséeff, p. 424.

22 *Manas* (Eitel, p. 93b).

23 The index represents the first of the *gochi nyorai* (the five *dhyāni*-Buddhas), products of the Knowledge of the Ādi-Buddha.

24 Anezaki, *Buddhist Art*, pp. 34, 35.

25 Gonda and Ōmura, p. 3, li. 7): "this represents the nonduality (of body) of the *ri* and the *chi* (which are two)."

Cf. Soothill, p. 360a–b, for the explanation of the term *ri-chi*. This phrase also signifies (Gonda and Ōmura, p. 4, li. 1) "interior attestation, absolute perfection." Cf. Soothill, pp. 219b, 397b.

26 *BD* 1194c, according to the *Ichijichōrinnōkyō* (*T.* 955, XIX, 313b–315c): "The fist may contain the Knowledge of the Law of all the Buddhas."

27 Cf. *BD* 1187c. For the *kongōkai*, besides the Knowledge of Dainichi (*hokkaitai-shōchi, dharmadhātujñāna*), Knowledge of the absolute in which the opposition between subject and object ceases (Glasenapp) and which is expressed by the *chi ken-in*, there exists the group of gestures called *shi-in* ("four mudrā") which symbolize the Four Knowledges. (Cf. the Five Knowledges, Glasenapp, *MB*, p. 85). The Four Knowledges are:

1 *Daienkyōchi*, the Mirror Knowledge (Sk. *ādarśa-jñāna*) pertaining to Ashuku (Akṣobhya): *BD* 18c. The Knowledge of the round mirror reflects all the Knowable.

2 *Byōdōshōchi*, the Knowledge of the identical nature of the essences (Sk. *samatājñāna*), pertaining to Hōshō (Ratnasaṃbhava). This is one of the Four Knowledges of the Bodhisattvas who, having passed the stage of seeing-self, the seventh Knowledge of ordinary Beings, attain the *chi-e*, Wisdom, the point at which is put into execution the principle known as *jitabyōdō-no-chi*, the principle of equality (oneness) between the self and others: *BD* 1493b. In Sk. *samatājñāna*, the Knowledge of the quality of all beings in the fundamental unity (Glasenapp).

3 *Myōkanzacchi*, the Knowledge of perspicacity (Sk. *pratyavekṣaṇajñāna*), pertaining to Amida (*BD* 1720c), the Knowledge which understands all details, confusing nothing.

4 *Seijosakuchi*, Knowledge which produces acts (i.e., which perfects acts), (Sk. *kṛtyānuṣṭhānajñāna*), pertaining to Fukūjōju (Amoghasiddhi). (*BD* 1511 and 1512, fig.). It is the Knowledge of what must be done to accelerate the salvation of all Beings (Glasenapp).

De Visser (*ABJ*, p. 242, concerning the text of a *gammon*, votive document), cites the Four *Chi-in*:

1 *Daichi-in* (*mahā-jñāna-mudrā*)
2 *Sammaya-in* (*samaya-jñāna-mudrā*)
3 *Hōchi-in* (*dharma-jñāna-mudrā*)
4 *Kommachi-in* (*karma-jñāna-mudrā*).

According to the *Jñānasiddhi*, based on Bhattacharyya, *Two Vajrayāna Works*, p. xix: *Vajrayāna* signifies the Knowledge of *Vajra* which in turn is equivalent to:

1 The Knowledge of *Ādarśa*: on the imitation of the reflexion seen on a mirror, in the same way the *dharmakāya* is traced on the mirror of Cognition.

2 The Knowledge of *Sama*: this is the cognition of the *Tathāgatas* which stresses the Equality that exists between them and Beings.

3 The Knowledge of *Pratyavekṣaṇa*: this knowledge is originally pure, without beginning, naturally shining; it fills the universe.

4 The Knowledge of *Kṛtyānuṣṭhāna*: the "duties" of the Buddhas should be executed everywhere and always; these "duties" are incumbent on all Buddhas.

5 The Knowledge of *Suviśuddha*: by means of this knowledge, the ascete frees himself from the obstacles of the passions (*kleśa*) and of the Knowable (*jñeya*), which impede the attaining of *nirvāṇa*.

28 "It is probable that the irruption of *śākta* ideas in Tantrism, an irruption of which the first documents, at least in the domain of Buddhism, are still untouched, took place at a period when Tantrism was already completely formed" (*IC*, p. 424). (N.B. "The problematical presence of a *śakti* at Mohenjo-Daro" (*IC*, p. 425).

29 Conze, *Buddhism*, p. 178.

30 Glasenapp, *MB*, p. 37: "She endeavors to interpret everything in a superior, spiritual way."

31 Conze, p. 194.

32 Maraini, *Secret Tibet*, p. 91.

33 Renou, *IC*, § 2363.

34 Ibid. For sexual practices in Tantrism, see Eliade, *Yoga*, pp. 162–273.

KANJŌ-IN

1 Cf. Eitel, p. 3b, Abhishekair. Cf. *goshu-kanjō*, the Five Kinds of Kanjō: Soothill, p. 125a; cf. also the *Mūrdhābhiṣikta abhiṣecana*.

2 This mudrā is not mentioned in the *BD*. Cf. Akiyama, *Buddhist Hand-Symbol*, p. 26.

3 Cf. the likeness of this hand pose with that of the mudrā of Aizen Myō-ō (Rāga-vidyārāja) in *Hō.*, p. 16b. Compare also with the so-called *uttarabodhi* gesture in Gordon, *Iconography of Tibetan Lamaism*, pp. 22 and 23, and Waddell, *Buddhism of Tibet*, p. 337. See *jō-in*, n. 26.

4 *BD* 247a. Cf. the description of attributes and mudrā used in the *kanjō* rite as set forth in the *Asabashō*. Cf. also Eliot, *Japanese Buddhism*, p. 328. Glasenapp, *MB*, ch. entitled "Les Rites Abhisheka," pp. 115–26, gives the details on a Tantric *abhiṣeka* in Japan.

5 Eliot, p. 236.

6 Toganoo, *MK*, p. 472, li. 1; the *Murimandarajukyō* (*T.* 1007, XIX, 657c ff.) notes that the priest is supposed to imitate the gesture of the Buddha accomplishing acts, such as turning the wheel of the Law, giving the *mani-kanjō*, showing his Compassion, etc.

7 Eliot (p. 328) cites this passage from Ch. LIX of the *Hizōki* of Kōbō Daishi. According to some, the *kanjō* ceremony was introduced to Japan by Saichō. For details concerning the *kanjō*, its historical development and practice, see Coates and Ishizuka, *Hōnen, the Buddhist Saint*, pp. 172–76.

8 Glasenapp (*MB*, p. 115) cites F.W. Thomas, "Abhisheka," in Hastings, *Encyclopaedia of Religion and Ethics*, I, 20–24.

Toganoo (*MK*, p. 472, li. 6–7) mentions *Bhagavat Purāṇa* and the *Rājataraṅginī*.

9 The *Nirvāṇakālika* of Pādalipta, ritualistic text of the Jaïna, "promises a son to him who has none, to a dethroned king his restoration" (Glasenapp, *MB*, p. 115).

10 The *Agnipurāṇa*, ch. 90: "A master confers a Shivaite *abhiṣeka* on his pupil in order to dispense to him happiness" (Glasenapp, *MB*, p. 115).

11 Glasenapp, *MB*, p. 118.

12 Ibid., p. 116, for texts.

13 The first information about the rite with relation to Buddhism is Shrīmitra (Eitel, p. 158b), who explained the object of the *abhiṣeka* in the translation which he made of the *Mahābhiṣekamantrasūtra* (*Kanjōkyō*, *T*. 1331, XXI, 495a ff.) — Glasenapp, *MB*, p. 116.

14 *Hō.*, p. 195b: The unction ceremony of the Five Buddhas (*gobutsu-kanjō immyō*): "This ceremony consists of a quintuple Unction applied, with the Seals, to different places on the head of the adept, places respectively consecrated to each one of the Five Buddhas of the Diamond World: this rite aims at initiating him to the Five Knowledges which are connected with them (cf. *Himitsu jirin*, 334)." Cf. *IC*, p. 569, § 1168, "les *nyāsa.*"

15 Glasenapp, *MB*, pp. 116–17.

16 *Abhiṣeka* of Śrī Lakṣmī, North *Toraṇa*, Sāñchī, I century B.C. (Coomaraswamy, *EBI*, Pl. VI, fig. 23).

BUPPATSU-IN

1 Cf. *Hō.*, p. 171b. Also called *hachi-in* (*BD* 1399a): *hanjikikuyō-in* (*BD* 154c): *chijin-in* (Sk. *pṛthivīmudrā*); *butsubusammaya-in.*

2 *BD* 1399a. According to the *Dainichikyō* (*Kokuyaku Daizōkyō*, Vol. L, 117). See also *BD* 1564b and *Daisho* (*T*. 1796, XXXIX, 716a).

3 *BD* 1399a.

4 Ibid.

5 *Kokuyaku Daizōkyō* (*Dainichikyō*, *mitsu-in-bon*), Vol. L, 117.

6 As if to hold a bowl. Cf. the *hōhachi-in* under *jō-in*, n. 56.

7 *Hō.*, p. 171; the formula which corresponds to this gesture is *namaḥ samantabuddhānāṁ bhaḥ.*

8 *Jikkanshō*, VII, *hōhachi-in*; cf. *BD* 1564b.

BASARA-UN-KONGŌ-IN

1 *BD* 1445c. Second of the five principal gods of the *jimyō-in* of the *taizōkai maṇḍala*. In Japanese, Ba-sa-ra-un (*taizōkai*) or Bazara-un-kongō (*kongōkai*); also known as Shōsanze-kongō. According to the *Hizōki*, several symbolic objects are attributed to this divinity: left hand — lance, bow, rope; right hand — *vajra* with three points, sword.

Vajrasattva: "This latter, considered in Japan as the *dhyāni*-Bodhisattva of Ashuku, is placed with the highest Buddhas by Indian Buddhism which makes of him a sixth *dhyāni*-Buddha, the head of this group, and confuses him often with the Ādi-Buddha, whom he replaces, moreover, in Tibet" (*Si-do-in-dzou*, p. xiii).

Getty (p. 181) calls this mudrā the gesture of the supreme and eternal Buddha, the wrists crossed at the breast indicating intensity.

2 Cf. Getty, Pl. IIb (Tibet) Vajradhara.

3 *Si-do-in-dzou*, p. 118; the diamond fist symbolizes the fundamental vow of Kongōsatta (Vajrasattva).

4 Cf. Eitel, p. 177b: Trailokya, the Three Worlds = earth (*bhūr*), sky (*bhuva*),

and atmosphere (*svar*). Trailokya symbolizes also the three sorts of Beings. And p. 197b: *Vijaya* = victorious one. Gōzanze appears as a Bodhisattva in the *Lotus of the Good Law* under the name of Trailokyavijaya, Victor of the Three Worlds (*Si-do-in-dzou*, p. xiv). The Three Worlds of Buddhism are: *yoku*, world of desire; *shiki*, world of form; *mushiki*, world without form (cf. Soothill, p. 70b, s.v. *sankai* (three worlds).

5 Cf. Koizumi, no. 26.

MUSHOFUSHI-IN

1 Mochizuki, *BD*, Pl. 17; see also 1954 edn., 4836c–37b. Cf. *mushofushi-in*, as it is classified in the *Hō.*, p. 29a: cf. also Pl. IV, 1, of the *Hō.* This name means literally: the mudrā [symbolizing that] there is no place [where the Three Mysteries] do not reach.

2 Cf. the *"Sceau de la conque,"* *Si-do-in-dzou*, p. 38.

3 Smidt, p. 115: "Die sechs Ursubstanzen." Usually there are but Five Elements: earth, water, fire, wind (air), void, to which, however, may be added "mental," thus making Six Elements. Cf. Soothill, p. 134a, s.v. *rokudai.*

4 The Four Kinds of *Maṇḍala*, according to the *BD* (1670a) are:

 1 *Dai mandara:* the statues of the Buddhas and Bodhisattvas. Here *dai* refers to the Five Elements.

 2 *Sammaya mandara:* attributes and *in* representing the original vows.

 3 *Hō mandara: shuji* (*bīja* or germ syllables) and *dhāraṇī* (*shingon*).

 4 *Komma mandara:* the acts of the Buddha. Cf. the classification in Diag. II.

5 Smidt, p. 115.

6 *Ritō* is a symbol of (*taizōkai*) Dainichi. *Ri* denotes the *taizōkai* and *chi* denotes the *kongōkai.* Cf. also the *kūrin* in the *Taizō inzu* (*Daizōkyō zuzō*, VIII, 186, fig. 32).

ONGYŌ-IN

1 *BD* 154a, li. 11: transcription of the Sk. = *an-ta-so-na-in* (?).

2 *Marishidaibakemangyō* (*T.* 1254, XXI, 256b).

3 *BD* 154a. Other sūtras giving this gesture are: *Marishidaibakemangyō* (*T.* 1254), *Ichijichōrinnōyugakangyōgiki* (*T.* 955), *Marishibosatsuryakunenjuhō* (*T.* 1258), *Marishi-tendaranijukyō* (*T.* 1256), etc. See Mochizuki, *BD* (1954), 361b.

4 Eitel, p. 97b. Cf. Elisséeff, "Mythologie du Japan," p. 419.

5 Getty, p. 117.

6 Ibid. Eitel (p. 97b) says that in China this divinity is also called the mother of the Dipper. It is the Taoist belief that she resides with her husband in Sagittarius. In Brahmanism the divinity is a "vindictive form of Durgā or of Pārvatī" (p. 75a). Cf. Soothill, p. 405a, s.v. Chaṇḍī. Marīcī is the principal emanation of Dainichi (Vairocana). The *Marishi-tendaranijukyō* (*T.* 1256, XXI, 261b–262a) mentions her worship by offerings; hence interest in this divinity must date from the VI century in China, the Chinese translation of this sūtra having occurred between 502 and 557.

7 Cf. Eitel, p. 74b, s.v. Maritchi: "In Brahmanic mythology the personification of light, off-spring of Brahmā, parent of Sūrya." In China, this god is represented as a feminine divinity having eight arms, two of which hold symbols of the sun and the moon. The Taoists call her Queen of the Sky. Soothill, p. 435a: "A goddess, independent and sovereign, protectress against all violence and peril."

8 Mochizuki, *BD* (1954), 36a (*Marishitengyō, T.* 1255, p. 260b, li. 5–20).
9 Ibid.; cf. image in *BD* 1665a (*T.* 1255, 261a, li. 21–29). Marishiten herself appears holding a palm-leaf fan in her left hand while she makes the *segan-in* with her right.

GEBAKU KEN-IN

1 *BD* 439b. One of the Four *ken-in* (cf. Intro., *supra*). See also Mochizuki, *BD* (1954), 1833b–c.
Names also used: *kengobaku*, the inflexible bonds; *kongōbaku*, the adamantine bonds. *Baku* = Sk. *bandha(na)*, "bonds." This is, according to the *Hō.*, p. 48b, the name given to the Passions and especially to the three fundamental passions: attraction, hate, and error, because they obstruct liberation (cf. the same reference for other definitions according to different schools).
The Four Bonds are: attraction, hate, excessive adhesion to the disciplinary rules, self-seeing (*Hō.*, p. 122b). In the *Sāṃkhyakārikā* (*Kinshichijūron, T.* 2137, N. 1300), the *baku* are the bonds which attach the Male (*puruṣa*) to Matter (*prakṛti*).
2 *BD* 439b: *daśabhūmi* = the 10 stages of the 52 sections of the evolution of a Bodhisattva into Buddha. For the enumeration of the Six Stages, cf. Soothill, p. 47b: Eliot (*Japanese Buddhism*, pp. 341–43) gives the Ten Stages according to the *Jūjūshinron* by Kōbō Daishi.
3 *Si-do-in-dzou*, p. 17.
4 Ibid.
5 Ibid., p. 103: *yoku* = desire (*kāma*), *élan*.
6 Ibid.
7 Cf. the portrait of Gembō by Kōkei in Grousset, *Japon*, fig. 38; *ST*, IX. Also the famous portrait of Fukū (Amoghavajra) of the Kyōōgoku-ji (Tōji), Kyoto (*ST*, VII).

POSTURES AND THRONES

1 *Āsana* is an ambiguous word: 1) little support for the feet or the foot, seat, socle, or pedestal (*pītha*: Rao, p. 17); 2) pose of the legs in the seated attitude of certain divinities; "a particular mystic position of the lower limbs"—Bhattacharyya, *IBI*, p. 190. Cf. the 32 *āsana* mentioned by Bose, *Principles of Indian Śilpaśāstra*, pp. 56–57. Renou, p. 128: "the act of seating oneself or of being seated; way of sitting; camping; situation, place.
1a Eliade, *Yoga*, p. 54. For *āsana* in Indian literature, see his Note, p. 382.
2 Cf. Coomaraswamy, *EBI*, pp. 39–59, "The Place of the Lotus Throne."
3 Cf. Warner, Pl. 145, and Appendix B, p. 65, for the types of pedestals.
4 For example, cf. *Hō.*, Pls. II, 1 and VII, 1. The Buddha is represented in *padmāsana* almost since the beginning of anthropomorphic iconography—from the Āndra period (Coomaraswamy, *EBI*, p. 48).
5 Cf. *Hō.*, Pl. IV, 1 and 2.
6 Cf. Hackin, *Guide*, Pl. XV (Tibet); Getty writes that Maitreya as Buddha has no support for the two feet, but as Bodhisattva each foot is upheld by a lotus flower.
7 Getty, p. 164; Sirén, p. 133. Rao (p. 17) writes that in India, the *padmāsana* was of circular or oval form, never rectangular. The same is true in Japan; cf. the octagonal throne, *ZZ*, Pl. 102.
7a Cf. Mochizuki, *BD* (1954), 898c.
8 *Kekkafuza* (*BD*, 297c–298a). According to de Visser (*ABJ*, p. 168, n. 1): "This

is sitting like a Buddha . . . with the soles of the feet apparent": cf. *Daijii*, I, p. 1041; and Eitel, p. 117a, s.v. *kafu-za*. According to some authorities, the left leg reposing on the right signifies the subjugation of the demons (cf. *sokuchi-in*): the inverse signifies the benediction or pure meditation. According to the *Butsuzō—ikonogurafī* (p. 54) the first posture is called *kōma-za* and is characteristic of Amida; the second is called *richizō-za* and is characteristic of Dainichi Nyorai.

Bose (*Principles of Indian Śilpaśāstra*, p. 57) describes the *padmāsana* (after the *Gheraṇḍa Saṃhitā*): "Place the right foot on the left thigh and similarly the left one on the right thigh, cross the hands behind the back and firmly catch hold of the great toes of the feet as crossed. Place the chin on the chest and fix the gaze on the tip of the nose." He adds that for painted images, only the first condition is fulfilled.

The denomination *zenkaza* is also used: legs completely crossed, to distinguish the *kekka fuza* from the *hankaza*, legs half crossed.

9 Stern, "Art de l'Inde," p. 131: "but from the VI century on (the post-Gupta period, VI–VII centuries), one sees statues seated in the European manner after the royal attitude of Sassanid and Kushāna kings," a position (that is, with the ankles crossed) which existed in China as early as the Wei dynasty.

10 *BD* 483b, *kongō-za*. Williams (pp. 195–96): "adamantine, unchangeable, or fixed pose (Vajra palana)."

Cf. the discussion of this subject in Coomaraswamy, *EBI*, pp. 43ff. This term does not exist in Pāli texts, but it may frequently be found in Mahāyānist sūtras.

Bose (p. 58) cites this description of the *vajrāsana*: "make the thighs light like adamant and place the legs by the two sides." Cf. Tucci, *Teoria e pratica del mandala*, p. 26.

11 Or a swastika (Getty, p. 176). The swastika is connected with the esoteric doctrine; some sects adopted it as a special symbol.

12 Cf. Coomaraswamy, *EBI*, fig. G, p. 43.

13 Mallmann (*Intro.*, p. 255) notes correctly that the *padmāsana* indicates the throne which serves for all divinities and by this fact is inappropriate as a name for this attitude. Getty (p. 41) writes "adamantine pose, soles of the feet apparent." Cf. de Visser, *ABJ*, p. 168, n. 1, "The Diamond pose" (*kekka fuza*).

14 *Aṅguttara Nikāya*, I, 124, cited in Coomaraswamy, p. 45.

15 Coomaraswamy, p. 50.

15a Soothill, p. 386b.

16 Ibid., p. 52. Hsüan-tsang speaks of this throne; cf. Beal, *Si-yu-ki*, p. 114.

17 Mallmann, p. 255. As early as post-Gupta art of Ellorā, this pose is attributed to Mañjuśrī and to Avalokiteśvara. Cf. Mallmann, fig. 2, p. 182: Sārnāth; Pl. 14a: Padmapāṇi.

18 *BD*, 1432c–33a. This posture may also be called *hanza* or *kenza*, according to Hisano Ken, "Butsuzō no shurui to gyōsō," p. 3a. Cf. *Daijiten*, p. 387, s.v. *kekka fuza*. According to de Visser, *ABJ*, p. 168, "half-crossed-legged-sitting," is the same with the right foot, but the left is placed under the right knee (cf. *Daijiten*). *Kongōkekka* (*BD* 479c) is the same as *hanka-za*, according to the *Shugokokkyō* 2 (quoted in *BD* 479c).

19 *Rikishi-za* (?) (*Rikishi*, *BD* 1783c: *Rikisha*, *BD* 1784a).

Vīra = strong man, hero (Eitel, p. 203b).

Bose, p. 58, describes the *vīrāsana* thus: "one leg (the right foot) to be placed on the other (left) thigh, and the other foot to be turned backwards." This position is to be replaced by the *sukhāsana* (happy posture). Cf. Grousset, *L'Inde* (1949), Pl. I, fig. 2.

20 According to Sirén, p. 133. This posture is like the *sattvāsana* of Getty (p. 165)

or the *satvapalana* of Williams (p. 196). In this latter attitude, the legs are locked in *vajra paryaṅka*, the soles of the feet scarcely visible. This would be, according to Williams and Waddell, the one which symbolizes the end of the Buddha's meditation. Cf. Mochizuki, *BD* (1954), 4247c. According to Sirén, the *left* sole is up. Mallmann (*Intro.*, p. 258) speaks of the *paryaṅka*, in which the legs are crossed but the soles hidden, and Williams of the *niyamapalana* ("sub-active pose") in which the two soles are hidden.

20a Mochizuki, *BD* (1954), 4248a.

21 *BD* 1433c.

22 *BD* 1758a.

23 *Yogāsana: Paryaṅka Bandhana* (Eitel, p. 117a). Bose (p. 58) describes the *yogāsana* (according to the *Gheraṇḍa Saṃhitā*) thus: "Turn the feet upwards, place them on the knees: then place the hands on the *āsana* with the palms turned upwards; inspire, and fix the gaze on the tip of the nose." This position is also called *dhyānāsana*.

24 For information relative to this manner of sitting, cf. Bapat, "Pallatthikā," p. 47: "Apte's Sanskrit-English Dictionary explains the word *paryastikā* as 'sitting upon the hams' or as an equivalent of *Paryaṅka* which is explained as a piece of cloth girt round the back, loins, and knees while sitting on one's knees. Closely associated with this is the *yogapaṭṭa* which Apte explains as a cloth thrown over the back and knees of an ascetic during abstract meditation."

Cf. Waddell, p. 145, for the attitude of meditation of the Lāmas in Tibet.

25 Cf. Eitel, p. 208a, *Yoga*; pp. 208f., *Yogātchārya*.

26 Ibid., p. 209a.

27 *Siddhi* (Eitel, p. 152). For the eight powers which constitute the *Siddhi*, cf. p. 209a. Cf. also Bhattacharyya, *An Introduction to Buddhist Esoterism*, p. 83: "1) atomisation, 2) levitation, 3) magnification, 4) extension, 5) efficacy, 6) sovereignty, 7) mastery (over elements), 8) capacity to will actual facts." For the 34 *Siddhi*, cf. p. 84.

27a Eliade, *Yoga*, pp. 54–55.

28 Or *sukhāsana* (Sirén, p. 133). Waddell (p. 336) calls this attitude "Enchanter's Pose," but there seems to be a certain confusion about this designation which is placed here under the heading *mahārājalīlāsana*. Getty (p. 165) calls this pose *rājalīla*.

Bose (p. 58) writes that usually the *sukhāsana* replaces the *vīrāsana*. Sukhāsana: "left foot is placed on the right thigh and the other foot is stretched downwards." This position is also known by the designation *ardha-paryaṅka*. Cf. Grousset, *L'Inde* (1949), Pl. II, fig. 3.

29 Mallmann, *Intro.*, p. 254; at Ellorā, this attitude devolves on Mañjuśrī and Avalokiteśvara. For Pāla-Sena Art, cf. Pls. XIVc and XI; for Lokanātha, Pl. VIIId.

30 This pose is seen in China as early as the Wei (cf. Sirén, Pl. 33), but it was later to become a characteristic posture of the Bodhisattvas.

31 Or *lalita* (Foucher, *Iconographie bouddhique*, p. 67, n. 5), *rājalīlā* (Getty); Grousset, *L'Inde* (1949), Pl. II, fig. 4.

32 Sometimes Monju is represented with the right leg folded and the left knee raised. This posture is called *vāmārdhaparyaṅka*.

33 Mallmann (p. 254): "Among Avalokiteśvaras, this attitude is reserved for Siṃhanāda and for certain Siṃhāsana-Lokeśvaras."

34 Waddell, Foucher, Mallmann. For them, on the contrary, the left leg hangs down. Others call this the *lalitāsana* "enchanter's pose" (Getty, Williams).

35 Foucher, *Iconographie bouddhique*, p. 67, n. 5.

36 Mallmann, Pls. XIIa, b, d.

37 Foucher, *Iconographie bouddhique*, p. 67, n. 5. Texts according to Bendall and Rouse (trs.), *Śikshāsamuccaya*, p. 125.

38 *"Attitude à l'européenne"* (Mallmann); *pralambapādāsana* (Coomaraswamy); cf. the discussion relative to the Sanskrit term used to designate this attitude in Mallmann, pp. 256–57.

39 Cf. Hackin, Pl. XV.

40 Mallmann, *Intro.*, p. 257: "we know . . . in India only one image of Avalokiteśvara represented thus: it is the one which figures as the *principal god* at Ellorā IV."

Auboyer, "Un Aspect du symbolisme de la souveraineté," pp. 89–90, notes: "the so-called European pose is not reserved for Maitreya . . . it is seen in the representations of Avalokiteśvara (Ellorā, Buddhist Cave, II)."

41 Ibid., p. 90.

42 Foucher, *Beginnings of Buddhist Art*, Pl. IV.

43 Auboyer, p. 90.

44 Ibid., Pl. XXXIXb: Central Java.

45 Wei Dynasty: cf. Sirén, Pl. 150a – dated A.D. 525. Davidson (*The Lotus Sūtra in Chinese Art*, p. 59) notes that this position with the ankles crossed "could hardly be that of Śākyamuni, but it is the most common position of his successor, Maitreya, who, we safely conclude, then is here portrayed." The most famous examples of pendent legs are found at T'ien Lung Shan (Sirén, *Les Arts anciens de la Chine*, III, Pl. 60B, dated VI cent. A.D.). Munsterberg, "Chinese Buddhist Bronzes at the Kamakura Museum," p. 107, Pl. 6: this position is rare in Buddhist art of the Far East (p. 108).

46 Auboyer, "Un Aspect du symbolisme": the Kondō of the Hōryūji and several other specimens belonging to the Nara period.

47 Davidson (p. 59) gives the following description: "one arm is raised so that the index finger may touch the face. The other hand rests on the ankle, which is crossed on the thigh opposite from which the leg hangs pendent. This is the position usually reserved for Śākyamuni's first meditation or Maitreya's meditation and is common in the group of Chili sculptures under consideration."

48 Bachhofer, *Early Indian Sculpture*, p. 98; cf. the position of the hands in the pensive attitude in the Ajaṇṭā wall-paintings (Gupta, *Les Mains dans les fresques d'Ajanta*, p. 19); cf. Foucher, *AGBG*, fig. 408, p. 211.

49 Musée Guimet, no. 1222/8: Gandhāra; Foucher, fig. 409, 410, and 428.

50 Sirén, Pl. 29, left leg reposing on the right knee and left hand raised at shoulder level toward the chin. Pl. 135, Pl. 50; two Bodhisattvas on each side of a Buddha take this pose of reflection – the one on the right has the left leg on the right leg and touches the chin with the left hand index; the Bodhisattva on the left is arranged in the opposite manner. Pl. 52: same as the preceding, but all the fingers touch the chin. Pl. 246 has the left hand on the ankle; Pl. 248, on the calf; Pl. 244 has the left hand on the instep.

51 Ashton, *An Introduction to the Study of Chinese Sculpture*, Pl. XXX, fig. 2.

52 Sirén, Pl. 568.

53 This statue is to be identified as Miroku despite the tradition which sees in it a Nyo-i-rin Kannon. The attitude is called "meditative in half-lotus-posture" (*hanka shi-i*).

54 Sirén, Pl. 50: Foucher, fig. 540, p. 653.

55 Ashton, Pl. XX, Avalokiteśvara (Six Dynasties). Getty (p. 83) writes: "This attitude of the god signifies 'meditating on the best way to save mankind.'"

56 Koizumi, 55.

57 Sirén, p. 143: "As a general rule, the personages (in this attitude) are entitled Nyo-i-rin Kannon, but they do not have, that I know, a single one of the attributes of Kwanyin." See Ashton, Pl. XV.

Foucher, p. 236: "The specialized use of this flower could constitute an insurmountable objection against any attempt to connect carriers of the red lotus (*padma*) with Maitreya . . . and yet Japanese artists have attributed the melancholic and pensive pose of Maitreya, with his elbow resting on one of his raised knees, his head leaning against the index of his right hand, to their Miroku." Cf. fig. 548, p. 667, which shows a Miroku with only one index raised.

Cf. Grünwedel, *Mythologie des Buddhismus*, p. 27, fig. 22; and Warner, Pls. 47–67.

58 Warner, Pls. 47, 48, 50, 51, and 63. Pl. 60: the left hand lies on the instep—also Pl. 55. Pl. 58: the left hand lies on the ankle.

59 Rao, p. 17: oval in form, characteristic of a mirror and having the head and the legs of a tortoise.

60 *Makara*, "monster shaped like a fish" (Eitel, p. 93a). The *makara*, the rearing lion, and the elephant form the three-element theme (cf. Auboyer, "Un Aspect du Symbolisme" p. 90) which is identified with the attitude of Maitreya and the *dharmacakramudrā* and which is impregnated with the symbolism of royalty.

61 Siṃhāsana-Lokeśvara in *lalitāsana*: Mañjuśrī (Mallmann, *Intro.*, p. xii, a, b, d) and Avalokiteśvara in *mahārājalīlāsana*. Getty, Pl. XIV: Maitreya.

The lotus seat and the lion seat are very often combined in a single seat. For bibliography concerning these seats, see Coomaraswamy, *EBI*, p. 77, n. 76.

62 The royal aspect of the elephant is present in the throne of the Burmans, which is an elephant seat. Cf. Getty, Pl. VIIIb: Gautama Buddha in *padmāsana* and making the *sokuchi-in* on a socle formed of elephant heads.

Mus (*Barabuḍur*, p. 582, n. 4) cites Scherman, "Buddha im Fürstenschmuck," p. 25 and n. 1 (with references) and li. 4 of the offprint.

Originally Akṣobhya is figured on a lion seat, but later he is seated on an elephant seat with the *vajra* as attribute: this would lead to the metamorphosis of Śākyamuni into an Akṣobhya (Mus, Pt. 6, ch. I, p. 581).

63 *Hō.*, pp. 1–3. *Kongōchōrengebushinnenjujiki* (*T.* 873, XVIII, 299b ff.) quoted in Gonda and Ōmura, p. 2.

64 Cf. *Kokuyaku Daizōkyō*, vol. on symbolism, fig. on p. 189.

65 Cf. ibid., fig. on p. 192.

THE ATTRIBUTES: INTRODUCTION

1 Cf. *BD* 592b: *cihna* or *lakṣaṇa* (Foucher, *Iconographie bouddhique*, p. 69) = Sino-Jap. *sōgō*. For transcriptions of *lakṣaṇa*, see *BD*, 1776b; Takata (*Indo nankai no bukkyō bijutsu*, p. 45) writes that *shōgō* = *lakṣaṇa-vyañjana*, the 32 marks distinctive of the Buddha; the mudrā; the symbolic objects.

2 Certain attributes, such as the alms bowl and the *vajra* are regularly associated with certain Buddhas.

3 Cf. Coomaraswamy, *EBI*, Pls. I, II, and V, fig. 18.

4 Advayavajra lived around the XI cent. and was an adept of the Akṣobhya cult (cf. Bhattacharyya, *IBI*, p. xxix). His works are found in the *Advayavajrasaṃgraha*.

5 Glasenapp, *MB*, pp. 106–107.

6 Waddell (p. 340) gives a list of 29 objects: trident, drum, chisel-knife, *vajra*,

double *vajra* (*viśvavajra*), rosary, lotus, sistrum, jewel, flames, rope (snare), bell, wheel, skull, *vajra* dagger, lance, club, dagger, sword, ax, hammer, goad, mace, thigh-bone trumpet, conch shell, chain, stick (pike, water vase).

Cf. *ST*, I, Senju Kannon: a list of 38 objects; Gonda, *SMH*, for the symbolic objects of the Shingon sect; and Gordon, *Iconography of Tibetan Lamaism*, pp. 12–19.

ALMS BOWL

1 Often the transliteration *pa-ta-ra* is used. See *BD* 1397c; and Eitel, p. 117b. The alms bowl of the Buddha is supposed to have been brought to China in A.D. 520 by Bodhidharma (Soothill, p. 418a); cf. also Eitel, p. 117b.

2 Foucher, *AGBG*, pp. 415ff.: "On the example of the 'predestined of former times, the Buddhas perfectly finished,' the Buddha Śākyamuni may not accept an offering with his hands but only with a bowl (*pātra*). Since he had thrown the golden vase of Sujātā in the river Nairañjanā before setting out toward the tree of Knowledge, he has nothing with which to receive the alms of the merchants."

Cf. ibid., p. 416. Foucher mentions the followings texts which elaborate on the details of the *pātra* legend: *Buddhacarita*, XV, 64; *Lalitavistara*, XXIV; *Mahāvastu*, III, 304; *Mahāvagga*, 1, 4, 1. For other texts, cf. Ono Gemmyō, *Bukkyō no bijutsu oyobi rekishi*.

3 According to Edkins, *Chinese Buddhism*, pp. 24–25.

4 The Six Things (*rokumotsu*) are: *1 saṅghāṭī*, the patch robe; *2 uttarā saṅghāṭī*, the stole of seven pieces; *3 antara vāsaka*, the inner skirt of five pieces; *4 pātra*, the alms bowl; *5 niṣīdana*, a stool; *6* a water strainer (Soothill, p. 136a). The first three are known as the *san-e*, the three robes.

5 Soothill, p. 457b, s.v. *ōki*.

6 Cf. Mallmann, *Intro.*, p. 182, fig. 2. The form of an inverted bell may come from the legend that, in order to give the model of the first stūpa to his disciples, the historical Buddha inverted his *pātra* (Mallmann, p. 272). For the description of the historical Buddha's bowl, see Foucher, *La Vie du Bouddha*, pp. 51f.

7 Sirén, p. 138. Cf. *hōbachi, hachi-in, buppatsu-in*.

8 Ibid.

9 Cf. *ST*, I, Senju Kannon (painting) carries a bowl in the 16th arm (left); cf. Tsuda, *Handbook of Japanese Art*, fig. 319.

10 In Sk., Bhaiṣajyaguru. Yakushi's bowl should probably not be called a *pātra*. It is more precisely a medicine bowl. In China, according to Sirén (p. 139), Yakushi "carries (often) in one hand a little round pharmaceutical kit or a covered bowl; the other hand lies on his knee where it holds the 'golden fruit.' " Cf. n. 11 under *jō-in*, which gives details on the *yakkon-in*.

Cf. *Jikkanshō*, scroll VII, which shows the *hōbachi-in*, a bowl reposing on the two hands joined in *jō-in*.

In statues of Yakushi nyorai the left hand lying in the lap and holding the *kusuri tsubo* or medicine jar, is considered by Esotericists to be in the *yogan-in*. Yakushi never holds the "jewel pearl" despite the fact that the *kusuri tsubo* sometimes resembles it.

11 Cf. *ZZ*, Pl. 95: the left hand extended as if to hold a bowl; compare to Pl. 102 of the same.

12 Cf. Yakushi, wood, Hōrinji, Suiko period (Warner, Pl. 30 and *ST*, IX). The divinity holds a bowl in the left hand, which is held somewhat away from the body, while with the right hand the divinity makes the *semui-in*.

245

The statue from the Saimyōji (*ZZ*, Pl. 17), dated 1047, shows Yakushi in *padmāsana*, the right hand in *semui-in*, the left hand reposing on the left knee and holding a bowl. Cf. *ZZ*, Pl. 18, 21 (dated 1074), 102.

AX

1 Williams, p. 22.

2 *ST*, I, (Senju) Kannon holds an ax in the 6th right arm.

BELL

1 "A bell, gong, or any similar resonant article" (Soothill, p. 407a). The *Dainichikyō* (in *Kokuyaku Daizōkyō*, Vol. L, 115) uses a transcription of the Sk., i.e., *kenda*. See also Eitel, p. 59a, and *BD* 201a, s.v. *kane*.

2 Mallmann, *Intro.*, p. 273: "the bell as an attribute apparently accompanies either prayer or the exuberant dance of Tantric Śivaite divinities."

3 *BD* 201a.

4 For the use of the bell in the unction ceremony (*kanjō*) according to Advayavajra, cf. Glasenapp, *MB*, p. 122.

In Japan one of the characteristic sounds of eventide is the vibration of the temple bell as it rings (in theory, at least) the 108 peals for the 108 passions which bind Sentient Beings to this phenomenal world.

5 The different forms of handle: *stūpa* handle (Gondo, *SMH*, p. 24, fig. 31); *vajra* handle (p. 25, fig. 32); handle in the form of a (triple) jewel (p. 26, fig. 33); handle in the form of a single-pronged *vajra* (p. 27, fig. 34); handle in the form of a three-pronged *vajra* (p. 28, fig. 35).

6 The bell is always matched to the vajra, in respect to the number of points. See the excellent example of a Javanese *vajra* bell in Visser, *Asiatic Art*, Pl. 211 (p. 503).

7 Glasenapp, *MB*, pp. 105–106. Concerning bells and their pealing, cf. Doré, *Researches into Chinese Superstitions*, V, s.v. *Buddhist Bells*, pp. 124–27.

8 Cf. Koizumi, no. 36; Aizen Myō-ō holds a bell in the second hand left; in his lap the fifth hand right carries a five-pronged *vajra*. Note Kongōsatta, who bears the *vajra* as his particular symbol; he also holds a bell (Getty, p. 6).

9 *ST*, I, Senju Kannon (painting) holds a bell in the 14th right hand.

BOW AND ARROW

1 In *ZZ*, Pl. 157, one of the 22 adamantine generals, Haira *taishō* (*BD* 1386c) holds an arrow in the right hand, a bow in the left.

2 The Bow of Compassion (*hi*) is held in the left hand and the Arrow of Knowledge (*chi*) in the right.

3 Cf. *ST*, I: Senju Kannon, the arrow is held by the 10th left hand, and the bow by the 10th right hand. Cf. Koizumi, no. 36, statue of Aizen Myō-ō with 6 arms; the lower right hand holds an arrow, the lower left a bow.

4 Cf. the benevolent Jizō of the Kongōrinji (*ZZ*, Pl. 69), who holds an immense arrow as big as himself, in the right hand, while with the left hand he holds the wishing jewel, *cintāmaṇi*.

5 *Hō.*, p. 16.

6 Ibid., Pl. I. Cf. pp. 15–16, figs. 6, 8, 9. Renou, *IC,* p. 496, § 1022: "While it is true that the notion of 'desire' in the cosmogonic order has been exalted since the Atharvaveda, a clearly defined image of a god of Love does not go back further than the epic period."

CONCH SHELL

1 *BD* 1615b, s.v. *hōra (turbinella rupa).*

2 Gonda (*SMH,* p. 60) cites the *Dainichikyō* 2 (*T.* 848, XVIII, 12, li. 22).

3 *Gāthā* = hymn or song often present in the sūtras: usually every line has 4, 5, or 7 words. The act of "ringing" the conch indicates the turning of the wheel of the Law.

4 Gonda, *SMH,* p. 60: *Daisho* (*T.* 1796). For other texts, see Mochizuki, *BD* (1954), 4645c–4646a.

"The worlds in all directions" = "the 10 directions of space, i.e., the eight points of the compass and the nadir and zenith" (Soothill, p. 50b).

5 Cf. the use of this attribute as a symbol of the Doctrine in the *kanjō* ceremony: Glasenapp, *MB,* p. 122.

6 Williams (p. 73) cites Ruskin, *St. Mark's Rest,* p. 237. Cf. *Hō.,* p. 169a, *rahotsu,* "curls in the form of a conch."

7 *Si-do-in-dzou,* p. 38.

FLY WHISK

1 Renou, *IC,* p. 470, § 2178.

2 *BD* 237a.

3 *BD* 1498a.

4 *BD* 1589b.

5 *Binayazōji* 6 (*T.* 1451, XXIX, 229b, li. 15 ff.); quoted in *BD* 1589. Cf. Zimmer, *The Art of Indian Asia,* II, Pl. 50.

6 Mallmann, *Intro.,* p. 275. Cf. *Asabashō* 48: Fukūkensaku Kannon with 8 arms carries the fly whisk in one of her right hands.

7 Cf. the fly whisk which figures in a painting (dated 765) of the Marquis Inoue, *Hō.,* p. 118a. Cf. *ZZ,* Pl. 136.

Toganoo (*MK,* p. 44) notes that this whisk doubtless symbolizes the noble lineage of the personage in question. To Hugo Munsterberg (p. 103) this attribute symbolizes "that Kuan Yin is filled with such compassion toward all beings that he is not even willing to harm a fly." For a Zen usage, see Suzuki, *Mysticism: Christian and Buddhist,* p. 66.

8 Reischauer, *Ennin's Travels,* p. 186. Reischauer notes that this "duster-like symbol [is] thought to represent either leadership (the tail of the leader deer) or a brush to sweep away the impurities of the world."

JEWEL

1 Also: *shu* (jewel), *nyo-i-hō* (wish-granting treasure: *Hō.,* p. 179a), *nyo-i-mani* (wish-granting gem; *BD* 1348b), *gyokushuhō* (jewel treasure), etc. See Eitel, p. 96a.

Lévi and Chavannes, "Voyages des pèlerins bouddhistes," p. 102, n. 1: Nyo-i = "conforme aux désirs." It "designates that supernatural power which saints possess to bend the physical world to their desires."

2 Eitel, p. 96a. Rémusat, *Foĕ kouĕ ki*, p. 90: "Mani . . . , a word which means free from stain, and which designates the pearl. This is a brilliant and pure substance, free from stains and impurities. This is why the *Yuan kiŏ tchao* [Manual of the Pratyeka Buddhas — is it a question of *T.* 842? — E.D.S.] calls it also *ju-i* (according to one's desire, to one's intent): the riches that one wishes to possess, vestments, food, any thing which is necessary — one may procure them by means of this precious object, *according to one's desires*, and this is the origin of the name."

Although Japanese authorities identify the *maṇi* with the pearl, Finot (*Les Lapidaires indiens*, p. xv) writes that "*maṇi* means only a precious stone (Manu, XII, 61)."

3 Getty, "a jewel"; Soothill (p. 191b), jewel, crystal, pearl.

4 Eitel: a fabulous pearl; *BD* 1424b cites the *Hizōki* (notes of Kōbō Daishi): "The *maṇi* is a precious stone, the pearl (?). The moon is called *mizu-mani* (water *maṇi*), and the sun is called *ka-mani* (fire *maṇi*). This is the meaning."

5 If the group has 9 *maṇi* they represent the Nine Jewels (*nava ratna*) borrowed from Brahmanism. If the group has 7 *maṇi* they represent the Seven Jewels (*sapta ratna*). The following are the seven Buddhist jewels, which frequently figure in China and in Tibet (Getty, p. 167, s.v., *maṇi*; Zimmer, *Philosophies of India*, pp. 130–31):

1 the golden wheel, standing for the universal perfection of the Law. It is supposed to have fallen from the skies at the moment of the investiture of the *cakravartin*.

2 the *maṇi* or jewel, which grants desires.

3 the royal consort or ideal woman.

4 the white horse or sun-steed of the *cakravartin*.

5 the white elephant or royal mount. It stands for the propagation of the doctrine.

6 the perfect Minister or civil officer, whose generosity removes poverty and whose justice assures the well-being of all.

7 the perfect General or military leader, whose sword of knowledge repulses the enemy. Cf. Getty, p. 45, for the 13 precious ornaments; concerning this same subject, cf. Bhattacharyya (*IBE*, pp. 152ff.), who speaks of the "Six mudrās," which designate here the ornaments.

Cf. *tri-ratna:* Eitel, pp. 181–82.

6 The pearl (in China) has three divisions or five divisions (Williams, p. 407).

7 Glasenapp, p. 157: men = buddha; women = *prajñā.*

8 In Japan and in China, this pearl may often be found without the flame. This attribute is often seen in the form of a roof finial surmounting holy buildings in Japan.

9 This flame recalls the *triśūla*, which Burnouf believes serves as an invocation to the supreme divinity. The *triśūla* in the form of a flame or trident may surmount the round object which, according to Beal, symbolizes either the sun surrounded by a flame or the empyrean.

10 Cf. Jizō: *ZZ*, Pl. 75.

11 Eliot (*Japanese Buddhism*, p. 346) writes that sometimes the gods hold a colored ball which is supposed to represent the jewel of riches and of generosity. Getty (p. 149) notes that the *maṇi* at the top of the *shakujō* carried by Bishamonten signifies the "completeness of fortune and virtue."

12 Eitel, p. 96a.

13 Soothill, pp. 191, 330; Williams (p. 407) writes that *maṇi* means "free from stain," brilliant, and becoming more and more pure.

14 Getty, p. 168.

15 Ibid., s.v. *cintāmaṇi.*

16 This form is associated more precisely with Avalokiteśvara (Mallmann, *Intro.,*

p. 270). In India, according to Mallmann, the *cintāmaṇi* is held in one of the right hands of the six-, twelve- or sixteen-armed Avalokiteśvara.

17 *T.* 261; Mochizuki, *BD* (1954), 4132c.

18 *T.* 203; ibid., 4132c–33a.

19 *T.* 643; ibid., 4133a.

20 *T.* 1509; ibid., 4133a.

21 Cf. Warner, no. 9: Kannon, wood, Suiko period (Yumedono, Hōryūji): Koizumi, no. 55: Nyo-i-rin Kannon with six arms.

A very common position in the Suiko period is that of Warner's no. 104. The Yumedono Kannon holds the jewel between her two hands, in front of her breast; the right hand is face up, the left, face down.

22 Warner, no. 106. Kannon (Hōryūji), holding a vase in the right hand and a jewel in the left.

23 Warner, no. 49 (also *ST*, I), Nyo-i-rin Kannon has her right hand in *semui-in* and the left hand lying on the heel of the left leg, the ankle of which is placed on the right knee. The jewel is represented in the diadem. Cf. *ST*, I, image of Ārya Avalokiteśvara (Shō Kannon), above whom are suspended Seven Jewels: "these jewels seem to represent the Buddhas of the past."

The famous statue of the Chūgūji, often called Nyo-i-Kannon, shows no attribute characteristic of this divinity. Its attitude rather indicates Miroku. (Warner, no. 67, writes "Miroku.") Cf. n. 57 under Thrones and Postures, *supra*, in the present text. The *Nihon no chōkoku* (Sept. 1952, p. 7) calls this statue Miroku.

24 *ST*, VI: Śrī (Jōruriji, Yamashiro, Tempyō period) holds in her raised and advanced left hand the jewel which grants wishes, while the right hand hangs down in *segan-in*. *ST*, I: painting in the Yakushiji (Nara), VIII cent., Kichijō-ten holding in the left hand a *cintāmaṇi*, while with the right hand she forms the *semui-in* (?). The Kichijō-ten of the Nara Museum Collection, Tōmyōji (Nara), Jōgan period (794–887), offers a jewel with the left hand, while the right hand hangs at her side.

Grousset, *Le Japon*, fig. 30: Kichijō-ten, Jōruriji (Kyoto), XII cent., the left hand raised, palm up, holds the jewel; the right hand makes the *segan-in*. *ZZ*, Pl. 25, Kichijō-ten of the Rokumaji holds the jewel in the left hand.

25 Hackin, *Guide*, Pl. X: Turkestan, Tun Huang, Kṣitigarbha holds in his right hand the jewel surmounted by a flame; the left hand is in *vara* (?) *mudrā*. The Jizō of the Tōdaiji (*ZZ*, Pl. 61) holds the jewel with the left hand: this jewel is not surmounted by a flame; the right hand held a sistrum. Cf. Pl. 89. See de Visser, *ABJ*, p. 440: according to the *Saishōōkyō*, Ch. VII, sect. 14.

26 *Nyoirindaranikyō* (*T.* 1080, XX, 188b–196b) quoted in Mochizuki, *BD* (1954), 4133b.

27 *Jizōbosatsudaranikyō* (*T.* 1159 B, XX, 655b ff.) quoted in Mochizuki, *BD* (1954), 4133b. Warner, no. 23: Shaka Trinity, Kondō (Hōryūji), Suiko period, in which figure Fugen and Monju on each side of the Buddha: they hold the jewel between their two hands whose little and ring fingers are slightly inflected. In Koizumi (no. 53), the divinity holds a jewel (?) with the right hand at the level of the breast; in the left hand, a *shakujō*.

28 *Jikkanshō*, I: (*kongōkai*) Hōshō holds the jewel with the left hand.

LANCE AND TRIDENT

1 Cf. Mochizuki, *BD* (1954) 1507c, s.v. *sankogeki*. Cf. Coomaraswamy, *EBI*, pp. 15–17, for the discussion concerning the term *nandi-pada*, which designates the *triśūla*.

2 Ibid., Pl. VI, fig. 23.

3 Williams (p. 376) calls the trident *sanko-shō* Ch., *san ku chang.*

4 Mallmann, *Intro.*, p. 274.

5 Coomaraswamy, *EBI*, p. 14; cf. fig. A, p. 15: ". . . our triśūla may also be thought of as a single vajra."

6 Combaz, *l'Evolution du stûpa*, p. 112.

7 Coomaraswamy: cf. Pl. I, fig. 1, and Pl. II, fig. 1, the pillar of the tree of life (North *Toraṇa* of Sāñchī, c. 100–150 B.C.). In fig. 2, twelve *triśūla* represent the 12 solar months. Pl. IV, fig. 1 (Amarāvatī, c. 100 B.C.), the *cakra* and the *triśūla* are represented on the soles of the feet. Pl. VI, fig. 23 (inside of the North *Toraṇa*, Sāñchī, I cent. B.C.). For the Sāñchī sculptures, see also Zimmer, *The Art of Indian Asia*, II, Pls. 7–12.

8 Cf. Foucher, *Beginnings of Buddhist Art*, Pl. I, figs. 5–8. Cf. Toganoo, *MK*, Pl. 37.

9 Cf. Coomaraswamy, Pl. VI, fig. 22.

10 A not wholly Buddhist symbolism. Cf. *cintāmaṇi.*

11 Coomaraswamy, pp. 13ff.

12 Coomaraswamy notes that by addorsing two *triśūla*, the form of a *vajra* is obtained. It is incontestable that in all the Far East the *vajra* also is the symbol of power, strength, and authority.

13 Cf. Warner, fig. 40, 41. Jitoku-ten holds a lance, and Tamon-ten with his right hand holds the trident and with his left a *stūpa*: Hackin, *Guide*, p. 21: the Guardian King Vaiśravaṇa, in Turkestan, is always armed with a lance.

14 Gonda and Ōmura, figs. 331–35.

15 Mallmann, *Intro.*, p. 271. There is an association with Tantrism and its Three Mysteries. "Ascetics called *tridaṇḍin* bear this name because they carry three sticks bound together, a sign of their threefold discipline (in thought, word, and act)."

LOTUS

1 "The World-lotus naturally blooms in response to the rising of the Sun 'in the beginning'; in answer to and as a reflection of the light of Heaven mirrored on the surface of the waters" (Coomaraswamy, *EBI*, p. 20).

2 Getty, pp. 172–73, s.v. *padma.* The Buddhas, like the lotus, exist through themselves (*svayambhū*).

3 For the connection between the lotus and the Tree of Life, cf. Coomaraswamy, pp. 17–18. For bibliographic references concerning divine birth, the seat, or the lotus throne, cf. Coomaraswamy, pp. 18–19.

4 Getty, pp. 172–73: cf. here the Nepalese legend.

5 After Coomaraswamy, p. 21. For early use of the lotus symbol as a pedestal at Amarāvatī (III cent. A.D.), see Zimmer, *Art of Indian Asia*, I, p. 173, and II, Pl. 92a.

5a Ibid., I, p. 175.

6 Coomaraswamy, p. 20.

7 For the role of the lotus in the representations of the "Descent of Amida" as a bond between the two worlds, cf. Linossier, "L'Iconographie," p. 119.

8 *Saṃyutta Nikāya*, III, 140; "Just as, Brethren, a lotus born in the water, full-grown in the water, rises to the surface and is not wetted by the water, even so, Brethren, the Tathāgata, born in the world, full-grown in the world, surpasses the world, and is unaffected by the world" (Coomaraswamy, p. 21).

9 After Coomaraswamy, p. 59.

10 In the hands of Padmapāṇi, the lotus represents the creative power of the divinity. The use of the lotus may also be noted on the porcelains of Ching-te Chen, where it figures as the symbol of summer; cf. Parry, "Chinese Pottery," p. 32a.

11 The garland of lotus worn by the priest in the *rājasūya* ceremony respresents: *indriyam* (sensorial operation), *vīryam* (virility), and *kṣatram* (temporal power) — Coomaraswamy, *EBI*, p. 21.

12 Soothill (p. 443a) explains the kinds of lotus as follows:

puṇḍarīka, Nymphoea alba (white).
utpala, N. caerulea (blue).
kumuda N. rubra (red).
nīlotpala N. cyanea (blue).

13 I.e., *Nymphoea rubra*. Cf. the Sino-Japanese *kuren*, and the transcription of the Sk. *padma*, i.e., *ha-do-ma*. See *BD* 1423a for the texts which establish the pronunciation of this name. Shingon adepts say *"han-do-ma."*

Cf. the example of the red lotus, Foucher, *Icon. boud.*, Pl. IV, 1, 2, 3, 4, in the hands of Avalokiteśvara.

The red lotus is one of the signs seen on the feet of the Buddha. It lends its name to the Red Lotus hell (*kuren jigoku*), seventh of the eight cold hells, where the skin of the damned bursts like the buds of the red lotus. Eitel (p. 11b) writes that the cold produces blisters not unlike lotus buds.

14 I.e., the *kumuda* or *utpala*. Sino-Jap. transcription: *upatsura* (*BD* 114a). *Remmoku*, the eye of the (blue) lotus, may also be cited as a term which indicates the marvelous eye of the Buddha. Cf. Foucher, *Icon. boud.*, Pl. VI.

15 I.e., the *puṇḍarīka;* particular symbol of purity. To this lotus corresponds the sixth of the eight cold hells, the hell of the blue lotus. Soothill (p. 443a) notes that if the color of the lotus is not noted, the use of a generic word, such as *ren* or *ke*, alludes to the white lotus.

16 Coomaraswamy (*EBI*, p. 21) notes a *līlā-kamala*, "lotus of play," representing the universe as a plaything of the supreme divinity, just as the lotus held by a human being constitutes a sort of plaything. In Nepal and in Tibet, the lotus is usually represented in full flower.

17 For the Shingon sect, the use of the chrysanthemum with a single stem represents the *dharmakāya* or Essence Body.

Eliot (*Japanese Buddhism*, p. 339) writes: "He [Yakushin 827-906] was also the founder of the Hirosawa school of Shingon, school meaning merely a branch which prescribes a special method of study, not which has new doctrines of its own on any important point. . . . Shōbō [832-909] founded the Ōno school."

18 Utilized by the An school.

19 The Three Virtues: *dai jō* (Great Concentration); *dai chi* (Great Knowledge); *dai hi* (Great Compassion); cf. Soothill, p. 87b.

20 Used by the Tendai sect and by the Daigo school of Shingon.

21 Cf. the *mandara* called the *butsugen mandara* of the Shinkō-in, Kyoto (*Mikkyō daijiten*, II, Pl. 126) and the *taizōkai mandara* (ibid., following p. 1492).

22 No representation of the Buddha supported by a lotus seat exists before the II cent. A.D., but texts reveal the lotus as a support since ancient times (Coomaraswamy, *EBI*, pp. 21-22).

23 In a painting from the caves of Tun Huang, the first footprints of the Buddha are represented in the form of lotus flowers which spring up in his steps; cf. Stein, *Ruins of Desert Cathay*, II, Pl. VI.

251

24 Coomaraswamy, *EBI*, p. 20.

25 Auboyer, *Le Trône et son symbolisme dans l'Inde ancienne*. Coomaraswamy, "The Position of the Lotus Throne," in *EBI*.

26 *Asabashō* 47: Kannon with 11 heads and 4 arms makes the *semui-in* with her right hand and her left hand holds a lotus. Examples in which the right hand is in *varamudrā* and in which the left hand holds a vase (which replaces the lotus) may also be seen. According to other texts (cf. ibid.), Kannon with 2 arms makes the *varamudrā* with the right hand and in front of the breast the left hand holds a vase containing a lotus. Ibid., 48, Kannon with 8 arms holds a lotus in one of her left hands.

27 Mallmann, *Intro.*, p. 267.

28 Avalokiteśvara = Padmapāṇi ("the one who holds the red lotus in his hand").

29 Cf. Mallmann, p. 268. Pāla-Sena (Bengal) = VIII–XII centuries.

30 Cf. Sirén, *La Sculpture chinoise*, Pl. 282. For Kannon's willow branch, see *Senjusengenkanzeombosatsudaihishindarani* (*T*. 1064, XX, 117b, li. 17–23).

31 Ibid., Pl. 322A.

32 Cf. Koizumi, 22: with the left hand the Bodhisattva held an attribute (lotus, vase) while with the right hand he makes the *segan-in* or the *an-i-in* (the hand pendent, palm out); cf. *segan-in*.

Jikkanshō, VII, the Bodhisattvas most often hold the lotus in the left hand: Kannon is represented in *padmāsana*, holding the lotus in the left hand.

Koizumi, 27, wooden statue (Heian period?), with the right hand, the Bodhisattva was holding a lotus (?), and with the left he makes the *segan-in*, the hand almost flat in the lap because of the seated position.

33 *BBK*, p. 508. Cf. Koizumi, 36: Aizen Myō-ō carries a bow, a bell, a lotus, a *vajra*, and an arrow, and makes the *kongō-ken* (Diamond Fist). Note also that the bow and arrow symbolize forgetfulness and the lotus "appeases guilty agitation" (Elisséeff, "Mythologie du Japon," p. 402.

34 Sk. Kṣitigarbha. Kṣitigarbha is represented at Tun Huang on a single lotus which supports the two feet (Hackin, *Guide*, Pl. X).

35 Statue of Jizō at Tun Huang with two lotuses (Getty).

36 *Hō.*, p. 29b: *Jikkanshō*, I, attributes the lotus to (*kongōkai*) Amida; cf. in this same scroll of the *Jikkanshō* (*kongōkai*) Fukūjōju seated on a lotus. The gesture of Amida holding a lotus in one or two hands is called *muryokōshō-in* (Gonda and Ōmura, p. 8), mudrā of Muryōkō (Amida) victorious.

37 Williams, p. 220.

38 Gonda and Ōmura, p. 55 (and fig. 84) give the text of the *Hizōki* (*BD* 1461b; composed by Kōbō Daishi during his sojourn in China).

According to the *Jishibosatsugiki* (*T*. 1141, XX, 595, li. 9ff.): "In the middle is erected an image of Miroku (Jishibosatsu). He wears the crown of the Five Tathāgata: in the left hand he holds a lotus on which reposes a (*dharmadhātu*) *stūpa* of the Essence World; his right hand makes the *seppō-in*, and he is seated with his legs crossed, soles up" (Gonda and Ōmura, p. 55).

39 Getty, Glossary, s.v. *lotus*.

MIRROR

1 See *BD* 83b.

2 Cf. the use of the mirror in the *kanjō* ceremony in Glasenapp, *MB*, p. 122.

3 Ibid., p. 106.

4 Cf. *ST*, I, Senju Kannon (painting), who carries the mirror in her fifth right hand.

5 *Hō.*, p. 40a, s.v. Ashuku. Cf. the connection of this attribute with the Mirror Knowledge, *daienkyōchi* (n. 27 under *chi ken-in*, *supra*), one of the Four Knowledges and one of the *shi-in* ("four seals"), characteristic of Ashuku. Cf. *BD* 18c.

RELIQUARY

1 *So-to-ba* (Sk. *stūpa*), a mound (Soothill, p. 359a), a *hōtō*, or precious tower or tower for precious reliques (Eitel, p. 160a).

2 Sk. *caitya-karaṇa.*

3 Cf. Foucher, *Beginnings of Buddhist Art*, Pl. I. Toganoo, *MK*, fig. 37.

4 *Saddharma-puṇḍarīka*, tr. Kern, pp. 227f. Cf. tr. by Burnouf, ch. XI, pp. 145+46.

5 This notion of universal king (*cakravartin*) developed under the Maurya, perhaps under the influence of Iran.

6 Cf. Combaz, "L'Evolution du stûpa en Asie," IV, 30.

7 Ibid., p. 40. It is interesting to note the resemblance between the Javanese and Tibetan stūpas and the alms bowl of the Buddhist monk.

8 Ibid., p. 41.

9 Ibid., p. 98. According to Mus (*Barabuḍur*, pp. 115ff.) the pillar is the cosmic axis, a kind of central mountain. For a study of the cosmic pillar, cf. Przyluski, "Le Symbolisme du pilier de Sārnāth," pp. 481–98.

10 According to Smidt, p. 203; based on the *Himitsu hyakuwa.*

11 Glasenapp, *MB*, p. 107. Earth: square or cube; water: circle or sphere; fire: triangle or pyramid; air: half circle or half sphere; void: triangle surmounted by a half circle or pyramid placed on top of a half sphere. Cf. the stūpa of the tomb of Kōbō Daishi on Mt. Kōya. For sūtra of geometrical forms, see *Sonshōbucchōshuyugahōkigi* (*T.* 973, XIX, 369b).

Combaz (p. 56) gives the following table:

part	form	element	syllable	color
base	square	earth	*aṃ*	yellow
superstructure	triangle	fire	*raṃ*	red
top of superstructure	crescent	air	*haṃ*	black
terminal point of superstructure	crescent or circle	void	*khaṃ*	various

This symbolism is attested in the *Fă houa wen kiu*, cited by Rémusat in *Foĕ kouĕ ki*, pp. 91, 92.

12 According to Combaz, IV, p. 77:

First tier	The Four Applications of the mind: to the body, to the senses, to thought, to things.
Second tier	The Four Efforts.
Third tier	The Four Factors of miraculous power.
Fourth tier	The Five Faculties (i.e., the Five *kon*; cf. my Diag. II.
Base of the dome	The Seven members of Enlightenment: the *harmikā* or finial indicates the Eightfold Path.
Mast (tree of life)	The Ten Knowledges. Each of the ten umbrellas corresponds to one of the powers of the Buddha. The 11th, 12th, and 13th umbrellas represent the three applications of memory characteristic of the Buddha. The great

umbrella which surmounts the pinnacle symbolizes the great compassion of the Buddha toward all Sentient Beings.

The moon The pure thought of Enlightenment.

The sun Replacing the mirror = the Four Transcendental Knowledges and the peak of supernatural faculties.

The mastery of these qualities permits the adept to unite with the supreme Buddha (Vairocana).

13 This explanation is according to Smidt, VI, pp. 203–204.

14 Ibid., p. 204. This stūpa bears the mystic syllables *"a-ba-ra-ka-kya"* written on the frontal part. For the syllables of other sects, cf. this same reference. Cf. also no. 32, under "The Contribution of Tantrism," *supra.*

15 There are several variants at Barabuḍur.

16 The Guardian Kings (Tamon-ten, Vaiśravaṇa), Jikoku-ten (Dhṛtarāṣṭra), Sōchō-ten (Virūḍhaka), and Kōmoku-ten (Virūpākṣa) figure in all the religious iconography of Tibet, China, and Japan. Combaz (p. 143) gives the following list: Dhṛtarāṣṭra plays a sort of guitar: Virūpākṣa holds in his right hand a jewel in the form of a reliquary and in his left hand a serpent; virūḍhaka tramples on a demon; Vaiśravaṇa holds in his right hand a banner and in his left a stūpa. Cf. Sirén, *Histoire des arts anciens de la Chine*, Pls. 387, 388, 389. These kings figure, two by two, on the tower of Hiang-chi monastery near Si-an-fu (capital of the T'ang).

17 Warner, nos. 41, 32, 33; Koizumi, nos. 45, 49; *ST*, I: "The Four Mahārājas of Heaven."

18 Combaz, p. 142: "A passage of the Lalitavistara lends to the four guardian kings of the world a complete arsenal of arms and mail coats, even a plume."

19 Koizumi, no. 44; Tamon-ten (Bishamon-ten, Vaiśravaṇa) holds in his right hand a lance and in his left hand, at shoulder level, as if to display it, a stūpa. Fig. M (Pl. XXXI): the base is in the form of a lotus and the six balls replace the original parasols and probably symbolize the Six *pāramitā* or Perfections (cf. Pl. XXXI, fig. O).

Koizumi, no. 45: Tamon-ten holding a stūpa of a different form (fig. N. Pl. XXXI): cf. the stūpa in the *Asabashō* 73. Warner, no. 41 (*ST*, IV), shows Tamon-ten (Hōryūji) holding a pagoda with the left hand, a trident with the right.

Cf. "Stūpa" under the heading "Jewel," *cintāmaṇi, supra.*

Cf. *Hō.*, Bishamon, pp. 79–83, and figs. 37, 38, 39.

20 Getty (p. 21) writes that Maitreya carries in his crown a *"stūpa*-shaped ornament which is his distinctive mark."

21 *Jikkanshō*, I: (*taizōkai*) Dainichi carries a stūpa, which is based on the type that is composed of geometric forms and reposes on a lotus; the whole thing is surmounted by symbols of the moon and the sun (fig. P) —cf. n. 12, *supra.*

ROPE

1 Williams, p. 252.

2 Ibid.: this attribute is one of the Eight Treasures.

3 Mallmann, *Intro.*, p. 270.

4 *BD* 412c. For the use of the rope in the *kanjō* ceremony, cf. Glasenapp, *MB*, p. 123. Note the use of the rope by Durgā, wife of Śiva; also by Varuṇa, the water god, who rules the clouds, rain, etc.

5 *BD* 1335c.

6 The Three Studies: *1* discipline refers to the *vinaya; 2* concentration refers to the sutrās; *3* wisdom refers to the *śāstras*. Cf. Soothill, p. 63a, s.v. *san gaku,* "three studies."

7 Cf. *Zuzō daishūsei,* p. 16: Fudō holds the sword in the right hand and the rope in the left. See figs. 107–120. See also Koizumi, no. 35. Fudō holds in the right hand a sword (with four sides) terminating in a *vajra:* in the left hand, pendent, he holds a rope whose two ends are supplied with a ring and a lotus bud (?).

8 Cf. *ST,* Fudō (Acala) of the Kōōgokokuji (Tōji), Kyoto. This divinity is supposed to be an incarnation of Mahāvairocana. He holds in his left hand a sword and in his right a rope which symbolizes his role as subduer of demons.

9 See Mochizuki, *BD* (1954), 949c–950b.

10 *Hō.,* p. 43b.

11 In Sk., *pañca-vairamaṇī.* See Soothill, p. 118b. Fujishima, *Le Bouddhisme japonais,* p. xxxix, calls them the Five "Precepts": *1 prāṇātighātād virati; 2 adattādānād virati; 3 parastrīgamanād virati; 4 mṛṣāvādād virati; 5 madyapānād virati.*

12 Bhattacharyya, *IBI,* p. 195.

ROSARY

1 Also in Sino-Jap.: *juzu* (*BD* 985c and *Hō.,* 38b, s.v. *ashamara*); *juju* (Gonda, *SMH,* pp. 72ff.); *hasoma* (*BD* 1397b); *mālā* (Soothill, p. 436a).

2 Also in Sk. *akṣamālā.*

3 The importance of the rosary in Southern Buddhism is not so great as that accorded it in Northern Buddhism. See Gonda, *SMH,* p. 72ff.

4 Williams, p. 310. Cf. the Four Rosaries (*shi nenju*) Soothill, p. 175a.

5 Gonda, *SMH,* p. 74. The 108 honorable ones in the *vajradhātu* (*kongōkai*) are called, in Japanese, *hyakuhachi-son.* The 108 passions and delusions are also called the 108 karma bonds.

6 Williams, p. 310. The number 18 plays an important role in Hinduism: thus, 108 (with the insertion of zero) and 1008 (with the insertion of 2 zeros). There are 108 Upaniṣads, 108 names of Viṣṇu in the Mahābhārata, and 108 names for Śiva.

Note the sacred character of the number 108 in Tibet; there are 108 volumes of the Kangyur (in certain editions), 108 signs of Buddhahood, 108 votive lamps. There are also 108 names of the Buddha (*Hō.,* 194a). Soothill, p. 8a, s.v. 108 (*aṣṭaśatam*): "The 108 kleśa, distresses, disturbing passions, or illusions of mankind, hence the 108 beads on a rosary, repetitions of the Buddha's name, strokes of a bell, etc., one for each distress."

108 is the number of beads on a Śivaite rosary and is commonly used as a quasi-magical number in various religions in India. Its importance derives from 10,800, its multiple, the number of moments in the year and the number of verses in the Ṛg Veda, according to the *Śatapathabrāhmaṇa* (Filliozat).

6a On the number 108 see Scheftelowitz, "Die bedeutungsvolle Zahl 108 im Hinduismus und Buddhismus."

6b Doré (*Researches into Chinese Superstitions,* V, 526–28) notes (somewhat irrelevantly, it seems) that the 108 beads equal the total of the twelve months, the 24 terms into which the solar calendar has been divided, and the 72 divisions of the Chinese year into periods of 5 days: $12 + 24 + 72 = 108$.

7 Waddell (p. 202) states that, according to tradition, the largest of the three

beads corresponds to the Buddha: the outside little one corresponds to the Community and the inside little one to the Doctrine.

8 The string represents Kannon (Gonda, *SMH*, p. 74) and consequently is red to symbolize the divinity's Compassion.

9 Gonda, *SMH*, p. 73, li. 13ff. The *kazutori* may also be composed of 6 beads on two strands. In this case each bead stands for one of the Six Perfections.

10 For different ways of holding the rosary, cf. the *Soshicchigiki* in *Daizōkyō zuzō*, VII, 17, fig. 58 (*butsubu*); 59 (*rengebu*), 60 (*kongōbu*).

11 Mallmann, *Intro.*, p. 270.

12 The rosary is almost always held in the right hand of Avalokiteśvara with two hands; the left carries a red lotus, "but later it will no longer be an attribute of the two-handed Avalokiteśvara." The water vase (*kamaṇḍalu*), the red lotus (*padma*), and the rosary (*akṣamālā*) constitute, according to Mallmann (*Intro.*, p. 266), the common attributes of Avalokiteśvara.

13 Beal, *A Catena of Buddhist Scriptures from the Chinese*, p. 393, and Getty, p. 171 (whose note refers to Beal). Cf. Burnouf, tr., *Lotus de la bonne loi*, p. 264.

14 Gonda, *SMH*, p. 74.

15 Ibid.

16 *ST*, VII, cf. Shunjō (1167–1228), a monk of the Shingon sect. He rebuilt the Tōdaiji after the fire in 1180. Cf. the statues of Unkei and Tankei of the Rokuharamitsuji, Kyoto. For different ways of holding the rosary, cf. the *Soshicchigiki* (see n. 10, *supra*).

SCROLL AND BRUSH

1 Kōmoku-ten, *ZZ*, Pl. 133, carries a brush (right hand) and a scroll (left hand). Cf. also Pl. 4.

2 Cf. Williams, p. 311.

3 Mallmann, *Intro.*, p. 271. The leaves are called *baita* (Sk. *pattra*) —*Hō.*, p. 47b.

4 *ST*, I, Senju Kannon: for example, the brush is held in the 13th right hand, while the scroll (sūtra) is held in the 14th right hand.

5 Cf. Warner, nos. 3, 7: Kōmoku-ten (Virūpākṣa), one of the four divine *mahārājas* (the others: Tamon-ten [Vaiśravaṇa], Jikoku-ten [Dhṛtarāṣṭra], Zōchō-ten [Virūḍhaka]) in the Kondō of the Hōryūji, holds in his right hand a brush and in his left a scroll. Cf. also the *ST*, IV.

6 Cf. Taizan-ō (*ZZ*, Pl. 91). *BD* 1099a: Taizan *pukun*. According to Matsumoto Eiichi (*Tonkō-ga no kenkyū*, I, pp. 757–61) one of the attributes of Vasetta (Vasu Ṛṣi) of the Pāli sūtras is a scroll —cited from Davidson, *The Lotus Sutra in Chinese Art*, p. 47 and n. 59.

SISTRUM

1 *Sistre* (*Hō.*) *canne* (*tsue*: Matsudaira), *crosse* (Sirén), sounding staff (Getty), monk's staff (Soothill), alarm-staff (Williams).

2 See *BD* 802a: *shakujō* (pewter stick), *shinjō* (voice stick), *ujō* (sounding stick), *chijō* (knowledge stick), *tokujō* (virtue stick).

3 *Khakkhara* = *kikira* (*BD* 237a; Soothill, pp. 368a, 418b).

4 Warner, *Buddhist Wall-Painting*, Pl. XVII: Kṣitigarbha. Sir Aurel Stein found the representation of this attribute at Tun Huang on banners and wall-paintings. Von le Coq notes its presence at Turfan (Getty, p. 169).

5 Williams, p. 4.

6 Mochizuki, *BD* (1954), 2152c; according to the *Shibunritsu* (*T.* 1428, XXII, 956a ff.); also cf. Matsudaira, "La Canne et Jizō," p. 275.

6a *Daibikusanzenigi* 2 (*T.* 1470); Mochizuki, *BD* (1954), 2152c.

6b *T.* 1503; Mochizuki, *BD* (1954), 2153a.

7 Williams (p. 4) states that the Buddha is supposed to have possessed a pewter staff, the handle of which was in sandalwood and the rings in pewter.

8 More rarely with 8 rings. Cf. the Old Man Kāśyapa in Chavannes, *Mission*, Vol. I of plates, Pl. CXCVII (no. 323, Cave M). This personage holds a sistrum in the right hand (8 rings). Also cf. Pl. XII of Hackin, *Guide*.

9 Pain, the cause of pain, the cessation of pain, the path which leads to the cessation of pain.

10 ZZ, Pls. 46, 50. Certain sects make it the representation of Mount Meru (Getty).

11 *Pratyekabuddha* = a solitary Buddha, without masters, without disciples; = Buddha-for-self, who seeks enlightenment for himself alone (*engaku*) —*Hō.*, Suppl. to the 1st fasc., p. 11.

12 Mochizuki, *BD* (1954), 2152b.

13 This translation is based on the *Shakujōkyō* (*T.* 785, XVII, 724a, li. 23ff.) quoted in *BD* 802a. The text confirms Matsudaira's translation "la canne de l'Intelligence." The vital essence is supposed to reside in the head of the sistrum (cf. Matsudaira, "La Canne et Jizō").

14 Cf. *BD* 1755c.

15 Cf. Maspéro, *Les Religions chinoises*, p. 73.

16 Koizumi, no. 13: Jizō holding a sistrum (National Treasure); Getty, Pl. XXXIII, b, c, d. ZZ, Pl. 77, wishing jewel and sistrum (in the right hand).

17 Koizumi, no. 53: Monju holding in the right hand a jewel and in the left a sistrum with six rings.

18 *ST*, VII: cf. the photograph of the sistrum belonging to the Zentsūji (Sanuki). To the knowledge of the present writer, the *khakkhara* is not a symbol of Avalokiteśvara in India. The *Asabashō* 48, indicates that Fukūkensaku Kannon (Sk. Amoghapāśa) carries a sistrum in the upper left hand. Getty claims (incorrectly) that Fukūkensaku Kannon is not a part of the Shingon pantheon (cf. Getty, p. 80). The 1,000-armed Kannon carries the *shakujō* in one of her 40 arms, whence the name *shakujō-shu*, or *shakujō* hand.

19 Yakushi is so represented specifically in Chinese paintings, where he is also depicted mounted on an elephant. See de Visser, *ABJ*, p. 566.

SWORD

1 *Riken*, the short sword which symbolizes Amida and Monju, is the emblem of their Knowledge, their power of discrimination, and their victory over Evil.

2 *Khaḍga* (Foucher, *Icon. boud.*, p. 70).

3 For the use of the sword in the *kanjō* ceremony, according to the *Candamahāroṣaṇatantra*, cf. Glasenapp, *MB*, pp. 122–23.

4 Williams, p. 353. Williams also notes (p. 353) that in Taoism the sword is the special emblem of Lü Tung-pin, one of the Eight Immortals; it symbolizes the victory of this worthy over Evil. Lü, armed with the sword, goes throughout the world subjugating the powers of darkness.

5 According to the *Dainichikyō*, cited in Gonda and Ōmura, p. 144, li. 6–7. Cf. Ibid., chapter on Fudō, pp. 144–51.

According to the *BD* 1535a, the sword signifies (a) Knowledge of the Mean, a knowledge as unshakable in the domain of existence as in that of void; (b) the defeat of Māra brought about by brandishing the sword of Knowledge of the Mean, which characterizes the lack of polarity. See also Suzuki, *Zen and Japanese Culture*, pp. 90ff.

6 *Zuzō daishūsei* 40, shows Fudō carrying the sword in the right hand, while with his left hand erect he upholds a six(?)-spoked wheel. On p. 16, cf. figs. 107–20. Koizumi, no. 35: the pommel of his sword is in the form of a *vajra*.

7 Gonda and Ōmura, figs. 257 and 258.

8 The 9 Realms are: desire, paradise after earthly life, paradise of cessation of rebirth, land of wondrous joy, land of abandonment of thought, land of infinite space, land of omniscience, land of nothingness, and land of knowledge without thinking or not thinking (cf. Soothill, pp. 16–17).

9 *ZZ*, Pl. 150: Monju holds the erect sword in his right hand, the attribute of the left hand is lost.

10 Koizumi, no. 20.

VAJRA

1 Also *bazara* (*BD* 475a); cf. *Hō.*, p. 62b; Soothill, p. 280b; and Mochizuki, *BD* (1954), 1333–1335. Tib. = *rdo rje*.

2 *Vajra* signifies (according to Glasenapp, *MB*, pp. 23–24):

 1 Diamond, precious stone.
 2 Thunderbolt, attribute of Indra and other divinities; in a general way, any kind of arm capable of being put into action (e.g., water *vajra* (poetical = the transparency of water; a *vajra* word = a word which acts).
 3 Scepter which priests of the Esoteric school hold (present in the armorial bearings of the Dalaï Lama).
 4 Symbol of the Absolute (*śūnyatā*).
 5 First part of certain names indicating indestructibility, etc. (e.g., Vajrabodhi, Vajrasiddhi). (*Vajrapāśa*, the lasso, is so called when a *vajra* is attached to the end of the rope; this is an unbreakable, adamantine rope with which to tie the enemies of Buddhism.)

Conze, *Buddhism*, p. 178: "Itself unbreakable, it breaks everything else. In later Buddhist philosophy the word is used to denote a kind of supernatural substance which is as hard as a diamond, as clear as empty space, as irresistible as a thunderbolt."

3 Getty, p. 180.

4 Soothill, p. 201.

5 Cf. Contenau, *Manuel d'archéologie orientale*, figs. 111, 124, 139, 663, 697, 704.

6 Cf. Contenau, *La Civilisation d'Assur et de Babylone*, figs. 19 and 22.

7 Double *vajra:* cf. the likeness between this form and the sign placed "at the end of a subject of composition because it (is) derived from the character which means nirvāṇa (without passions) and which is the last stage in the perfection of the soul" (Ymaïzoumi, *Shidda*, p. 331).

8 Getty, p. 180. The Indian three-pointed *vajra* is flat, the points separated, while the Tibetan *vajra* (*dorje*) is round and, since the points are closed, resembles a lotus bud.

9 Indra in the Hindu legend represents temporal power (*kṣatra*) and Agni spiritual

power (Brahmā). Thus Indra is called *"vajrin, vajra-bāhu"* (Coomaraswamy, *EBI*, pp. 14–15).

10 Cf. Coomaraswamy, p. 15, for the use of the *vajra* in the Buddhist legend.

11 Cf. *BD* 475a. The *Bommōkyōkoshakuki* (*T*. 1815, XL, 687b ff.), quoted in *BD* 475a: "What is characteristic of the diamond (i.e., hardness) is called *kongō*." *Sanzōhōsu* (*BD* 620c), quoted in *BD* 475a: "One says *kongō* because it (is a question of) the extreme hardness of a diamond."

12 Diamond World. *Hō.*, p. 62.

13 According to Advayavajra, the *vajra*, symbol of sovereignty, figures in the ceremony of unction, *kanjō* (Glasenapp, *MB*, p. 122).

14 Cf. Advayavajra, p. 23 in Glasenapp, *MB*; cited on page 105.

15 The *kongōkai* symbolizes Knowledge (inseparable from Reason) considered as essential for individual salvation; the *taizōkai* symbolizes Reason (inseparable from Knowledge), considered as essential for the salvation of others.

16 Fujishima, *Le Bouddhisme japonais*, p. 92.

17 Cf. Coomaraswamy, *EBI*, p. 15, for bibliography on this subject. For the Vedic vajra, cf. pp. 14f.

18 Foucher, *Beginnings of Buddhist Art*, Pl. I, fig. 6.

19 Hackin, *Guide*, p. 21.

20 Cf. Coomaraswamy, Pl. VI, fig. 26. The Vedic *vajra* may well have been of this kind (p. 14). Mochizuki, *BD* (1954), 1334a, in the *Jishibosatsuryakushuyuganenjuhō* (*T*. 1141), last volume. 1–5-pronged vajras are explained and in the *Daihimitsuōmandara 5* (*T*. 889) such *vajra* as the following are mentioned: Tathāgata's *vajra*, marvelous *vajra*, anger *vajra*. Also mentioned are the 1, 3, 5, and 9-pronged types as well as the 4-faced, 12-pronged type.

21 Ibid., p. 44.

22 Ibid., Pl. VI, fig. 27.

23 Ibid., p. 44.

24 Ibid.

25 "In Shingon symbolism, the vajra, Kongō, is always represented as 'supported' by a lotus, that is, by a universal 'ground,' the relation of vajra to lotus being that of 'impartible essence' to 'universal substance'; and it is in the 'middle region', i.e. 'round about' the axis of the vajra, between the centre and the felly of any wheel, that all existence is extended" (Coomaraswamy, p. 45).

26 Cf. Coomaraswamy, Pl. VI, fig. 27. Compare with the *kombei*, sticks used for the symbolic operation of the cataract, from the point of view of form and use (*Hō.*, p. 261a, fig. 79).

In the Matrix World the prongs (of the *vajra*) repose in vases called *amṛta-kalaśa*, and are surmounted by a three-pointed *vajra* (cf. *Hō.*, p. 269b). Coomaraswamy (p. 14) reports that the Ṛg Veda speaks of a three-pointed *vajra* (Ṛg Veda, I, 52, 15).

27 Cf. Glasenapp, *MB*, fig. on p. 23 (or p. 112 in *Buddhismus*). Coomaraswamy (p. 14) speaks of a "Four-angled rain producer" mentioned in the Ṛg Veda, VIII, 7, 22.

28 See Soothill, pp. 168–84.

29 The *vajra* is said to have been introduced into Tibet by Padmasambhava in the VIII century. Cf. Milloué, *Petit guide au Musée Guimet*, p. 100: image de Dorje.

30 Gonda and Ōmura, p. 35.

31 The Five Elements (earth, water, fire, air, void) form the phenomenal world (*taizōkai*): added to them is Discernment (*shiki*; Sk. *vijñāna*) as the sixth element, which

represents the *kongōkai*. The two worlds (*taizōkai* and *kongōkai*) are inseparable, indivisible, for there is, of course, no Discernment without the other elements. This sixth element (*vijñāna*) is subdivided into the Five Knowledges. Cf. Soothill, p. 120, who gives the following:

1 *Dharmadhātu-prakṛti-jñāna*: Dainichi-center-void.
2 *Ādarśa-jñāna*: Ashuku-east-earth.
3 *Samatā-jñāna*: Hōshō-south-fire.
4 *Pratyavekṣaṇa-jñāna*: Amida-west-water.
5 *Kṛtyānuṣṭhāna-jñāna*: Fukūjōju-north-air.

32 Glasenapp, *MB*, p. 105.

33 Elisséeff, "Mythologie du Japon," p. 402. The *vajra* given to the adept during the *kanjō* ceremony (unction) is supposed to be able to ward off demons.

34 Gonda, *SMH*, p. 35.

35 Williams, p. 363: cf. also club (*kan-jō*), emblem of authority, p. 226.

36 *BD* 290b.

37 Gonda, *SMH*, p. 35.

38 Coomaraswamy (*EBI*, p. 15) claims — incorrectly, by the way — that the Shingon sect uses types of *vajra* having from 1 to 8 prongs.

39 Soothill, p. 16a.

40 Ibid., p. 16b.

41 Ibid., p. 18a.

42 *Hō.*, p. 48a. Cf. Bajarahani (i.e., Vajrapāṇi).

43 Bhattacharyya, *IBE*, p. 129.

44 Cf. *ST*, II. Vajrapāṇi of the Tōdaiji (Nara) holds a single-point *vajra*, and Nārāyaṇa holds a club.

45 Cf. the portrait photograph of Gonda Dai-ajari in his *SMH*.

46 The *Jikkanshō*, scroll I, indicates the *vajra* (five-pointed) as the attribute of Ashuku. In Tibet, the five-pointed *vajra* is associated with Amida; the single-pointed is associated with Muryōju; the *viśvavajra*, that is, the double *vajra* in the form of a cross with Fukūjōju — it is also the attribute of his *śakti*, Tārā: (five-pointed) with Kaifuke-ō.

For the *viśvavajra* (i.e., *komma kongō* or *karma-vajra*), cf. Coomaraswamy, Pl. VI, fig. 28. Consult his note concerning this *vajra* for the explanation of its use and its symbolism.

The *takara-no-bō*, held in the right hand of Bishamon and Uhō Dōji, should not be confused with the *tokko* or single point *vajra*.

VASE

1 *Hō.*, p. 265a: *byō* is the "generic designation for different sorts of receptacles most generally intended to contain water: vases, pitchers, vials, bottles."

2 *Kalaśa*: for transcriptions see Soothill, p. 442a. Mallmann (*Intro.*, p. 266) notes under the common attributes of Avalokiteśvara the *kamaṇḍalu* or water vase. *Hō.* (p. 265a) gives the *kuṇḍikā* as the water-jar of a monk, iconographic attribute, or ritual vase. Eitel (pp. 79–80) glosses *kuṇḍikā* as "watering pot." *Kalaśa*: bellied jar, miraculous vase Bhadraghaṭa, containing "all that may be desired" (cf. *Hō.*, p. 267b); this term is used in Esotericism. The equivalents of *kalaśa* are: *hōbyō*, "jewel jar," and *kembyō*, "wisdom jar," this latter being the symbol of Earth (p. 268a). Wisdom jar is probably a bad translation of the Sk. *bhadraghaṭa*, which may correspond to *kuṇḍikā*. Tib. = *tse-bum*.

3 For disciplinary jars, recipients of a utilitary nature, cf. the article in *Hō.*, pp. 265ff.

4 *Hō.*, p. 266a–b (bracketed material as in the edn. of *Hō.*). Coomaraswamy and Kershaw ("A Chinese Buddhist Water-vessel") try to show that this jar with a thin lip and a lateral spout, which I-ching describes, though well attested in Buddhist sites in India before I-ching, does not appear in archaeology and in Far Eastern art until the VIII cent. (p. 270a). Cf. Gairola, "Evolution du pūrṇa ghaṭa."

5 Glasenapp, *MB*, p. 99.

6 *Hō.*, p. 270a. Tucci (A propos d'Avalokiteśvara," p. 178) reports: "It is quite understandable that little by little the *kamaṇḍalu* became a lotus; the symbolism of the two is the same; the base, in the liturgy of India, from the times of the rituals expounded in the *Brāhmaṇas* up to the *ghaṭasthāpana* of the *pūjā* as is practiced even today, is the symbol of the magic universe where the priest operates (see *Tibetan Painted Scrolls* [Pls. 59–63 and] p. 377, no. 33)."

Cf. also R. Stein, "Jardins en miniature d'Extrême-Orient," pp. 53ff.

7 *BD* 206a.

8 Ibid.; *Rokujūkegonkyō* 59 (*T.* 278, IX, 776a, li. 14–15), tr. Buddhabhadra. The *Hō.* (p. 267a) speaks of a *kudokubyō* "which permits the granting of all wishes" and a "vase of plenitude," *honnōgada* (Sk. *pūrṇaghaṭa*).

9 Williams, p. 384. There is also a wisdom vase (*Hō.*, p. 268a) symbolic of the element earth, for earth both contains and sustains every thing.

In the unction ceremony (*kanjō*), the master dips from the vase (*kalaśa*) the water with which he will sprinkle the neophyte, an action which is supposed to grant symbolically to this latter the nectar of Knowledge (cf. *kanjō-in*).

10 *Hō.*, 267b. For the unction rite, 6 or 18 *kalaśa* may be made either in precious metals (gold, silver, etc.), or in porcelain. They are filled with filtered water, which is perfumed with diverse aromas. For further details see *Hō.*, p. 267b. Cf. ibid., p. 268a, for the *gobyō kanjō*.

11 Gonda and Ōmura, p. 18. Dainichi (Vairocana, center); Hōshō (Ratnasaṃbhava, south); Amida (Amitābha, west); Fukūjōju (Amoghasiddhi, north); Ashuku (Akṣobhya, east) —Soothill, p. 120.

The vases correspond also to the colors: red (NE), yellow (SE), blue (SW), black (NW), white (middle) — Gonda. The vase in the middle is larger than those situated in the four cardinal points.

12 The water of the five vases symbolizes the Five Knowledges of the Tathāgata in order that he may continue the genealogy of the Buddhas (Tajima, p. 12), or the Five Esoteric Sections (Buddha, Lotus, Jewels, Diamond, Act (*Hō.*, p. 267b).

13 *Hō.*, p. 268b: "In Japan the flower vases form with the incense burners (*kōro*) and the candle holders (*shokudai*) what are called the complete altar fittings (*gusoku*). These three objects are already mentioned together in a Chinese text going back probably to the T'ang dynasty" (*Chokushuhyakujōshingi* — *T.* 2025, XLVIII, 1141c).

14 *Hō.*, p. 267b: "precious substances, numbering twenty (5 mineral jewels [*hō*], 5 cereals, 5 perfumes, 5 medicinal plants), which represent in reduction the cosmic treasures."

15 Gonda, *SMH*, p. 18.

16 *Senjusengenkanzeombosatsudaibishindarani* (*T.* 1064, XX, 117b) specifies that even in this case the jar is the Convention Form of Brahmā and that it is necessary to address this hand of Kannon if one desires to be born in Brahmā's heaven (*Hō.*, p. 267a).

17 Mallmann, *Intro.*, p. 267. The water vase is the oldest attribute of Avalo-kiteśvara, but the red lotus the most frequent.

18 The Indian vase is round or oval; the Gandhāran one is pointed and without a base. If the vase is supported by a lotus flower, it is generally provided with a base and a spout. No vase of Avalokiteśvara, as Mallmann notes, possesses the filling tube which the ascetic's vase normally has.

19 *Hō.*, p. 269a: *"ho* Jar"; this bird is accepted as being a *garuḍa*. Pots of this type may have been made originally in a country called Ho, to the north of the Himalayas. The Tibetan term, *bya ma bum* = Sk. *karaka; bya ma* signifies "female bird."

20 The water vase of Avalokiteśvara in India is always held by a left hand: rare in statues of Avalokiteśvara with two arms, frequent in statues of Avalokiteśvara with six arms (Mallmann, *Intro.*, p. 267). Kannon with two arms in Japan is often provided with the vase (Warner, nos. 77, 79, 82, 94, 96–100, 105, 106).

Cf. Warner, no. 14: Kannon of the Kondō, Hyōryūji, holding a vase in the left hand and making the *segan-in* with the right; no. 31: Kannon (Hōryūji) — the vase is in the left hand and the *segan-in* is formed by the right hand. Cf. *ST*, I, Kannon with 1,000 arms (Senju Kannon), who carries a water vase in her fourth left hand.

21 Cf. the two-armed Kannon (*Hō.*, Pl. XX), who holds a willow branch in her left hand and a bell in the right.

22 Sirén (*La Sculpture chinoise*, p. 143) writes that the vase "contains the heavenly dew, the nectar of immortality which they [the gods] are supposed to sprinkle about on their adorers."

23 *Hō.*, p. 268b.

24 Gonda and Ōmura, p. 54, fig. 83. The *kuṇḍikā* serves as a Convention Form for Maitreya in the Diamond World. It follows the description made by Gijō (I-ching; *Nankai-kikinaihōden, T.* 2125, quoted in *Hō.*, p. 266a). Cf. also *Daizōkyō zuzō* I, pp. 916 (fig. 100), 1071 (fig. 56), 1123 (fig. 38), 1180 (fig. 60), quoted in *Hō.*, p. 266a.

25 Cf. Mallmann, *Intro.*, p. 266. The *amṛta-kalaśa* figures also in the circles (*maṇḍala*) separately according to the ritual.

26 *Hō.*, p. 267a; this is also the attribute of Amoghapāśa (Fukūkensaku), Cuṇḍī (Shundei), Agni (Katen), and Atri (Ateiri), in the Matrix World (p. 269a–b).

27 Getty, p. 169.

BIBLIOGRAPHY AND ABBREVIATIONS

BIBLIOGRAPHY AND ABBREVIATIONS

AB: Art Bulletin. Providence, R. I., or New York.

ABJ: see DE VISSER, *Ancient Buddhism in Japan.*

ADVAYAVAJRA. *Advayavajrasaṃgraha.* Edited by Mahamahopadhyaya Haraprasād Shāstri. (Gaekwad's Oriental Series, 40.) Baroda: Oriental Institute, 1927.

AGBG: see FOUCHER, *L'Art gréco-bouddhique du Gandhâra.*

AKIYAMA, AISABURŌ. *Buddhist Hand-Symbol.* Yokohama: Yoshikawa Bookstore, 1939.

ANAND, MULK RAJ. *The Hindu View of Art.* London: Allen and Unwin, 1933.

ANEZAKI, MASAHARU. *Buddhist Art in its Relation to Buddhist Ideals, with special reference to Buddhism in Japan.* Boston: Houghton Mifflin, 1915.

APTE, VAMAN SHIVRAM. *Practical Sanskrit-English Dictionary.* Poona: Shiralkar, 1890.

ARVON, HENRI. *Le Bouddhisme.* Paris: Presses universitaires de France, 1951.

Asabashō. Compiled by Shōchō. Ms. in the Musée Guimet, by several copyists, 1811–12.

———. ———. In: *Dainihon bukkyō zensho,* 35–41. Tokyo: Bussho kankō-kai, 1912. (7 vols.)

ASHTON, LEIGH. *An Introduction to the Study of Chinese Sculpture.* London: Benn, 1924.

AUBOYER, JEANNINE. *Les Arts de l'Extrême-Orient.* Paris: Presses universitaires de France, 2nd edn., 1949.

———. "Un Aspect du symbolisme de la souveraineté dans l'Inde d'après l'iconographie des trônes," *Revue des arts asiatiques* (Paris), XI (1937), 88–101.

———. *Les Influences et les réminiscences étrangères au Kondō du Hōryūji.* (Publications du Musée Guimet: Documents d'art et d'archéologie, 2.) Paris: Geuthner, 1941.

———. "Moudrâ et hasta ou le langage par signes," *Oriental Art* (London), III (1951), 153–61.

———. *Le Trône et son symbolisme dans l'Inde ancienne.* (Annales du Musée Guimet: Bibl. d'études, 55.) Paris: Presses universitaires de France, 1949.

AVALON, ARTHUR [Sir John Woodroffe], ed. *Principles of Tantra,* by Shiva Chandra Vidyrārnava Bhattāchāryya Mahodaya. London: Luzac, 1914–16. 2 vols.

BACHHOFER, LUDWIG. *Early Indian Sculpture.* Paris: Pegasus Press, 1929.

BAGCHI, PRABODH CHANDRA. "On the Canons of Image-making: *Piṅgalāmata,* ch. IV," *Journal of the Indian Society of Oriental Art* (Calcutta), XI (1943), 9–31.

BAPAT, P. V. "Pallatthikā," *Vāk* (Deccan College, Poona), I (Dec. 1951), 45–51.

BBK: see ONO GEMMYŌ, *Bukkyō bijutsu kōwa.*

BD: see MOCHIZUKI, *Bukkyō daijiten;* also ODA TOKUNŌ, *Bukkyō daijiten.*

BEAL, SAMUEL. *A Catena of Buddhist Scriptures from the Chinese.* London: Trübner, 1871.

BEAL, SAMUEL, tr. *Si-yu-ki. Buddhist Records of the Western World.* From the Chinese of Hiuen Tsiang [Hsüan-tsang] (A.D. 629). London: Trübner, 1884. 2 vols.

BEFEO: Bulletin de l'Ecole Française d'Extrême-Orient. Hanoi.

BENDALL, CECIL, and ROUSE, W. H. D., trs. *Śikshā-Samuccaya: A Compendium of Buddhist Doctrine compiled by Śāntideva chiefly from earlier Mahāyāna Sūtras.* London: Murray, 1922.

BHATTACHARYYA, BENOYTOSH. *The Indian Buddhist Iconography.* London: Humphrey Milford, Oxford University Press, 1924. (Abbr. *IBI.*)

——. *An Introduction to Buddhist Esoterism.* London: Oxford University Press, 1932.

——, ed. *Two Vajrayāna Works.* (Gaekwad's Oriental Series, 44.) Baroda: Oriental Institute, 1929.

BODDE, DERK. "On Translating Chinese Philosophical Terms," *Far Eastern Quarterly* (Berkeley, Cal.), XIV (1955), 231–44.

BOSE, PHANINDRA NATH. *Principles of Indian Śilpaśāstra.* (Punjab Oriental Series, 11.) Lahore: Punjab Sanskrit Book Depot, 1926.

BOUSQUET, JACQUES, tr. *Praśna Upaniṣad.* Paris: Adrien-Maisonneuve, 1948.

BRUNOFF, MAURICE DE, ed. *Histoire de l'art du Japon.* (Commission impériale du Japon, Exposition universelle de Paris.) Paris: Brunoff, 1900.

BUHOT, JEAN. *Les Arts de l'Extrême-Orient.* Paris: Larousse, 1933. 5 fasc. ("L'Art des origines à nos jours," 49–53.)

——. "La Pluralité des bouddhas, les principaux personnages du panthéon bouddhique," *Bulletin de l'Association française des Amis de l'Orient* (Paris), VI (1923), 27–60.

Bukkyō Daijii [Encyclopedia of Buddhism]. Edited by the Ryūkoku daigaku. 2nd edn., Tokyo: Fuzambō, 1935–37. 6 vols.

BURGESS, JAMES. "Buddhist Mudras," *Indian Antiquary* (Bombay), XXVI (1897), 24f.

BURNOUF, EUGÈNE. *Introduction à l'histoire du bouddhisme indien.* Paris: Imprimerie royale, 1844.

——. See also *Saddharma-puṇḍarīka.*

Butsuzō—ikonogurafī [The Iconography of Japanese Buddhist Sculpture]. Compiled by the Iwanami shoten henshū-bu. Tokyo: Iwanami shoten, 1952.

BUTSUZŌ KENKYŪ-KAI, eds. *Nihon butsuzō zusetsu* [Japanese Buddhist Figures Illustrated]. Tokyo: Nishōdō shoten, 1934.

Butsuzō zui [Illustrated Collection of Buddhist Figures]. Designs by Ki no Hidenobu. Tokyo: Morie shoten, 1783. (Preface dated 1690.)

CHAPIN, HELEN B. "A Study in Buddhist Iconography," *OZ*, n.s., VIII (1932), 29–43; XI (1935), 125–36.

——. "Yünnanese Images of Avalokiteśvara," *HJAS*, VIII (1944), 131–86.

CHATTERJI, USHA. *La Danse hindoue.* Paris: Editions Véga, 1951.

CHAVANNES, EDOUARD. "L'Exposition d'art bouddhique au Musée Cernuschi," *TP*, XIV (1913), 261–86.

——. *Mission archéologique dans la Chine septentrionale.* (Publications de l'Ecole française d'Extrême-Orient, XIII, 2.) Paris: Leroux, 1913–15. (In two parts: "La Sculpture à l'époque des Han"; "La Sculpture bouddhique." With 2 vols. of plates.)

CHOU YI-LIANG. "Tantrism in China," *HJAS*, VIII (1944), 241–332.

CHURCHWARD, ALBERT. *The Signs and Symbols of Primordial Man, being an Explanation of the Evolution of Doctrines from the Eschatology of the Ancient Egyptians.* London: Sonnenschein, 1910.

COATES, HARPER HAVELOCK, and ISHIZUKA RYUGAKU. *Hōnen, the Buddhist Saint: His Life and Teachings.* Kyoto: Chion-in, 1925.

CODRINGTON, KENNETH DE BURGH. *Ancient India from the Earliest Times to the Guptas.* London: Benn, 1926.

——. *The Art of India and Pakistan.* A commemorative catalogue of the exhibition held at the Royal Academy of Arts, London, 1947–48. Ed. Sir Leigh Ashton. New York: Coward-McCann, 1949.

COMBAZ, GISBERT. "L'Evolution du stûpa en Asie," *MCB*, II (1932–33), 163–305; III (1934–35), 93–144; IV (1935–36), 1–125.

CONTENAU, GEORGES. *La Civilisation d'Assur et de Babylone.* Paris: Payot, 1937.

——. *Manuel d'archéologie orientale.* Paris: Picard, 1927–47. 4 vols.

CONZE, EDWARD. *Buddhism.* New York: Philosophical Library, 1951.

COOMARASWAMY, A. K. *Elements of Buddhist Iconography.* Cambridge: Harvard University Press, 1935. (Abbr. *EBI*.)

——. "Hands and Feet in Indian Art," *Burlington Magazine* (London), XXIV (1913–14), 204–11.

——. "Mudrā, Muddā," *JAOS*, XLVIII (1928), 279–81.

——. "The Origin of the Buddha Image," *AB*, IX (1926–27), 287–328.

——. "The Persian Wheel," *JAOS*, LI (1931), 283–84.

——. *The Transformation of Nature in Art.* Cambridge: Harvard University Press, 1934.

—— and DUGGIRĀLA GOPĀLAKRISHNĀYYA, trs. *The Mirror of Gesture, being the Abhinaya darpaṇa of Nandikeśvara.* New York: [2nd edn.,] Weyhe, 1936.

—— and KERSHAW, F. S. "A Chinese Buddhist Water-vessel and Its Indian Prototype," *Artibus Asiae* (Ascona), no. 2/3 (1928–29), 122–41.

COWELL, E. B., ed. *The Jātaka, or Stories of the Buddha's Former Births.* Cambridge University Press, 1895–1913. 7 vols.

CUMONT, FRANZ. *Fouilles de Doura Europos (1922–1923).* Paris: Geuthner, 1926.

Dainihon bukkyō zensho [Complete Collection of Japanese Buddhism]. Edited by Bussho kankō-kai. Tokyo: Dainihon bukkyō zensho, 1913–22.

Daizōkyō zuzō. See TAKAKUSU.

DAVIDS, T. W. RHYS, tr. *The Questions of King Milinda.* (Sacred Books of the East, 35–36.) Oxford: Clarendon Press, 1890, 1894.

DAVIDSON, J. LEROY. *The Lotus Sutra in Chinese Art; a Study in Buddhist Art to the Year 1000.* (Yale Studies in the History of Art, 8.) New Haven: Yale University Press, 1954.

DE BARY, WM. THEODORE, et al., eds. *Sources of Indian Tradition.* (Records of Civilization: Sources and Studies, 56.) New York: Columbia University Press, 1958.

——. *Sources of the Japanese Tradition.* (Records of Civilization: Sources and Studies, 54.) New York: Columbia University Press, 1958.

DEMIÉVILLE, PAUL. "Les Versions chinoises du Milindapañha," *BEFEO,* XXIV (1924), 1–306.

DE VISSER, M. W. *Ancient Buddhism in Japan.* Leiden: Brill, 1935. 2 vols. (Abbr. *ABJ.*)

——. "The Arhats in China and Japan," *OZ,* VII (1918/19), 87–102, 221–31. (Also a book: Berlin: Oesterheld, 1923.)

Dict.: see RENOU et al., *Dictionnaire sanskrit-français.*

DORÉ, HENRI. *Recherches sur les superstitions en Chine.* Shanghai: Missions catholiques, 1913–38. 8 vols. (*Researches into Chinese Superstitions.* Translated by M. Kennelly et al. Shanghai: T'usewei Printing Press, 1914–33. 3 vols.)

DUMONT, P. E. "The Indic God Aja Ekapād, the One-legged Goat," *JAOS,* LIII (1933), 326–34.

EBI: see COOMARASWAMY, *Elements of Buddhist Iconography.*

ECKARDT, ANDREAS. *Geschichte der koreanischen Kunst.* Leipzig: Hiersemann, 1929.

EDGERTON, FRANKLIN. *Buddhist Hybrid Sanskrit Grammar and Dictionary.* New Haven: Yale University Press, 1953. 2 vols.

EDKINS, JOSEPH. *Chinese Buddhism.* 2nd edn., London: Kegan Paul, 1893.

EITEL, E. J. *Hand-book of Chinese Buddhism, being a Sanskrit-Chinese Dictionary, with Vocabularies of Buddhist Terms in Pali, Singhalese, Siamese, Burmese, Tibetan, Mongolian, and Japanese.* Hongkong: Crawford, 1888.

EJŪ. *Jikkanshō* [Ten Volumes of Notes]. In: *Dainihon bukkyō zensho.* Supplement, 1–10. Tokyo: Bussho kankō-kai, 1922. Collotype, 1932.

ELIADE, MIRCEA. *Yoga: Immortality and Freedom.* Tr. Willard R. Trask. New York: Pantheon (Bollingen Series LVI), and London: Routledge and Kegan Paul, 1958.

ELIOT, SIR CHARLES. *Japanese Buddhism.* London: Arnold, 1935.

ELISSÉEFF, SERGE. "Mythologie du Japon," in *Mythologie asiatique illustrée.* Paris: Librairie de France, 1928.

FINOT, LOUIS. *Les Lapidaires indiens.* (Bibliothèque de l'Ecole des Hautes Etudes, Sciences philologiques et historiques, fasc. 111.) Paris, 1896.

——. "Manuscrits sanskrits de Sâdhana's retrouvés en Chine," *JA,* CCXXIV:2 (July–Sept. 1934), 1–86.

FOUCAUX, MARIE (FILON). *Histoire du Bouddha Sakya-Mouni depuis sa naissance jusqu'à sa mort.* (Bibliothèque orientale elzévirienne, ed. Philippe Edouard Foucaux.)

FOUCHER, ALFRED. *L'Art gréco-bouddhique du Gandhâra*. Paris: Leroux, 1905, 1951. 2 vols. (Abbr. *AGBG*.)

——. *The Beginnings of Buddhist Art, and Other Essays in Indian and Central-Asian Archaeology*. Tr. L. A. Thomas and F. W. Thomas. Paris: Geuthner; London: Milford, 1917.

——. *Etudes sur l'iconographie bouddhique de l'Inde*. (Ecole pratique des Hautes Etudes, Section des sciences religieuses, Bibliothèque de l'Ecole, XIII, 1–2.) Paris: Leroux, 1900–1905. 2 vols.

——. *La Vie du Bouddha, d'après les textes et les monuments de l'Inde*. Paris: Payot, 1949.

FRANKE, R. OTTO, tr. *Dīghanikāya, das Buch der langen Texte des Buddhistischen Kanons*. Göttingen: Vandenhoeck und Ruprecht, 1913.

——. "Mudrâ = Schrift (oder Lesekunst)?," *Zeitschrift der deutschen morgenländischen Gesellschaft* (Leipzig), XLVI (1892), 731–34.

FUJII SAHYŌE. *Fudō goma shiki* [Private Notes on the Fudō *homa*]. Kyoto: pub. by the author, 1922.

FUJISHIMA RYAUON. *Le Bouddhisme japonais*. Paris: Maisonneuve, 1889.

GAIROLA, C. KRISHNA. "Evolution du pūrṇa ghaṭa (vase d'abondance) dans l'Inde et l'Inde extérieure," *Arts asiatiques* (Paris), I (1954), 209–26. Based on a thesis defended at the Ecole du Louvre, January 4, 1954.

GALE, JAMES S., tr. *Korean Folk Tales*. London: Dent and Sons, 1913.

GANGOLY, ORDHENDRA COOMAR. *South Indian Bronzes*. Calcutta: Indian Society of Oriental Art, 1915.

GETTY, ALICE. *The Gods of Northern Buddhism*. Oxford: Clarendon Press, 1914; 2nd edn., 1928.

GHOSH, MANOMOHAN, ed. and tr. *Nandikeśvara's Abhinayadarpaṇam; a Manual of Gesture and Posture Used in Hindu Dance and Drama*. Calcutta: 2nd edn., Mukhopadhyay, 1957.

——. *The Nāṭyaśāstra*. Calcutta: Royal Asiatic Society of Bengal, 1951.

——. *Pāṇinīya Śikṣā, or The Śikṣā Vedanga ascribed to Pāṇini*. Calcutta: University of Calcutta Press, 1938.

GLASENAPP, HELMUTH VON. *Mystères bouddhistes*. Tr. into French by J. Marty. Paris: Payot, 1944. (Orig.: *Buddhistische Mysterien*. Stuttgart: Spemann, 1940.) (French edn. abbr. *MB*.)

——. "Tantrismus und Śaktismus," *OZ*, n.s., XII (1936), 120–33.

GONDA RAIFU. *Mandara tsūge* [General Explanation of Maṇḍalas]. Tokyo: Heigo shuppan-sha, 1927.

——. *Shingon mikkyō hōgu benran* [Manual of Esoteric Cult Implements]. Tokyo: Heigo shuppan-sha, 1927. (Abbr. *SMH*.)

—— and ŌMURA SAIGAI. *Butsuzō shinshū* [A New Collection of Buddhist Figures]. Tokyo: Heigo shuppan-sha, 1927.

GOPĪNĀTHA RAO, T. A. See RAO, T. A. GOPĪNĀTHA.

GORDON, ANTOINETTE K. *The Iconography of Tibetan Lamaism.* New York: Columbia University Press, 1939.

GROUSSET, RENÉ. *Les Civilisations de l'Orient.* Paris: Crès, 1929–30. 4 vols.: *L'Orient; L'Inde; La Chine; Le Japon.* (*L'Inde* appeared in a 2nd edn., without vol. no., 1949.) (Tr. Catherine Alison Phillips: *The Civilizations of the East.* New York: Knopf, 1931–34. 4 vols. 2nd printing, 1941.)

GRÜNWEDEL, ALBERT. *Buddhist Art in India.* Tr. Agnes C. Gibson and Joseph Burgess. London: Quaritch, 1901. (Orig.: *Buddhistische Kunst in Indien.* Berlin: Speman, 1900.)

——. *Mythologie des Buddhismus in Tibet und der Mongolei.* Leipzig: Brockhaus, 1900.

Guide: see HACKIN, *Guide-catalogue* . . .

GUPTA, SAMARENDRANATH. *Les Mains dans les fresques d'Ajanta.* Paris: Bossard, 1921.

——. "With the Five Fingers," *Modern Review* (Calcutta), XII:8 (Aug. 1912), 166–74.

HACKIN, JOSEPH. *Guide-catalogue du Musée Guimet: Les Collections bouddhiques.* Paris: Van Oest, 1923. (Abbr. *Guide.*)

——. *La Sculpture indienne et tibétaine au Musée Guimet.* Paris: Leroux, 1931.

HACKMANN, HEINRICH. *Erklärendes Wörterbuch zum chinesischen Buddhismus: Chinesisch-Sanskrit-Deutsch.* Leiden: Brill, 1951–52. 5 parts.

HAMILTON, CLARENCE H., ed. *Buddhism: a Religion of Infinite Compassion. Selections from Buddhist Literature.* New York: Liberal Arts Press, 1952.

HASTINGS, JAMES, ed. *Encyclopaedia of Religion and Ethics.* Edinburgh and New York, 1908–27.

HEMMI BAIEI. *Indo reihaizō no kenkyū* [A Study of Indian Cult Statues]. Tokyo: Tōyō-bunkō, 1935.

HENDERSON, HAROLD GOULD, and PAINE, ROBERT TREAT, JR. *The University Prints: Oriental Art*, Series O, Sec. 11: *Japanese Art.* Newton, Mass.: University Prints, 1939.

Himitsu jirin [Dictionary of Esoteric Buddhism]. Compiled by Tomita Gakujun. Tokyo: Kaji sekai shisha, 1911.

Himitsu sandan goma ki [Esoteric Three-altar *Homa*]. Tokyo: Bukkyō shorin, 1943.

HISANO KEN. "Butsuzō no shurui to gyōsō" [Aspects and Varieties of Buddhist Statues], *Nihon no chōkoku* [Japanese Sculpture], Geppō 2 (Dec. 15, 1951), 1–4.

HJAS: Harvard Journal of Asiatic Studies. Cambridge.

Hō: see *Hōbōgirin.*

Hōbōgirin: Dictionnaire encyclopédique du bouddhisme d'après les sources chinoises et japonaises. Ed. by Sylvain Lévi, Junjirō Takakusu, and Paul Demiéville. Tokyo: Maison franco-japonaise, 1929–37. 3 fasc. See also *Taishō Issaikyō.* (Abbr. *Hō.*)

HOMMEL, FRITZ. "Pali *muddâ* = Babylonisch *musarū* und die Herkunft der indischen Schrift," in WÜST, *q.v.* (pp. 73–84).

HOSHIDA KŌSABURŌ. *Saiun jikkō* [Golden Clouds and Merciful Light]. Tokyo: Yoshida Kōsaburō, 1921.

HSÜAN-TSANG (Hiuen Tsiang, Hiouen-Thsang, Yuan Chwang). See BEAL; JULIEN; WATTERS.

IBI: see BHATTACHARYYA, *The Indian Buddhist Iconography.*

IC: see RENOU et al., *L'Inde classique.*

I-CHING, comp. *Bongo senjimon* [One Thousand Sanskrit Characters]. Kyoto: Yama-shiroya (Fujii Sahyōe), n.d. (photographic reproduction of volume originally pub. in 1773).

Intro.: see MALLMANN, *Introduction à l'étude d'Avalokiteśvara.*

ISHIMURA RYŪSHŌ, comp. [*Shingon mikkyō.*] *Sambō kōjin-ku hihō* [Esoteric Cere-monies for Offerings to the Sambō (*triratnā*) Fierce Divinity]. Kōya-san: Mat-sumoto Nisshindō, 1954.

JA: *Journal asiatique, recueil de mémoires et de notices relatifs aux études orientales.* Paris.

JAOS: *Journal of the American Oriental Society.* Boston.

JULIEN, STANISLAS, tr. *Mémoires sur les contrées occidentales, traduits du sanscrit en chinois, en l'an 648, par Hiouen-Thsang.* Paris: Imprimerie Impériale, 1857. 2 vols.

Kakuzenshō, in: *Dainihon bukkyō zensho.* Tokyo: Bussho kankō-kai, 1913–22. (Vols. 45–51.)

Kaneko Ryōun. "Butsuzō no in" [The Mudrā of Buddhist Statues], *Nihon no chōkoku*, Geppō 4 (Apr. 15, 1952), 1–4.

KAWASAKI YOSHITARŌ, comp. *Chōshun-kaku kanshō* [Catalogue of the Chōshun-kaku Collection]. Tokyo: Kokka-sha, 1914. 6 vols.

KIRFEL, WILLEBALD. *Der Rosenkranz, Ursprung und Ausbreitung.* (Beiträge zur Sprach-und Kulturgeschichte des Orients, 1.) Walldorf (Hesse): Verlag für Orientkunde Dr. H. Vorndran, 1949.

KLEEN, TYRA DE. *Mudrās, the Ritual Hand-poses of Buddhist Priests and Shiva Priests of Bali.* London: Kegan Paul, 1924.

KOIZUMI SAKUTARŌ, ed. *Kain shōja shinkan* [New Collection of Buddhist Sculpture in Japan]. Tokyo, 1926.

Kokka [An illustrated monthly journal of the fine and applied art of Japan and other Eastern countries]. Tokyo: Kokkasha, 1891– .

Kokuyaku Daizōkyō [Japanese translation of the Chinese Tripiṭaka]. Edited and pub-lished by Kokumin bunko kankōkai. Tokyo, 1917.

Konjaku monogatari [Tales of Past and Present]. In: *Kokushi taikei*, Vol. XVII. Tokyo: Kokushi taikei kankō-kai, 1933.

KRAMRISCH, STELLA. *Indian Sculpture.* London: Oxford University Press, 1933.

KUDO RISABURŌ. *Nihon seika* [Representative Examples of Japanese Art]. Nara: Kei-kaen, 1908. 4 vols.

KUNI MATSUO. See STEINILBER-OBERLIN.

La Meri (Russell Meriwether Hughes). *The Gesture Language of the Hindu Dance.* New York: Columbia University Press, 1941.

Lévi, Sylvain. "Les Missions de Wang Hiuen-ts'e dans l'Inde," *JA*, XV (1900), 279–341; 401–468.

——. "Wang Hiuan-ts'ö et Kaniṣka," *TP*, XIII (1912), 307–9.

——, and Chavannes, Edouard, trs. "Voyages des pèlerins bouddhistes: L'Itinéraire d'Ou-k'ong (751–790)," *JA*, VI (1895), 341–84.

——. See also *Hōbōgirin.*

Liebenthal, Walter. "Chinese Buddhism During the 4th and 5th Centuries," *Monumenta Nipponica* (Tokyo), XI (1955): 1, 44–83.

Lin Li-kouang. "Puṇyodaya (Na-t'i)," *JA*, CCXXVII (July–Sept. 1935), 83–100.

Linossier, Raymonde. "L'Iconographie de la 'Descente d'Amida'," in: *Etudes d'orientalisme,* published by the Musée Guimet in memory of Raymonde Linossier, Vol. I. Paris: Leroux, 1932.

Lloyd, Arthur. *The Creed of Half Japan: Historical Sketches of Japanese Buddhism.* London: Smith, Elder, 1911.

L'Orange, H. P. *Studies on the Iconography of Cosmic Kingship in the Ancient World.* (Instituttet for sammenlignende Kultur-forskning, Serie A: Forelesninger, 23.) Oslo: Aschehoug, 1953.

LS: see Renou, *Littérature sanskrite.*

Lüders, Heinrich. "Die śākischen Mūra," *Sitzungsberichte der Preussischen Akademie der Wissenschaften* (Berlin), XXXIII (1919), 734–66.

Majumdar, R. C., ed. *The History of Bengal.* Ramna: University of Dacca, 1943– . (Vol. I– .)

Mallmann, Marie-Thérèse de. *Introduction à l'étude d'Avalokiteśvara.* (Annales du Musée Guimet, Bibl. d'études, 57.) Paris, 1948. (Abbr. *Intro.*)

——. "Notes sur les bronzes du Yunnan représentant Avalokiteśvara," *HJAS*, XIV (1951), 567–601.

Maraini, Fosco. *Secret Tibet.* New York: Viking, 1952.

Maspéro, Henri. *Les Religions chinoises.* (Publications du Musée Guimet, Bibliothèque de diffusion, 58.) Paris: Civilisations du Sud, 1950.

Mathews, R. H. *A Chinese-English Dictionary.* Revised edn. (photolithographed from the 1931 Shanghai edn.), Cambridge: Harvard University Press, 1945.

Matsudaira Norimitsu. "La Canne et Jizō," *France-Japon* (Paris), no. 30 (1938), 275–83.

MB: see Glasenapp, *Mystères bouddhistes.*

MCB: Mélanges chinois et bouddhiques. Brussels.

Mikkyō daijiten [Dictionary of Esoteric Buddhism]. Kyoto: Mikkyō jiten hensan-kai, 1931–33. 3 vols.

Milloué, Léon de. *Petit guide illustré au Musée Guimet.* Paris: Leroux, 1910.

MITSUI EIKŌ. "Jikkyō nisō wa ika ni gakushū saru beki-ka" [How to Learn the Two Aspects of Tendai Teachings—Phenomenal and Extra-phenomenal], *Kōya-san Jihō* (Mount Kōya), Sept. 11, 1954, pp. 2–3.

MIYANO YŪCHI and MIZUHARA GYŌEI, eds. *Shingon mikkyō zuin shū* [Collection of Illustrated Mudrā of Shingon Esotericism]. Kōya-san: Matsumoto Nisshin-dō, 1953.

MIZUHARA GYŌEI, comp. *Shido kegyō shidai* [Order of Advancement in the Four Degrees]. Kōya-san: Matsumoto Eitarō, 1953.

MK: see TOGANOO, *Mandara no kenkyū.*

MOCHIZUKI SHINKYŌ. *Bukkyō daijiten* [Dictionary of Buddhism]. Tokyo: Bukkyō daijiten hakkōjo, 1932–36. 2nd edn., Tokyo: Sekai seiten kankō kyōkai, 1954. (Abbr.: Mochizuki, *BD;* if without date = 1st edn.)

MONIER-WILLIAMS, SIR MONIER. *A Sanskrit-English Dictionary.* Oxford: Clarendon Press, 1872.

MUNSTERBERG, HUGO. "Chinese Buddhist Bronzes at the Kamakura Museum," *Artibus Asiae* (Ascona), XIX (1956): 2, 101–10.

MÜNSTERBERG, OSKAR. *Chinesische Kunstgeschichte.* Esslingen a. N.: Neff, 1910. 2 vols.

MURAYAMA JUNGO. *Yasan reihō shū* [Collection of Kōya-san's Priceless Treasures]. Tokyo: Kokka-sha, 1909.

MUS, PAUL. *Barabuḍur; esquisse d'une histoire du bouddhisme, fondée sur la critique archéologique des textes* . . . Paris: Geuthner, 1935. 2 vols.

N.: see NANJIO BUNYIU.

NAIDU, B. V. N.; NAIDU, P. S.; and PANTULU, O. V. R. *Tāṇḍava Lakṣaṇam; or, The Fundamentals of Hindu Dancing. A translation of the 4th chapter of the Naṭya Śāstra of Bharata.* Madras: G. S. Press, 1936.

NANJIO BUNYIU, comp. *A Catalogue of the Chinese Translation of the Buddhist Tripiṭaka; The Sacred Canon of the Buddhists in China and Japan.* Oxford: Clarendon Press, 1883; reprint, Tokyo: Maruzen, 1929. (Abbr. N.)

Nanto jū-dai-ji ō-kagami [Catalogue of Art Treasures of Ten Great Temples of Nara]. Comp. by the Tokyo bijutsu gakkō. Tokyo: Ōtsuka kōgeisha, 1932–34. 25 vols.

Nihon butsuzō zusetsu. See BUTSUZŌ KENKYŪ-KAI.

Nihon kiryaku [Chronicles of Japan in Outline]. Ed. Kuroita Katsumi. Tokyo: Kokushi taikei kankōkai, 1929. 2 vols.

Nihon no chōkoku [Japanese Sculpture]. Tokyo: Bijutsu shuppan-sha, 1951. 4 vols. (I, Prehistoric Period; II, Asuka Period; III, Hakuhō Period; IV, Tempyō Period.)

NISHIOKA HIDEO. *Nihon ni okeru seiki sūhai no shiteki kenkyū (History of Phallicism in Japan).* Tokyo: Myōgi, 1956.

ODA JISHŪ. "Shingon mikkyō no mandara shisō ni tsuite" [Concerning the Mandala Concept in Shingon Esotericism], *Indo-gaku bukkyō-gaku kenkyū* (Tokyo), July 1952, 176–80.

ODA TOKUNŌ. *Bukkyō daijiten* [Unabridged Buddhist Dictionary]. Tokyo: Ōkura shoten, 1930. (One-vol. edn.). Reprinted, 1954. (Abbr. *BD*.)

OGAWA HARUAKI. *Tōyō bijutsu tokushū* [A Special Collection of Far Eastern Art]. Nara: Asuka-en, 1930.

ONO GEMMYŌ. *Bukkyō bijutsu kōwa* [Lectures on Buddhist Art]. Tokyo: Koshi-sha, 1927. (Abbr. *BBK*.)

——. *Bukkyō no bijutsu oyobi rekishi* [The Art and History of Buddhism]. Tokyo: Bussho kenkyū-kai, 1916.

——. *Butsuzō no kenkyū* [A Study of Buddhist Statues]. Tokyo: Takashima, 1926.

ONO KIYOHIDE. (*Shingon himitsu ryōbu shimpō*) *Kaji kitō oku-den* [Secret Tradition of Prayers and Incantations (in the Dual Shingon Esoteric Ceremonies)]. Tokyo: Jingū-kan, 1940.

OZ: Ostasiatische Zeitschrift. Berlin.

PARRY, DAVID. "Chinese Pottery," *Eastern World* (London), IV: 7 (July 1950), 30–32.

PELLIOT, PAUL. "Autour d'une traduction sanscrite du Tao Tö King" (Sec. I, 351–80: "A propos des missions de Wang Hiuan-t'sö"), *TP*, XIII (1912), 351–430.

PODUVAL, R. V. *The Art of Kathakali*. Trivandrum, Travancore: Department of Archaeology, 1933.

PRICE, A. F., tr. *The Diamond Sutra; or, The Jewel of Transcendental Wisdom*. London: The Buddhist Society, 2nd edn., 1955.

PRZYLUSKI, JEAN. "Mudrā," *Indian Culture* (Calcutta), II : 4 (April 1936), 715–19.

——. "La Roue de la vie à Ajaṇṭâ," *JA*, 11th ser., XVI (Oct.–Dec. 1920), 313–31.

——. "Le Symbolisme du pilier de Sārnāth," in *Etudes d'orientalisme*, published by the Musée Guimet in memory of Raymonde Linossier, Vol. II (pp. 481–98). Paris: Leroux, 1932.

——. "La Ville du cakravartin," *Rocznik Orjentalistyczny* (Lwow), V (1927), 165–85.

RAO, T. A. GOPĪNĀTHA. *Elements of Hindu Iconography*. Madras: Law Printing House, 1914–16. 4 vols.

REISCHAUER, EDWIN O. *Ennin's Travels in T'ang China*. New York: Ronald Press, 1955.

——, tr. *Ennin's Diary; The Record of a Pilgrimage to China in Search of the Law*. New York: Ronald Press, 1955.

RÉMUSAT, ABEL, tr. *Foĕ kouĕ ki, ou Relation des royaumes bouddhiques . . . , par Chy Fǎ Hian*. Paris: Imprimerie royale, 1836.

RENOU, LOUIS. *Littérature sanskrite*. (Glossaires de l'hindouisme, fasc. 5.) Paris: Maisonneuve, 1945. (Abbr. *LS*.)

[—— and FILLIOZAT, JEAN, with the collaboration of others.] *L'Inde classique: Manuel des études indiennes*. Vol. I, Paris: Payot, 1947. Vol. II (Bibliothèque de l'Ecole française d'Extrême-Orient, 3), Paris: Imprimerie nationale, 1933. (Abbr. *IC*.)

Renou, Louis; Stchoupak, N.; and Nitti, L. *Dictionnaire sanskrit-français.* Paris: Maisonneuve, 1932. (Abbr. *Dict.*)

Rowland, Benjamin. "Gandhāra and Early Christian Art: Buddha Palliatus," *American Journal of Archaeology* (Princeton), XLIX (1945), 445–48.

——. "The Hellenistic Tradition in Northwest India," *AB*, XXI (1949), 1–10.

——. Review of *The Life of the Buddha*, by Anil de Silva-Vigier, *Far Eastern Quarterly*, XV (1956), 623–25.

——, ed. *The University Prints: Oriental Art*, Series O, Sec. I: *Early Indian and Indonesian Art*. Newton, Mass.: University Prints, 1938.

Ruskin, John. *Lectures on Art.* In: *Works*, edited by E. T. Cook and Alexander Wedderburn, 24. London and New York: G. Allen, 1903–12.

[*Saddharma-puṇḍarīka.*] *Le Lotus de la bonne loi.* Translated by Eugène Burnouf. New edn., with preface by Sylvain Lévi. (Bibliothèque orientale, 9, 10.) Paris: Librairie orientale et américaine, 1925. 2 vols.

[——.] *The Saddharma Puṇḍarīka, or The Lotus of the True Law.* Translated by H. Kern. (Sacred Books of the East, 21.) Oxford: Clarendon Press, 1909.

Sakata Tetsuzen, ed. *Shingon-shū no kyōgi to jisshū* [Doctrines and Practices of the Shingon Sect]. Osaka: Dai ichi insatsu shuppan-sha, 1954.

Sawa Ryūken. "Nara-chō izen ni okeru mikkyō-teki bijutsu" [Esoteric Art Preceding the Nara Period], *Ars Buddhica* (*Bukkyō geijutsu*) (Tokyo), I (1948), 56–81.

Scheftelowitz, I. "Die bedeutungsvolle Zahl 108 im Hinduismus und Buddhismus," in Wüst, q.v. (pp. 85–88).

Scherman, L. "Buddha im Fürstenschmuck," *Abhandlungen der Bayerischen Akademie der Wissenschaften* (Munich), Phil.-hist. Abt., n. s., VII (1932).

Sekino Tadashi. *Chōsen no kenchiku to geijutsu* [Arts and Architecture of Korea]. Tokyo: Iwanami, 1941.

Senart, Emile. *Essai sur la légende du Bouddha, son caractère et ses origines.* 2nd edn., Paris: Leroux, 1882.

Shimbi taikan [Selected Relics of Japanese Art]. Edited by Tajima Shiichi. Tokyo: Nihon shimbi kyōkai, 1898–1908. 20 vols. (Abbr. *ST.*)

Shimizudani Kyōjun. *Tendai no mikkyō* [Tendai Esotericism]. Tokyo: Sankibō, 1929.

Sickman, Laurence C. S., ed. *University Prints: Oriental Art*, Series O, Sec. II: *Early Chinese Art*. Newton, Mass.: University Prints, 1938.

Sirén, Osvald. *Histoire des arts anciens de la Chine.* Paris: Van Oest, 1929–35. 6 vols.

——. *La Sculpture chinoise du V^e au XIV^e siècle.* Paris and Brussels: Van Oest, 1925. (Abbr. Sirén.)

SMH: see Gonda, *Shingon mikkyō hōgu benran.*

Smidt, H. "Eine populäre Darstellung der Shingon-Lehre," *OZ*, VI (1917–18), 45–61, 180–212; VII (1918–19), 103–21.

Soothill, William Edward, and Hodous, Lewis. *A Dictionary of Chinese Buddhist Terms.* London: Kegan Paul, 1937.

Soper, Alexander C. "Early Buddhist Attitudes towards the Art of Painting," *AB,* XXXII (1950), 147–51.

——. "Roman Style in Gandhāran Art," *American Journal of Archaeology* (Princeton), LV (1951), 301–319.

ST: see *Shimbi taikan.*

Stäel-Holstein, A. von. "Avalokita und Apalokita," *HJAS,* I (1936), 350–62.

Stein, Mark Aurel. *Ruins of Desert Cathay.* London: Macmillan, 1912.

——. *Serindia; Detailed Report of Explorations in Central Asia and Westernmost China.* Oxford: Clarendon, 1921. 4 vols. (I–III, text; IV, plates.)

Stein, Rolf. "Jardins en miniature d'Extrême-Orient," *BEFEO,* XLII (1943), 1–104.

Steinilber-Oberlin, Emile, with the collaboration of Kuni Matsuo. *Les Sectes bouddhiques japonaises, histoire, doctrine philosophique, textes, les sanctuaires.* Paris: Crès, 1930. (Tr. Marc Logé: *The Buddhist Sects of Japan.* London: Allen and Unwin, 1938.)

Stern, Phillipe. "Art de l'Inde," in *Arts musulmans* (Extrême-Orient). Paris: Colin, 1939.

Suzuki, D. T. *Mysticism: Christian and Buddhist.* New York: Harper, 1957.

——. *Zen and Japanese Culture.* New York: Pantheon (Bollingen Series LXIV), and London: Routledge and Kegan Paul, 1959. (Rev. edn. of *Zen Buddhism and Its Influence on Japanese Culture,* Kyoto: Eastern Buddhist Society, 1938.)

T.: see *Taishō issaikyō.*

Tagore, Rabanindranath. *Some Notes on Indian Artistic Anatomy.* Calcutta, 1914.

[*Taishō issaikyō.*] *Tables du Taishō issaikyō, nouvelle édition du canon bouddhique chinois.* Published under the direction of Takakusu Junjirō and Watanabe Kaigyoku. (Supplementary fascicule to the *Hōbōgirin,* q.v.) Tokyo: Maison franco-japonaise, 1931. NOTE: Refs. to sūtras in the Taishō edn. of the *Tripiṭaka* are given in the following order: sūtra number (preceded by *T.*) according to the Tables in the *Hōbōgirin;* volume of the Taishō edn. (in roman nos.); page(s).

Taishō (shinshū) daizōkyō (zuzō). See Takakusu (both entries).

Tajima, R. *Étude sur le Mahāvairocana-Sūtra.* Paris: Maisonneuve, 1936.

Tajima Shiichi. *Tōyō bijutsu taikan* [Comprehensive Survey of Far Eastern Art], Vol. III. Tokyo: Shimbi shoin, 1908–18.

Takakusu Junjirō and Ono Gemmyō (eds.). *Taishō (shinshū) daizōkyō zuzō* [Illustrated Section of the *Taishō issaikyō*]. Tokyo: Daizō shuppan kankō-kai, 1932–34. 12 vols.

Takakusu Junjirō and Watanabe Kaigyoku (eds.). *Taishō (shinshū) daizōkyō* [or more commonly: *Taishō issaikyō;* Complete Tripiṭaka of the Taisho Period, 1912–26]. Tokyo: Taishō issaikyō kankō-kai, 1924–32. 100 vols.

TAKATA OSAMU. *Indo bukkyō-shi* [History of Indian Buddhism]. Tokyo, 1944.

——. *Indo nankai no bukkyō bijutsu* [Indian and Southeast Asian Buddhist Art]. Tokyo, 1943.

TAZAWA ATSUSHI and ŌOKA MINORU. (*Zusetsu*) *Nihon bijutsu-shi* [Illustrated History of Japanese Art]. Tokyo: Iwanami, 1933.

TOGANOO SHŌUN. *Himitsu jisō no kenkyū* [A Study of Esoteric Thought]. Kōya-san: Kōya-san Daigaku shuppan-bu, 1935.

——. *Hizō hōyaku to kaisetsu* [The *Hizō hōyaku* and Its Explanation]. Kōya-san: Kōya-san shuppan-sha, 1949.

——. *Mandara no kenkyū* [A Study of the Maṇḍala]. Kōya-san: Kōya-san Daigaku shuppan-bu, 1932. (Abbr. *MK.*)

——. *Mikkyō shisō to seikatsu* [Esoteric Thought and Living]. Kōya-san: Kōya-san Daigaku shuppan-sha, 1939.

——. *Shingon-shū tokuhon* [Shingon Reader]. Kōya-san: Kōya-san shuppan-sha, 1948.

TOKI HORYŪ. *Si-do-in-dzou: Gestes de l'officiant dans les cérémonies mystiques des sectes Tendaï et Singon.* Tr. from Japanese by S. Kawamura and ed. by L. de Milloué. (Annales du Musée Guimet, Bibl. d'études, 8.) Paris: Leroux, 1899.

TOMITA GAKUJUN. *Himitsu jirin* [Dictionary of Esotericism]. Tokyo: Kaji sekai shisha, 1911.

TP: T'oung pao. Leiden.

TSUDA NORITAKE. *Handbook of Japanese Art.* 2nd edn., Tokyo: Sanseido, 1936.

TUCCI, GIUSEPPE. "A propos d'Avalokiteśvara," *MCB*, IX (1948–51), 173–219.

——. "Some Glosses upon the Guhyasamāja," *MCB*, III (1935), 339–53.

——. *Teoria e pratica del mandala; con particolare riguardo alla moderna psicologia del profondo.* Rome: Astrolabio, 1949.

——. *Tibetan Painted Scrolls.* Rome: Libreria dello Stato, 1949. 2 vols. text, 1 vol. plates.

VENKATASUBBIAH, A. *The Kalās.* Madras, 1911.

VIŚĀKHADATTA. *Mudrārākṣasam.* Ed. and tr. C. R. Devadhar and V. M. Bedekar. Bombay: Dhawale, 1948.

VISSER, H. F. E. *Asiatic Art.* New York: Seven Arts Book Society; Amsterdam: De Spieghel, 1952.

WADDELL, L. A. *The Buddhism of Tibet, or Lamaism; with its cults, symbolism and mythology, and its relation to Indian Buddhism.* 2nd edn., Cambridge: Heffner, 1934. Reprinted, 1958. (Abbr. Waddell.)

——. "The Buddhist Pictorial Wheel of Life," *Journal of the Royal Asiatic Society of Bengal* (Calcutta), LXI (1892), 133–55.

WALDSCHMIDT, ERNST. *Gandhāra, Kutscha, Turfan: eine Einführung in die frühmittelalterliche Kunst Zentralasiens.* Leipzig: Klinkhardt and Biermann, 1925.

WALEY, ARTHUR. "Did Buddha die of eating pork? With a note on Buddha's image," *MCB*, I (1932), 343–54.

WARNER, LANGDON. *Buddhist Wall-Paintings: A Study of a Ninth-Century Grotto at Wan Fo Hsia*. Cambridge: Harvard University Press, 1938.

——. *Japanese Sculpture of the Suiko Period*. New Haven: Yale University Press, 1923. (Abbr. Warner.)

WARREN, HENRY CLARKE, tr. *Buddhism in Translations*. (Harvard Oriental Series, 3.) Cambridge, Mass.: Harvard University Press, 1896.

WATTERS, THOMAS. *On Yuan Chwang's Travels in India* A.D. *629–645*. (Oriental Translation Fund, n.s., XIV.) London: Royal Asiatic Society, 1904–1905. 2 vols.

WILLIAMS, CHARLES A. S. *Outlines of Chinese Symbolism*. Peiping: Customs College Press, 1931.

WOODROFFE, SIR JOHN (pseud., Arthur Avalon, q.v.). *Shakti and Shākta*. 3rd. edn., Madras: Ganesh, 1929; 5th edn., 1959.

WOODWARD, FRANK LEE, tr. *The Book of Kindred Sayings (Saṇyutta-nikāya) or Grouped Suttas*, Part IV. London: Oxford University Press, 1917.

WÜST, WALTHER, ed. *Studia Indo-iranica*. (In honor of the 75th birthday of Wilhelm Geiger.) Leipzig: O. Harrassowitz, 1931.

YMAÏZOUMI and YAMATA, trs. "Shidda: résumé historique de la transmission des quatre explications données sur le sanscrit," *Annales du Musée Guimet* (Paris), I (1880), 321–33.

ZIMMER, HEINRICH. *The Art of Indian Asia*. Completed and edited by Joseph Campbell. (Bollingen Series XXXIX.) New York: Pantheon, 1955. 2 vols.

——. *Philosophies of India*. Edited by Joseph Campbell. New York: Pantheon (Bollingen Series XXVI), 1951; London: Routledge and Kegan Paul, 1952.

Zōzō meiki [Catalogue of Buddhist Sculpture with Dated Inscriptions]. Tokyo: Kōkogakkai [Archaeological Society of Japan], 1926. (Abbr. ZZ.)

Zuzō daishūsei [Buddhist Icons, Illustrated]. Tokyo: Bukkyō chinseki kankō-kai and Bukkyō tosho kankō-kai, 1932. 5 vols.

ZZ: see *Zōzō meiki*.

INDEX

INDEX

Abbreviations used in the index: m. = mudrā; attr. = attribute; post. = posture. * indicates an illustration on the page cited. The superscript numbers indicate notes.

Abhayaṃda/Avalokiteśvara, see Kannon
abhayamudrā, see *semui-in*
abhiṣeka, 112, 202²¹
abhiṣeka(na)-mudrā, see *kanjō-in*
act, one of Three Mysteries, 19
Act Seals, *see* karma sign
adara/gasshō/ādhāra, 41, 42, 213⁴¹, 214⁴⁶
ādarśa, see *kagami*
Ādi-Buddha/first Buddha, 104, 159; flame symbol of, 105, 107, 236²⁰, 237³⁴; spiritual essence of, 209³⁸, 229²⁹; system of, 234⁵⁴
Advayavajra, 141, 244⁴
Aggregates, 32
ahiṃsā, 59
Aizen Myō-ō, 148,*149, 246⁸
Ajaṇṭā, 44, 63, 94
Akṣobhya, *see* Ashuku
alms, giving of, indicated by *segan-in*, 53–54
alms bowl, 113, 143–44, 245–46
Amarāvatī, 43, 96
Amida/Muryōju, Muryōkō/Amitāyus, Amitābha: as Ādi-Buddha, 209³⁸; attrs. of, 141, 143–44, 162, 177, 183, 191, 195; in Esotericism, 25, 32; m. of, 45, 53, 54, 64–65, 70, 73–75, 83–84, 91–92, 100–101, 214⁹, 230⁴³; nine classes of, 71, 73–75, 92, 224⁶¹; thrones, 94, 95, 132, 135, 240⁸
Amida butsu seppō-in, 71, 222⁴⁷
Amoghasiddhi, *see* Fukūjōju
Amoghavajra/Fukū, 18, 206⁴
anathema formulas, 208²⁹
Anger Fist/*funnu ken-in*, 39–40
an-i-in/vitarkamudrā, vyākhyānamudrā/an-wei-yin/appeasement, 66–75, 220–24; identification of Yakushi with, 45; *renge-za* and, 125; *segan-in* and, 52

an-i-shōshu-in/an-wei shê-ch'ü yin, 69, 75
añjalimudrā, see *kongō-gasshō*
antara vāsaka, 245⁴
an-wei-yin, see *an-i-in*
anzan-in/an-shan-yin, 80–81, 82
appeasement, m. of, 66–75
appetiser/*mahāmudrā*, 201¹⁵
Apte, Vaman Shivram, 242²⁴
argumentation, 66, 70
arhat, 174, 255⁴
arrow, *see yumi, ya*
art, 10–16; contribution of Tantrism to, 21, 24–25; evolution of m. in, 43–48
art of calculation/*mudrā*, 202¹⁷
arūpadhātu/Formless World, *see* Three Worlds
āsana/za/postures, 52, 121–37, 240–44; *see also specific posture*, e.g., *renge-za*
Asaṅga/Sino-Jap. Mujaku, 17, 18
Ashuku/Akṣobhya: attrs., 25, 32, 165, 191, 227²³, 253⁵; in Esotericism, 25, 32; m. of, 83, 214⁹, 227²³·²⁶; throne, 134
ashuku-in, 83
āśrama, 83
āsravakṣaya/"exhaustion of leaking," 218³⁷
assurance, gift of, 61
asura, 32, 34³³, 217¹⁶
Aśvaghoṣa, 59
attributes/*lakṣaṇa/sōgō*, 9, 15, 141–95, 210⁴⁵, 244–50; color and shape of, 35; identification of specific Buddhas by, 44–45; as m. with form, 35, 36, 37
Auboyer, Jeannine: on *maṇḍala*, 25, 209³⁷; on m., 13, 27, 56–57, 68, 201¹⁰; on post. of Maitreya, 243⁴⁰
Aurangābād, 63
authority, 67, 150
authority/*muddā/muddikā*, 6–7

MUDRĀ, SIGNIFICATIONS *etc.* (*cont.*):

Expository m. of the Correspondence Body, 223[58]; of the Essence Body, 65, 73

exposition of the Law, 70

Felicity of Knowledge, 101

fear, granting the absence of, see *semui-in*

First Knowledge m. which conducts souls to enlightenment, 102

flowers, 72

fulfilling of the vow, see *segan-in*

formless, 35

giving, 51–54

good fortune or joy, 71

great, 36–38

Great Knowledge, 102, 105

great wisdom *stūpa*, 115, 116

hiding forms, 117–18

inner bonds, 39–40, 119–20

inviting all the saints to descend upon the altar, 29, 211[13]

karma, 93

Kichijō-ten, 71, 72, 101

Knowledge Fist, see *chi ken-in*

Law, 36–37

Lotus Fist, 38–39

Marishi-ten, 117

medicine bowl, 228[11]

meditation, 92

mind at work, 92

Mirror Knowledge/*myōkanzacchi-in*, 91–92, 236[27]

mother, 38

Mysterious Laws, 29

offers the saints perfumed water, 29, 211[14]; precious seats, 29, 211[15]

outer bonds fist, see *gebaku ken-in*

perseverence in meditation, 92

Prajña-pāramitā, 29

preaching, 51, 61

precious receptacle of Marishi-ten, 117

predication of the Law, 101

protection of the body, 29, 69, 210[11]

purity/*shōjō-in*, 28–29, 210[5]

saints, 29, 211[13]

Six Elements, 105, 235[1, 4]

stable bonds, 119

stūpa, 115–16

supplication, 76

suppressing, see *sokuchi-in*

suppressing darkness, 102

suppressing demons, 81, 82

supreme Enlightenment, 69

supreme meditation, 92

surprising the good of the earth, 82–83

Tathāgata, 92, 235[4]

Three Dharma, 203[29]

Three Mysteries, see *mushofushi-in*

touching the ground, see *sokuchi-in*

tranquillity, 68, 69

turning of the wheel of the Law, see *tembōrin-in*

two "wings," 75

tying the Three Worlds, 220[68]

ubiquity, see *mushofushi-in*

universal m. of the Essence Worlds, 115

universal offering (to the saints), 29, 211[16]

unopened lotus, 79

vajra, 224[1]

Vairocana, 102, 115

Victor of the Three Worlds, 114

warning, 226[11]

womb, 89, 229[28]

* * *

muga-jū, 64, 219[67]

muga mui, 60

mugyō/m. without form, 35

muhr/seal, 201[16]

Mujaku, *see* Asaṅga

multiple-armed statues, 52, 145, 147, 148, 151, 165, 178

Munōshō, *158

Munsterberg, Hugo, 247[7]

mūra/coin, 201[16]

Muryōjunyorai-in, 92

Mus, Paul, 168

musarū, 6

mushofushi-in/*wu-so-pu-chih-yin*/m. of the ubiquity (of the Three Mysteries), 65, 73, 115–16, 239

myō, see *bīja*

myōkanzacchi-in/m. of the Mirrow Knowledge, 91–92, 236[27]

Myōmon-ten, 137

Myō-ō, *see* Guardian Kings

Mysteries/*sammitsu*, 19–26 *passim*, 115–16, 187–88, 206[8]

Mysterious Laws, m. of, 29

mystic circle, *see* circle, mystic

mystic formula, see *dhāraṇī*; *mantra*